WRITERS AT THE MOVIES

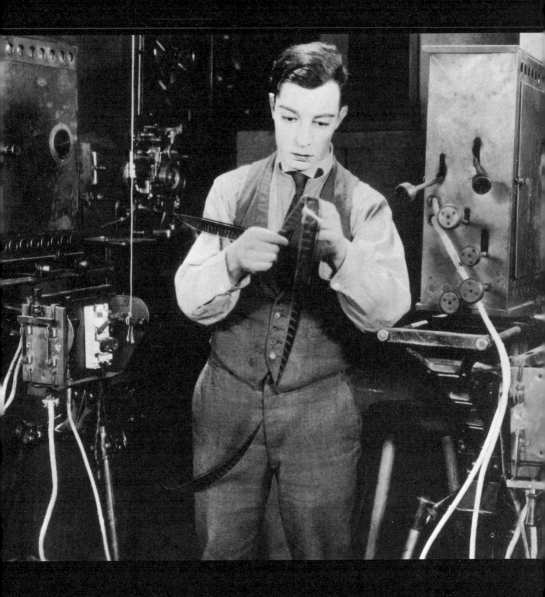

Perennial

An Imprint of HarperCollins*Publishers*

WRITERS

AT THE

MOVIES

Twenty-six Contemporary Authors Celebrate

Twenty-six Memorable Movies

EDITED BY JIM SHEPARD

FIRST EDITION

Designed by Kate Nichols

Library of Congress Cataloging-in-Publication Data is available.
ISBN 0-06-095491-4

00 01 02 03 04 ❖/RRD 10 9 8 7 6 5 4 3 2 1

CONTENTS

INTRODUCTION

riters at the Movies began with some short pieces on movies that I wrote for the *New York Times* Arts and Leisure Section, and the response that I received. I got letters and E-mails from film professors and students and just plain devotees, and a surprising number mentioned how valuable they found a writer's perspective on film. Then the poet Lawrence Raab, in conversation, remarked that a group of essays like the ones I'd been writing would make a great anthology. Now there was a thought: what *about* compiling a list of the fiction writers and poets you most admire and asking them to pick one movie and write about it?

Most writers I knew seemed to have private and intense relationships to particular movies, and most of them had never before been asked to write about film, or at least to do so with so much freedom. I told those I approached that they could write an appreciation, a deconstruction, a close reading, a memoir, a guilty pleasure, or just about anything else. Part of the excitement involved seeing which movies they would choose, and part involved seeing what they would do with them.

They didn't let me down. The contributions run from the engaging and the smart to the stupendous. All of them are illuminating on the movies under consideration and on the minds turned loose on those movies. What's represented here is the best sort of intellectual play. The essays make you want to go out and see the movie, or see it again. They make you want to read the writer's work. They suggest that fiction writers and poets are in some ways the ideal respondents for film: distanced enough for the required critical detachment, and yet still fans; innocent enough about the technical apparatus to experience the preanalytic emotions necessary to seduction, and yet acutely aware of the ways in which, as in all the arts, form guides our reactions to produce meaning.

This collection is, finally, what its subtitle asserts it to be—a celebration of film—and each of the essays demonstrates its author's passion for the medium, or at least for what the medium every so often achieves. As writers, we may never know how much our ways of perceiving have been conditioned by a lifetime of movie watching. We write about movies, in other words, not only because we love them, but because their cultural power obligates our response.

WRITERS AT THE MOVIES

BOOK INTO FILM: CHABROL'S
MADAME BOVARY

DIRECTED BY CLAUDE CHABROL

Claude Chabrol lives in Gennes, a small town on the southern bank of the Loire, upstream from Angers. The river here is sluggish and shallow enough for high-summer fishermen merely to punt their boats. A basic box-girder bridge crosses the flow in two leaps, setting its foot down on a humpy island of sand. This bridge (or, more likely, its predecessor) was the site of a famous rearguard action by cadets of the nearby Saumur Military Academy against the advancing Germans in 1940. On the other side of the Loire lies La Rosette,

whose traditional small-town rivalry with Gennes can take strange forms. A few days before I met Chabrol, a woman from La Rosette decided to drown herself by jumping off the bridge. An emergency call came through to the *sapeurs-pompiers* of La Rosette. "None of our business," they replied. "There isn't enough water on our side for her to drown herself." So the caller was obliged to put the phone down and redial the fire brigade of Gennes, who arrived too late to save the unfortunate woman.

Provincial France, now trundled through by British caravans rather than German tanks, has always specialized in tragedies of the comic grotesque, their private misery magnified by casual, uncaring public circumstances. Like the case of Delphine Couturier, the bored and fanciful wife of a health officer in the Norman village of Ry in the 1840s. She was remembered as a pretty woman with a taste for reading and interior decoration (her double curtains of yellow and black were much remarked on), who took first lovers and then poison, the latter in 1848. This obscure *fait divers* from the Vexin region became, in less than a decade, the magnificent and cruel machine of *Madame Bovary*. Not that Flaubert's imaginative transformation of the story impressed Delphine Couturier's servant, Augustine, who survived her mistress by more than half a century. Interviewed as amazingly late as 1905, when she was seventy-nine, Augustine was invited to compare her mistress's death in 1848 with the fictionalized version. Her reply is one of Life's great rebukes to Art: "Ah!" she said, "It was all much sadder than in the book."

G iven Chabrol's expertise with violent provincial drama, it's surprising that he wasn't asked to film *Madame Bovary* before 1991. The novel itself had fascinated him from an early age—earlier, in fact, than he initially remembered. When the film project was announced, he routinely commented that he must have first encountered Flaubert at the age of fifteen or sixteen. But after shooting began, the flagrantly French truth came back to him. He had been thirteen at the time, growing up in the Creuse:

> I started reading *Madame Bovary* the day before I lost my virginity.
> It made a very strong impression. I was fascinated. I didn't under-

stand everything, but I was under its spell. And then the next day, I had a rendezvous with the girl I was in love with. We went for a walk in the woods. We were wearing *sabots*. We had our walk, we kissed a lot, and then what had to happen happened. . . . By the time I walked her home it was getting dark. We were holding hands, I was kissing her, but at the same time I was in a hurry to get home and carry on with my book. So I walked her back a little more quickly than was necessary, and as soon as I was alone I ran home as fast as I could. I had to go back through the wood, it was dark, and as I ran I lost one of my *sabots*. It was too dark to find it, and I had to hop my way home, with only one thing on my mind: getting back to my book.

This (distinctly filmic) reminiscence suggests a new dinner-table question. Instead of "Do you remember where you were when Kennedy was shot?" we should ask, "Do you remember what you were reading when you lost your virginity?"

Chabrol freely admits that his output, while prolific and often swift—he made a German TV version of Goethe's *Elective Affinities* in twenty-six days—had been variable in quality. "I think on the whole I prefer the films that I like and that did badly to the films I made that I dislike and that did well." "Are there any," I asked, "that you don't like and that also did badly?" "Oh, that happens. For a long time I thought I had made the worst film in the history of the cinema. *Folies Bourgeoises*. Dreadful. But then I saw Joshua Logan's *Fanny*, an American adaptation of [Marcel] Pagnol, with Charles Boyer, Horst Buchholz, Maurice Chevalier, and Leslie Caron. Then I knew I had not made the worst film in the world."

Madame Bovary, of which Chabrol is properly proud, was filmed at Lyons-la-Forêt, a spruce little town in the Eure studded with *antiquaires* and guard-dog notices. There is a certain misconceived rivalry between Lyons-la-Forêt and the village of Ry as to which was the "real" Yonville of Flaubert's novel. Chabrol favored Lyons, partly on grounds of topographical plausibility (which is contestable) and partly because of the shared *yon* of each name (though an equal case could be made for *Ry* being the end of "Bovary"). "I got myself hated by the people of Ry," he says. "The only

part I kept of Ry was the church." The rivalry is misconceived for two reasons: First, because given that the village is portrayed as a steaming compost heap of bores, prudes, hypocrites, charlatans, and know-nothings, why should anywhere want to claim itself as the original? But they do. Lyons-la-Forêt rather more smugly and successfully: It declines any overt boast, while knowing that it has the prettier face, and that its cinegeneity has landed both Renoir and Chabrol. Ry is more strident in its claims, not least because they are stronger. It is indeed just the sort of undistinguished one-street village Flaubert had damningly in mind. In the churchyard there is a memorial tablet from the Fédération Nationale des Ecrivains de France to Delphine Couturier (later Delamare), without whom indeed. As you descend from the church you encounter La Rôtisserie Bovary, Le Grenier Bovary (antiques), Vidéo Bovary, and Le Jardin d'Emma (flowers). There is even a shop, whose depressingly whimsical title would probably have amused Flaubert, called Rêve Ry. The point is thoroughly made by the time you reach the village's main tourist attraction, the Museum of Automata, a collection of five hundred moving models, three hundred of which, on the ground floor, recreate scenes from *Madame Bovary*. The figures are a few inches high and oscillate mechanically to background music. See everyone sway, sway together at Emma's wedding! See Emma dancing at the ball! See Binet coming out of his duck barrel! See Hippolyte having his leg sawn off! See Emma ripping off her clothes with Léon! It is all innocently tacky and dangerously hilarious, the only sort of "illustration" of his novel that Flaubert, with a grim twinkle, might for once have blessed. In the same exhibition space you can examine a life-size reconstruction of Homais's *pharmacie* (in fact, the Pharmacie Jouanne Fils) and two coach lamps that once belonged to Louis Campion, the "original" of Rodolphe Boulanger. These souvenirs produce a curious effect. It is one thing to linger over buffed or frayed memorabilia once touched by the living hand of a great writer or artist, another to gawp at personalia that have been wrested from their original owners by the power of a work of art. Are these really Louis Campion's coach lamps? Not anymore. Genius has effected their legal assignment to Rodolphe Boulanger—or Rodolphe, as his reader friends know him. And so you stare at a real item that once belonged to an imaginary character.

According to Chabrol, the inhabitants of Lyons-la-Forêt were at first all Norman and mistrustful about the film, but are now not just reconciled to it but commemorating it. Chabrol's crew "improved" the village square with a fake fountain; liking it, the municipality commissioned a genuine working replica for the long term. Similarly most people in Lyons were happy to have false fronts attached to their houses and shops. There was only one recusant, an estate agent in the main square. So whenever a wide shot was required, a wagon piled high with hay would be conveniently parked to block out modern commerce. Perhaps the estate agent disapproved of the book. When Stephen Frears was preparing to film Choderlos de Laclos's novel *Les Liaisons Dangereuses*, his location scout came across the perfect château on the border of Brittany and the Vendée. Praise was offered, negotiations entered into, times and prices discussed, agreement reached. At the last minute the owner inquired the name of the film they proposed to make. The title of Laclos's novel was mentioned. *"Pas de ces cochonneries sous* mon *toit"* ("None of that filth beneath *my* roof") replied the owner, and chased the money away.

The story of Emma Bovary promises cinemagoers, if not exactly *cochonneries*, at least the life and death of a transgressive woman. MGM advertised its 1949 Vincente Minnelli production with the slogan: "Whatever it is that French women have, Madame Bovary has more of it!" Stars drawn to the role (in adaptations of varying looseness) have included Lila Lee, Pola Negri, Jennifer Jones, and now Isabelle Huppert. There have been American, German, Argentine, Polish, Portuguese, Russian, and Indian Emmas. The first French screen Emma was Valentine Tessier in Jean Renoir's 1933 version. "Half swan, half goose," was Pauline Kael's unflattering description of her performance. Certainly she was too old for the part (being in her mid-forties); worse, her style of acting was too old as well, being part Comédie Française and part tie-me-to-the-track silent-screen exaggeration. As Charles, Pierre Renoir (Jean's brother) managed the realist mode more convincingly, but was hampered by being made up to look like Flaubert himself, so that an eerie sense develops of an author walking through a transmogrification of his own work, wondering what they've done to it. Apart from Hippolyte's operation and Emma's death, there's a genteel and strangely underpowered feel to the whole

enterprise; Darius Milhaud's perky music sounds appropriate, which it shouldn't.

Before the film's release, an hour was hacked from its original three, and commercial failure ensued (though you can't imagine a director's cut being necessarily better—merely longer). In *My Life and My Films* Renoir pointedly makes no mention of the final product, choosing instead to describe a game called "Lefoutro" (*foutre* being French for "fuck") which director and stars played over convivial dinners at Lyons-la-Forêt:

> A napkin folded in the shape of the male organ was placed in the middle of the dinner-table, and the rule was that it must be studiously ignored. Anyone who showed the slightest sign of being distracted by it was rapped three times over the knuckles with "lefoutro" while the following sentence was pronounced: "I saw you making advances to your neighbour. You insulted Monsieur Lefoutro. You are hereby punished and your fault is pardoned." The guilty person could protest—"How could I have insulted Monsieur Lefoutro when I was busy cutting up my chicken?" In this case a vote was taken and the penalty doubled if the sentence was confirmed. Harmless games of this kind did more to prepare us for the next day's work than tedious discourses.

A decade later Renoir was working in Hollywood, and attempted to remake the film. His letter of June 8, 1946, to the producer Robert Hakim at RKO shows a hopeful director bending the book (and the novelist's intentions) in order to give the project contemporary relevance and morality:

> The refusal to face facts and look at life from the realistic standpoint is quite a common failing among the young girls of today. And in America particularly, if so many women jump from one divorce into another, and end by living an extremely unhappy life, it is really because, like Emma Bovary, they waste their time hunting for an impossible ideal man. . . . I want to show . . . that if her

[Emma's] life had been built on sounder principles, she would have been perfectly happy with her husband.

Renoir's proposal came to nothing, and it was MGM, three years later, that released the only Hollywood version of the novel. The eighteen-year-old François Truffaut saw it the following year and pronounced it "MIND-BOGGLING!"—which is unlikely to have been a compliment.

In fact, Truffaut turned out to be the silent link in the chain of descent from Renoir to Chabrol. In 1960, after the success of *Les Quatre Cent Coups*, Jeanne Moreau asked him to direct her in a *Madame Bovary* she would also produce. Truffaut turned her down. As he wrote to Renoir, "Knowing all your films almost by heart, I would not be able to stop myself from copying entire scenes, even unconsciously." Instead, he explained, "I have another project with Jeanne. . . . It's called *Jules et Jim*." Moreau next approached Chabrol, who also declined; she had, as he tactfully put it to me, "certain ideas" about the role.

In the end Chabrol found his Emma in Isabelle Huppert. She is a long way from Valentine Tessier, and just as far from Jennifer Jones. Where other actresses give us a sort of pouty boredom that yet seeks to flirt with the audience, Huppert offers severity, anger, and an irritation raised to the condition of nausea. She gives Emma a lucid awareness of her own condition: "She is a victim who does not behave like a victim." Huppert has a capacity to empty her face of expression in a way that both alarms and seduces; like Charles, we blunderingly want to make things right for her. And this harshness and frustration are in place most of the way: She has the control and seeming lack of vanity to hold back her moments of full beauty to match those rare times (with Rodolphe and Léon, never with Charles) when the catching of happiness seems possible.

I asked Chabrol how he obtained this, and other carefully authentic performances (only Lheureux is a comic cut too far). He is deliberately unmystifying. "First, there is the matter of selection. I choose Flaubertians, so they won't want to change things, so they can express themselves without any *trouvailles de comédien*. I explain that my idea is to be as faithful as possible to Flaubert. They reread the book at the same time as the scenario. Isabelle claims she hadn't read *Madame Bovary* before

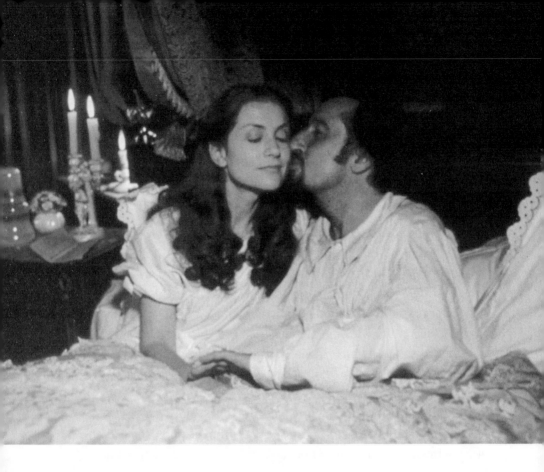

making the film, but I remember her reading it on the set of *Violette Nozière*. . . ." But how does he create their performances with them? "I work with actors I know, so I can feel when they're not happy. I talk to them before—if they go wrong I have dinner with them and then it goes all right the next day." So what sort of things do they discuss? "Well, Isabelle thinks that one of her profiles is better than the other—I never know which. She was worried that fidelity to Flaubert might conflict with her better side. So I let her have her good profile. The thing about actors is that they must be free yet protected. I never understand those who direct in terms of hours and minutes. I only show the actors the general direction; I give them a pointer. Then occasionally I make small but precise suggestions." For instance? "Well, I might tell Isabelle to open the window more slowly."

It sounds like a hands-off technique of remarkable tact. It also sounds too good to be true. Jean-François Balmer, who played Charles, gave it a

different slant. "He is someone who directs a very great deal, although when you see him on the set he never says a word, either positive or negative. He just lets the actor get on with it, stew in his own juice. But I think that he's very subtle and very controlling, because the way in which he places the camera, the way in which he chooses the focus, obliges you to be his prisoner, to be within the frame he chooses. So in fact you have very little latitude. He catches you in a pincer movement. An agreeable one, but a pincer movement all the same."

Chabrol's film is without argument the most faithful adaptation so far, a work of intense devotion to the text. Paradoxically this merely emphasized the question of whether he should have done so in the first place. Every Flaubertiste knows that the novelist famously forbade illustration of his work, on the ground that fixing a character's appearance inhibits the reader's imaginative freedom; worse, he actively prohibited—from the very first year of publication—any theatrical adaptation of *Madame Bovary*. Greater fidelity therefore assumes greater disobedience. Chabrol's counter is skillful, and as convincing as it could be. First, Flaubert had a cinematic way of writing, both in preliminary composition—visualizing scenes in detail before writing them down—and in his annotations of movement: "The director's requirements are already integrated into the text." Second, while theater is confined to a fixed point of view, that of the spectator, film operates in a "game between subjectivity and distance"; this is an exact parallel of Flaubert's prose technique, which eases fluidly between objective description and *style indirect libre*. Third, Chabrol is usefully convinced that had Flaubert lived a century later, he would have wanted to write and direct films; thus Chabrol can consider himself as Flaubert's "technical adviser" on the project. And finally, "There is betrayal only if I invent or depart from the novel."

Chabrol's beat-by-beat fidelity to the novel is probably unprecedented in the history of cinema. For example, he established an inventory of all the noises mentioned by Flaubert—bird calls, buzzing wasps, bleats, and baas—to use as a basis for the sound track. So there is no noise in the film that is not in the book. I was surprised that the sun always seemed to be shining in the film—Normandy is, after all, one of the most pluviose provinces in France—and wondered if this was simple meteorological luck

during the shooting. Chabrol courteously directed me back to the text: "It rains very little. There is a storm at the moment when Charles and Emma set off for Yonville. The characters often refer to heat and to morning mist. Perhaps it rained in Flaubert's head. But not in his book, so not in the film. Nor were the reasons partly economic, as I had also suspected: "We could easily have hired the *sapeurs-pompiers*." As long as they didn't try to get them from La Rosette.

When I saw the film, I thought I picked up two moments of Chabrolian invention, even if neither was much of a betrayal. Isabelle Huppert shows us her tongue on only two occasions—the first time, very early on, when she licks out the bottom of a wineglass as a coarse come-on to Charles, and the second, right at the end, when the tongue is burgundy with blood and she is dying. This subtle linking of eroticism and death was, as it turned out, in the novel all along (though more strongly accentuated by being made visual). The other was a tiny moment as Charles and Emma are leaving their wedding feast: Charles, bumbling along beside his bride, manages to drop his hat and then awkwardly pick it up. Apart from being in character, this also seemed to point usefully forward to the probable maladroitness of the wedding night. Pressed, Chabrol admits to not exactly an invention but rather a *trouvaille* (find). "We did the scene three or four times. In only one of them Charles dropped his hat. It was the best take. But let's call it a *trouvaille* that comes from Flaubert."

But film must also find, and state, at a basic level; it cannot not be specific. Flaubert builds up Emma's physical presence in the novel with a sort of delicate fetishism, in allusions to her hair, the tips of her fingers, her shoes—touching and tickling her extremities like a boy whipping a top to get it spinning. Chabrol has to show us Huppert complete, from her first appearance. There are also things the writer sees but forbears to mention. In a letter to the historian and philosopher Hippolyte Taine a decade after the novel was published, Flaubert explained how he might picture to himself an entire room in which the action was taking place, with all its furnishings, and yet never mention such surroundings in his text. "There are many details that I don't write down; for instance, in my own mind, Homais is lightly marked with smallpox." What do you do about some-

thing like that? Chabrol says that you use only what is in the novel, not what is in the extraneous material. (You can also blur matters by giving Homais a beard.)

However, Chabrol did go back to the original scenarios Flaubert wrote before embarking on the novel. These are succinct summaries, often robustly expressed, of key actions or attitudes; they are not unlike a screenwriter's jottings. It was here, for instance, that Chabrol found guidance on the film's sexual tone. The novel makes the point that in Emma's relationship with Léon, he is more her mistress than she his. The scenario puts it more brutally: *"La garce le chevauche"*—"the bitch bestrides him"—an annotation Chabrol follows literally when the couple get to bed. On the other hand, he jibbed at some of Flaubert's earthier indicators, like the description of Emma after one of her encounters with Rodolphe: "She came back from the garden with her hair full of come."

If Chabrol's film marks the high point of fidelity in treating the original text, with Flaubertistes straining to identify this or that minor invention, Vincente Minnelli's 1949 version seems free-associative by comparsion. Is there a single line of original dialogue, a single line of the narrative prose, which makes it through to the final cut? The film opens with Flaubert's trial: The prosecuting counsel demands a conviction while banging the rail in front of him with a bound copy of *Madame Bovary*. Pedants may immediately mock: There was no bound copy of the novel at the trial, for the simple reason that the work existed only as a serialization in the *Revue de Paris*. James Mason, as Flaubert, then addresses the court in reply—something the novelist was far too canny to do in reality—offering a defense of the book that, while plausible to modern ears, was far from that presented by his advocate in 1857.

Such minor adjustments—and major restructuring—are typical, guilt free, and, in a way, blameless. A property is homogenized by a production process into an entertainment whose psychology must be plausible to its makers and comprehensible to its customers. Or, to put it in Chabrol's words, "It's a Western." And as such, seriously and properly made. Thus the ball scene is spectacular: Emma is the whirling belle, the cynosure, and Charles the drunken dolt who spoils her fun and gets humiliated; when

Emma seems about to faint, servants are sent with chairs to break some windows. The novel's point, of course, is that it was all much more ordinary than this: What glowed in Emma's anticipation, experience, and memory was mere jolly routine to the other partygoers, who scarcely noticed the unimportant doctor's unimportant wife. Similarly, when Rodolphe ducks out of running away with Emma, it looks well and Hollywood to have her standing with packed trunks outside Homais's pharmacy while the coach thunders heartbreakingly past; but Rodolphe's betrayal was never so grand. Like a true, authentic coward, he merely slipped away. Such differences between film and book unwittingly endorse one of the novel's greatest lines. When Emma goes to see *Lucia di Lammermoor* in Rouen, she guilelessly compares opera's emotions and lifestyle with her own. "And now she knew the paltriness of the passions that art exaggerates." Minnelli's film, in this respect, is operatic.

Irritation at such "betrayal" of the book is short-lived and pointless. It's more interesting to compare what Hollywood imagines to be human psychology with what Flaubert faultlessly observed to be the case. In Hollywood they prefer the cause-and-effect of human behavior to be a lucid unit: if *a*, then *b*. What provokes Emma's dissatisfaction and boredom? Reading all those Romantic novels, nothing more, nothing less. In this simplification Hollywood revealingly puts itself on exactly the same level as Charles and his mother, who both try to stop Emma reading such fiction; the elder Madame Bovary argues that one has the right to alert the police if a bookseller persists in his trade as a poisoner. More creative is the adjustment Minnelli makes with the operation on Hippolyte's clubfoot. The problem is how to retain sympathy for Charles: If, as in the novel, he botches the operation so badly that the little fellow's leg has to come off, won't this terminally disenchant popcorn eaters who place their faith in the medical profession? The solution is as follows: At the last minute Charles declines to operate on Hippolyte, pleading lack of experience. For this honorable decision he is mocked by the assembled villagers who are peering in at the apothecary's window (such scorn helping us to retain sympathy for Charles). However—again if *a*, then *b*—because Charles has failed to become a famous (and potentially rich) person by performing the operation, Emma goes off for the first time with Rodolphe. This, in turn,

helps popcorners retain sympathy for Emma: Everyone can understand how you might be driven to a bit on the side if your husband turns out to be a low-achieving wimp. While Flaubert and Chabrol follow the more brutal and complex realities of human behavior, Hollywood worries about sympathy rather than truth.

But fidelity has a downside too. Once you realize that little is being invented, then (presuming you know the book), you also realize that little, except perhaps the acting, is going to surprise you. Oh, you feel, well, if we're here in the novel now, then we've got five minutes on that bit, ten on the next, then such-and-such happens, and so on. Furthermore, prose narrative and film narrative inevitably pull against each other. One of the novel's climactic moments, still shocking to read, comes when Emma and Léon fuck in the closed cab as it careers around the streets of Rouen. It is a key moment in Emma's degradation, a vortex of lust, desperation, and snobbery ("They do it like this in Paris" is Léon's seducing phrase). The scene lasts a long time in the book, even if it occupies only a page of prose, and its effect is the more powerful because Flaubert never goes inside the cab but lets us deduce events by annotating the vehicle's path, changing destination, time of hire, and by evidencing, at one point, the remnants of a torn-up letter being thrown from the window. In Chabrol's film—the director admits it—this scene doesn't work (it doesn't work for Renoir either). It can't be long enough, and it somehow can't be shocking enough (Oh, now they're doing it in a cab instead of in bed, you think). And because film always pulls toward the specific, Chabrol feels obliged to give us a glimpse of Emma and Léon inside the cab, just to confirm that they aren't playing Scrabble. There are moments when cinematic specificity enhances—for instance, in the goriness of the doctoring—but mainly the effect of the medium is to iron out the book, to flatten its rhythms.

French Flaubertistes generally applauded Chabrol's film; French film critics had their doubts. "Too academic," some said, blaming the very fastidiousness others praised. "They accept fidelity in minor works," Chabrol muses. "Hitchcock was very faithful to *Rebecca*—no one denounced him for his fidelity. Besides, I always believed that cinema and literature were going in the same direction, were companions." This may be true in the

widest sense, but Chabrol's film, by its very scrupulousness, forces us to address the question of Book into Film. What do we want of it, what is it for, whom is it for? Though cinema has been raiding literature high and low for an entire century, there's still unease about the collaboration, or victimization. A Shakespeare play may become a Verdi opera without disturbing the theatrical or operatic communities (perhaps in part because Shakespeare was himself intensely parasitical on other sources). But cinephiles tend to feel that a book-based film is less authentic, less purely a film, whereas the book-devoted are wary of . . . what? Vulgarization, simplification, loss of subtlety, for a start; loss of control over how you as reader re-create the characters and action; loss of the experience happening inside of you, and in your own time of choosing, rather than out there, publicly, for a period of time imposed by someone else. Is the film an easy way in for those daunted by a classic novel, or a way of avoiding it altogether? And for those who know the book, is the film a parallel experience, an extension, or an alternative?

I used to mistrust filmic infidelity, and would knowingly point out anachronisms, misquotations, nonquotations, hair color changes, and so on. The director's principal task was to protect the integrity of the book against his own and his backers' instinctive desire to coarsen and banalize. Now I am much less sure. Partly this comes from the experience of having a couple of my own novels turned into films. One was made by the French director Marion Vernoux. I met her—appropriately enough, aboard a cross-Channel ferry—half an hour after shooting had finished. The first thing I found myself saying was, "I hope you have betrayed me." "Of course," she replied, with a complicit smile. Neither of us exactly meant it, though we knew what we meant all the same.

Chabrol maintains that if Flaubert had lived in the age of cinematography, he might well have made films. This is true: He did, after all, try the theater. But if so, he wouldn't have made *Madame Bovary*. Not just in the sense that he wouldn't have adapted it from its prose form, but in the wider sense that if he had decided to recount the story of Delphine Couturier with storyboard and lens rather than quill pen, he would necessarily have imagined it differently from the very start. He would have thought about the external eye rather than the internal; he would

have known that screen dialogue doesn't work like page dialogue; he would have imagined the impersonating actor alongside the character; he would have thought differently about time, and about light. So is this what the loyal filmmaker should do? Are faithful adaptations inherently unfaithful—indeed, the more faithful, the more unfaithful?

At the end of my visit to Chabrol, we sit over breakfast, the scented Anjou air lightly polluted by a miasma of burnt toast. The morning radio is preparing the French for their annual lemming dash to beach, second home, or up-country *pension*. A bland voice reports the findings of a survey into national expectations in the matter of holiday romance. Fifty percent of Frenchwomen apparently hope that the amorous encounter will extend beyond the duration of the holiday. By contrast, only 15 percent of Frenchmen want such affairs to continue after bag-packing time. Chabrol shrugs. "They need a *survey* to tell us that?" Another summer, another heartbreak. Today's Emmas murmuring, *"J'ai un amant."* Today's Rodolphes thinking, She's not bad, the doctor's wife, I think I'll have her. They should read the novel before their holidays. Or see one of the films.

Would it make any difference? A book is only a book, a film is only a film. Today's Rodolphes might reflect that after all it is only—or mainly— Emma who suffers, whereas Rodolphe returns from his cowardly flight and ends up sharing a companionable beer with Charles. If so, they should be directed out of both film and book, and back into the prehistory of the novel, back into life.

Louis Campion, original owner of those carriage lamps in the Ry museum, was overwhelmed by the death of his "Emma." We know that he would sometimes come to mourn with "Charles"; that he suffered financial ruin and emigrated to the United States; that he later returned to France, and committed suicide in Paris, *"en plein boulevard"* (right on the street). We know little else. His life beyond *Madame Bovary* is there to be invented by anyone bold enough to write—or film—a sequel. For him too the words of Delphine Couturier's aged servant apply: "It was all much sadder in the book."

BUFFALO '66

DIRECTED BY VINCENT GALLO

t's important to not read this essay if you haven't seen this movie. The movie holds up upon re-viewing, but in watching it a second and then a third time, I was startled by how, more than most films, wildly *alive* it had been when seen for the first time.

Another reason for the movie's exceptional "first-time" strength is that it is punctuated with several strange and surprising, beautiful respites, or step-aside scenes, in which the characters seem to be directed to almost purposefully step outside the flow of the narrative. In these scenes, the lighting changes, and all the other characters fall back, while one main

character emerges from the others' midst, and sings, or dances, or offers a soliloquy. . . . These scenes, or performances, are not a kind of self-conscious Woody Allen–ish thing, but are conducted more like the play of children who improvise with an utter lack of affectation, lost in the sheer beauty and mystery of stepping off into unexplored or unexpected territory.

Such moments—there are perhaps half a dozen of them studded throughout the film—can take your breath away the first time; you can't believe the movie's going where it's going: that the director's willfully risking a good thing—a movie about redemption that is already compelling in its "straight" or orthodox structure.

Each time the movie slides into one of these strange eddies, however, it's a fine thing, and there's no substitution for seeing these scenes for the first time—being surprised, enveloped, by both the unusual imagery as well as the density of those scenes' emotional content.

Forgive, then, the windy admonition not to read this essay if you haven't yet seen the movie. It's astounding, how vital and different this movie is.

The movie begins with the feral-looking Billy Brown (Vincent Gallo) being released from prison on a typical Buffalo winter day. The view of his release is from above, somehow private and knowing, and somehow slightly magnified and wobbly—almost as if we might be watching him through the optics of some surveillance device, or even a rifle scope. He moves briskly, trotting, as if confused: in flight, escaping. He's dressed in blue, and with the exception of his strange and little-boyish (like his name) brilliant red boots, nearly everything around him—the steel concertina wire, the pavement, the snow—is tinged with blue. This blueness contrasts sharply with the harsh bright red bricks of the prison, as he hurries past it.

Billy curls up in the fetal position on a park bench, overcome by a wave, a collision, of memories so jarring that we understand that even his sleeping in the misty drizzle is a relief and a release from the prison of his memories.

He awakens some time later, shivering, as if to a second life: possessing nothing, and with everything new before him again.

We spend the next long scene, or series of scenes, watching with no small degree of mounting tension as he searches for a place to piss. The prison won't let him back in, so he takes the bus all the way into the city, where the restroom at the bus terminal is closed. With increasing desperation, bent over in discomfort and then pain, he reels through crowds, trying to find a place to void his toxins, but unable to find one.

(An interesting thing happens during this extended scene. As Billy is clawing desperately at himself, grabbing at his zipper in wild agony, it seems to the viewer that surely he can stand no more, and that at any second the viewer is going to be exposed to the unpleasantness of a public urination. It is with relief, later into the scene, that we avoid such exhibition—but the duration of the camera's focus on Billy and his zipper seems for the longest time [five to ten minutes of reeling around] to indicate otherwise. In the end, it seemed to be like an exhibitionism barely withheld.)

Back in scene, Billy starts to urinate in a parking lot, behind a parked car, but just at that moment, the car's owner (a woman he had earlier asked for directions to a bathroom) comes walking out to her car, and he lurches away, still in anguish.

He finally finds a bathroom in a dance studio, a bathroom with an honest-to-goodness functioning urinal.

Unfortunately, however, he finds himself standing shoulder to shoulder with another man who gazes down admiringly as Billy unzips; and at this invasion of privacy—"You're so big," the man praises—Billy goes ballistic, shoves the spying man out of the bathroom, and curses that now he's too upset to piss.

In the gymnasium through which he had rushed on his way to the urinal, there was an aerobic step-dance class going on. Several muscular, athletic women (dressed mostly in red) were dance-exercising furiously, while at the back of the group was a heavier, softer woman dressed in filmy blue, focusing intently on the instructor's cadence, but quite out of step with the frenetic drum-stepping of the others: laboring to keep up with the thunderous rhythm, as her breasts (but no other part of her) seem to shake to the same earnest rhythm of the other dancers' legs.

Still intent on trying to get the dance down, she glances over her shoul-

der with mild curiosity at Billy Brown as he stumbles past the first time, en route to that unhappy encounter in the narrow public urinal.

In short enough order (scripted and filmed with powerful, desperate intimacy and despair), Billy has, through a tense phone call, established himself as being deeply imprisoned by the need to impress his parents, as well as possessing a temper that, though not flash-point trigger-happy, seems to know no governance once it is ignited. He kidnaps the woman in blue, Christina Ricci—Layla is her name, an assonance as dreamy as her persona—and though she struggles, so passive is she in the struggle that the only words she speaks are, "You're hurting me"—not even, *Stop, you're hurting me.*

Billy kidnaps her to take her home to introduce to his parents—he's told them he's happily married. (So detached are they from him, and he from them, that they don't know he's been in prison for five years). He hijacks Layla's car.

Never in the movie will we hear him speak her name. Instead he gives her another name, the name of the girl he had a crush on all throughout grade school. It's in this scene, the kidnapping and carjacking, where we understand finally the fullness of Billy's craziness. I'm not sure how he manages to convey beneath his crazed temper that, well, *he's not a bad guy*, but somehow, he does. He doesn't seem to accomplish this trick of engaging our tentative sympathies by his yearning for reformation. He's polite and earnest, curious—all pleasant enough qualities on the surface— but if anything, he's oblivious to the rages that pass over him: as if they are like fevers that flare up, burn brightly, and then fade.

On the way to his parents' house, Billy stops to piss in a park and informs Layla that if she looks at him, "I'll take a bite of your cheek off and I'll shit you out." We're not sure we believe his ferocity, however, and somehow a delicate balance is struck by Gallo, between the portrait of a possibly homicidal madman and a lonely, frightened boy. It might be easy to play the wide extremes of these two characterizations, but Gallo's virtuosity in this character is that he hugs, as if for dear life, the thin line that separates the two. It's an amazing thing to watch, and all during the movie we keep waiting for Billy to snap and fall off that high wire: falling to the downhill side, of course.

Billy finishes pissing—ridding five years' worth of toxins, it seems—and comes back to the car a relatively new man, pausing to moan and gasp almost orgasmically in his relief. "First thing," he says, when he's finished gasping his pleasure, "I'd like to apologize. I've been backed up. . . ."

Ricci's sphinxlike expression is unbelievable. She's completely expressionless—one imagines she might still be listening to the tap-dance music in her head—and the most expression she gives in this scene is an odd little sniffling, a quick wrinkling of her nose, animal-like, that could mean anything, really, but that we understand to mean that something he's said has made contact with her, has maybe even touched her: that it's as if she's awakened, slightly chrysalis-like, from whatever cocoon she was hibernating in.

The movie continues to push—deliciously so—to dovetail the traditional, orthodox narrative, with its traditional developing story line, with the absurd. Billy becomes extremely fidgety when approaching his old house—a drab tiny box in the suburbs, festooned with Buffalo Bills signs and posters, red and blue banners in the windows—and before knocking, he sits down on the steps of his old house and tells Layla "Will you hold me a second," and when she does—holding him, we see clearly, not because she has been told to, but because she wants to—he snaps, "Don't touch me," and we the viewers (and surely Layla) feel a new and certain hopelessness: Surely no reclamation can occur with this man's damaged soul. Surely he's a goner. You could bet the farm on it.

Billy rises, knocks on the door. He hasn't seen his folks in five years. His father—Ben Gazzara, as Jimmy (we hear his name only once, faintly, unintelligibly, and indirectly)—answers the door, stares at him without expression, then turns away and grumbles to his wife, "It's your son."

Billy's mother, Jan—Angelica Huston (we also hear her name only once or twice, incredibly faintly both times)—shows only a little more expression, but her demeanor is more one of befuddlement—as if she is only just now realizing that, why yes, it *has* been a long time since she's seen her son. She invites them in.

Billy has commanded Layla to "be nice" or he'll kill her, right there in front of his parents, and nice she is; she blooms, chats garrulously, unfolding with a prep-school vivacity that is made all the more bizarre by the

filmy blue nightgown-dress she's still wearing, her half-bare breasts still poised to spill, despite the cold.

Billy's mother is a Buffalo Bill fanatic, and it was indirectly for this that Billy went to prison. He had bet ten thousand dollars he didn't have on the Bills in the Super Bowl, and lost it when the kicker, the fictitious Scott Wood, missed a last-second field goal—"wide right," the kick was called—and in exchange for his life, and his debt, the mob allows Billy to confess to a crime he didn't commit; hence the five years in prison.

Billy has vowed to kill the kicker who missed the last-second field goal and ruined (or so he believes) his life.

When I first read that this was the premise of the movie, I almost didn't go to see it. It sounded gimmicky and manipulative. But you soon understand, watching the film, that Billy doesn't want to kill the kicker, Scott Wood, in the literal sense. What he wants is to erase his demons: and he is filled with them.

We're made to understand gradually, in stages, that Billy's parents are crazier than Billy. His mother is so obsessed with the Bills that she watches endless replays of old games (we don't realize she's watching a replay until she fast-forwards through a commercial). Here Billy loses his swagger and his attitude, and becomes more than ever like a little boy, bickering now and again with his parents but accepting with strange passivity such blood-curdling pronouncements as the one his mother fairly spits out: "I wish I'd never had you."

It's in this sequence—dinner with the folks—that the movie pushes beyond its previous narrative borders in bold fashion, taking its first confident steps into the surreal.

Billy's father, it turns out, did some nightclub singing when he was younger, and at Layla's insistence, is coaxed into taking her into his room, where he clears his raspy throat, sheds his heavy New York accent, and begins crooning a flawless "Fools Rush In" while Layla watches adoringly, mesmerized.

As Billy's father sings, the wrinkles in his dirty T-shirt vanish, his pot-belly tucks in slightly, his muscle tone improves, and his face softens. He appears ten years younger, and, amazingly, sophisticated—a subdued red-hued spotlight illuminates him—though as soon as he finishes the song,

the strange lighting disappears, and he's returned immediately to the sad-sack land of who he is: an old, washed-out, grouchy couch potato. "All right now, that's enough of that shit," he rasps at the end of his beautiful singing, and Layla and Billy's father step back into the flow of the movie.

What that singing scene is like, I think is an egg, a capsule, of space and time, and of *sweetness*, that by all rights should be mocked and hooted at in this post-ironic, desperately hip day and age; but in some weird way, the scene rides successfully the borderline between farce and sweetness. As well, there's something dignified in the way the characters treat this strange scene, which I viewed as a metaphor for the transformative power of art. (While Billy's father is singing, all traces of his previous churlishness left his face, and Layla, while listening, had lost her haunted, wary, slightly stupefied look. She was just listening, and enjoying.)

In the aftermath of this scene, both Billy's father and Layla seemed to be existing just barely at the farthest, faintest edge of embarrassment, but in a pleased manner: embarrassed at having encountered, and shared, not sentimentality, but sentiment, far more intimate.

The scene pushes limits not so much for experimentalism's or gimmickry's sake, but because the times, with us benumbed within them, need and demand such push. Look at similar impulses outcropping in contemporary movies: the infamous over-the-top violence in *Pulp Fiction* that becomes a parody of violence; the wonderful strangeness of sliding down the tunnel into the actor's cortex in *Being John Malkovitch*; and the multiple endings, as if in a choose-your-own-adventure, in *Go*. Such structural leaps seem almost a physical response, at least as instinctive as calculated, to move those stories and their characters outside the increasingly confining and (estranging) bounds of the times.

In *Buffalo '66*, even as the scene of Billy's father's singing arcs startlingly outside of the story limits or boundaries that have previously been laid down, the scene's momentum carries it back into the story, furthering the story: revealing to us, and reminding us, that this is a movie about an extremely fucked-up young man coming from an even more fucked-up family.

(At different times in the movie, a technical device, more effective

than traditional flashbacks, lets us see occasionally the repressed memories of Billy and his family, by virtue of a postage-stamp-sized screen set into the larger overall movie screen, so that both scenes, flashback and straight narrative, play simultaneously. These flashback scenes generally involve abuse, neglect, anger.

As an interesting side note, during the flashback in which Billy remembers details of his imprisonment, we recognize, in the slam-bang fashion of the prison photographer's portraits of judge, jury, and defendant, a nod to the almost identical closure of scene in the Coen brothers' *Raising Arizona*: a nod so vigorous that for a moment we half-expect to hear the eerie crooning warble of that soundtrack.)

Billy wanders into his parents' bedroom to call his friend Goon—a passive, dimwitted, slothlike man who, overweight and shirtless, and with his seriously unkempt, Medusa-like hair, seems startlingly androgynous. Goon's eerie olive-yellow skin appears to be jaundiced, as if he's never voided any waste in his life, and curled up on his bed in the corner of his little room, waiting for his mother to fix his supper, he seems sleepy, befuddled by the world. As Billy tries to find out from Goon how to track down the ex-field-goal-kicker Scott Wood, there's more of that strange lilt toward exhibitionism barely restrained: the camera moves in tight during the phone conversation so that Goon's turgid yellow, hairy belly, and his unzipped pants, fill the screen—Goon's rubbing his belly, and slipping his hand in under the waistband of his underwear, inches away from the camera—and when Goon counsels Billy not to do anything "bad," Billy gets angry and ends up calling Goon a "stupid retard," lashing out at him with the word again and again, spittle flying from his lips, so venomous is his hatred, and then Billy hangs up, trembling.

If it is often only the little touches that separate a great movie from one that is merely very good, watch at the end of this scene for the way in which Billy recomposes himself, following his toxic outburst: the way in which he neatly, and with just the right combination of fatigue and perhaps confusion, straightens the bedspread on which he had been sitting, when he'd placed the call; tidying up, now.

fter one final and bizarre argument with his father, Billy bids
farewell to his parents (they fawn over Layla on her departure and
ignore Billy), and the two anti-heroes hurtle off into the grayness of late
afternoon, with Billy still intent (unbeknownst to Layla) on tracking down
and killing Scott Wood.

Billy is jumpy after the visit with his parents, and straightaway begins
transferring his anger and frustration, yelling at Layla for overdoing the
wifely part: for bragging about how she thinks Billy's the sweetest and
most handsome man she's ever met.

Here we see the most significant amount of spark from Layla yet.

I did what you asked me to do, she tells him.

Seething with more built-up toxins, it seems, Billy heads for his old
glory-grounds, the bowling alley, where he evidently had once been a child
prodigy—and why not, for what better sport with which to transfer aggres-
sion than hurling a titan wrecking ball at the precarious, defenseless pins
at the far end of the lane, superilluminated in their strange light?

His friend Sonny (Jan-Michael Vincent) checks him back into his old
locker—the two men evince more friendship, more intimacy, than we have
seen anywhere in the movie thus far—and as Billy opens his old locker,
we're treated to one of the movie's strong and critical subplots. We see the
photo of a girl, though it's not really a true photo but more of a magazine
or yearbook kind of cut-out. When Layla inquires about her, Billy explains
that this was his girlfriend, but no longer—that he had to let her go.

As they move to the lanes and lace up their shoes, there's another one
of those bizarre episodes embedded like some irreducible capsule inside
the rest of the film.

As with the previous strange scene (Billy's father's singing), a drama-
tic shift in camera angle, lighting, and pace signals that we're back into the
weird zone. The camera focuses in tight on gestures that are so overtly
sexual as to seem almost comedic, though the actor's and actress's move-
ments, filmed now in slow motion, are so deliberate—so passionate, in
their own unaware way—that nobody's laughing. Instead, the shots are
vested with an accumulating sadness and loneliness: two characters emo-

tionally and physically separated from each other, seemingly for no reason whatsoever. Billy's fingers searching out and entering the holes of the bowling ball; Layla unzipping her overjacket to reveal even more of her breasts; Billy rubbing his shining ball quickly, expertly, with a cloth, until it shines like a cherry: These characters could be giving each other their attention, sexually and otherwise, rather than existing as if each is on the other side of an invisible but insurmountable wall.

Once Billy begins to bowl, it's all strikes, of course; despite the five-year layoff, he's maintained perfect mastery and control over at least this one element of his life. After each strike he pumps his fist and congratulates himself with shouted, orgasmic *oh—oh—ohs!*

What comes next is my favorite scene in the movie. The strikes (and exclamations) are coming too easily; of course the ball must become jammed, back behind the pins, and the reset button must fail. And of course Billy must come unglued, cursing that he has lost his groove. He lashes out at Sonny to hurry up and go fix the damn thing.

What follows, however, is not as predictable as that quick three-beat scene. Acting exquisitely bored, yet somehow more alive than we have seen her yet, and seeming relieved too that Billy has been forced by circumstance to relinquish, even if for a moment, his fierce focus on the game, Layla saunters across the parquet, positioning herself not quite in front of him—and, humming lightly to herself, begins to tap-dance (as the lighting dims again, and she, like Billy's father before her, glows).

It's an eerie dance, and you spend the first minute trying to decide whether it's sultry or innocent before realizing that it's neither of these things: She's just happy and showing off a little—calling out for love, and love's reformations.

The best and most eerie part of the scene, for me, occurs at the end, where the "artful" lighting fades—she is released from her husk, her shell, of color and surreality; and she makes her transition out of that magical lozenge, back into the harsh lighting reserved for reality, but continues humming nonetheless, and stops once or twice to do a little toe-tap, even if slightly clumsy now, as if still carrying some moth-dust residue of that magic with her back into the real world.

The diction with which Billy closes this scene (still refusing to look

directly at her) is almost identical to the line his father had uttered, after crooning his beautiful ballad to Ricci: "Okay, stop it, all right."

This movie is afraid of nothing. When the lane is finally reset and Billy steps up to bowl again, we know he's going to toss a gutter ball; and when Layla asks if she can have a try, and Billy says yes, and she rolls a strike— well, so what? It would be experimentalism for its own sake, distracting, to have the sun rise in the West only for the sake of avoiding anything predictable. Again, one of the things that impressed me most about this movie was the confidence with which the director moved across the familiar and the achingly predictable, en route to the startlingly, boldly original: doing so with a fullness of confidence, not needing to prove or display his originality at every possible juncture. It's fine that Billy rolls the gutter ball, and Layla the strike. It's okay. It's just fine.

As if bearing to us trays of delicacies, the movie continues its feast of genius. When Billy excuses himself (disgusted by, rather than taking joy in, Layla's strike) he goes to a pay phone (a powerful recurring motif: his symbolic crying for help, and his connection, or umbilicus, often, to the real or outside world) and he asks directory information for the phone listing for Scott Wood's business. (It was from Goon, in his earlier call, that he found out the name of Wood's establishment.)

When asked by the operator how that's spelled, Billy fizzles; we can almost hear the crackling and fizzing going on in his brain as circuits begin to melt under the pressure of his obsession, and the pressure of his life: a pressure that is manifesting itself now in even the physiological motor skills of speech.

"I don't know, Wood, Wooo—" He tries to pronounce "Wood" for the operator, but can't spit it out, and we understand even a little more sharply—in case we had forgotten—that it's a hard world for Billy Brown.

He manages to obtain the listing, and calls the club, and in this conversation, obtains Wood's schedule. Billy's face remains impassive as he registers the information—like some savage nocturnal creature, Wood evidently sleeps through the day and doesn't show up at the club until 2 A.M.—and we're left with the hope, hinted at by the calm passivity in

Billy's face as he learns of Wood's schedule, that that's all this is, *information*, and that the slow, awkward bond that's developing between Billy and Layla will supplant, and shove aside, this mindless need or urge for revenge.

We're aware, somehow, that the race between these two impulses is on, but so poignant are the moments of crude tenderness between the lash of tantrums that as viewers—as saps—we find ourselves betting on love, and believing only what we want to believe.

Billy returns to a bored and disheartened Layla—she's quickly discovered it's no fun bowling by herself—and, ever the obsessive, he wants to take some photos of the two of them together in the little self-serve photo booth, to

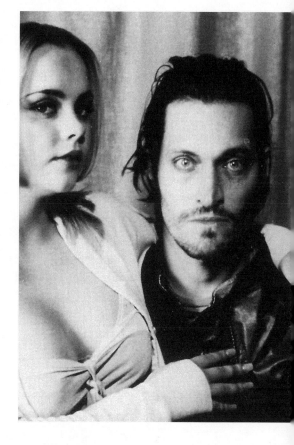

mail to his parents: determined to show them that he is happy.

This scene, though filmed "straight," possesses also the strange "outsiderness," the lucidity, of the two previous surreal scenes—the grasping, reaching, emotional content that seems to extend even beyond the film's earlier such scenes.

I think it's extremely effective that this third "strange" or "outside" scene is filmed straight—in real, rather than surreal, light—as if to show that the characters *have* progressed, and are seeking earnestly to travel beyond the shells of their benumbed, confused imprisonment.

Within the fiercely bounded circumscription of the photo booth—the two of them are barely able to fit within it, with Layla sitting on Billy's lap—he's able to have a better chance at controlling the intimacy, or—in the beginning—the representation of intimacy. At first Layla is laughing,

mugging wildly for each flash of the camera (again, a wonderful piece of acting—her transformation from sleepy, passive, unfeeling zombie to a laughing woman-in-love, is astounding and memorable—but Billy becomes almost immediately uncomfortable with this display of unfettered joy; and uncomfortable too, we can see, with joy's vital, intimate proximity). He scolds Layla, tells her to cut the funny stuff and to look loving—she gleefully obliges, smooching on him with relish, which unhinges him further—and he admonishes her here that she's supposed to look loving, but not "too" loving. "We're in love," he says, but "we're the couple that doesn't touch each other."

What will follow this browbeating of joy and spontaneity is an utterly incredible piece of acting by Ricci. Billy's sullen force of will is still dominant, but you can see—with no words ever being spoken—Layla's fierce determination, almost stern, to not let love be chased away; to put a different face on love—to do whatever it takes to hold that joy, that feeling, within her—and she settles in, with visibly conscious effort, to produce, before each camera flash, a traditional, sweet, and loving expression of love, while Billy continues to glower steadfastly at the camera-as-enemy, like the scowling portraits of peasants from some century before. We can see, in this magnificent acting, the effort between flashes, the determination of Layla to assume that loving, traditional mask.

Through subtle, subconscious efforts, she reaches deeper with each "smile"—sorrow, doubt, and fear flicker in the lines around her eyes, the first we've seen in her face, before each photo, as she prepares for each photo.

And though Ricci is the star of this scene, Gallo is not merely a bystander: His own suffering, rigid mask, in contrast to the plasticity of Ricci's, and her earnest, almost suddenly frantic willingness to please, is its own work of fine acting; and spectacularly and poignantly acted too is the touch where, after switching the interchangeable background curtain in the booth so that it provides a blue background—"This is the blue period," Billy says, with the same somber face (only after the moment has passed do we recognize it for what it is, a fledgling attempt at humor, rather than more monomaniacal control). Billy then "lapses," and proceeds to instruct Layla in how important it is to provide just the right and

proper expression of love and devotion; and it is on this third "take" that we see the most beautiful acting by Ricci.

(As Billy is chastising Layla for her inability to achieve or provide just the perfect degree of attachment-and-detachment, he lapses again into a linguistic tic—ranting about how he wants them to look like a husband and wife that "spends" time together. He pronounces the word "span," however, despite having evidenced no strange or unique accent heretofore, and doesn't appear to be able to get it right; as he rants on, he manages to use the verb "span," in one participle or another, twelve times, and pronounces it, each time, as *"span,"* or *"spanning"*: as if here exists some small but complete block in his synapses, or some curious missing piece of knowledge, known to everyone else in the world, but which he never learned—how to pronounce this one simple word—and again, we're reminded of how far he has to go, and of the uphill nature of the struggle; that this small tic, or gap, is but one visible representation of a daunting morass of similar, and far larger, gaps below.) *That's what you do when you're in love*, he lectures her. *You span time together.*

From the photo booth, they travel to a Denny's; Layla isn't hungry, but has a child's craving for hot chocolate—for sweetness. They pause in front of a billboard that urges ORGAN AND TISSUE DONATION—hearts, flesh, that kind of thing—and then walk into the Denny's, through a parking lot that is filled with red and blue cars, valor and loyalty, and into the crimson interior of the restaurant.

Here the light wavers again—takes on that strange slightly surreal focus—as a woman, possibly drunk or perhaps only slightly unbalanced mentally, comes staggering in, dressed somewhat whorishly, and in the company of an odd-looking businessman-clown kind of guy.

The dazed woman and her companion slide into a booth right across from Billy and Layla, and as if he can tell who she is by scent alone, Billy has all along been averting his face from the strange woman (Rosanna Arquette), whom we can recognize immediately as an aged version of the woman in the photo in Billy's bowling locker: the true Wendy Balsam, tottering on her high heels, and giggling, dizzy, insipid.

She spies Billy—seems drawn to the fact that he's got his face averted—and, after staring at him a moment, demands, "Hey, weren't you in my third-grade class?"

Yes, Billy responds, as if busted, without looking at her; and to Billy's increasing mortification, the true Wendy Balsam (after she and Layla have a brief discussion over who's the real one) reminisces to the world in general, it seems, how Billy was always hanging around her house; how any time she looked out her window, she'd see him out there. ("I had a friend who lived over there," Billy says, defensively.)

Wendy's companion invites them to come sit in the booth with him and Wendy—"since you were in school together," he says, which sets the real Wendy, whom we see now is crazier than a shithouse rat, off into a new paroxysm of laughter—and Billy declines. Wendy howls, leans over as she coughs out her laughs, leans toward them for a moment as if endeavoring to let her breasts spill out of the top of her open shirt—again, the motif of exhibitionism—that which is exhibited, versus that which is withheld, is sounded, and the prurient image is approached though not broached.

Wendy Balsam pulls the businessman over to her side of the booth, and, as if seeming to consciously taunt Billy, begins some seriously feral making out with the businessman.

Layla leans forward and in a stage whisper, having deduced the story of Billy's crush, scolds Billy for ever having taken an interest in such a person in the first place, much less having placed her on a pedestal. "You're too good for her," Layla praises him.

This support has a surprising effect, and again, we watch as the hero stumbles. Rather than accept Layla's encouragement, Billy lashes out at her kindness, gouged by the conflict of the inner demons her praise has set against one another. He lashes out at her, as he has in the past, and as he does, she hunches up, sniffles, and wipes her nose with her hand, but digs in, as she hasn't done earlier; juts her jaw, and seems to be trying to make a stand in the land of the living.

"Girls stink," says Billy. "They're evil."

There's disbelief in Layla's face, and we can see perfectly how much she's trying to hide the crush of her spirits at hearing this pronouncement: a mixture of utter disappointment combined with the fatalistic belief that

love never would have worked out for her anyway, with both of those emotions hidden perfectly beneath the mask of her studied impassivity; as if none of it is any big deal to her, and is so unimportant as to not even deserve feigned nonchalance. She sniffs, wipes her nose again, waiting; waiting for the next moment, the one without him—which, she seems to be telling herself, will be no different than the ones she has spent with him.

"Let's go," Billy says, rising, full into his manic mode now.

"I'm not going," she says.

He stares, astounded—as if Goon had stood up to him. "Fuck you," he says.

"Fuck you too," she says.

He leaves, runs out of the restaurant, in full red-booted flight. Layla melts, but only after he is gone; she curls up, wounded, though we understand she'll survive.

He's got to return, of course. And perhaps it's a little too neat, almost formulaic—the first tinge of such neatness in this movie—but what brings him back to her is the inability, once again, to void the accumulation of his toxins. Once again he can't find an open restroom, and is directed ultimately to return to the Denny's, where Layla's still just sitting there, hanging out in limbo—having returned fully, we can see, to her existential shell, and still waiting on her hot chocolate. Billy reels into the bathroom, where, in the privacy of that lonely place, and under the broken-hearted lighting of all those fluorescent bulbs, he breaks down, melting in on himself: collapsing into a birdlike, fetal tangle of arms and legs, horrified, it seems, by his own semblance in the mirror. "No one's ever going to love me," he whimpers, after he's slid to the floor.

Like any hero, however, he rises later, resurrects himself—splashes water on his face—and ventures back out into the restaurant to face Layla, and apologizes yet again—is born yet again, as awkward and spastic in this tormented back-and-forthness as any hatchling reptile seeking to thrash its way out of the rubbery shell, hungry for warmth—and they leave.

There's time, he decides, to go get a hotel room and lie down for a little while; and whether as an excuse for intimacy, or because he simply doesn't know what to do between that moment and his 2 A.M. rendezvous with Scott Wood, we're not sure; and we get the feeling that, as has been

the case always thus far, neither is Billy: that there is some of both. (When Layla asks, again, if he wants to go to a hotel, there's a moment of startling intimacy when he reaches for her hand, and it takes a second for us—and her—to realize he's totally unaware of touching her as he does this; he's only trying to see her watch better. "Okay," he says, still studying her watch, "we got time"—and we understand as well, now, that indeed he does still intend to go kill Scott Wood.)

There seems to be some new peace or at least resignation working around the edges of him, visible almost as a corona of fatigue; as if he's become weary not just of the day's events but of the burden of being Billy, and of holding that monstrous anger; and we can see how appealing the idea must be, to simply lie down on a clean bed and rest for a while.

Another strange scene at the check-in, in which time seems to slow almost to a crawl—as if highlighting the fact that this is the matrix, the filler-stuff, of life—with flat-lit, utterly emotionless acting by Billy, Layla, and the tired-eyed hotel clerk.

Conditioned as we are by the crispness of narrative plots and structures, we keep waiting, like creatures unweaned, for something to happen in this scene—we pass one beat without incident, two beats, three beats, and still nothing—the rhythm is disrupted, boredom attenuated, slack water entered—and still nothing happens.

"How many nights?" the clerk asks.

"One night."

"Here, fill this out. Rooms are $29.95, $34.50 with tax. I'm going to need driver's license and cash, or a credit card. Checkout time is 11 A.M., and there's no smoking in the room."

While all this deadly dull info is filtering in, Billy is listening to Layla, who is speaking to him urgently about the real Wendy Balsam, as Billy half-tries to ignore her—stranded, it seems, between the slack-water-mundane of the robotlike hotel clerk and the impending life-force of change that Layla not only represents but is, with her growing affection, demanding—for his sake, not hers.

The room is procured. Billy and Layla ascend to it not like romantic newlyweds, but like the refugees they are, seeking brief asylum from the

world; or like some long-married couple returning to the same tiny flat in which they have lived for the last forty years. Four walls and a roof: safety from the swirl, the strange maelstrom of reality, and the vast betrayals and confusions beyond those walls.

Sitting on the bed—the only furniture in the room—Layla asks, "You never went out with Wendy Balsam, did you?"

Now it's Billy's turn to jut his jaw and confront some inner truth. "No," he says quietly.

Layla is silent, digesting this sadness.

Billy opens up further. "Ah, I hated school so much," he says, and the words, so freighted with fatigue, even across all that distance of time, seem to be pulled from him as if still wrapped with barbed wire. Layla just sits there, listening—luminous in her blue dress, thick blue glitter eyeshadow: absorbing.

In this scene, Billy looks as haggard, as exhausted, as we've seen him yet. He wants to take a bath, to cleanse himself as if before battle, it seems, and goes into the bathroom and begins running hot water.

Layla can't bear to be left alone in the little room—it's in this subtle moment, I think, that she realizes she's made her leap, that she's fallen in love with him, and has acknowledged to herself that she wants, even needs, him—the greatest vulnerability yet, after having tried (somehow we know this) to not place herself in that position again; and she asks, then pleads, to come into the bathroom with him, saying she doesn't want to be alone. "I'm freezing, Billy," she says.

No. Maybe. Okay, he says—she's like water, pressing, flowing—not overtly insistent, but not relenting, either—*okay,* he tells her, *you can come in, but don't look at me,* and he crawls into the bathtub in his underwear, to avoid exhibiting himself. "If you look at me one time," he says, "I'm going to throw you out of the room." What a far cry this is from the earlier threats such as, "I'll bite your cheek off and shit it out"—but again, we can't tell if this "softening" is the result of some deepening attachment he might be forming for Layla, or whether he's simply now just so god-awfully worn down.

Soon enough, of course, sitting on the edge of the tub, she's looking at

him—*No looking, I said*—and soon enough, too, she's undressed and in the tub with him—having cornered and trapped him, finally, despite his almost frail protest, "I don't take baths with people."

He seems at last gentled, or calmed—though again, whether by her or by sheer physical fatigue—or some combination of both—we can't yet be sure.

(As they emerge from the tub, much later, Billy's still in his underwear, and the camera seems again to promise the voyeur's glimpse of body as the nude Layla rises, dripping; but the camera veers away just at the last instant before her significant breasts are about to appear above the line of the bathtub.)

With a nod by the director Gallo to Truffaut, the lovers lie on the bed as if they have fallen from a great height—as if stunned by narcolepsy, wide-eyed awake but unseeing, entranced on the wide bed, with the gulf between them, each thinking his or her most desperate and solitary thoughts—and finally, slowly, gently—with utmost vulnerability (will he reject her yet again?)—Layla reaches a hand over to Billy, who accepts it awkwardly. Crookedly they edge in closer (Layla's restrained hunger is achingly raw), and then spoon and nestle, as if taking refuge from some howling wind.

The scenes of their love beyond this point are shown in those Truffaut-like glimpses of white lighting, slow frames, and time-lapse fragments of moments that are the emotional opposite of the violence of the jarring, spinning flashback fragments we've seen earlier in the movie.

The scene is filmed from the ceiling, looking straight down, so that we're reminded of earlier perspectives with their themes of anchoredness or entrapment: previous camera angles that wavered slightly, as if in confusion or anxiety, while looking up at the dwarfing skyline of buildings following Billy's release from jail, or the distant overhead canopy of trees in Billy's childhood neighborhood. This newer perspective gives the viewer a dramatic sense of freedom and release.

There's a newfound normalcy about the two of them, when they later disentangle. As Billy separates himself from her gently, cautious but

unsuccessful in his attempts to avoid waking her, we're shocked by this mild transformation—a gesture of concern for someone other than himself, the first we've glimpsed—and both characters seem less fragile, more confident: as if all their struggles lie behind them now.

Billy's packed a pistol for his visit to Scott Wood, and it's an extension of this newly awakened consideration, even tenderness, with which he tries to hide from Layla his purpose and intent. She awakens anyway, and is distrustful when he says he is only going out to get a cup of coffee.

"When are you coming back?" she asks.

"Five minutes—what do you mean?"

"I just have this feeling you're not coming back."

"I just told you, I'm coming back—I'll be back in five minutes. I'll get you a hot chocolate."

"I really like you," she says. "I'm going to be really sad if you don't come back. Just tell me if you're not going to come back. Don't lie to me. If you want a coffee, go get a coffee. Just come back."

Billy seems paralyzed, like a deer caught in the headlights: wanting to be truthful, to avoid hurting her later; but wanting, too, to protect her with his stealth; to keep his mission a secret for just a little longer. We can't tell whether he's trying to hypnotize her or perhaps himself as he repeats, "I told you, I'm coming back."

The phrase "I love you" has been uttered in thousands of movies, but rarely if ever as poignantly or bravely as in the small voice of Ricci, with its one coal of hope, as Billy goes out the door, his back turned to her; and in the curve of his back, and the finality of his exit, we see both anger and shame at his inability to respond in kind.

Brilliant, careful editing jars us into the next scene; truck roar fills the speakers, and as Billy trots across the street to Scott Wood's Solid Gold Club, it seems that the trucks are on the verge of flattening him. The ominous portents of closure seem everywhere; Billy stops outside to call Goon—to apologize, of all things, for his behavior, and to bequeath to Goon, like a child, his special items: his good-luck pen, his bowling locker, etc.

Animal-like, looking for all the world like a caged primate picking at fleas, Goon plucks at, and examines, various fur balls on his body as he labors in the conversation to make sense of the change that has come over Billy. Again, Goon's nearly nude body looks strangely androgynous, and there's a brief, disturbing view of a wild-eyed guinea pig, trapped in a tiny wire cage next to Goon's bed.

As Billy enters the club—the final leg of his journey—we can see his eyes widen, can see him suck in his breath and gather his resolve as he enters what surely must look to him like the portals of hell: nude dancers of all sizes and shapes gyrating in flamelike orange light, punctuated by synapse-numbing stutterings of incandescent strobe lights. He moves slowly but steadily toward the bar, taking it all in in a sweeping glance, like a hunter, but above all, looking for Wood. Billy moves toward the bar and leans across it, where a trick of the camera angle makes it appear at first that he's staring intently at a hostess's bare breasts, but then the camera pulls back to show us that he's asking directions of another waitress; and when she points toward a back table, we see Wood sitting there as if waiting for Billy all his life, as a caricature of depravity itself: corpulent, sprawling, shirtless, and glassy-eyed, with three topless dancers fondling and caressing him, and a dog-collar-looking thing fastened around his neck.

We've all seen pretty much the same movies, audience and director alike. When Billy pulls out the pistol and fires, in slow-motion-Western-violence, on an enraged Scott Wood—the back of Wood's head is taken away—before turning the gun on himself and squeezing the trigger, with macabre, calamitous results—I think there must be no viewer who does not emit a deep groan of disappointment; wishing it had not ended this way but also understanding logically if not emotionally that this was the obvious destiny for such a tortured and injured life, even though redemption had been so unbelievably close. Bitter is our disappointment at Billy's inability to have seen just how close it was.

Gallo is, however, generous, in that he gives us the miracle we long for. We're treated to a second ending; we understand, after the violent scene,

which it turns out was but an imagining, a projection seen by Billy looking forward, by much the same mechanism—the compartmentalization of flashback—with which he had viewed many of his life's actions and events from the past.

We watch, giddy with relief, as Billy shakes his head, clearly pitying Scott Wood; and, like some teenager shaking off a proferred cigarette from his friends, Billy turns and leaves, and we understand that the demons within him are finally calmed.

A particularly nice touch appears in the next scene. Billy hurls his pistol over a high wall, and one can't help but wonder if this isn't also some bravado by Gallo, well-earned, in an attempt to show Hollywood that indeed, miracle of miracles, a good movie, a great movie, *can* be made without a gun as either character or crutch; that the gun, though present briefly in this movie too, was never much more than a red herring.

It's still dark out. In the hotel across the street, a single light still burns, waiting. Billy's been redeemed and transformed, but he's still Billy; he makes a quick call to Goon and reneges on his previous maudlin call, sounding now like the feisty Billy of old—though so mellow has he become that the worst threat he can summon is to promise that if Goon gets near his bowling locker he'll give him, "swear to God, a karate chop in the head." And there's more of the movie's incredibly wry humor; when Goon asks him what kind of person Scott Wood was, Billy shrugs and says, "He seems like a nice guy—just like a normal guy." And then, like some jaunty teen, he tells Goon, "I gotta go. My girlfriend's waitin' for me."

We—or rather, our affections for the transformed Billy—are not out of danger yet. Swept away by his transformation, he dashes over to the doughnut shop to get hot chocolate and candy for his sweetheart. He's euphoric, and it's obvious, by the relish he takes in shopping for just the right cookie (heart-shaped, red as a rose, fresh-baked) that this is the first time in his life he's been able to indulge in such a small pleasure. He doesn't seem to notice that the entire interior of the doughnut shop is decorated in a lurid blood red; nor does he seem to notice the ominous camera angle, shot from a corner of the room, unobserved by him: the eye of unknown

danger, of ambush. It's a scene that's uncomfortably reminiscent of the diner episode in *The Wild One*.

As Billy's ebullience continues to soar, we become ever more tense, aware somehow of that unwritten rule in all movies, and some of life, wherein all positives must be countered by negatives. For some reason, some skill in editing and filming and acting, we're on the edge of our seats, certain that a robber is about to come in, and that Billy will somehow get caught in the crossfire. He's the only one in the world who doesn't know it as he banters on, buying a cookie for a grumpy old man, telling him to take it home to his girlfriend, and lavishing upon the counter clerk a generous and jovial tip.

His purchase completed—his love requited—he gathers his gifts and turns to leave. Seconds earlier, a car has been heard driving up outside, the sound of its tires unnaturally loud—even menacing.

He's oblivious: a fool in love. There's only one door leading out, the same one through which he came, and still he doesn't seem to notice that he's trapped.

He hurries out through that door—nothing, and no one, stops him—and across the street, and up the stairs to that one burning lamp, where he's received into her waiting arms, in morning's first light.

You feel a little guilty at the pleasure you feel at such a satisfactory ending, but the guilt is balanced by the awareness that the happy ending is an earned one: uncontestably deserved, and artfully balanced: a bold and generous portrayal of a life not so much snatched from the precipice as instead hauled, hand over hand, up from a hellish abyss.

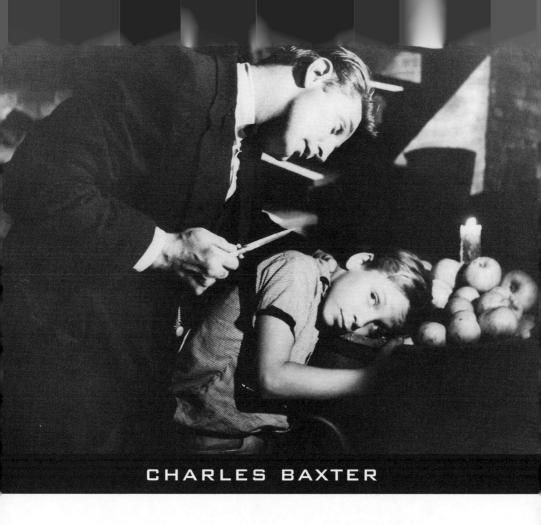

BREAKING THE BODY OPEN:
THE NIGHT OF THE HUNTER

DIRECTED BY CHARLES LAUGHTON

harles Laughton's *The Night of the Hunter* (1955)—the only film he ever directed—begins with the heavens before it bothers to move down to earth. In the film's first shot, we see the old matriarch, Rachel, played by Lillian Gish, inhabiting the night sky. Dressed in white, cameo-pasted against the stars and surrounded by her foster children, she begins a story for her audience, which also apparently includes us. It seems we're about to hear a fairy tale. "Now, children . . . ," she says, looking directly out at the lens, and as she

begins her saga about false prophets in sheep's clothing, the camera aims itself downward and begins to descend, and we see what the earth, as opposed to the heavens, is made of: farmland, rivers, and bodies—the living bodies of children playing hide-and-seek, and a murdered woman's corpse that these children find in a basement. Then, drawing back, but still peering down from the unearthly heights it would rather not give up, the camera, in another high-angle long shot, locks onto Preacher Harry Powell, a killer-evangelist, invariably dressed in contrasting black, driving his Model T down a country road. Harry is always on the move, always looking for another sinful female body to open up with his switchblade.

This preacher does not inhabit the earth so much as the underearth, the realm of avenging demons, and he and Rachel, the two extremes governing this movie, male and female, heaven and underearth, light and dark, create a world of absolute contrasts, a polarized division of realms: a landscape of sentimentality, melodrama, madness, and terror through which two children try to find a path. It is a remarkable movie, and it is like almost no other American film of its time—or of ours.

That *The Night of the Hunter* is often very funny does not lessen its effects. The film seems to inhabit almost every extreme it can discover for itself, and its emotional temperature is feverish right from the start. Visually, musically, and dramatically, its materials are entirely in black and white, and its adults who are still in the grip of sexual feelings are typically homicidal or spellbound. The movie's giddy hyperemotionality, processed through ultrasophisticated expressionistic means out of D. W. Griffith and F. W. Murnau, is amazingly undisguised and straightforward, as if the story's project—a completely impossible one—is the recovery of innocence for children who have lost it. Those children finally do include everyone who happens to be in the audience, but it is an invocation to innocence that any spectator is perfectly free to refuse. What is therefore disconcerting about *The Night of the Hunter* is its combination of naïveté and knowingness. This movie is too sophisticated and scary for children and, as a melodrama, too weirdly earnest for many adults.

In its high-contrast extremes *The Night of the Hunter* lives on tenaciously in the memory of most of its viewers, who find themselves either loving or hating its mixture of horror, visual poetry, and comedy; its styl-

izations and curiously fevered sentimentality and antinaturalist theatrical-ism. It is as if Brecht—in some hypothetical afterlife—had been forced to work on a horror film and had found himself paired off with Sherwood Anderson. The Brecht element is supplied by the film's director, Charles Laughton, who had worked extensively with Brecht on *Galileo*; the Anderson element is supplied by James Agee, who is credited with the script, and Davis Grubb, the author of the novel that served its source.

As a story *The Night of the Hunter* has an almost uniquely inscrutable and yet funny creepiness, intensified by a set of extraordinary perfor-mances by the cast, including Robert Mitchum, Shelley Winters, Lillian Gish, and Evelyn Varden. Its tonal ambiguity is probably the result of a high-strung semicomic sexual hysteria in the direction and performances, and an equally fervent fanaticism enacted by several of the adult characters in the source story toward its child characters, a fanaticism that is finally undone by an equally powerful pastoralism. This weird mixture creates a mood that feels like a hybrid of *The Turn of the Screw* and, say, *Auntie Mame*.

Everything intensifies the effect of contrasts, of homicidal righteous-ness versus innocence: the antirealist production design, Stanley Cortez's slightly hallucinatory black-and-white photography, and Walter Schu-mann's musical score for chorus and orchestra. Its only true descendant may be Terrence Malick's first film, *Badlands*. But really, it is in a genre of its own: expressionist screwball terror.

Lyric horror, bucolic shocks: the film's images have stayed with me from the time I first saw it thirty-five years ago: Shelley Winters as Willa Harper, her throat slit, lashed to a Model T at the bottom of a river, her hair mixing diaphanously with water weeds; Robert Mitchum as Preacher Harry Powell, left hand (famously) tattooed with HATE and right hand tat-tooed with LOVE, employing his switchblade as an avenging phallus that spontaneously opens and rips through his clothes at a girlie show; the two orphaned children escaping down the river in their father's rowboat, fol-lowed—no, *stalked*—by their predator-preacher-stepfather, typically seen in a backlit silhouette; the river itself framed by wildlife (rabbits, owls, and frogs); and, at the movie's climax, the boy, John, falling to his knees in ter-ror, crying out, "Don't! Don't!" (as his evil stepfather is arrested in exactly the same sequence as his good father was at the beginning) and then

hammering the captured stepfather with his sister's doll, whose cloth body—the last female body in the movie to be opened up—finally explodes with stolen money.

Like many horror stories and fairy tales, *The Night of the Hunter* contains a landscape without stable and protecting fathers, where children have no safe place to be protected from marauding adult males and therefore no place from which they can grow up. And while its supposedly happy ending seems to suggest a safe harbor for children presided over by a matriarch, that harbor is given such a hard sell that it seems almost as unstable as the sources of terror for which it means to be the remedy. The film's terror is more believable than its pastoralism, but both operate at fever pitch and both seem equally solitary. *Men are peculiarly unsuited for fatherhood*, this film informs us, *but they seem to be the only ones available to do the job until they are all jailed and the women can take over.* Like Griffith's films and the German silent movies it occasionally evokes, *The Night of the Hunter* manages to combine sadism, comedy, and sentimentalism so carefully that the viewer gets to weep and to have the shit scared out of him simultaneously.

This is hardly an ideal aesthetic response. Still, it has the virtue of contrariness and embarrassment, and it forces the viewer to reconsider some of the perennial sources of melodrama and sentimentality, both of which it employs with amazing effectiveness. In this sense, the film seems almost shockingly personal (a *personal* thriller!) and if the viewer doesn't take the movie personally, if he or she refuses its invocation to innocence, it hardly exists as a cinematic event or a story at all, or it becomes laughable (I have witnessed hip undergraduate audiences hooting at it in derision). Horror films are not typically designed for adults; this one avoids the problem by trying to convey its audience back into childhood, à la Murnau. This is a risky business. The movie stakes out a position for the recovery of childhood that is overcharged and untenable but at the same time apparently sincere, weirdly heroic, and rather beautiful. It's not a cool movie. Everywhere you place your hand, it feels warm or hot to the touch. Such passion involves an extraordinary courage, no matter how wrongheaded the whole enterprise may have been, particularly in what would otherwise be a suspense film made under commercial constraints. *The Night of the*

Hunter's ingenuousness explains why so much of the movie clings to the memory, like any obsession with a viral or contagious genetic structure, and why the film was initially a complete flop at the box office.

The plot of *The Night of the Hunter*, its family romance, neatly removes a well-meaning father and replaces him with an ill-meaning psychopath. The film is based on a 1953 novel by Davis Grubb, and its screenplay is supposedly by James Agee and is printed in *Agee on Film*, published in 1960 by the Beacon Press. This in itself is interesting. In his fine biography of Charles Laughton, Simon Callow reports that Laughton wrote most of the screenplay on his own (Grubb apparently assisting), Agee by that time having fallen into suicidal alcoholism. Callow reports that Agee wrote a 350-page unshootable script, loaded down with unusable details of backwoods country life. This is not the script printed in *Agee on Film*. The movie does have traces of Agee's preoccupations, particularly the loss of a family's father from *A Death in the Family* and the ways of Appalachian people—and the mood of aggressive pastoralism is certainly characteristic of Agee as well, but Callow asserts that Agee's hand is absent from the script, and it must be said that the West Virginia visible in the film is about as authentic as the smell-of-the-studio countryside in Murnau's *Sunrise*.

The plot, however, follows the novel point for point. The time is the Great Depression. To feed his family, Ben Harper has robbed a bank and during the escape has killed two men. After being wounded in the shoulder, he flees with ten thousand dollars and manages to get back home. Believing that women cannot hold secrets and that his wife has no "sense," he entrusts the ten thousand dollars he has stolen to his son, John; their secret is that the money is hidden inside Pearl's cloth doll. In addition Ben forces John to swear that he'll look out for his sister and protect her forever. As soon as John swears to do so, his father is arrested, tried, and taken away to prison to await his execution. It's as if John has agreed to become an adult too soon: to take on secret knowledge and to take on the role of the guardian.

In prison his father's cellmate is Preacher Harry Powell, who badgers

Ben to tell him where the money's hidden but who gets nothing out of him. Once the Preacher is freed from prison—he may be a serial killer but has only been *caught* driving a stolen automobile—he makes his way to Cresap's Landing, West Virginia, first to woo and wed Willa Harper, having assumed that she knows where the money is and that he can get the secret out of her. When that doesn't work and he has eliminated Willa from the picture, in both senses (given his taste for eliminating widows, he resembles charming, psychopathic Uncle Charlie in Hitchcock's *Shadow of a Doubt*), he starts in on the children, John and Pearl. In both the book and the movie, these scenes have a studied and heavily charged claustrophobia that is finally released when John escapes with Pearl to the river and launches his sister and himself in a rowboat headed downriver.

In the second section of the film, which is in the form of an extended antinaturalist lyric nightmare, a visual reverie, the Preacher pursues them—he is always, in a sense, on their horizon as they flee from him and beg for food. At last the rowboat touches shore near the farmhouse of Rachel Cooper, an old tough woman who takes the two children under her care as she has taken several other castoffs and orphans. In the film's third and last section (the novel's five sections have been telescoped by Laughton and Agee into three), the children are protected and safeguarded from the Preacher by Rachel. A great good faces down a great evil and effectively defeats it. Harry Powell is finally captured and arrested after Rachel has wounded him—in the shoulder, a wound identical with Ben Harper's—with her shotgun. After being put on trial, the Preacher is pursued by a lynch mob, until he has been taken away for storage and safekeeping to await *his* execution. At the end of all this, the children's *childhood*—this is the claim—is restored. They are thus the participants in a fable of reclaimed innocence—despite the fact that their father has been executed, their mother murdered, and they have been chased and threatened with murder by a psychopath posing as their stepparent. The shadows of the Preacher, which have appeared on John's bedroom wall from early on in the film, are banished forever. (Perhaps the most implausible article of faith in the whole film.) Rachel gives John a watch for Christmas, and in the closing shot, she looks directly at the camera as she did at the

start and, speaking of children, announces to us triumphantly, "They abide and they endure!" The novel's coda is hardly less fervent:

> But the night of the hunter was gone forever and the blue men would not come again. And so John pulled the gospel quilt snug around his ear and fell into a dreamless winter sleep, curled up beneath the quaint, still calico figures of the world's forgotten kings, and the strong, gentle shepherds of that fallen, ancient time who had guarded their small lambs against the night.

Well. The bright purple prose and the moral uplift of the film's ending both labor to take us back to the heights from which we started. It won't work—it never does—because, even with a Christian Nativity evoked, "strong, gentle shepherds" are in short supply no matter how you write the sentences, and they always have been, because, to speak cynically for a moment, there isn't much in it for them. But the movie encourages us to believe in them anyway, possibly even to *be* them, which is an interesting and possibly self-defeating project of faith in reaffirmed goodness after every trace of it has been temporarily wiped out, a project that is more weirdly interesting than the irony I am applying to it here.

The copy of *The Night of the Hunter* I have been consulting is a Dell paperback, which I purchased for fifty cents at Bacon Drug in 1963, when I was in ninth grade and living outside Excelsior, Minnesota. Bacon Drug was located across the street from Excelsior's farm store. In those days mass market paperbacks for sale in drugstores included Signet Classics (Dostoyevsky, Thomas Hardy, Jane Austen), New American Library's Mentor series (Aristotle, Plato), Bantam Classics (Stendhal), Avon Bard (Kate Chopin, Christina Stead), Penguin Classics (an extensive series of translations, in cheap editions with tiny print on paper that eventually yellowed), and Pocket Books' more middlebrow novels. There was also the usual trash. I only mention the phenomenon because thanks to a drugstore paperback display I bought *The Night of the Hunter* when I was

fourteen and consequently found myself mesmerized by a literary work. Then I went on to buy other books at Bacon Drug, where the quality of the titles was higher than in many *bookstores* several decades later.

I was gripped by Davis Grubb's novel and had no idea why, despite the fact that I myself had a stepfather, a man with great charm and an absolutely terrible temper who had replaced my father, whom I never knew and who had fallen dead at a picnic of a heart attack when I was eighteen months old. My familial inventory also included a mother who seemed to be living under some sort of complicated spell, and two brothers who were never around because they had been mysteriously whisked off to military school. I could have found a displaced-father plot in *Hamlet*, but I actually found it in *The Night of the Hunter*.

When I saw the movie version several months after reading the book, I felt myself removed from the audience and located *inside* the story, that odd feeling of cinematic transference I sometimes had whenever I felt

almost physically transported up to the screen and couldn't get down from it. What I write about *The Night of the Hunter* from here onward has to take into account that sense of being transfixed and transported, though what I bring to it now are the analytic skills—such as they are—of my maturity, and not the terror and exhilaration of my early adolescence, though I persist in thinking that what is really important here are those preanalytic emotions, those moments when, as somebody's stepchild, I was helplessly absorbed by this particular story.

The Night of the Hunter begins with the figure of Harry Powell, without whom there *is* no story. As played with brilliant actorly gusto by Robert Mitchum, this character, a source of gleeful narrative energy, peripatetically travels, seduces, and murders, using an all-purpose singsong revivalist's delivery whenever he speaks. "Child-*ren? Chil*-dren!" He is a great villain: stylish, seductive, entertaining, plausible, always lively, consistent even in his lunacy. Like one of Hitchcock's villains, he worms his way into society by charm, feeding people the charming lies they want to hear. When bored, he lapses absentmindedly into hymn singing, particularly his signature tune, "Leaning on the Everlasting Arms." Piety is second nature to him, as are hatred and mayhem, and erotic righteousness has made him dogmatically mad. Harry Powell claims to be interested in goodness and in souls; in actuality he is interested in money and more particularly in killing women whenever their sexuality outrages his crazy Protestant prudery, which is most of the time—*any* display of womanly sexuality sends him in the direction of butchery, which he performs as a sacrament on orders from God.

In at least two scenes in the movie, we watch as Harry Powell listens to his personal deity. We see Mitchum tilting his head, in full attention, as if carrying an invisible cellular phone, attending to his orders to murder. These moments have an utterly creepy conviction, as if infused with the sober politeness of a homicidal visionary who tips his hat whenever God tells him to kill somebody. In the one scene in which we witness the Preacher lowering his knife to a woman's neck, the scene is staged in an upstairs bedroom under a peaked roof, with ecclesiastical lighting, as if the

whole thing were taking place on a sacrificial altar. The woman—his wife, Willa—has her arms crossed like a Crusader, raptly waiting for her death, her deliverance.

Often when Harry is introduced or reintroduced on screen, the soundtrack's composer, Walter Schumann, gives him an initial four-note brass phrase on the soundtrack, G up to B flat, down to A, and then up to C, an authoritative and nerve-racking musical ID card interwoven by scurrying and frightened string figures. The Preacher's motif is quite similar to what Bernard Herrmann, five years later, was to devise for Norman Bates in *Psycho* as *his* madness motif. The difference between Norman and the Preacher, however, is that Harry Powell never stops being himself, justified in his task, and he doesn't always care for his job, which is not murder so much as the stamping out of female attractiveness and recreational sex. Murder is required to effect this stamping out. "Lord, I am tired," he complains aloud, driving his car. "I am *tired*." Continuing his ruminations as he drives by a cemetery, he says, "Not that You mind the killings. Your book is full of killings."

Occasionally he falls into musing. Thinking about the vast expanse of women, he says, "You can't kill a *world*." That's about the extent of his self-restraint.

What Mitchum brings to these scenes, besides his usual secure and self-assured masculinity, is the wily smarm and smooth patter of the evangelist and the seducer, an oily and semicomical seductive backwoods salesmanship, which at a moment's notice switches to an intimation of bestial rage. The Preacher loves being who he is, and Mitchum conveys this happiness with great energy. He gives the Preacher a practiced and professional insincerity. Harry Powell, whatever else he is, acts his roles joyfully. Even his rage is joyous. His face, often lit from the side by Stanley Cortez to emphasize his dividedness, goes instantly from a smile to a truly frightening grimace of possessed fury, as if an animal lived just under the surface of the formal attire and the wide-brimmed hat, an animal equipped with a switchblade. Mitchum thought it was his best performance, and he was right.

According to Simon Callow, Laughton told Mitchum, "I want you to play a diabolical shit," to which Mitchum's reply was, "Present."

Harry Powell's oppositions between cleanliness and dirt, purity and defilement, are most graphic in the film's most famous device, the four letters of HATE tattooed on the fingers of his left hand, and LOVE tattooed on the fingers of his right. The Preacher's trademark sermonette sets the two hands arm wrestling against each other—staged, in the movie, in Walt Spoon's ice-cream parlor before an admiring audience including Walt's gawking, credulous wife, Icey, played as a noisy over-the-top pious and prissy hypocrite by Evelyn Varden. Setting his two hands to battle, the Preacher looks like an institutionalized schizophrenic whose limbs are waging hand-to-hand combat within the same body. In his sermonette, right-hand love always wins, of course, but it is the battle of hand against hand that suggests a human body at war with itself, semi-mechanized, a body possessed by and for a madman. The LOVE enacted by Harry Powell is not the sort anyone would welcome anyway. In a later scene, he slits Willa's throat with the right hand (of LOVE).

You can't, in the initial world this movie creates, get free of the impression that all the adults are behaving like variety-show figures acting out some form of vaudeville Protestantism, in which everyone loudly asserts a sort of bogus cleanliness. All the adults in Cresap's Landing, in the first part of the story, are obsessed with purity and cleanliness, as if adulthood naturally meant, more than anything else, getting dirty. The two forms of filth they *claim* to want to get free of are money and sex. Given such a setup, a preacher who is willing to take their money and their bodies (whatever they're willing to give) is part of a rich Protestant cultural tradition of the seducer-prelate playing to a houseful of suckers.

The scenes in which Harry Powell gives his sermons and displays his charm—in the ice-cream parlor, or at a riverside Sunday picnic—are directed and staged by Laughton and photographed by Stanley Cortez so that the pastoralism of Norman Rockwell and D. W. Griffith (there are iris-outs) is employed to create a sense of eerie, creeping, shivering malevolence just beneath the sunny surfaces. Here every stance of innocence is disingenuous. Money is the text, but sexuality is the ubiquitous subtext (text and subtext trade places after the Preacher marries Willa), either one of which can get Willa killed. The Sunday picnic scenes are shot from John's point of view, with the Preacher speaking to Willa inaudibly in the

distance, as if a child cannot know what is said in such conversations. But it is John and not his mother who has what the Preacher really wants and desires. This is the key to the movie.

The Preacher doesn't want Willa's body or her love (he only pretends to want it), he wants her money, and John has that, which turns the Preacher, in effect, into someone who, transfixed by what the boy has, *looks* like a relentless unstoppable pedophile, even though he acts on the surface as if he's just after the ten thousand dollars. The ten thousand dollars in this movie is something of a red herring, as is the forty thousand stolen by Marion Crane in *Psycho*.

The film makes no sense if you imagine Harry Powell going after the children merely for the money from their father that they have been ordered to squirrel away somewhere. Money creates passions, but not like that, not that nightmarishly, not exactly in these obsessive-feeling images. It's no accident that the money is hidden inside a body. Harry, with his hatred of women, will not be satisfied with money. He seems to want something dreadful from the children—something he can't actually ask for. This is the source of the movie's palpable creepiness. What gives Harry Powell and the movie its particular passion is the relentless obsessiveness he has about the children, the fixed mania in the way he looks at them and corners them, and the way that the walls close in on them whenever he questions them or has them sit on his lap, taunting them with food that they cannot eat until they give him what he wants; and the switch of the text/subtext, money and sexuality, gives his pursuit of them its unique (and, for the 1950s) unnamable disturbance.

His first victim in this show is Willa Harper. Shelley Winters's role is a thankless one, since the character she plays is bedeviled and bewildered most of the time. This character has no forward motion—Willa is always reacting to something she has not initiated, a terrible problem for any actor in creating variety in a performance. After marrying Harry, Willa is seen in a revival meeting lit by railroad flares (we see these torches again at the end, in the lynch-mob scenes—no detail in this movie is ever orphaned, everything seems to happen twice), confessing that she drove her first husband to rob banks by demanding money for "face paint." This is another red herring. Willa can buy face paint but she can't buy attrac-

tiveness to Harry, no matter what she does. In this story, what does this *particular* stolen money buy? It buys sex appeal, all right, the sex appeal of filthy lucre, but Willa doesn't have it and never had it; the children do. It's as if the secret of the money gives them, John especially, a quasi-sexual aura. This is money hidden in the secret body, a small body, and you have to rip into the body to get the money out. Here, as elsewhere, money and sex get mixed up, displaced, confused. After telling Harry that she doesn't know where the money is, and Harry lies to her that it was thrown into the river, weighted down by a cobblestone, Willa announces, "I feel clean now. My body's just a-quiverin' with cleanness." This sort of quivering is the only sort that Harry will allow her body to do, and Shelley Winters gives the scene a slight comic overtone, a sort of zombie Protestantism.

In her other scenes she gives her line readings a kind of breathtaking mindlessness, a feeling of possession, as if, as an actress, she was presenting an idea of the role and was hanging onto that idea for dear life. It's hard not to feel that, as an intelligent woman, she's reluctantly playing Willa as a dumb cluck, adrift in a tidal wave of misogyny. By contrast, Mitchum inhabits his role in a way that Winters, for the most part, seems unable to inhabit hers—Quint-like, he wants something *out* of the children and keeps heading forward toward them to get it. Unlike Willa, he knows what he wants. We have entered the world of campy religious mania, with the wrong people—the adult mother—innocent of the most important thing (where the money is), and with the children presented as the knowing ones, the ones who know where the Preacher's desires are hidden and who would rather not know what they know. What they can't do is break faith with the ghost of their father. In these scenes we are, again, close to the narrative convolutions of *The Turn of the Screw*.

Winters does have one great actor's moment: After she has overheard Harry shouting at her daughter and now knows that he's been lying in every detail, she enters the house, sees him, and in a brief medium shot her face goes instantly rigid in a smiling, vacant despair. This single shot of her face is unforgettable: it is as if her whole life has come to this point and will go no further. The movie gives her only two chances to be beautiful and attractive. In the first, her wedding night with Harry, she is dressed in a nightgown and is delicately lit, barefoot, and physically vul-

nerable as she speaks her husband's name as a prelude to their lovemaking. But Harry, of course, will have none of this. In an effort to make Willa physically ugly, he snaps on a harsh overhead light and forces her to stand before a mirror, as he tells her that her body is the temple that men since Adam have defiled. Its only purpose is to "beget" more children. The glare from the bulb seems to slice her up into chiaroscuro pieces. After getting back into bed, she prays to God to get as clean as Harry wants her to be.

She gets her wish. After Harry has slit her throat, she sits attached to the Model T at the bottom of the river, permanently and forever baptized, washed eternally by the currents. These are horror scenes shot rhapsodically in the studio tank, as a sort of watery elegy to the beauty of this woman. In this extraordinary set of shots, with her body finally cut open, thrown away, and placed in the river in the very locale where Harry has claimed the money was, Willa seems to have become almost a water goddess, a sleeping naiad whose hair is mixed and tangled with weeds. The shots are so lovingly extended and the cutting so subtle that you think Shelley Winters herself must have stopped breathing altogether in order to pose for them. It looks simple, but it's not clear how the thing was done. Scrubbed and clean at last, Willa appears to be either resting or waiting in the car for her date, her underwater gentleman caller, to arrive. (In *Psycho*, by contrast, the offending woman's body is disposed of in the muck of a swamp. Typically with Hitchcock, one is not cleansed in death but, if anything, becomes more dirty than before, becomes the dirt itself, a bloody problem, as in *Rear Window* and *Rope*, of drawing-room clutter, sanitation, and physical disposal.)

The only gentleman caller in this film's first half is the Preacher, who, when he holds out his hands, is after something—the better to snuff it out. In a final confrontation with John and Pearl, he rushes up the basement stairs, chasing them, his hands held aloft like . . . well, a preacher, reaching toward the thing he wishes to possess.

In this movie's first half, there is one male on whom John relies after his father dies: an avuncular figure, a genial fisherman and drunk named Birdie Steptoe, who is (significantly) repairing John's father's skiff. But Birdie too is henpecked, even if only by a chiding photograph of his now-deceased wife. As his name suggests, he is ineffectual and flighty. Like

Walt Spoon, Birdie seems to have renounced all the masculine virtues, such as they are. Once your father is dead, there's no getting him back; for John the landscape fills up with male drunks and weaklings and promise breakers, none of whom can put up much of a resistance to the progress of evil. It's as if fatherhood itself—the whole principle of the thing and its attendant virtues and responsibilities—has disappeared from the face of the earth, has been buried with his father. When John and Pearl, having been found out by the Preacher, run to Birdie's for refuge, Birdie is lying on the floor, dead drunk, helpless, out of it.

"There's still the river," John says aloud, whereupon he launches himself and Pearl into his father's boat, the Preacher chasing close behind, cutting through the underbrush using his switchblade as a machete. Once the two children start drifting down the river in their father's skiff—Ben Harper's last legacy holding them up—the movie undergoes a great transformation. At this point *The Night of the Hunter* changes registers so radically that some viewers never recover from its sudden alteration in tone. Laughton's direction of the next four pages of the screenplay takes the movie in two directions: toward an American pastoral fantasy of escape on the one hand (we are never far, here, from *Adventures of Huckleberry Finn*), and toward the stylizations of D. W. Griffith's films and German art cinema on the other.

What in any other director's hands would have been a brief set of bothersome transition scenes shot on location turns here into a sequence of hypercharged visual lyrics. The effects are heightened by the art direction, which emphasizes the studio backdrops as if we are not in a "real" world at all so much as a child's dreamworld dominated by symbols, and by the lighting, which emphasizes silhouettes, mere outlines, and deliberately unreal domestic scenes. We see the children floating downstream, sleeping in their father's boat, small and model-like, we see (as they do, from outside a window) a bird in a cage being fed by its owner, we see the Preacher riding along the horizon at a distance, and we see and hear the small animals along the riverbank—the chorus of nature in the foreground for which the children are the background. We see the children begging for food. We see, in effect, nature taking over.

As if all that weren't enough, Walter Schumann's score introduces a soprano singing a lullaby. The viewer's heartstrings are not being tugged

here, they're being grabbed and yanked and pulled at, and what seems to be giving the scenes such terrible urgency, almost a lyric agony, is an acute sense of orphanhood and victimization, a sense of not being *looked after* but of being *looked for*, which seems to have no ending, which has slipped out of chronology altogether. "Don't he ever sleep?" John asks from a hayloft, seeing the Preacher clip-clopping by on his horse. Well, no, he doesn't: In this section, we have a sense of the endless night visited upon them by this obsessive maniac—which seems to leave them stranded in a perpetual childhood, which also seems to be the perpetual time-sense of trauma. All these particular children have is their father's boat and the river, in which their dead mother rests.

In an essay on Laughton in the *New York Review of Books*, the critic James Harvey argues that Laughton's work, particularly in this film, is infused with an odd sexual unhappiness and self-pity, a "grandiloquent folksy-artsy style," but these scenes don't seem personal so much as meta-physical—Brecht again—as if the lyric feverishness had been turned in the direction of Theodore Roethke's "all things innocent, hapless, forsaken" and had been forced to dramatize those three categories in starkly allegor-ical outlines.

It is difficult visually to get from horror to poetry in a single step, and very few filmmakers have ever managed it without hokum—Murnau, Ingmar Bergman, Carl Dreyer come to mind. A cold Protestantism seems to suit such transitions, a sense of fresh-frozen sexual repression and some sort of errant spiritual life shuddering in its tracks. In other hands the effort to get poetry out of horror goes stagy or operatic (think of Cocteau, Polanski, or James Whale). *The Night of the Hunter* is not completely free of hokum, but under Laughton's direction, the children are held in a kind of suspended animation, no longer children and not yet adults, monumen-tally uncared-for except by the director, who lavishes all his visual gifts on them: It's as if the film is singing a lullaby to them that they can't hear. This intimacy with the children is slightly unnerving. The emotion embedded by the direction is out of all proportion to the story and the events on the screen, which results in a kind of poetry. John and Pearl feel encased in these scenes, further miniaturized, almost nonhuman, shell-shocked by trauma, almost completely emptied out, but still the object of the

Preacher's untiring pursuit and the director's undivided attention. The scenes only take a few minutes but are meant to feel like (an) eternity.

What Laughton wishes to convey here, I think, is the endlessness of traumatic experience, the way it never seems to contain itself, its irrelevance to clock time, its feeling of the omnipresence of the perpetrator. This may be why John obsesses after his father dies about acquiring a watch, so that some sort of normal chronology can start up again sometime. Normal time can't be resumed until the movie enters its last section, and Rachel Cooper appears.

Whatever else *The Night of the Hunter* may be, it is not cynical. Something or someone has to save the children from the predator who pursues them, and it turns out to be a nearly sexless old lady who is nearly as much man as she is woman. Single-handedly she has organized a household, handles a shotgun, marches back and forth on her porch when on guard, and delivers countersermons to the Preacher's. She is—it seems a shame to say so—too good to be true, but there isn't an ounce of irony in Lillian Gish's performance, or a single moment when she breaks character until the film's last two scenes, with the result that, as long as she is on-screen and performing her given actions, her character has life. (When she begins to ruminate in the film's denouement, she becomes unreal and starts to give the whole show away.) Since Harry Powell is too bad to be true, the terms of his badness are completely involved with human sexuality and greed; therefore the terms of Rachel Cooper's goodness must involve the same terms in reverse. She doesn't care much about money, and though she does have a son she rarely hears from, it is hard to imagine her ever having been married, and in current narrative time, she seems to have escaped the quagmire of human longing altogether. The last few scenes in the film are dominated by white (linens and snow, in particular), in a child's version of Christmas.

In the world of this film, the villains and psychopaths must be tracked down and executed, and goodness and the presumption of childhood restored. There is something either Victorian or naïve and sweetly hopeful about all this, this gestural move in the direction of the restoration of safety.

Contemporary sensibilities are, for the most part, dead-set against it. For innocence we have substituted knowingness and irony. We are more likely to be persuaded by the endlessly extended final shot of Jonathan Demme's The Silence of the Lambs, in which Dr. Hannibal Lecter, dressed in Hawaiian shirt and straw vacation hat, strolls amicably into a crowd and vanishes among its members. This, we think, is the realism of the macabre, or at least as much realism as we are likely to grant a melodrama. You don't get your innocence back after you've lost it, and you don't recage the Blatant Beast once he's gotten out of the zoo.

James Harvey and others have deplored The Night of the Hunter's will to innocence, what he calls its self-congratulatory benevolence, its "fantasy of loving kindness." Is this a fantasy to deplore? Harvey acknowledges that American films methodically traffic in the will to innocence, and although he doesn't say so, it's at the center of most of our great musicals and many of our funniest screwball comedies. But he seems especially offended by the fantasy of loving-kindness and the will to innocence positioned at the end of a melodramatic thriller. Besides, loving-kindness is much worse, much more offensive, than innocence. Thrillers aren't supposed to get anywhere near the territory of loving-kindness. To do so—even to make the effort—is somehow embarrassing.

If this kind of fantasy is a thought-crime, it hasn't been committed in American films to this degree in a long time, maybe since the silent film era. And the trouble with this particular narrative tone (one does think of Spielberg here, his unsuccessful efforts in this direction, as in Empire of the Sun) is the sense of being dosed with sugar, overdosed with it, suggesting nothing so much as the total impossibility and implausibility of enacting any sort of goodness at any time, an enactment that most critics would deny as mere cynical manipulation anyway. But the ending of The Night of the Hunter does not feel cynical or calculating so much as futile. Loving-kindness, we feel, will not get the job done in Hollywood or much of any-where else in an era dominated by violence and irony, and if The Night of the Hunter falters, goes gestural, lapses into hokum and the borderlands of kitsch, it does so in its last section, where it does try to eradicate the shadows it has created by means of an extreme—an extreme of faith. Extremes of evil can be believed, but extremes of goodness probably cannot.

The problem, I think, is not so much with the tone as with a story that cannot quite right itself after it has tilted in one direction: It can't be tilted back. Narratives have a kind of logic embedded in them, and this one has a very particular logic about fathers and men generally. The two fathers or father figures who appear in it are both violent, arrested, and sentenced to be executed; the remaining men in the story are ineffectual or drunk, or both. By the film's end Rachel Cooper has replaced them all. No bad men are visible at the end of the film because no men are visible there, period. All the talk about children and endurance and what abides and endures is a way of praising childhood at the expense of adulthood. There isn't a single adult male in the film who isn't crazy, violent, or weak. No wonder childhood gets praised to the skies. No wonder, Rachel says, in the last words of the film, speaking of children, that "they abide and they endure." They had better endure as children, the boys especially, because once they become adults, they're goners. The wishfulness of the ending is simply a way of creating in the tone what cannot be created in the narrative logic of the story—that is, a sense of stability, and a sense of possibility in growth. You can't credibly claim that boys will grow up to be good men if you haven't been able to show a single good man anywhere in your story. And that's why *The Night of the Hunter* feels broken, or tilted, or Humpty-Dumptied, in its ending. The movie ends where it begins, with the heavens, the starry sky, but it's impossible to believe in those exalted heights anymore.

Still, the film's sense of conviction is dumbfounding, jaw-dropping. You get to the end of *The Night of the Hunter* feeling that you have never seen anything like it in your entire life. Even the movies that look like it really *aren't* like it. If the movie falls just short of being a great film or a masterpiece, it is nevertheless one of the strangest and most affecting and most memorable things ever put on the screen—a *sincere* thriller, of all things—a cinematic act of heroism.

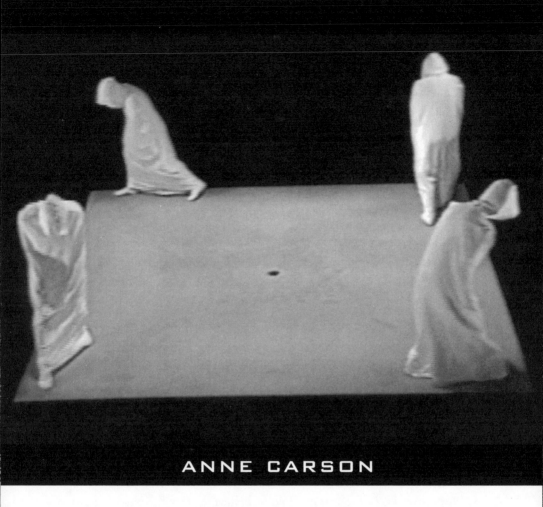

ANNE CARSON

QUADRAT I AND II

WRITTEN AND DIRECTED BY SAMUEL BECKETT
FOR SDR TELEVISION (STUTTGART, 1981)

how does it begin

Begins on a thinness—thin as the plate of reality that you climb back up over (from behind) when waking out of a too bright dream—and thinly on the plate Beckett has balanced his little factory of clear marks. Clear marks tilt and run on the plate never exasperated, never clumsy, never cruel. All the clear marks he drained off the exasperated, clumsy, cruel antics of Malone and Molloy and Mildred, of Mag, Moran, Macmann, Mercier, Minnie, Winnie, Worm, Watt and

Christ and so on (I guess) ended up here, saved for study, motioned in a picture.

why save clear marks

Better question: does Beckett strike you as a person who ever interrogated his own economic impulses? So once you have decided to save clear marks, you may hope to find yourself "beyond that black beyond" where everything not clear, not marked, just goes away. Going away is key. Even the clear marks seem to be trying to go away.

do they go away

Yes, but they come back then go away again and it ends amid exits. It ends in time, I mean stranded.

is there a plot

To keep moving at all times and not touch the hole at the center of the thinness. Each clear mark moves in from a corner of the thinness (which is rectangular) dodges around the hole, moves out to a different corner of the thinness, paces around the edge to the nearest counterclockwise corner, moves in from that corner, etc.

what's the hole for

"Abgrund ist E" said Beckett. Don't ask me what E is. He also said "danger zone."

how many marks

From one to four at any given time. They add or subtract themselves in sequence: 1, 2, 3, 4, 3, 2, 1 by exits and entrances: pure *Ringkomposition*, like a battle scene in Homer. I am speaking ideally. In fact Beckett starts his sequence at 2 and shuts off the camera before the last exit.

how do they look

No faces just cloaks. Blue red yellow white in *Quadrat I*, all white in *Quadrat II*. They look tense. As clear marks go these are experts. "Some ballet training would be desirable," said Beckett.

does sex matter

"Sex indifferent," said Beckett.

what about music

Hollow tink-tonk percussion sounds in *Quadrat I*, synchronized to the movements of the clear marks, everything busy as a hedge of crickets: Do you know the type of archaic Chinese poetry called "crazed glaze"? Nothing in *Quadrat II* but the shuffle of feet.

big mood swing

The all-white ones go slower, seem sadder, that poached-in-eternity look Beckett acquires in his last photos.

why white

Beckett people call this an accident. Some German technician played back the tape of *Quadrat I* in black-and-white, and Beckett saw it and wrote *Quadrat II*. You can credit this if you like. But he was always playing with translation, wasn't he? And *Endgame* plays back very differently than *Fin de Partie*. His very strong ideas about the difference were already formulated in 1931, when he lectured to students in a Paris *lycée* on "Racine and the Modern Novel." French is more of a work language than English he told them. "The French, cerebral transmission, statement rare, the English climactory," he said. Most of the students were doing their nails but one of them (Rosie) wrote down everything he said in a small notebook which she was courteous enough to show me. She wrote down his approval of Racine's atmospheric backgrounds and disapproval of Balzac's "floodlit facts." She wrote down a Proustian location "between the incandescent body and the damp body" but didn't catch what he said Proust said was between them. She wrote several times the phrase of "integrity of incoherence" and mentioned her sadness that at the end of the term he went off thinking himself a bad lecturer. He was not, she felt, bad. Pauses came at wrong places in his talk, he was grateful for them. I wish I'd kept in touch with Rosie.

Quadrat quiz

Match each item of Column A with that item of Column B which most effectively completes its lessness:

Column A Column B
tongue catastrophe

further on danger

There is a "jerky turn" ever repeated by each one who reaches the hole, wavers there, then flicks away. Repeated. They forget. Do they forget? On the other hand they never forget. The danger of forgetting is withheld. I see no danger in it.

do I detect a question of genre

"Piece for four players, percussion, and light," said Beckett.

and the light

Raised frontal, icy and important. Important to him. "If there were only darkness all would be clear. . . . But where we have both dark and light we have also the inexplicable," he said in a well-known interview (1961). I am inclined to take this concretely. After all, a "dark" theatre is one where no play is on. But Beckettpeople pounce on such remarks as if they were Catherine pulling feathers out of a pillow in *Wuthering Heights*: "Did he shoot my lapwings, Nelly? Are they red, any of them? Let me look!"

Soon the down is flying about like snow.

Gets the down up like no other, does he not?

Troy quiz

Let's say you glance out a window of Priam's palace at Troy and see there a thinness on which men in identical garments move monotonously hacking one another to death, will you call this

1. necessity
2. work
3. servitude

4. glory
5. TV

Justify your answer using diagrams (metal-punch machine) from Simone Weil's *Factory Journal*.

how much time passes between Quadrat I and Quadrat II
"*Hunderttausend Jahre*," said Beckett.

how much time passes within Quadrat I and Quadrat II
Hard to say. The clear marks go snooping around until he cuts off the camera. We get a section of time—razored out—but whose.

would you say he thematizes his medium
no, he thematizes himself—like Elvis singing *How Great Thou Art* he's a one-man quartet.

Quadrat is a religious work
No.

perhaps an infernal work
No.

simply a game
I do not find games simple.

I mean that a game is pure means
Yet this game serves Beckett's end.

what is it (Beckett's end)
To avoid being asked this question.
To be neither punished nor rewarded.
In translating into a tongue that has no word for "neither" you have to explain it by "don't know which is the way." By none of their ways, by way of not this world, by way from wrong start, etc. Or—as Homer might say—with "the leap of evening."

J. M. COETZEE

THE MISFITS

DIRECTED BY JOHN HUSTON

The Misfits (1961) was put together by a notable set of collaborators. The film is based on an original screenplay by Arthur Miller. It was directed by John Huston; and it starred Marilyn Monroe and Clark Gable in what turned out to be their last big roles. Though it was not a great box-office success, it continues to hang around on the fringes of critical attention, and deservedly so.

The plot is simple. A woman, Roslyn (played by Monroe), visiting Reno, Nevada, for a quick divorce, gets friendly with a group of part-time

cowboys and goes off with them into the desert on a jaunt to trap wild horses. There she discovers that the horses will end up not as riding mounts but as pet food. The discovery precipitates a breakdown of trust between her and the men, a breakdown that the film patches over only in the most uneasy and unconvincing of ways.

Aside from the ending, the script is a strong one. Miller is operating at the tail end of a long literary tradition of reflecting on the closing of America's western frontier, and the effects of that closing on the American psyche. Huckleberry Finn, at the end of the book about him by Mark Twain, still has the recourse of lighting out for the territories so as to escape civilization (and Nevada, in the 1840s of Huck's childhood, was one of those territories). Miller's cowboys, a century or so later, are trapped in the States with nowhere to go. One of them, Gaye (Clark Gable), has become a gigolo preying on divorcées. Another, Perce (Montgomery Clift) scrapes together a living as a rodeo performer. The third, Guido (Eli Wallach), exhibits the dark side of the male homosociality of the frontier, namely a vicious misogyny.

These are Miller's misfits, men who have either failed to make the transition to the modern world or are making that transition in an ignominious way. The three are presented with a roundedness that is rare in cinema, the result of Miller's deft professional stagecraft.

But of course Miller's title has a second, ironic meaning. If the cowboys are misfits in Eisenhower's America, the Nevada mustangs are even more deeply so. There used to be thousands of them; now there are only pitiful troops up in the hills, barely worth being exploited. From being an embodiment of the freedom of the frontier, they have become an anachronism, creatures with no useful place in a mechanized civilization. It is their lot to be herded and hunted from the air; if they are not yet being shot from the air, that is only because their flesh would spoil before the horse butcher could arrive with his refrigerated truck.

And then, of course, Roslyn is a misfit too, in ways less easy to put a finger on, ways that lead us to the creative heart of the film. Miller was married to Monroe at the time, though the marriage broke up during the course of the filming, and one suspects that the character of Roslyn was shaped around Monroe, or around Miller's sense of who the inner Monroe

was or could be. In some of the more impressive scenes of the film, Miller and Huston do no more than create a space in which Monroe can act out herself, create herself.

Ironies run particularly deep here, since Monroe in part incorporated, and in part (one would like to think) struggled against, the dumb-blonde self that the Hollywood star system prescribed for her; and anyway it is not always easy to distinguish the elusive charm of the character Roslyn from the slack, Nembutal-induced good humor of Monroe herself.

The key scene here occurs about thirty minutes into the film. Roslyn has been dancing with Guido, with Gaye and Roslyn's older friend, Isabelle (Thelma Ritter), looking on. Roslyn is charming, full of life; but whatever further signals she is sending out, Guido misreads. To him the dance is sexual courtship; but Roslyn keeps evading him in a way that is beyond mere coyness. Eventually she dances out of the house into the evening sun ("Watch out!" calls Gaye. "There's no step!") and continues her dance around the trunk of a tree, falling at last into a semi-undressed coma.

Gaye understands what possesses Roslyn no better than Guido does, but he knows enough to hold Guido back. The two men and Isabelle stand and watch in bafflement while Roslyn—who at this point, one can recognize with historical hindsight, might as well be Monroe herself, or at least Arthur Miller's Monroe—does her thing.

What is Roslyn-Monroe's thing? In part, one must concede, it is Angst of a rather hand-me-down kind, for which Left Bank café existentialism must be blamed. But in part, too, it has to do with a resistance to the highly focused and even regimented models of sexuality purveyed not only by Hollywood and the media but by academic sexology. Roslyn is dancing out a diffuse and—in the light of the rest of the film—forlorn sensuality to which neither Guido's sexual predatoriness nor Gaye's old-fashioned suave courtliness is an adequate response.

Another haunting scene comes toward the end of the film, when it is brought home to Roslyn with full force that the men have been lying to her, that finally they care more for the macho exploit in which they are involved—capturing the wretched horses—than they care for her, that pleas and even bribery will get her nowhere. In despair and rage she tears herself away from the men; she screams and rants and weeps against their

heartlessness. To a more conventional director, this high moment—the moment when all veils are torn from Roslyn's eyes and she realizes that, as a woman and perhaps also as a human being, she is alone—would have seemed an opportunity for *acting* in an old-fashioned sense: for intense close-ups for crosscutting from face to angry face. In fact Huston shoots the scene contrary to such conventions. The camera stays on the side of the men; Roslyn is so far away that she is almost swallowed by the expanse of the desert; her voice cracks; her words are almost incoherent. The effect is disturbing.

But the scenes—the long sequence of scenes—that stay most indelibly in the mind are those involving the horses.

In the credits to any film involving animal participants that is made nowadays, at least any film made in the West, cinemagoers are assured that no hardship was caused to the animals, that what may have appeared to be hardship was only filmic sleight of hand. One presumes that such assurances were brought about by pressure from animal rights organizations on the film industry.

Not so in 1960. The horses used in the filming of *The Misfits* were wild horses; the exhaustion and pain and terror one sees on the screen are real exhaustion and pain and terror. The horses are not acting. The horses are the real thing, being exploited by Huston and the people behind Huston for their strength and beauty and endurance; for the spiritual integrity of their response to their enemy, man; for actually being what they seem to be and are held to be in the mythology of the West: creatures of the wild, untamed.

The point is worth stressing because it brings us close to the heart of film as a representational medium. Film, or at least the visual component of naturalistic film, does not work via intermediary symbols. When you read, in a book, "His hand touched hers," it is not a real hand that touches a real hand but the idea of a hand that touches the idea of another hand. Whereas in a film, what you see is the visual record of something that once really happened: a real hand that touched another real hand.

Part of the reason why the debate on pornography rages on over the

photographic media when it has all but died out in the case of print is that the photograph is read, and justifiably so, as a record of something that really happened. What is represented on celluloid was actually done at some time in the past by actual people in front of a camera. The story in which the moment is embedded may be a fiction, but the event was a real one, it belongs to history, to a history that is relived every time the film is rolled.

Despite all the cleverness that has been exercised in film theory since the 1950s to bring film into line as just another system of signs, there remains something irreducibly different about the photographic image, namely that it bears in or with itself an element of the real. That is why the horse-capturing sequences of *The Misfits* are so disturbing: on the one side, out of the field of vision of the camera lens, an apparatus of horse wranglers and directors and writers and sound technicians united in trying to fit the horses into places that have been prescribed for them in a fictional construct called *The Misfits*; on the other side, in front of the lens, a handful of wild horses that make no distinction between actors and stuntmen and technicians, that don't know about and don't want to know about a screenplay by the famed Arthur Miller in which they are or are not, depending on one's point of view, the misfits, who have never heard of the closing of the Western frontier but are at this moment experiencing it in the flesh in the most traumatizing way. The horses are real, the stuntmen are real, the actors are real; they are all, at this moment, involved in a terrible fight in which the men want to subjugate the horses to their purpose and the horses want to get away; every now and again the blonde woman screams and shouts; it all really happened; and here it is, to be relived for the ten-thousandth time before our eyes. Who would dare to say it is just a story?

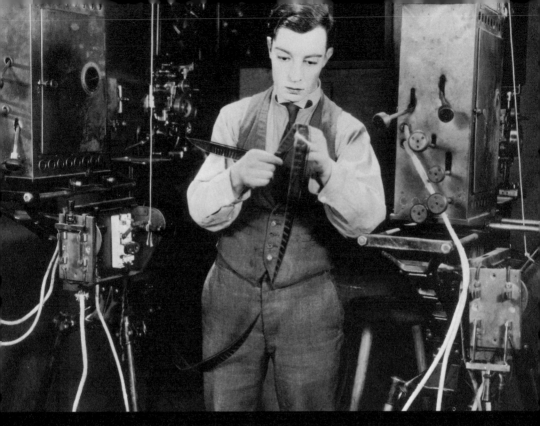

ROBERT COOVER

SHERLOCK, JR.

DIRECTED BY BUSTER KEATON

BEFORE YOU CLEAN UP ANY MYSTERIES, CLEAN UP THIS THEATER, says (in a printed title) the irate theater manager at the beginning of Buster Keaton's classic silent comedy *Sherlock Junior*, an admonition I could easily take to heart when first I saw this great film in the sixties, intent as I was then on making the dust fly in the house of fiction.

Growing up in the thirties and forties in small-town middle America, where the only legitimate entertainment besides pinball, bushwhacking,

and the school teams were the movies, meant saturation by genre: lots of Westerns and war pix, monsters, gangsters, detectives, comic duos, musicals and screwball comedies, tearjerkers and Bible epics. Which I soaked up and then, growing up, abandoned, along with all the other childhood myths and fairy tales. It took the great European innovators of the early sixties to lure me back again to a medium I thought too shaped by formula and money.

And it was not till then that I—and much of the rest of the world—rediscovered at last the magic of silent film, an art form largely neglected and even by then half destroyed, rescued only by museums, private collectors, "art" movie houses, and television when it was almost too late. Our parents grew up on the silents, were amazed by sound, never looked back. We who grew up on sound had to reach maturity before discovering that sound—and color—had in some ways corrupted film's original beauty and diminished its power, film being essentially a gestural medium, a kind of shadow play, suggestive of life itself, and thus most poignant and convincing in silent black-and-white.

Life's shadow play is for me, at best, absurdist comedy; at worst, not so funny, comedy then akin to horror. Thus, by my lights, filmmakers of the likes of Buñuel and Godard are realists, the only sort around, and Buster Keaton among them, maybe the best and truest of them all, a consummate artist, devoted to his craft, continually testing its limits, and as brave as he was funny.

Most filmmakers are unabashed tricksters, bunkoing their gullible audiences with their cunning optical hocus-pocus, not least among their wiles the illusion of the frame, its edges defining reality's limits, its power residing in part in the abysmal darkness beyond. A film, unlike a painting, does not hang in the light. It does not even hang but appears out of the darkness and disappears into it again. But in his famous frame-within-a-frame sequence in *Sherlock Junior* (a veritable sourcebook for self-reflective postmod filmmakers like Woody Allen), Keaton does hang the frame in the light, and moreover he disturbs its integrity, jumping in and out of it, challenging not only its reality but the reality of the world in which it, in another frame, exists.

All right, so (presumably) it happens in a dream. In the film, Keaton is

a young moviehouse projectionist who aspires to become a great detective. He is in love with the boss's daughter, but is falsely accused of stealing her father's watch and so has seemingly lost the girl. While projecting a romance, he falls asleep and dreams that he enters the film, as do all the other characters in his "real" life, displacing the romance actors. When he first tries to enter the film, he gets thrown back into the audience. He charges back in but the image shifts so that he goes "in" but ends up outside. The background then goes through a series of rapid cuts while he suffers continuity: He sits on a bench, finds himself sprawling on a city sidewalk, stands and starts to walk and nearly falls over a cliff, and is in turn endangered by a train, frozen in a snowbank, drenched by the ocean, dumped back in the garden. By now the outer moviehouse frame (the screen) has disappeared: we have entered his dreamworld, a world of magical events, wild rides, and miraculous rescues. The dream does its business: When he awakes, the crime has been solved and he has won the love of the boss's daughter. The film being projected shows him what to do next.

In this surreal comedy of layered dreams, the use of a dream as a plot device only serves to remind the audience, both in the film and out, that its dream or fictional worlds and waking or "real" worlds are so intimately intertangled, the plots of each informing and directing each, a theme much on my mind when first I saw it. As were doubles, disguises, clocks and thresholds, the search for identity, role-playing, boundary anxiety, the struggle against entropy and disorder with love and courage, all present here, explored and hilariously mocked at the same time, and not least the idea of projection in all its filmic, mental, and psychoanalytic meanings.

What persists throughout this film of rapid metamorphic changes and ceaseless pratfalls is the comedian's reassuring resilience, his good-natured humility and stony dignity, his ongoing chin-up presence in an absurd and unfair world. I think I needed that, too, when I saw it, and, decades on, need it still.

STEPHEN DOBYNS

THE TITICUT FOLLIES
AS COMEDY

DIRECTED BY FREDERICK WISEMAN

onsider the following sequence: Two guards lead a naked man down a hall. One guard calls out, "How come your room's so dirty, Jim?"

The naked man is so angry that the soft part of his forehead between the eyes looks like a small fist. He stares down as he walks with his hands in front of his genitals. He has short-cropped gray hair and is a little under six feet, of average build, unshaven. He has a good head, a

wide brow—a handsome man if he weren't being hurried down a hallway naked by two uniformed guards, if he weren't furious.

"Goddamn thing is dirty, then," says Jim. His voice is such a growl that the words are hardly intelligible—a noise like heavy canvas tearing.

"What?" says the first guard.

"What'd you say?" says the second guard.

"What?" says the first guard. Both guards look healthy and well-fed. Although insistent, they show no irritation. They are mildly affable and businesslike.

"I didn't say anything," says Jim. Again the canvas tearing—a voice that has never experienced any gentle passage in this world.

"What?" says the first guard.

"Speak up, Jim, I can't hear you," says the second guard. "What'd you say?"

They have climbed a flight of stairs, and now Jim stops, standing against one more light-colored brick wall, with his hands over his genitals, looking even more furious, if such is possible, but keeping his eyes lowered. He refuses to answer. In the background people are shouting, doors are slammed, metal is being dropped on concrete.

One of the guards points down the hall. "Come on, Jim, come on. Let's go wash up. Let's go get shaved."

They lead him along, still ragging him a little. Jim takes small steps and has a slight slouch. They lead him to the barber chair at the end of the hall. As Jim sits down, one of the guards asks, "How's that room, Jim?"

"Very fine, very clean," says Jim.

And in that moment a few things become clear. Jim's irony is not only a bit of rebellion, it is also the attempt to hang on to a smidgen of self-respect. He may be kept naked in an empty cell with no hope of being released, but he still has a touch of defiance. Jim's slouch, his whole physical stance, hands across the genitals, bent knees, flabby ass, show how far he has been pushed down, but he still has something left—some scrap of metal, a few unbroken sticks, whatever the last traces of dignity might be.

Provoked, the guard leans past the barber—another guard—and hovers over Jim, reclining in the barber chair with his head back.

"What'd you say?" says the guard. "How's that room?"

Jim doesn't respond. The barber-guard lathers Jim's cheeks with a brush. Water is running in the background.

The guard gets increasingly angry. "How's that room, how's that room, Jim? Answer." He slaps Jim's arm.

"You going to keep that room clean, Jim?" asks the barber.

The two men lean over on either side of Jim. "Yes, sir," he says, without deference.

"How come you got it all dirty last night?" asks the barber. As he talks he slops lather across Jim's mouth.

Jim answers by saying something about the weather, that it's a little cooler than it was yesterday, leading both guards to say, "Anhh? What?" "What'd you say, Jim?" going at him from both sides.

Now the barber grips Jim's head with one hand, putting a thumb under his jaw and clamping his fingers at the top of Jim's skull, forcing his head this way and that as he draws the razor across his cheeks.

"How's that room going to be tomorrow, Jim?" asks the guard.

By the look of Jim's stubble, he hasn't been shaved for a week. He isn't allowed to shave himself and is kept naked in an empty room because he is thought to be suicidal (one wonders why). The barber doesn't shave him gently, and the razor is pulled across the bristles like a dull mower pushed across a patch of ferns. Jim makes no response to the shaving except to hold himself a little tighter. He ignores the guard's question.

The barber-guard turns Jim's head to get his attention. "Hey, how's that room going to be?"

"Very neat, very clean," repeats Jim.

"How come it's not clean today?" says the barber-guard. "You told me that yesterday. What happened?"

Jim doesn't answer.

"How come you ripped all your clothes up?" says the barber-guard, referring to his paper clothes.

Jim still doesn't answer. The barber is shaving around his mouth.

"How's that room, Jim?" asks the second guard.

"Very clean," says Jim, "I keep it . . ." He starts to stutter.

"What'd you say? Answer me, Jim," says the second guard.

Jim doesn't speak and stares at the ceiling. The barber grips his nose,

squeezing it and pulling it upward, as he shaves quickly around Jim's mouth. Suddenly the barber slices Jim's lower lip. It begins to bleed. The second guard pats the blood with a towel. Jim doesn't even wince—this, too, is a small act of rebellion.

The barber wipes off the rest of the soap and steps back. "Okay, Jim."

Jim gets up, his lip still bleeding a little. "Thank you very much indeed. Thank you, boys." When he speaks without anger, one can hear he has an educated voice, even somewhat distinguished.

As Jim starts to walk away, the barber says, "Take a drink of water, Jim, before you go back."

"All right." Jim turns. "On the house, isn't it?" His laughter has the sound of a heavy file against metal. It's devoid of humor.

"Yeah," says the barber, turning the faucet, "on the house."

It's the one light moment, and as Jim is escorted back downstairs the ragging starts again. "How's that room going to be tomorrow?"

"Great, great," says Jim, again looking down as he moves along the hall.

"Anhh?" says a guard.

"Spic and span. Very clean," says Jim, raising his voice as he descends the stairs.

"What?" says the other guard.

Jim stops at the bottom. "Yes . . . !" he shouts. His words come out as such a jumbled roar that it is impossible to separate one from another.

The two guards watch him with mild, hateful expressions. One guard stands with his hands on his hips, and when there is a pause in Jim's bellow, the guard asks, "What are you doing, Jim? Morning, Jim."

"Morning!" It sounds like the devil clearing his throat.

"How's everything going to be in the morning, Jim?" asks the guard.

"It's going to be the best of mornings!" His words are barely containable.

"Anhh? What?"

Then Jim loses control. All the tendons in his neck stand out; his mouth becomes a lacerated space, a piece of ripped fabric as his gums pull back from his teeth; the eyes distort, forehead knots—it's an image of the last vestige of civilized veneer stripped away. He bellows something like, "I

said I'd have it clean, didn't I?" but it's as if he's piled twenty voices on top of one another, as if all the times he has said the same thing have been jumbled together and forced through his mouth at the same moment and this is what has so distorted his face, this is why he looks so wild.

"What?" says the first guard, smugly.

"Didn't I?" screams Jim.

"What'd you say?" says the second guard, just as smug.

"Didn't I?" screams Jim.

"What'd you say? Can't hear you, Jim," says the first guard.

Then Jim sinks back into his quieter rage and continues down the hall. The guards keep at him, but he ignores them. They have already beaten him; he has already lost what shred of control he had had left. Now their words are no more than pinpricks.

When they get Jim to his cell, he hops inside—almost lively—saying, "Thank you very much. Thank you very, very much."

It is a completely empty brick-walled, wooden-floored room, about twelve by twelve feet, with a large barred and wire-mesh-covered window—a cell in a building dating from the 1850s.

For the first time Jim removes his hands from his genitals and touches his lip, where the barber cut him. Then he begins walking back and forth, doing a rhythmic stamping with his bare feet—ONE, two, ONE, two, ONE, two—that echoes loudly in the bare room. He covers his mouth with his right hand and occasionally looks toward the door. He has a sly expression and takes sly glances. Back and forth, back and forth, and it's no longer walking. At times he stamps in place. Initially it seems very primal, as if returning to some earliest archetypal image, and in a way it's more disturbing than anything that came before—not that Jim is naked, but that he appears to be dancing; not that he is mentally disturbed or criminally insane or sadistically victimized, but that his last rebellion is reduced to this sly dancing. He has been beaten down 99.99 percent of the way and he is dancing. Not happy dancing or mournful dancing or triumphant dancing—this is fuck-you dancing. And his little prick in its sad bush bounces slightly as he stamps.

Then Jim stops and leans against the wall and looks at us: a look of

fierce attention, as if we were the page of some unpleasant book he was being forced to read. And he concentrates. He despises us, and he dislikes being watched. What is striking about Jim is that his eyes appear to have such wisdom. When he looks one could easily think he knows more about the world than anyone else in the entire institution and that he is looking out with a kind of mocking pity. *You still have your little illusions,* he seems to say. When I first saw him do his dance, I thought the primal quality was like an ape's—some African gorilla in a clearing, a Neanderthal under the moon. Seeing the scene over and over, I move Jim to the other side. He is the iconoclast, the cynic, the supreme logician forced to spend years in solitary confinement for his opinions, with only his nakedness and defiant dance and the eye that peels you like a grape.

So Jim stares out at us, and the guard's voice calls "Keep that room clean, Jim," and again Jim begins his dance. Then he begins to beat against the window frame, keeping up the trochaic rhythm, then he stamps, and then he leans against the wall in the corner, watching us again.

The invisible guard says, "How 'bout keeping that room clean, Jim?" Jim salutes. On the wall are dark streaks like shit might make if smeared on a wall with the fingers.

Another guard asks, "You play the piano, Jim?"

"Yes," says Jim.

So the guards ask him where, and Jim says at his home in Fitchburg—84 Arlington Street. Then the guards ask if he is a schoolteacher. Jim has begun to speak very clearly, with no trace of the disturbed man who was dancing just seconds ago. He says he taught arithmetic and mathematics for a short while in a junior high school and had attended Fitchburg State Teachers College, Fitchburg Normal School, Fitchburg Business College, and Fitchburg High School.

Then a guard asks, "You graduate with honors, Jim?"

Jim notices the mocking tone. He had been speaking with a touch of pride, but, hearing the tone, Jim realizes the question is not motivated by interest, but is part of his torment. He grows thoughtful, then sad, as if he had told himself never to trust them, never, never to fall for anything they might say, and here once more, foolishly, he had let it happen. He, too, had trusted a bit of the illusion. And so he says nothing.

———

These are scenes from a comedy—not the sort of comedy that makes you laugh, or laugh all the way through, but the sort that tries to portray the entire range of human values—a comedy in the way Chekhov meant the term, a comedy in the way *The Cherry Orchard* is a comedy—that funny play that ends with an old man being locked up alone in a house to starve to death, or *The Seagull*, that funny play that ends with a suicide. This is a comedy that was so disturbing that it was banned for twenty-four years, from 1967 until 1991.

The sequence with Jim—his last name was Bullcock—is also a turn in a variety show about a variety show: Frederick Wiseman's *Titicut Follies*, filmed at the Massachusetts Correctional Institution at Bridgewater in 1966.

Wiseman told me that this ragging of Jim Bullcock about his room happened every time he was taken out to be showered or shaved. Wiseman only filmed it once. At that time Jim Bullcock had been in Bridgewater for nineteen years.

Bridgewater has four sections—a maximum-security prison for the criminally insane, a section for sexual offenders, one for juveniles, and one for alcoholics. Wiseman filmed only in the first. *Titicut Follies* was the name of the annual staff-prisoner variety show—a name that was changed to *Bridgewater Follies* after the film wound up in the courts. The prison is located on Titicut Street in Bridgewater, in the southeast part of the state—"Titicut" being the old Indian name for the region—and in 1966 it had about 950 inmates. This was Wiseman's first documentary film, although two years earlier he had produced Shirley Clarke's *The Cool World*. When Wiseman was filming *Titicut Follies*, he was still teaching law at Boston University, so the filming, which took twenty-nine days, was stretched over three months.

Once people started seeing the film, however, and reviews appeared, problems arose. Wiseman described these events in an interview in the *Civil Liberties Review* (Winter/Spring 1974):

> Ever since I began to take law classes to Bridgewater [in the late 1950s] I'd wanted to do a film there. The superintendent of

Bridgewater approved the idea, but permission had been denied by the state commissioner of corrections. Then a friend of mine who was a state legislator arranged for me to see Elliott Richardson, who was then lieutenant governor and had health, education, and correctional institutions under his jurisdiction. I saw Richardson, explained what I wanted to do, and he called the commissioner of corrections in my presence, endorsing the idea. A few weeks later the commissioner of corrections wrote that I could go ahead if I got the permission of the state attorney general, then Edward Brooke. Brooke's office issued an advisory opinion saying a film could be made in Bridgewater if I had the permission of the superintendent, and pictures were taken of "consenting" inmates.

Since I had the permission of the superintendent, I went ahead and made the film. Richardson was one of the first persons I showed the completed film to, in a screening room along with the

superintendent of Bridgewater and Richardson's driver. Richardson thought the film was great. He understood it, understood what I was trying to do with it, and congratulated me warmly. The superintendent asked him whether I should show it to anybody else in state government, and Richardson said no, not even the governor, who was then John Volpe. The conversation took place in a sound studio. Unfortunately, it wasn't recorded.

That was in June of 1967. In the fall of '67 the film was about to be shown publicly, and it had begun to be reviewed. A former social worker wrote to the governor saying how dreadful it was that a film showing naked men could be shown publicly. Then some state legislators decided to hold public hearings, not about the dreadful conditions at Bridgewater that the film showed, but rather about how I had gotten permission to film there. I was attacked viciously in the press, the Boston Herald, for example, for exploiting the poor inmates at Bridgewater and trying to make money off their misery.

Richardson—who had then shifted from lieutenant governor to state attorney general—was in trouble because he had not told his advisors that he had been instrumental in getting me permission to make the film. When he told them, I think he was advised that he had better move actively against the film to protect himself. So he got a temporary restraining order from a superior court judge against showing the film in Massachusetts. That's what started the proceedings.

State Representative Robert L. Cawley, the Democratic vice-chairman of the legislative commission that held hearings to discover how Wiseman was able to make such a film, accused Wiseman of using hidden cameras to show Jim Bullcock naked in his empty cell. And Wiseman was accused of attempting to make a get-rich-quick "Mondo Cane–style shockumentary" to recoup the money he had lost on The Cool World. The Boston Herald was particularly relentless, running an article every day for three months—accusing Wiseman of showing men masturbating and other pornographic material, as if there were something sexually exciting about

old, naked, crazy men. Perhaps genitals are visible for two minutes out of the eighty-four.

Again in the *Civil Liberties Review* interview, Wiseman said:

Actually, there were three allegations made by the state. One was that I had breached an oral contract giving the attorney general, the commissioner of corrections, and the superintendent at Bridgewater the right to exercise final censorship over the film. [Wiseman swore there had been no oral contract.] Secondly, they charged, the film was an invasion of the privacy of one of the inmates. This man is taken naked from his cell, is slapped by the guards, shaved by them while they banter about his past as a school teacher, taunted about why he doesn't keep his cell clean, and then returned naked to his cell. [No laws against invasion of privacy existed in Massachusetts at that time.] The third claim was that all receipts from the film should be held in trust for the inmates.

At the trial, the Judge found that I had breached an oral contract and had violated an inmate's privacy, but he rejected the trust requirement. He ruled that the film could not be shown to the general public in Massachusetts, and that all prints and negatives should be destroyed. He said there were no First Amendment issues, and that the film was "a nightmare of ghoulish obscenities."

Later the judgment was modified to say that the film could not be shown anywhere in the world except to "legislators, lawyers, sociologists, social workers, doctors, psychiatrists, students in these or related fields, and organizations dealing with the social problems of custodial care and mental infirmity."

The government, the courts, and the media had a variety of complaints, but their major complaint came down to Jim Bullcock's genitals. And those genitals are only seen in his cell—he keeps them covered when he is out in the hall. And in his cell they are only seen when he is stamping back and forth, when he is doing his dance. There are no close-ups of Jim Bullcock's genitals. We see his whole body from the door, from the other side of the room. His genitals are in no way peculiar—perhaps a

little small, that's all. Normal, nervous genitals. No, it's the dance that's obscene—its apparent primal quality. A naked old man in an empty room miserably stamping back and forth, doing a defiant little fuck-you dance. And what is obscene is that we have put him there and have forgotten him. What is obscene is that a camera has found him and reminded us that we have put Jim Bullcock in a dungeon and forgotten him. What is obscene is that Jim Bullcock in his torment has begun to inflict the feeling of empathy upon us, even those of us unaccustomed or seemingly unable to feel empathy.

Titicut Follies is the most literary of Wiseman's movies. Anton Chekhov's "Ward 6" presents an equally painful depiction of a man in a mental ward, and it, too, was judged obscene and ran afoul of the censors. And in Jim Bullcock's little dance we also see Melville's Bartleby the Scrivener saying, "I prefer not." The dance conveys judgment and claims kinship with us in one gesture. Then, after establishing that kinship, Jim Bullcock rejects us. He wants no part of us. That also is obscene. It's part of what makes *Titicut Follies* a "*Mondo Cane*-style shockumentary."

But the fact that this is the Massachusetts Correctional Institution at Bridgewater is no more than pretext. Eventually, that part will be forgotten. It's like gossip. And the court stuff and the banning of the film will be no more than anecdote, an amusing distraction for college freshmen. If the film has life, it will have to be as something closer to art than exposé, because it doesn't pretend to give an accurate picture of Bridgewater. We don't come away with any clear idea of how the prison operates, its structure, how the day is broken up, all those details.

In reading about the movie, we learn—scandalously—that hundreds of men were locked up for dozens of years, even up to forty, without ever being tried for anything. Simply for observation. Wiseman told me about one sweet old man named Kippy, who in the movie sings "Chinatown" and wiggles his ears. Kippy had a horse-drawn ice-cream cart on Cape Cod and one day decided to attract children to his cart by painting his horse to look like a zebra. The police disapproved, arrested him for vagrancy, and sent him to Bridgewater for observation. Having no one to speak up for him, he had been there thirty-five years when Wiseman arrived in 1966. Kippy had never in his life been in an automobile. The first time was when he got sick

and had to be taken up to Massachusetts General Hospital in Boston during Wiseman's filming. No other state in the nation has a prison for the criminally insane like Bridgewater. Well, it's hard to separate the facts of Bridgewater—the very scandal of the place—from *Titicut Follies*, the movie.

Instead of presenting us with an analysis of a state institution, Wiseman gives us a variety show. The film begins and ends with music. In between there are seven other sequences of men singing (one man sings while standing on his head). In two further sequences, men play musical instruments. And there are men giving set pieces that can be seen as comic turns. One shows a Communist agitator wearing an engineer's cap at a jaunty angle, who speaks so quickly and forcefully that spittle pops from his mouth. He has been talking more or less rationally about the government's lies concerning the Vietnam War. Then he says:

"There's one great factor that influences the war in Southeast Asia—this is this: America is the female part of the earth world, and she is sex crazy. Her sexiness brings on wars, like the sperm that is injected by man into a woman and by woman into her own body. It has the same effect, same influence, except this is in a gigantic pattern. You mean to tell me that after you've had a sex intercourse you feel fine or you feel healthy? You don't."

The other comic turn is by Borges, whom we see several times, a ranter who often speaks in his own invented language—tall, lean, impassioned, shouting—with a towel draped around his neck and one arm outstretched (Wiseman was accused of including him as a mockery of the pope.). In the exercise yard, next to the man singing while standing on his head, Borges disclaims:

"What is indulgences? Indulgences is where even the blessed Virgin and Father Mulligan there with his confessional there, tell the truth and expose it and call it down to Warden Johnson, and things like that, and they get around to it. Even the rabbi. Ah, not only the rabbi but the Christian Scientists and the minister. We know all about them for I know everything, because I'm psychic. I read their fucking minds. They're no good. They're moneychangers. They're Judases and that's all. And I'll tell you one thing, even Pope Paul is not without sin, even him and the cardinals and the See of Trent. . . . And I announce the rightful pope now is

Archbishop Fulton Sheen and the other one Cardinal Spellman, so help me God. I, Borges, say so."

The movie begins with eight men singing "Strike Up the Band." Dressed in white shirts, dark pants, bowties and silly hats, each holds two pompoms, which they move in unison as if signaling with semaphores. They are up on a stage and behind them in glitter letters it says TITICUT FOL-LIES. We know nothing about these men, but they are all deadpan, concentrating but deadpan. Not a smile anywhere. And they look a trifle nervous, as if afraid of doing something wrong. Their voices are amateurish, slightly off-key, as is the band—drums with lots of cymbals, horns, saxophones, piano. But "Strike Up the Band" is a jolly tune and they carry it through. The camera moves back and forth among them, moving into their faces and away. Maybe they are medicated, maybe they are depressed. At the end of the song they raise their pompoms and permit themselves small smiles.

Eddie runs onto the stage—master of ceremonies in a dark suit with a carnation in the lapel, perfectly coifed wavy gray hair. He pumps his hands at the audience for more laughter. He is a man with an Ed Sullivan fixation. "They keep getting better," he says in a flat Boston accent. He looks tremendously pleased with himself, and his face keeps twitching. We don't know if he is an inmate or a guard but because of the constant twitching we assume he must be an inmate. He has the unresponsive eyes of a sociopath. Actually, he is a senior guard and was the man who took Wiseman through the prison ("He had more compassion than most," Wiseman told me.) In the film he is vaguely Mephisthophelian, a character partly out of *Faust*, partly out of *Cabaret*—always upbeat and at the edge of demonic. Now, on stage, he explains the next act is a Western jamboree, but since it will take them a moment to set up, he'll tell a joke: "These two beetles are walking down the street, and they saw Father Mulligan, and he had a broken arm, and they said, 'Father, how did you break your arm?' and he said, 'I fell in the bathtub,' and they said, 'Gee, that's too bad, Father.' So they continue to walk down the street. So one of the beetles says to the other, 'What's a bathtub?' And the other beetle says, 'T'hell do I know. I'm not a Catholic.'"

Eddie twitches his mouth, his thin lips, nods his carefully waved hair, and jumps back behind the curtain.

Then comes the first of Wiseman's violent transitions. We immediately see Eddie again, but dressed in a guard's uniform with a tie and a policeman's hat, looking angry and walking in front of the camera. It's a strip search in a room of mostly old men, standing around naked or half dressed, looking bored, anxious, bereft of any trace of dignity, blanked out, doped on Thorazine. It is a large, brick-walled room with peeling paint and benches along the walls. A guard shouts, "Quincy, Quincy! Next, over here! Get your clothes!" Guards paw through the clothes. Piles of paper taken from the men's pockets litter the floor. The guards are smoking. Now the guards are calling for a man named "Somersault." The search is perfunctory, the guards impatient. A flat-topped, well-fed guard barks at a small, muscular black man, telling him to stretch out his arms and "turn around, take your stuff, and get over here and get dressed," in tones of deep dislike. Soon the men file out.

The first sequence of the men onstage in orderly rows and the second sequence with the men in a jumble—these establish Wiseman's range. Within that range he again and again attempts to join the awful and the comic in one sequence. By "comic," I don't mean funny, though it might elicit a guffaw. In Baudelaire's essay on the essence of laughter, he argues that laughter derives from Satan, that it exists to show one's superiority to someone else, that it was given to humans after the Fall both as evidence of original sin and as our cry of grief that we have been driven from the Garden. "The sage laughs not but in fear and trembling," he writes. Be that as it may, such an expression of the comic is a long way from Disneyland.

I want to look at three scenes that combine elements of the awful and the comic.

The first is an interview between Dr. Ross, the Hungarian doctor, and a young man, James, who has been remanded to Bridgewater for having sexually molested an eleven-year-old girl. The doctor is in his fifties, wears a white shirt, and has thick gray hair and light-colored eyes—a Germanic face—and he pronounces his Vs as Ws. His teeth are ragged, and several of the lower teeth are missing. He chain-smokes.

James is in his twenties, about five feet tall with short dark hair and large ears, and wears a white, sleeveless T-shirt. He appears miserable and grief-stricken.

Dr. Ross's accent is very thick. When he talks he quickly squeezes his eyes together tightly rather than blinking. "Was any actual, ah, sexual, ah, relation between you and this female child?" Someone is typing in the background. Before James can answer, Ross continues, "How old was the child? Eleven?"

James agrees, and his look of guilt and shame deepens.

"And how did you feel about that you commit such crime?" asks Ross.

James has to concentrate to make out the doctor's words and as he concentrates, his expression of despair fades a little. "I didn't feel good about it."

"Did you have any, ah, conscious experience or any recollection about the time when did you have in your mind when you involved in this crime, you remember have you been drunk, you been under drugs, you been intoxicated or—"

This requires a lot of concentration. Then James interrupts. "I was drinking."

"You were drinking. What did you drink?"

"Whiskey."

Ross lights another cigarette. His questions have been mechanical, and he hasn't shown much interest in the answers. Further questions reveal that although James has only been caught this one time, he has abused other young girls, even his own daughter.

"How do you feel about you do things like that?" asks Ross. "How do you wife feel about it?"

"My wife says there's something wrong. Myself, I'd just as soon . . . the way I am right now, if I have to stay like this, I'd just as soon go to jail and stay here." James appears entirely defeated by whatever there is in himself he seems unable to control and doesn't understand.

Ross puffs on his cigarette. "How often do you masturbate a day or a week?"

James looks embarrassed. "Sometimes three times a day."

"That's too much! Why you do this when you have a good wife and she's attractive lady? She must to have not been giving you not too much sex satisfaction." James tries to disagree, but Ross overrides him. "You tired about your wife; you interested in other woman?" Again James tries

to interrupt, saying he is interested in any woman, but the doctor pushes the interruption aside. "Perhaps you want a macho woman—big, tall, husky, luscious-looking female. What you are interested in? Big breasts or small breasts?"

James scratches his head and thinks.

Ross adds, "In a woman."

James says no particular size, but Ross is no longer interested in the answer and pushes on. "You have any homosexual experiences? I guess you had. What was it?"

It turns out that James was involved with some group masturbation as a boy. Dr. Ross hardly listens.

"Then actually you don't understand that you are a sick man?" asks Ross.

"I know there is something wrong, otherwise I wouldn't do things like that, but that's the way I am, aren't I?"

"You have been in jail, you have been in house of correction, you've been in reformatory, you've been in Lymon School and another place; and you have been involved in criminal offenses as breaking and entering, assault and battery, driving without authority, and so forth; and then additionally there are moral charges: You're involved with your own daughter, with other young, immature children, female children; and then you've been trying to hang yourself, and you've been assaulting other people, and you've been setting fires, and you've been quite intolerant and apprehen-

sive and restless and depressed, and you think you are a normal man? What you think? And you still believe you don't need help? And some time ago *you* say that you need the help."

"I need the help, but I don't know where I can get it."

Dr. Ross looks thoughtful. "Here, I guess."

Then Wiseman abruptly shifts to a dazed zombielike man in the common room. The camera pulls back and we see the entire crowded room of zombielike men all standing doing nothing, looking worse than bored, with guards puffing away at their cigarettes. This is the help James is being offered.

The comedy in the scene between Dr. Ross and James is a literary sort of comedy. We see it in many of the Russians—Gogol, Dostoevsky, Chekhov, Bulgakov. "What you are interested in? Big breasts or small breasts?" We may think—but this is actually happening. This is real life. Does that make it more significant? Is *King Lear* less painful because it is a story? I find it more painful.

What makes the sequence between Dr. Ross and James so particularly painful are these comic elements. Were Ross articulate and brilliant, we might feel some hope for James. As it is, Dr. Ross is only part of James' torment and the comic element—the fact that parts can make us laugh (perhaps in fear and trembling)—bring this home to us. Later we see James led to his cell. He is stripped naked and pushed inside—a bare room like Jim Bullcock's.

Between these painful scenes are the musical numbers, which may be no more than Eddie sitting at a table, singing and rapping out a rhythm with his hands for the amusement of his fans. "It was there at the bar, where I smoked my first cigar, and the nickels, nickels, nickels rolled away. It was there by chance, that I stole a pair of pants, and now I am serving thirty days."

The next sequence to push the limits of the comic was edited in a way that Wiseman regrets. It is a famous sequence showing a force-feeding. A prisoner whose name is something like Malinovsky hasn't eaten for three days. Dr. Ross has him led down the hall by seven or eight guards. Malinovsky is naked and very thin and bony. Maybe he is sixty. He looks depressed but otherwise shows no emotion.

When they reach the end of the hall with a table, refrigerator, and several desks, Dr. Ross, who is smoking, says, "Do you agree to drink this food or will I have to put it through a tube through your nose into your stomach?"

Malinovsky makes no response. He stands covering his genitals and looking slightly abashed, as if sorry to cause all this trouble.

One of the guards, who is smoking a cigarette in a black filter rather like Winston Churchill's, chimes in, "You gonna drink it or he'll dump it down a tube through your nose?"

Several other guards repeat the question. Malinovsky indicates nothing but unresponsiveness and depression. They put him on a table. Ross drapes a small towel across his genitals. A cigarette dangles from Ross's mouth. Malinovsky has a faintly regretful look. He understands but will do nothing. No one is angry. They are just businesslike. The guards wrap pieces of cloth around Malinovsky's wrists and ankles, holding him down. Ross picks up the tube, and a guard hands him a jar saying, "This is the Vaseline, there ain't much of anything left."

Ross rubs the end of the tube around the rim of the jar. "You have any other grease, oil, or anything?" Guard goes looking for something. Ross is still smoking.

Malinovsky, lying immobile and expressionless, looks up at the ceiling. Ross still requires something for the tube. He tells the guards to write down on a piece of paper what they need in F Ward: mineral oil, ointment, butter, Vaseline, alcohol, and so on. He is dribbling cigarette ashes above Malinovsky's head. Then Ross rubs his finger around the jar to get the remaining bit of Vaseline, smears it on the tube, and begins to push the tube down Malinovsky's right nostril—not gently but quickly. Malinovsky squinches his eyes shut in discomfort but makes no noise.

A guard holds down Malinovsky's head with a towel. "This guy's a veteran," he says. "He's been tube-fed before." Malinovsky gags. The guard says, "Swallow, just swallow." A telephone rings.

Now for about four seconds the scene shifts to Malinovsky dead (we don't realize he is dead), and we see his face from below being lathered for a shave. A fly is walking across his forehead.

The scene shifts back to the tube feeding. Ross pours some water down

the funnel. The guards are talking business among each other—"Did so and so work the other day?" "No, he worked last week." Ross drags over a heavy wooden desk chair to stand on, to get above Malinovsky, the cigarette dangling from the center of his mouth. The camera focuses on the funnel. Ross stands on the chair, squinting because of the cigarette smoke in his eyes. The ash is now quite long. The soup is in a round take-out carton with an unpainted picket fence design. Ross holds the carton in his right hand, the funnel in his left, tries to maintain his balance on the chair, and squints. Then he begins to pour.

As he pours the scene shifts to a man's face. We first don't know what he is doing. Then we see he is shaving someone's neck. The man being shaved is very still. Again the scene is brief.

We shift back to Ross pouring the soup. Malinovsky is lying on his back and swallowing. Ross asks for more food. Admittedly the comic element up until now has been practically nonexistent—although the guards have a clown function. But here we have Dr. Ross trying to maintain his balance on the chair, standing over the funnel into which he is pouring the soup, with the cigarette in the middle of his mouth, his head tilted, and the ash about three-quarters of an inch long.

"The tension in the scene," Wiseman once told me, "comes from the anxiety of whether or not the doctor's cigarette ash will fall into the funnel."

This is the comic element. What keeps it from completely working and keeps the scene from being as excruciating as it should be is the intercutting between the force-feeding and the preparation of Malinovsky's corpse. The reason it doesn't work is because either now or later we feel we have been manipulated by the director.

The scene shifts back to the person being shaved. Maybe three seconds. Maybe we now realize it is Malinovsky's corpse. We shift back to Malinovsky being fed. The camera pans over his body to the guards, who look bored. We shift back to the mortician who is packing cotton under Malinovsky's eyelids. We shift back to the feeding. Ross is pouring down more soup. The ash is even longer. "Very good patient, very nice," says Ross. Getting down from the chair, he withdraws the tube, which is about three feet long. "Hey, that wasn't bad," says a guard. "He's a veteran."

Another guard says, "That was a good one." Ross wipes off Malinovsky's face. We shift to the mortician wiping off Malinovsky's face. Then to Ross wiping his face and a guard saying, "I think he's been tube fed before." Then to Malinovsky lying in his coffin in a suit and tie looking handsome with his hair combed. No longer does he look depressed, and he looks younger—maybe fifty. Back to Ross. They get Malinovsky onto his feet. "Okay," says a guard, "you've had your dinner." They lead him back to his cell, shut and bolt the door. We shift one last time to Malinovsky in his coffin. We see him from above being slid into the chiller in the prison morgue. The door clicks shut. Finis.

In an interview in *DoubleTake* magazine (Fall 1998) Wiseman said:

> I think that in some ways [*Titicut Follies* and *High School*] were a bit too didactic. I mean I wouldn't ever change them, but I think that if I were to edit them now I would probably edit them somewhat differently. . . . For example, in *Titicut Follies*, the intercutting of the force-feeding sequence with the man being made up for his funeral forces the connection between the scenes. The point that the man is treated better in death than life becomes too obvious. At the time, I thought it was really clever. Now it is just a mistake.

Chekhov once wrote in a letter to his editor Alexei Suvorin, "You are right to demand that an author take conscious stock of what he is doing, but you are confusing two concepts: answering the questions and formulating them correctly. Only the latter is required of an author."

In the force-feeding sequence Wiseman attempted to answer the question—it was an act of authorial manipulation. In the Jim Bullock sequence, he formulated it. He left it to the viewer to find an answer. That is what made it so uncomfortable.

The third sequence with elements of the comic involves a man by the name of Vladimir. We don't have all this information in the movie, but Vladimir was born in the Ukraine, was caught up in World War II as a child, and was brought to Massachusetts as an adolescent. When he was sixteen, his brother-in-law asked Vladimir to take him for a drive. They went to a convenience store, and the brother-in-law ran inside, robbed the

place, and shot and killed the clerk. Vladimir had no idea that this was his intention. He was sentenced to life imprisonment at Walpole. After eight years Vladimir began to have paranoid fantasies, dreams that the Nazis had surrounded the prison. He was sent to Bridgewater for observation. He had expected to be there a few days. When Wiseman arrived he had been there a year and a half. The irony was that in Walpole he had been about to receive executive clemency and would soon be released. He was clearly intelligent and had taught himself English. More than anything the sequences are reminiscent of something from *Catch 22*.

In the first Dr. Ross and Vladimir are talking in the prison yard. Ross is wearing clip-on sunglasses and smoking. Vladimir is about six feet, thin, freckled, Slavic, with curly light brown hair. He wears a wrinkled shirt.

Vladimir smiles, slightly mocking. His accent is negligible, and he speaks quickly. "You are giving me the same story again—'We are going to help you. . . .' May I ask why I need this help that you are literally forcing on me—"

Ross tries to interrupt, with his own heavy accent: "I am not forcing on you—"

Vladimir pushes ahead: "Obviously, I talk well, I think well, I *am* well, and you are ruining me just by keeping me here—"

Ross interrupts: "May I say something, we are not enforcing if you say I don't want to take the medication, we agree. . . ."

Vladimir again pushes ahead, "I don't want to stay here. I am a prisoner—"

Ross interrupts, "If you say I am not want to take the medication we agree that—"

Vladimir pushes ahead yet again: "That's not the principle, Doctor. The principle is that I am here obviously well and healthy, and I am getting ruined. If we sent me back to the prison where I might be able to get back out on the street . . ."

Ross says if Vladimir returns to Walpole, he will be sent back to Bridgewater that same day. Vladimir protests.

"If you don't believe it," says Ross, "spit on my face."

Vladimir looks astonished. "Now why should I do that?"

"Because if I say untrue," says Ross, "you know, unreliable things, I

should be punished. We send you back to Walpole today, you coming back tomorrow, maybe even tonight. Honest to God. You want to take a chance?"

Vladimir, who has been trying to interrupt, says quickly, "Yes, I certainly do."

Now who, in this exchange, has seemed the crazier of the two? However, Ross's explanation as to why Walpole would send Vladimir back so quickly is "because they look at you they know something wrong." It should be said that Dr. Ross looks very similar to Dr. Strangelove.

In the next sequence with Vladimir, he faces a board of Bridgewater psychiatrists. The head psychiatrist appears to be in his mid-thirties. Even though he is bald, he looks somewhat like a six-year-old boy who has undergone chemotherapy. Otherwise he has big ears and a funny slash of a mouth. There is also a woman, an elderly male psychiatrist and several others. Everyone except Vladimir is smoking. The head psychiatrist is saying that if he can see enough improvement, then—

Vladimir interrupts, "How can I improve if I'm getting worse? I'm trying to tell you, day by day, I am getting worse, because of the circumstances, because of the situation. Now you tell me until you see improvement, but each time I get worse. So obviously it's the treatment that I'm getting or the situation or the place or the patients or the inmates. I do not know which. I want to go back to prison where I belong. I was supposed to only come down here for observation. What observation did I get? You talk to me a couple of times. You say take some medication. What sort of medication did I get? Medication for the mind? I'm supposed to take some medication if I have some bodily injury, not for the mind. My mind is perfect. I'm obviously logical, I know what I'm talking about and I'm excited, yes. That's the only fault you might find with me, and I have a perfect right to be excited—I have been here for a year and a half and this place is doing me harm. Every time I come in here you say I look crazy. If you don't like my face that's another story, but that has nothing to do with my mental stability. I have an emotional problem now, yes, which I did not have before."

The head psychiatrist who has seemed completely indifferent asks in liquid tones, "What got you down here?"

"They sent me down here for observation."

The psychiatrist asks if Vladimir doesn't have work at Bridgewater.

"There is no work for me here. All I got is the kitchen, and all they do is throw cups around. In fact, it's noisy. They got two television sets that are blaring, machines that are going. Everything that is against the mind. One thing that a patient does need is quiet if I have a mental problem or even an emotional problem. Yet I'm thrown in with over a hundred of them, and all they do is yell, walk around, televisions are blaring. So that's doing my mind harm."

"Are you involved in any sports here?"

"There are no sports here," says Vladimir. "All they've got is a baseball and a glove, and that's it. There's nothing else. If I was back at the other place, I'd have all the facilities to improve myself. I'd have the gym, the school, I'd have anything I want."

"Are you in any group therapy here?"

"No, no, there is no group therapy. Obviously I do not need group therapy. I need peace and quiet. This place is disturbing me, it's harming me. I'm losing weight. Everything that's happening to me is bad. . . ."

Vladimir claims that by keeping him here they obviously want to harm him. The psychiatrist responds by saying that is interesting logic and lights another cigarette.

Vladimir gives the shrink a withering look. "If I am in a place, as if I were in some kind of hole or something, right? And you keep me there, then obviously you intend to do me harm. Isn't that perfect logic?"

The psychiatrist looks pitying and superior. He glances at his colleagues, so they can share in acknowledging the hopelessness of Vladimir's case, and he shakes his head. "No, it isn't, Vladimir."

And that's it. The comic element. Vladimir is taken away, desperate and crushed. The woman says that it's amazing because if you accept his premise, then everything else is true. But she adds that of course his premise is false—"He argues in a perfect paranoid pattern."

The head psychiatrist says: "He's been much better than this, and he's now falling apart. Whether this is a reaction to his medication is some-

thing we will have to look at. However, he was looking a lot more cata-tonic and depressed before. . . . And the louder he shouts about going back, the more frightened he indicates that he probably is." He decides to put Vladimir on a higher dose of tranquilizers in order "to bring the para-noid elements into better control." Then they can get him onto even stronger medication.

The sections with Vladimir might be the most horrific and most comic. We identify with Vladimir more easily. We think he could easily be us. We think that no matter what fantastically logical series of arguments we gave to the board of psychiatrists, they could blithely wave them away. Years later Wiseman learned that Vladimir had indeed gotten out of Bridgewater and was working in a supermarket.

Wiseman's films of institutions give him defined boundaries to work within—there is this place and there is the outside world. Within those institutions, or places, there are human beings—some we see a lot of, some little, some we think well of, some badly—but there are no charac-ters in the traditional sense, no heroes or villains. In a way the multitude of characters are one character. They represent different facets of one human being. We are each of us Dr. Ross pouring soup down a tube, and we are Mr. Malinovsky lying tied to the table. There is a scene from the *Follies* themselves in the middle of the movie, with Eddie and a tall black prisoner, Willie Williams, up onstage in glitter bowlers and black canes, hamming it up cheek to cheek, singing, "I want to go to Chicago town." They harmonize nicely. Eddie looks the nutsier of the two, and the only thing that distinguishes him as a guard is the great ring of keys hanging from his belt. But basically, for Wiseman, they are one person.

Otherwise what separates the prisoners and guards is luck. Wiseman's characters are representatives in the human comedy, as widely representa-tive as he can find. They are acts in Wiseman's variety show, and each comes on to do his or her little turn. *Titicut Follies* is the clumsiest of his films in terms of the cutting, the often static handling of the camera, the aggressively subjective arrangement of the sequences and transitions—after all, it was his first film. But this very rawness increases its strength.

It is a mistake to look at Wiseman's films only as a study of institu-tions. It diminishes them. As a study of an institution *Titicut Follies* is a

failure—too much is left out. How *Titicut Follies* employs the comic to heighten our sense of the tragic is genius, and the images stay with us for years. Jim Bullcock doing his naked fuck-you dance, as his shy pud bounces in its meager thatch, is a form of comedy pushed to an excruciating level. Even the sadistic ragging by the guards in another context would be no more than teasing—a form of joke, a comic turn. Dr. Ross asking the wretched child molester, "Perhaps you want a macho woman, big, tall, husky, luscious-looking female. What you are interested in? Big breasts or small breasts?" The head psychiatrist asking Vladimir if he is involved in sports and Vladimir's answer: "All they've got is a baseball and a glove, and that's it. There's nothing else." And even Dr. Ross's cigarette ash coming within a nanosecond of falling into the force-feeding tube. The laughter or near laughter elicited by these scenes creates pain. No mean feat.

This constant contrast of *Titicut Follies* can perhaps best be found in its conclusion, because the film has two endings.

In the next to last sequence, a body wrapped in a white winding sheet is removed from a tray in the prison morgue, put in a coffin by guards, and driven to a nearby cemetery. Only guards, prisoner-pallbearers, several prison officials, and the prison chaplain, Father Mulligan, with several of his acolytes, are in attendance. It is a gray, foggy day. No family, no tears. The service lasts less than a minute. Father Mulligan's final words are the last words spoken in the movie. "Remember, man, that thou art dust and unto dust thou shalt return." That's all. The people disappear. The scene ends with the coffin alone as if on a stage. Then, oddly, there is applause, then music.

We're back at *Titicut Follies* with the eight choristers we saw at the beginning. Although singing, they still aren't smiling. "So long for now, we'll take a bow—we hoped you liked our entertainment—gosh and how. It's time to go, we had our show. . . ."

All the participants join them onstage, the women, the band. The song obviously refers to the *Follies*, but also to the movie. Yet the farewell, as it were, is both this concluding scene and the preceding sequence with the coffin. On stage everyone waves. Eddie runs to the front with his face twitching and stands at the mike, raising his arms like Ed Sullivan. They

repeat the last phrase of the song, "Until another year we're through. . . ." The camera focuses on a boy next to Eddie with bad teeth, a cowboy hat, and a sweet, daffy smile. Someone brings flowers to the middle-aged ladies. They turn around and throw up their skirts in the best *Follies* style. The last shot is of the goofy boy's happy face as he claps his hands. Awful teeth, sweet smile—Wiseman's favorite combination.

One last little bit: In 1997 Wiseman ran into Elliott Richardson in the Bangor International Airport (Richardson died on New Year's Eve, 1999). Wiseman asked him about his role in the banning of *Titicut Follies*. Richardson thought a moment, considering the question. "Perhaps we overreacted," he said.

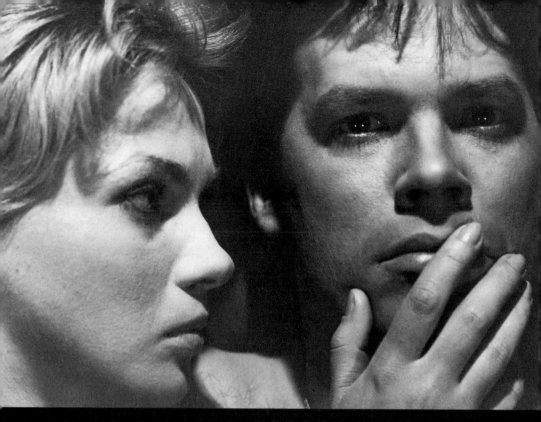

ASHES AND DIAMONDS

DIRECTED BY ANDRZEJ WAJDA

I n the late 1950s, when I became a teenager, Hollywood was browbeating the entire world with a vision of happiness and romance, and although those movies were the bluntest possible articulation of the ambitions of the culture to which I belonged, I remember almost nothing about them. In fact, I remember almost nothing about those years at all, and what I do remember has largely to do with other movies—movies that were coming over to us from Europe.

With the aid of a great wedge of lies and subterfuge, I occasionally

managed to escape my suburban home and sit for a while in Chicago's shabby Clark Theater, which showed two different splendid movies every day and stayed open all night long. I can see, with shocking clarity, the way the light fell on the dirty street in front of the Clark and smell the (horrible) aroma of the lobby. I can remember even the score from both Alain Resnais's *Hiroshima Mon Amour* (a movie that taught me that it was possible to portray, with great economy and precision, the polyphonic intertwinings of memory and the present) and Jean-Pierre Melville's *Les Infants Terribles* (a movie that taught me things even more surprising). The thought of Jean Seberg, wearing her *New York Herald-Tribune* T-shirt in Godard's *Breathless* can, even now, make me wild with the anticipation of freedom and worldly pleasures. And sometimes, when I turn on the radio, I still hear, for an instant, a phantom of Cocteau's phantom radio in *Orphée*, nasally intoning, *L'oiseau chante avec ses doigts . . .*

But the film I felt the need to see over and over was Wajda's *Ashes and Diamonds*, which emblazoned itself so forcefully on my brain that only a slight hypnotic nudge should enable me to screen it for myself, frame by frame, with my eyes closed.

What was this movie that meant so much to a young American girl? The story takes place over the night of May 7 and the morning of May 8, 1945, in a small town in Poland, where a young soldier of the Resistance, Maciek (Zbigniew Cybulski) has gone, under orders to assassinate the secretary of the local District Workers' Party, a man of evident decency. Maciek drifts into a liaison with a pretty bartender in the hotel where he's waiting for his victim, and this affair, of no more than a few hours' duration, strips both Maciek and the girl of their precious armor against human feeling. Maciek accomplishes his mission of murder just as Germany announces its unconditional surrender, and is himself hunted down and shot at the very moment he is trying to salvage some meaning for his life, which the war and his role in it (as heroic, in its way, as that role has been) have converted into rubble. The girl, no longer invulnerable to memory, longing, grief, and fear, believing that Maciek to have simply left, is invaded by the full horror of loss—former and future.

However irresistible the effects of this film, or its narrative sophistication and energy, or Cybulski's potent beauty, the film's allure for me might

seem rather puzzling. After all, the beauty of both Brando and James Dean was also potent, and the images and narrative pouring out of Hollywood were not only designed to ensnare, they also reinforced, like hammer blows, cravings already perfectly familiar to me. Entirely unfamiliar to me, however, were so many of the aspects of *Ashes and Diamonds* that must have been crucial to the people who made it and to my European contemporaries who saw it. Its very fabric—the historical context, the ideological issues, the attitudes of the writer and director—could not have been farther removed from my experience and education, and even my comprehension.

So why should it be the face of the bartender, beatified by the bleaching light of the triumphant morning as she's pulled into a grotesque, drunken, celebratory Polonaise, that the fourteen-year-old girl who became me has never relinquished? Or the soldiers, searching with their rifles for Maciek through sheets drying on the line, and the bloodstain soaking through whiteness? Why the body of the murdered party secretary, aging, heavy, lying like an odalisque just beyond a puddle of muddy rainwater that reflects the starry fireworks tumbling through the predawn sky?

I was living at that time with my parents in a Midwestern suburb that was, even by the stringent standards of 1950s America, "one of the best"— that is, one of the most tense and most synthetic. No speck of dirt on any floor, nor weed in any lawn, nor flaw in any family. Naturally, propriety was considered the most noble of virtues, but since the authorities who determined what *constituted* propriety were far away (in Boston, maybe, or on some planet populated by superior beings), no one knew what, exactly, might breach it, and we all had to be very, very careful, all the time.

I suppose the threat was not just ignominy but expulsion from this nervous paradise. I understood, vaguely, that my grandparents had come from "over there." Although my grandparents spoke many languages— most comfortably, I believe, Yiddish—I never heard a word of anything but English in my childhood. Once, when I was small, I asked my mother's father what it was like where he'd grown up. He said, "Cold." Europe, as far as I knew, was Paris. I was mystified by the rage my mother flew into

when my older brother bought a Volkswagen. I had an odd inability to read a newspaper or comprehend what I was being told in civics or history classes. Our flawless lawns were planted right on top of the world's dirt. And although my family were Jews in what was really a Protestant, "old" American stronghold, in one way or another it was the same for all of us; it was not only people like my parents and grandparents who had paid dearly for our comfort and happiness, history itself had paid dearly.

Clearly there was some sort of menace pressing in from all sides. And the duty of us, the children, was evident. In it my friends and I failed stunningly. Instead of radiating the luster of expensive well-being, we were morbid, snarling, and enervated. Although, in all our safety, we feared absolutely everything, nonetheless we longed for a sight of the reassuringly solid terrors that thronged just beyond the veiling around us.

Exasperated by the myopic blur of generalization cultivated on our behalf, we developed a taste for piercing specificity.

None of us subscribed for an instant to the program of "happiness" that had been set out for us. For us, the two alternatives seemed to be misery or fraudulence, and misery was by far the preferable one. By the time I was thirteen or fourteen, action painting and beat writing, both, to some degree, responses to this same dilemma, had exploded all over the United States; Chicago itself was an untiring host to the most thrillingly adventurous jazz musicians on the planet. Still, so insulated were we that we could hardly feel the reverberations; Chicago was only about a half an hour away from us, but we were not allowed to *go* to Chicago.

In our confinement we intercepted what messages we could from the outside world, and interpreted them in accordance with our needs. Perhaps if I'd been less ignorant, the Catholic monumentality of *Ashes and Diamonds*, with its repetitive iconography of martyrdom, would have offended me. Perhaps I would have been irritated by its heavy melodrama and heavy ironies. Perhaps I would have been repelled by the enshrinement of the pretty bartender who must have looked so like people from whom my Polish and Russian grandparents barely managed to escape. But as it was, scene after scene came to me directly, undamaged by any preconceptions, and as a great and lasting kindness; the girl, staring numbly out into the travesty of the new world she is about to enter, might have been my older and more courageous sister, going first.

RON HANSEN

BABETTE'S FEAST

DIRECTED BY GABRIEL AXEL

n 1949, after a glorious but expensive vacation in Venice, the Danish storyteller Karen Blixen considered writing fiction specifically for the high-paying American magazine market. An English visitor to the Baroness's estate of Rungstedlund, northeast of Copenhagen, challenged her to do so by wagering that she could not sell a story to the *Saturday Evening Post*, and she took the bet, though she was not sure what American magazines wanted.

"Write about food," the Englishman said, for she had been trained in the culinary arts in Paris; she was justly famous for her lavish, gourmet dinner parties; and even news magazines like *Life* carried recipes then. But there may have been a hint of nasty irony in his suggestion as well, for Karen Blixen was by then habitually ill—she'd contracted syphilis from her ex-husband many years earlier—and she ate so little that she was just skin and bones, weighing less than ninety pounds.

She wrote "Babette's Feast" in English, the language in which she had first told tales to her lover, the late Denys Finch-Hatton, an Oxford-educated trader and wilderness guide in East Africa who considered Karen his Scheherazade. She may have modeled the character of Madame Babette Hersant at least partially on Clara Svendsen, a well-educated Catholic schoolteacher from the north of Denmark who so loved Karen Blixen's books that she gave up her home and job to serve as the Baroness's maid, secretary, nurse, and literary executor. Karen seems to have based the self-willed, sophisticated, and introspective General Lorens Lowenhielm on the life and thought of the Danish philosopher Søren Kierkegaard and on her restless, much-revered father, Captain Wilhelm Dinesen, who had served in the Franco-Prussian War and in 1871 witnessed the Marquis de Gallifet's vicious slaughter and persecution of the insurrectionist Communards of Paris. Elements of her mother's puritanical side of the family probably influenced her depiction of two pious, unmarried sisters whose falling in love was as welcomed as child sacrifice. Even the story's location on a Norwegian fjord seems to have been chosen as a lookalike for the Jutland heaths she visited as a child.

In Karen Blixen's suave comedy, Madame Babette Hersant is the famous chef at the Café Anglais who flees Paris after the execution of her husband and son in the 1871 civil war and winds up in a desolate settlement in Norway. Working as a humble cook and housekeeper for two sweet, devout spinsters who have forsaken offers of marriage, wealth, pleasure, and fame to minister to a radically puritanical Lutheran sect established by their father, she's expected to prepare only frugal meals of salted codfish and ale-bread soup. But when, after fourteen years of service, Babette wins ten thousand francs in a lottery, she chooses to spend it

all on a magnificent feast that will celebrate the hundredth anniversary of the sisters' late father's birthday.

Seeing the exotic foods and wines grandly arriving from Paris in wheelbarrows, one sister goes out to their congregation, urging them to take no notice of this high cuisine for fear of offending God. One old man promises her, "We will cleanse our tongues of all taste and purify them of all delight or disgust of the senses, keeping and preserving them for the higher things of praise and thanksgiving."

But an epicurean army general who once was in love with one of the sisters has also been invited to the feast, and is bewildered to see his fellow diners consuming the finest Amontillado and turtle soup and Blinis Demidoff "without any sign of either surprise or approval, as if they had been doing so every day for thirty years."

Elated by Babette's artistry, the general offers a toast that he first heard from the Dean whose hundredth anniversary they are celebrating, and which he finally understands: "Mercy and truth, my friends, have met together," General Lowenhielm says. "Righteousness and bliss shall kiss one another."

Resentments and discord had begun to divide the old and failing congregation, but as they gradually give up their self-abnegation during Babette's feast, the dinner guests forgive each other and wind up outside, holding hands like children under the starlight.

"Babette's Feast" merges incongruities, reconciles the irreconcilable. With Søren Kierkegaard, Karen Blixen argues against the either/or proposition that there is only one correct way to live, that we are faced with a series of critical choices, and if we choose wrongly we are lost. In her story the hedonistic general finds in the miracle of Babette's feast both ecstatic pleasure and a joyful, magnanimous God whom he otherwise could not have imagined. The congregation of fractious puritans who chose a difficult, self-denying spirituality for themselves find in the feast the religious ecstasy they have sought and the sensual pleasure they have shunned. And Babette is satisfied because, as she says, she is "a great artist" and this is what she does, whether or not there are those who can fully savor it.

K aren Blixen lost the wager. Employing the male pseudonym Isak Dinesen—"he who laughs" plus her maiden name—she submitted "Babette's Feast" to the *Saturday Evening Post*, but the editors rejected it, as did the editors of *Good Housekeeping*, who felt it concentrated too much on the upper classes, which were, presumably, not their readership. She finally did manage to sell the story to the *Ladies' Home Journal*, where it appeared in May 1950.

She was sixty-five years old then. And Gabriel Axel was nearly seventy when he scripted and directed its winsome screen adaptation, *Babettes Gæstebud*, the Academy Award winner for the best foreign film of 1987. It's perhaps not surprising, then, that *Babette's Feast* focuses its gentle humor on the frailties, anxieties, and self-recriminations of the aging, while quietly congratulating its characters for their generosity, loyalty, religious conviction, humility, sanity, and self-discipline—qualities that are not often saluted in film.

My friend Jim Shepard was the first to alert me to the ways in which *Babette's Feast* slyly plays with the conventions of American movies that were called "women's pictures": sentimental melodramas like *Imitation of Life* and *Stella Dallas* about intense emotions being bottled up, about lives not fully lived, about heroines who abandon or deny their own wishes, dreams, ambitions, or dangerous stirrings of the heart in subordination to another person or in soulful obedience to an interior code of morality and conscience.

In the film *Babette's Feast*, as in Blixen's tale, the main protagonists are Martine and Filippa, sisters named for the German Protestant reformers Martin Luther and Philipp Melanchthon. The sisters' adored father was the founder of a puritanical Lutheran sect in a gray, dull, huddled village on the Jutland heaths, but now the Dean, as he was called, is long dead, and his elderly daughters devote all their hours and income to good works for a dwindling number of crotchety disciples. But there was a time many years ago when the hands of the girls were sought by bachelors who went to church just to see them, for the strikingly beautiful girls did not go to

parties or balls. The Dean (Pouel Kern) rejected their many suitors with the excuse that his daughters were his only handmaids, but in fact his theology was such that earthly love and marriage were thought to be of little worth, an illusion.

And yet there *were* romantic moments for them. A vain lieutenant in the hussars (Gudmar Wivesson), whose debts caused him to be banished to his aunt's manor for three months, chanced to see Martine (Vibeke Hastrup) while he was horseback riding, and he instantly fell in love with the idea of the higher, purer life she so attractively seemed to offer. She was largely imaginary, of course—a projection of all he was not—and he may have been a soldierly fantasy for Martine, who was curious about, if not excited by, the intensity of his interest. But in the end she saw Lorens Lowenhielm walk away with a cold if chivalrous good-bye. "I have learned here that life is hard and cruel," he said, "and that in this world there are things that are impossible." Lorens would go off and marry a lady-in-waiting to Queen Sophia, wear a monocle, recite high-sounding pieties, and rise in rank and importance in the Swedish royal court. Whereas Martine would stay in the village, doing the things she'd always done, sharing a bedroom with her sister; and if she did not pine for the handsome lieutenant, she did still remember him with nostalgia and silent pleasure.

Filippa (Hanne Stensgard) was wooed by Monsieur Achille Papin (Jean-Philippe Lafont), an *"Artiste Lyrique"* who left the Royal Opera in Stockholm to vacation in the silence and vacancy of the Jutland coast, but was so stunned at hearing Filippa's gorgeous singing in the church that he introduced himself to the Dean and offered his services as a voice coach, saying she was a diva who would have Paris at her feet. Although concerned that Achille Papin was a Roman Catholic, a papist, Filippa's father consented but worriedly listened with Martine as the singers joined in an insouciant duet about passion and desire. Filippa did not betray her father. Seemingly flustered by the tenor's flattery and her own unfamiliar sexual feelings, and all too aware that the success Achille wants for her would only constitute a loss to the village and the common good, she sacrificed her still incipient artistic aspirations and satisfied the Dean by announcing that she wished to discontinue her singing lessons. The grocer with whom the Frenchman was staying gladly delivered the message, and Papin

exited their world with the maudlin sigh, "Good-bye, my life, my heart, my hopes."

The softness of touch in this first act is wonderful. It could all have gone so wrong. The father could have been one of those hellhound men of religion that the movies have been giving us in Crayola colors ever since *Elmer Gantry* and *The Night of the Hunter*. Martine could have been jilted and pregnant, and Filippa could have run off with Achille in some corny variant on *A Star Is Born* or *Beaches*. Even without the sensationalism that some screenwriters are prey to, there could have been those errors of judgment, stress, and psychological analysis to which actors too often fall prey: their own anger, pain, and manias seething anachronistically through nineteenth-century characters who would be, and are, far more serene with their lot.

We have the holiness and gracefulness of Martine and Filippa in old age as evidence that theirs is not a hackneyed story of wasted talent, sexual repression, or that old domineering dad we stew so much about. Rather it is about balance, harmony, and prayerful consciousness, with freedom and boundaries, desire and discipline, joy and sorrow equally distributed for them as they are for everyone. When I first saw *Babette's Feast* I was cautiously waiting for one of those shammed and cynical moments to spoil it, and part of the lift I felt when I left this sweetest of films was in the realization that Gabriel Axel and his actors had been so reasonable, restrained, and respectful of the usualness of life.

The second act of *Babette's Feast* begins with a sound bridge and a darkening, and the film leaps ahead to a rainstorm on a September night in 1871. We see a hooded woman (Stephane Audran) struggle and tilt forward through the muck of a village street. Either a waif or a figure of death. She knocks at the door of the now much older sisters (Birgitte Federspiel and Bodil Kjer), is invited in, and seems to faint on their couch. Reading a letter of introduction from Monsieur Achille Papin, they find out that Madame Babette Hersant, like Empress Eugénie, has been forced to flee Paris due to civil war. "She, herself, narrowly escaped the blood-stained hands of General Gallifet," Achille writes. Imagining Filippa's

world as child-filled, happy, and full of honors—she twinges with the sting of that irony as she hears it—Achille writes of his own loneliness and lost fame and insists it was she who chose the better path in life. She secretly wonders. Consoling himself as well as her, Achille writes, "In Paradise I shall hear your voice again. There you will forever be the great artist God intended you to be. Oh, how you will enchant the angels!" And then in comic understatement, his letter concludes with the laconic postscript: "Babette knows how to cook."

Babette agrees to work for no wages, saying, "If you won't let me serve you, I will simply die." She seems to mean she needs their food and shelter, but the film will finally require us to give emphasis to the gravity of the word "serve." We see it the next morning as Martine schools their new servant in soaking their stale bread in ale and softening a fillet of cod that looks like the sole of a shoe. We'll learn later that Babette is a culinary genius, yet she now neither winces nor worries at their cuisine, she just calmly takes it all in. She is kin to those stoic missionaries who eat and drink whatever is set before them.

Babette gradually learns the Danish language. She learns to haggle with the fishmonger, to gently criticize the grocer for selling her rancid bacon. She pensively strolls along a jade green hillside at sundown—one luminous frame was used for the movie poster—and we notice that the palette has changed, the wintry tones of the film's first act having given way to rich pastel shades of peach and gold. She's the image of dignity and self-knowledge. She imitates the sisters whose Christian crosses ride on their chests, but she wears the Catholic form of the sacramental, with Christ crucified on it, and we have to decide for ourselves if it's an ecumenical act of solidarity or one of quiet counteraction. She may be miserable in this Jutland village, but she's mute about it. Even her lovely face is difficult to read: Is she just naturally solemn or is she indeed forlorn? And we wonder if anyone in the village has thought to ask.

A voice-over narrator tells us that fourteen years have passed since Babette joined the minister's daughters, so it's 1885—the year, interestingly, of Karen Dinesen's birth. The congregation is not only older but comically cantankerous, and without the late Dean's prophetic vision and stern governance they have only a crabbed and remembered form of reli-

gion, not its substance, and they're now wrecking their conferences with
pettiness, strife, and recriminations. To heal their differences, Martine
announces the dinner to honor the Dean's hundredth birthday. And in the
way of tales, in just the same week, Babette learns she's won ten thousand
francs in the French lottery. The sisters try to be happy about Babette's
good fortune, but they presume she'll now leave them, as have others with
whom they've been affectionate. But Babette has yet to say what she'll do.
She goes to the seashore to give it some thought, and, in a nice visual
metaphor for prayer, the camera tracks a white gull skimming just above
the North Sea. Quickly deciding, she strides purposefully back to the
house and, squeezing the crucifix at her neck, she asks the sisters one
favor: "I would like to prepare the celebration dinner for the minister's
birthday by myself."

She orders the ingredients from France, and we watch the food and
drink arriving in all their luxurious plenitude: a slatted cage holding ner-

vous quail; caviar, perhaps, in an oblong block of ice; a slowly blinking sea turtle; a box of fragile glassware; a case of *grand cru* Clos de Vougeot that has aged forty years.

Seeing the exorbitance, Martine is troubled enough that she has a hellish nightmare that unites in a comic, excessive way the fatted calf of the Bible, a pen-and-ink drawing of the grim reaper, and a vision of blood-red wine spilling from a tankard as a drunk falls facedown on a dinner table. Wakening, Martine connects Babette's proposed feast with sensuality, evil powers, and the makings of a witches' Sabbath, and she privately instructs the congregation to negate their senses and give the food and drink no attention, a *via negative* that already seems to have been central to their religious practice.

Eleven from the village are guests at the feast. The twelfth guest is General Lorens Lowenhielm (Jarl Kulle), now an eminence in the Swedish royal court, whom we find in the manor of the aged aunt he is visiting. Adjusting a monocle in his left eye, he tells himself in the mirror, "Vanity. All is vanity." And then he turns to see himself as the young lovesick hussar he once was. "I have found everything you dreamed of and satisfied your ambition, but to what purpose?" he asks himself. "Tonight we two shall settle our score. You must prove to me that the choice I made was the right one."

Meanwhile, Babette is cooking, and cinematographer Henning Kristiansen's camera cherishes each confident touch of food preparation, noticing in the once stark kitchen colors that are now as vivid and opulent as in a painting by Caravaggio: red meats, magenta wine, the jet black beads of spooned caviar, steaming copper cauldrons and skillets, Babette's auburn hair; and in the dining room, a snow-white tablecloth and the shining crystal, cutlery, and candlesticks she's purchased for the occasion.

Upon their arrival, the faithful of the sect join hands in the parlor and sing yet again a hymn we have heard many times, but whose words they seem not to have listened to: *Jerusalem, my heart's true home/Your name is ever dear to me/Your kindness is second to none/You keep us clothed and fed/Never would you give a stone/to the child who begs for bread.*

And then they go warily into the dining room, wanting, it would seem,

stones. Stunned by the extravagance as they begin their first course, one of the faithful whispers, "Remember . . . we have lost our sense of taste."

A gray-bearded villager agrees, "Like the wedding at Cana. The food is of no importance."

Cana, near Nazareth, was the location of a postwedding feast in the gospel account of John (2:1–11), in which the mother of Jesus informs her son that the host has run out of wine, and Jesus graciously turns the water in six stone jars into the finest wine the steward has ever tasted. The old villager is right: Food is never mentioned in that gospel account. But there's something crucially wrong with the interpretation that the food and the wine are of no importance, only the miracle, the sign. It's an anti-incarnational sentiment that ignores the mother and son's solicitude for the host's sudden embarrassment—though a good deal of wine must have been consumed there already—and strangely implies that the natural world that God brought into being is in some way an impediment to achieving the joys of heaven. *Babette's Feast* will say otherwise.

General Lowenhielm has no such misgivings about the good things of life, and is gratified to have been served the finest Amontillado he's ever tasted, real turtle soup, perfectly fashioned Blinis Demidoff, and an 1860 Veuve Clicquot champagne that the villagers seem to think is a variety of lemonade. Stunned by the magnificent quality of the feast, and hearing stories of the Dean's wisdom and miracles, the general intrudes on the villagers' reminiscences to narrate one of his own: that of a memorable dinner with some French officers at the Café Anglais in Paris where the head chef served them a dish of her own creation, *Cailles en Sarcophage*. And he mentions that General Gallifet, his host, told him that the head chef could transform a dinner into a love affair in which no distinction was made between the sensual and spiritual appetites. Seemingly unaware of the irony, Lorens goes on to say that General Gallifet—the man, we recall, who executed Babette's husband and son—swore that the head chef at the Café Anglais was the only woman he would consider shedding his blood for. She was *the* greatest culinary genius. And then Lorens smiles down at the quail in the pastry shell they are now eating. *"This is Cailles en Sarcophage!"*

Yet Lorens is so self-involved, and possibly disdainful of the hinter-

lands of Denmark, that he never questions who the chef in *this* kitchen is; nor do the villagers now give recognition to the author of the feast, though the general has given them good reason to take pride in their friend Babette. It's as if the food materializes from behind the kitchen door for them, without a source, without cost. Even as the guests begin to yield and delight in the feast, a smug village woman still insists, "Man shall not merely refrain from, but also reject any thought of food and drink. Only then can he eat and drink in the proper spirit." And then she simpers with self-satisfaction and sips some wildly expensive burgundy wine.

Axel devotes nineteen minutes—nearly one-fifth of the film—to Babette's haute cuisine, intercutting between the sheer pleasure of the diners, whose differences are mending under the influence of good food and wine, and the sheer labor of Babette, who seems content to practice her art without congratulations. Enough for her to get grins and swooning looks of ecstasy from the carriage driver who brought the general and his aunt, and who sits in the kitchen with Babette, hungrily sampling things and helping grind coffee beans.

Right after the enjoyment of the grapes that are meant to cleanse the palate, the general is so transfigured by the generosity and art of this foretaste of the heavenly banquet that he chimes his wineglass and stands to offer a toast. Quoting a favorite passage of the minister they're celebrating, Lorens recites from the King James version of Psalm 85, "Mercy and truth have met together. Righteousness and bliss shall kiss one another." Echoing Søren Kierkegaard, and sharing with the other guests the clarity and self-forgiveness seemingly induced in him by the graciousness of Babette's feast, Lorens indicates that, ideally, faith and ethics, plenty and discipline, love and responsibility are joined. Earlier he had asked his aunt, "Could many years of victory result in defeat?" And now he realizes that God is much larger than the grudging bookkeeper he had imagined. We all have anxieties about what we choose to do in life, he says, but our choice is of less importance once we realize that God's mercy is infinite, and that whatever we have sacrificed—marriage, children, artistic success, or career—will be given back to us in this world or in the next. We need only await mercy in confidence and receive it in gratitude.

We may be hard on him elsewhere, but here the general gets it. The

feast has converted him. Just as he educated the other guests in the etiquette of spooning the sauce of Blinis Demidoff or crunching the cranium of the quail to suck out its sweet brain, Lorens educates the villagers in an unimaginable forgiveness, and encourages them to see this exquisite feast, this magnificent sinful indulgence they so worried about, as a sign of God's magnificent love and grace.

Retiring to a parlor for postprandial champagne and coffee, the jolly guests exchange blessings as Filippa sits at the piano and sings a lullaby about nighttime and rest that is especially apt for the old: *The sand in our hour-glass will soon run out/The day is conquered by the night/The glories of the world are ending/So brief their day, so swift their flight/God, let Thy brightness ever shine/Admit us Thy mercy divine.*

At song's end, Lorens and his aunt arise to go home, and the others join them. Holding, as in a wedding, a flaming white candle between them, Martine hesitates at the door with the general, and in a medium close-up that rhymes with the lovesick lieutenant's good-bye to her many years earlier, Lorens now says, "I have been with you every day of my life. Tell me you know that."

She nods and says yes, and we understand just how much she's taken secret pleasure in memories of him.

Lorens declares that from this night forward he will dine with her, not with his body, which is unimportant, but with his soul. "Because this evening I have learned, my dear, that in this beautiful world of ours all things are possible." Precisely the opposite of what he had stated as a gloomy young man.

Martine gently nods, and he kisses her hand before solemnly going off, saying not a word to the cook.

Walking out into the cold, starlit night, the tipsy sisters and brothers of the congregation hold hands and sing a children's lullaby as they dance around the village well. And then Martine and Filippa find their way to the kitchen to finally thank Babette for the "very good" dinner. Sitting there alone and silent, her elbows on her thighs, Babette seems haggard but content in a job well done. Receiving the sisters' naive praise, she seems to remember other nights of adulation long ago in France, and confirms that she overheard Lorens as he talked of her enemy, Gallifet, by revealing what

she's kept secret thus far, that she was once the head chef at the Café Anglais. She says nothing about the emotions she must have felt as she served the friend of her husband and son's executioner. She just goes into the dining room to clear the table, where she shocks the sisters by saying she won't be returning to Paris, for the people she knew there are dead, and anyway she spent all the lottery money on the feast. "Dinner for twelve at the Café Anglais costs ten thousand francs."

The sisters are aghast that she's given all she owned for them, but she smiles and answers it was *not* just for them.

"Now you'll be poor the rest of your life," Martine says.

"An artist is never poor," Babette says, and she quotes Achille Papin: "Throughout the world sounds one long cry from the heart of the artist: Give me the chance to do my very best."

"But this is not the end, Babette," says Filippa. "I'm certain it is not." She recalls Achille Papin's consoling statement about the singing career she'd given up as she says, "In Paradise you will be the great artist that God meant you to be." Eyes welling with tears, she hugs Babette as she says, "Oh, how you will delight the angels!"

Babette's Feast can be looked at in a purely secular way as a glorious testimony to artistic passion and the intoxicating effect that the fine arts can have on those who have learned to pay attention. But it is also a highly metaphorical representation of liturgy, of the Christian recognition of God's graciousness, for which thanksgiving is offered in our eucharistic celebrations. Babette is, in many ways, a Christ figure, a mysterious sojourner in the village who forsakes her heritage and becomes a common servant until she hosts a Last Supper for twelve disciples in which their hungers and longings find satisfaction.

Religious faith enriches *Babette's Feast* but is not necessary for its esteem, for in plainer terms Karen Blixen's tale and Gabriel Axel's screenplay and film are masterpieces of awareness, of seeing into the middle of things, of saying yes to existence and the exaltations of art.

EDWARD HIRSCH

STEVIE: THE MOVIE

DIRECTED BY ROBERT ENDERS

Prologue: "Is She Woman? Is She Myth?"

All poets are misfits and oddballs, but there is something especially discomfiting and even improbable about the English poet Stevie Smith. "Who and what is Stevie Smith?" Ogden Nash asked in a Dorothy Parkeresque moment: "Is she woman? Is she myth?" Wearing a childlike pinafore and white lace stockings, telling a puzzled reporter, "I'm probably a couple of sherries below par most of the time," chanting or singing her poems in a

high, off-pitch voice at poetry gatherings in the 1960s ("She chanted her poems artfully off-key, in a beautifully flawed plainsong that suggested two kinds of auditory experience," Seamus Heaney once said: "an embarrassed party-piece by a child halfway between giggles and tears, and a deliberate *faux-naif* rendition by a virtuoso"), she seems so unlikely and, in retrospect, necessary: a welcome tonic, a heartbreaking brightness we needed all along. We still need this figure who arrived like a Blakean thunderclap with all the freshness, frivolity, and forthrightness of childhood, with all the sad and caustic insights of long experience. Thinking about her elemental poems, which are so cheeky and rash, so stingingly honest, impertinent, and deathward leaning, so filled with mordant wit and comic desperation ("learn too that being comical," she explains in a poem about Jesus, "does not ameliorate the desperation"), I keep wanting to adapt something Randall Jarrell once wrote about Walt Whitman. Someone might have put on her tombstone STEVIE SMITH: SHE HAD HER NERVE.

Poets haven't generally fared very well in the movies. Poetry is a minority art, and writing it is a strangely avid, interior, and intimate process difficult to penetrate and describe from the outside. Whether in perplexed desperation or simple bad faith (for the sake of the medium, let's call it desperation), directors and actors have often latched onto external mannerisms and affectations—the black beret, the wide cravat and crooked walking stick, the carelessly flung scarf—to display a poet's character. How many times I have suffered over the years watching mock poets—parodic nightmares of the effete snob—flitting across the screen. It's as if every poet had to be typecast with a pretentious accent and a stilted wardrobe, T. S. Eliot without the talent. (When it comes to the fatuous portrayal of a poet being inspired by historical events, nothing may be able to top the sentimental, stiff-upper-lip vigor of Kipling suddenly being moved to compose a famous poem, which the commanding officer then recites over Din's body, in *Gunga Din*.) So, too, there was something so radically antic and *fausse-naif* (to employ the word Philip Larkin devised for her), so quirky and fey, so scapular, self-mocking, and idiosyncratic about Florence Margaret Smith that I was pretty much *expecting* to be dispirited on a Friday night in 1981 when I sank down into a comfortably worn seat in a standardized movie complex in a northwestern suburb of Detroit to see

a film that was having a mild "success *d'estime*" (as the poet, who liked schoolgirl French, might have put it).

Stevie is a low-budget, low-tech art movie that was filmed in seventeen days in 1978. I find it surprisingly profound, deeply felt, though parts of it, perhaps inevitably, also feel quickly shot, hastily improvised. Many of the flashbacks are no more than single shots, spliced-in visuals. The *New York Times* reported that Robert Enders, its director and producer, sought funding from more than two dozen American studios before one final studio, Fine Artists, agreed to pick up the total production cost of five hundred thousand dollars.

Much of *Stevie* also retains the texture and quality—the vestiges—of a theatrical piece adapted into a film. Hugh Whitemore's highly verbal screenplay is based on his own sympathetic dramatic portrait, *Stevie: A Play from the Life and Work of Stevie Smith*, a two-act that had a notable West End run at the Vaudeville Theatre in 1977 and recurs often to Stevie Smith's own characteristically forthright writings. The movie, like the play, has a tiny cast of three characters: Stevie (Glenda Jackson), her unmarried aunt (Mona Washbourne), and an unnamed Man (Trevor Howard). Alec McCowen also comes in as Stevie's fiancé, Freddy, for a single troubling scene from her past, a play within the play.

The film also relies heavily on one setting: Stevie's cluttered, ragtag sitting room. The camera isn't stationary—it moves freely around the parlor—but Enders consciously restricts it to a lone unchanging room for most of the movie. It doesn't take long for us to feel comfortably at home in this mismatched, lived-in room with its lace-curtained bay window, its heavy furniture (an aging upright piano topped with piles of books, a wooden bureau), its vases of dried rushes standing next to potted plants, its framed sepia photographs. This ordinary setting can seem both endearingly dreamy and poignantly enclosed, though that may be appropriate for a poet who committed herself to living in the same house for more than forty years with an older relative in an outer London suburb ("Smart writing people think it is not at all chic to live in the suburbs with an aunt," she admits in the film, "but I don't care what they think. . . . I love Aunt and Aunt loves me. That's what really matters") and all her life complained of being enervated and stifled by boredom, at times almost luxu-

riating in its possibilities ("Sometimes, even now, I indulge in the utmost limit of boredom, so that when the telephone rings it is like an Angel of Grace breaking in on the orgy of boredom to which my soul is committed").

All through the movie one keeps hearing, almost eerily lifted out of chronological order, an amalgam of well-timed excerpts from her three loquacious and revealing novels (*Novel on Yellow Paper, Over the Frontier,* and *The Holiday*), her eight ever-startling collections of poems (*The Collected Poems of Stevie Smith*), and a particularly incisive interview with her friend Kay Dick, *Ivy and Stevie: Ivy Compton-Burnett and Stevie Smith.* (I'd also recommend the various truant essays, comical stories, and pungent letters posthumously brought together after the play and film were created: *Me Again: The Uncollected Writings of Stevie Smith.*) Whitemore gets some of the chronology wrong (the play was researched and written before two definitive biographies came out in the 1980s), but he gets the essential feeling right. The screenplay moves fluently—freely—between S. S.'s poetry and prose (she never made a very sharp distinction between them), and as a result the movie is layered with a thick autobiographical substratum—a filmy residue—of different genres. It's at bottom a found poem, a spiky love song. Here's a picture that keeps verbally turning, a portrait that keeps moving, a work of art that dramatizes the beguiling mystery, the who—the what—of Stevie Smith.

Preparing to Meet Stevie

I may have come into the theater in a skeptical mood (I've never been much of a moviegoer anyway), but I was in truth riveted to the film—I was lost in its world—from its first establishing shot, its initiatory scene. One hears the unmistakable *clippety-clop* of a horse walking on pavement, and then one sees a horse-drawn carriage pulling up to a row of narrow, semidetached, middle-class-town homes and letting out two Edwardian-looking women with two small girls in tow. This will turn out to be the three-year-old Peggy, her five-year-old sister, Molly, her mother, and her aunt, and they're arriving on an autumn afternoon at their end-of-terrace

house in suburban London, 1906. It's as if we're overseeing the decisive moment of their entry into Palmers Green from a neighbor's upper-story window across the street. The camera slowly zooms in on the four of them pausing on the sidewalk in front of their new home, a little female band sizing it up, as if taking in the future and all it contains, all it means. One of the women holds the girls' hands and gathers them protectively to her, the other opens the front gate and steps toward the house. A deep pause— a hushed intake of breath—for a turning point in four lives. The driver is unloading the suitcases from the carriage, but otherwise everything is silent, stilled, bathed in a blanched yellow light that evokes the past with grainy poignancy, like an early home movie. The film returns to this faded, almost wavering sepia light whenever it cuts back to the past. It does so often. The light itself acts as a memory screen to a world irrevocably gone.

The second scene, second tableau: A man opens the door to a front parlor—the sitting room—and pauses in the doorway. He steps into the middle of the room and pauses again, slowly looking around, surveying a landscape. An aura of sadness permeates the air. It's nearly seventy years later, and the inhabitants have now died; all the furniture is covered with white sheets. The whole house, which will turn out to be one of the main characters in the film, as it was in Stevie Smith's life, has a funereal aura, like a figure in mourning. A world has been wiped out. The nameless Man, played with grave formal acuity by Trevor Howard, will become the film's narrator, its omniscient third-person conscience, its somber Greek chorus. He moves wistfully through a cluttered room he knows well, lifts a small pillow—a back cushion—from a well-worn chair and drops it, as if sighing, wanders across the room to a glass-fronted bookcase, which he opens. He picks out the text he's looking for, turns toward the camera, toward each of us, leafs through it to the opening page, and begins at last to speak, to read aloud:

"'Life is like a railway station,' Stevie said: 'The train of birth brings us in, the train of death will carry us away.'"

"Hmm," the Man murmurs to himself, registering what he has just said. Then he closes the book with a small thump and introduces the film itself, as if lifting a curtain: "All aboard for a trip to the suburbs!"

Trevor Howard's prologue speech is followed by the unmistakable blast

of a moving train. We're hurled into the present tense. For one moment, one long shot, it's as if we're at the front window of that train, looking ahead, as if in a daydream, approaching a dark tunnel. Sitting in a darkened movie theater among strangers, entering another world to the rhythm of a moving train. There's the close-up of a train passing—we're both inside and outside that train, looking on. We've been thrust into modern-day London, preparing to meet Stevie herself riding home on her daily commute. The camera pulls back so that we can see her wearing a yellow winter coat and reading a book. We encounter her in the present tense—a middle-aged woman putting away her book, gathering her things, and heading for the door while the long red train pulls into the station.

It's a gray winter day, a chill nip in the air. This will be the gloomy weather—the stark backdrop—for the entire film. While the music comes up and the white-lettered credits flash onto the screen, we track S. S. marching home from the Southgate Station down the well-trod lanes of a woodsy suburban park. There's an iron gray lake in the background, ducks floating on a misty pond. She comes out of the park, turns down a street we now recognize, and comes to the familiar white-trimmed red-brick house. We've entered in mid-stream. But in a sense the whole film operates in the space between its two opening frames. The director offers us a portrait cast in time. It has the retrospective glow—the mournful aura—of death, but it also has the jubilant texture of a life—a sensibility—rescued from oblivion and held up to the light.

"A House of Mercy"

I'm conscious of the fact that I was at full import from the very beginning of this film because I was already steeped—hell, I was *soaked*—in Stevie Smith's work. It's a different—and perhaps lesser—film for those who are coming to Smith's work for the first time, who are unaware of its deadly innocence, its zany humor and torrential pain. It's an appealing but more introductory work for those who couldn't use it, as I did, to blood the work and gasp back into the poems. It takes its time to build its rhythms, accrue

its meanings. But I was, in a very real way, already predisposed, already prepared, to overread *Stevie*, my strategy here, my guilty pleasure. My foot was on the pedal. My immediate and deeply emotional response to the film was predicated on my relationship to its subject. It may even be at times incommensurate with the film's cinematic achievement, its status as a freestanding and wholly realized work of art in its own right—though not, I believe, with Smith's own work, her quirky hymns to death, her lived poetry. Yet I also trust the way the film insinuates itself—and propels Stevie—into the affective lives of its viewers.

Any lingering doubts I may initially have had about the basic veracity of the film were erased as soon as Glenda Jackson appeared in the screen. I'm still inspirited by how authentically she captures—she incarnates— Smith's signature style, her particular way of voicing herself, of being in the world. How naturally, too, Jackson carries off Stevie's distinctive look: the straight pageboy haircut with a loose fringe of bangs, the English schoolgirl outfit (a black long-sleeved top with a white Peter Pan collar, a locket brooch, and a wine-colored corduroy jumper). It's true that her height is a little jarring (Stevie was barely five feet tall and got her androgynous nickname after a popular jockey, Steve Donoghue) and she may seem a bit too robust to capture the full measure of Stevie's profound chronic fatigue, her physical fragility, yet she also captures something of the vulnerability—the unworldly unprotectedness—of this woman who was part elfin child, part caustic adolescent, part disenchanted adult. One thinks of the zestful storyteller, the sardonic comedian, the brainy agnostic, the social critic of class, the stoic philosopher. "I'm straightforward, but I'm not simple," Stevie told a friend near the end of her life. She was a complex, mercurial, and, in some ways, insoluble figure.

The drama kicks off from the moment Stevie comes through the front door of the house at 1 Avondale Road and calls out in a high voice, "I'm back! I'm back! Where are you?" to her aunt Margaret who is upstairs folding sweaters and putting them away in a dresser drawer. She's whistling as she does her housework—this sweet, practical person who,

unlike her niece, seems entirely at home in the world. "Up here!" she calls back. Her whole demeanor brightens when she hears Stevie's voice. "Just coming," she says, hurrying down the stairs. She'll hang up her niece's coat, make a pot of tea, bring in a snack tray with Battenberg cake and ginger nuts.

"I'm utterly exhausted, worn to a frazzle," Stevie declares in one of the leitmotivs of her adult life: "When I'm asked on the Day of Judgment what I remember best and what has ruled my whole life, I think I shall say: 'Being tired, too tired for words.'"

But she's soon revived, warming up at the electric heater built into the fireplace, launching into a tale about recording a short story at the BBC as her aunt comes back into the room.

"This is my aunt," Stevie says directly to the camera, bringing the audience into the sitting room with them, like a new acquaintance. "I call her 'The Lion of Hull.' She looks very lionlike, don't you think?"

Aunt Margaret is preoccupied. She's searching through the piles of books stacked on the piano. Too many books for her taste. (Stevie was a voracious reader. "A poet reading books is hungry for food," she said.) By the time that Aunt ("Not a literary person, thank God," Stevie declares) calls out—"Where are my glasses, Peggy?" and her niece answers, "In the fruit bowl," we've entered the zone of their domestic intimacy and mutual dependence. One of Stevie's late poems calls this "a house of female habitation" and "a house of mercy," a somewhat stern and reserved "[b]eing of warmth."

Speaking to the Camera, Talking to Lion Aunt

One striking feature of the performance is how naturally—how intimately—Jackson addresses the camera throughout the film. It's as if she is turning away from the conversation with her aunt to enter into another one with us. ("I spoke to the camera as a person," she told one interviewer.) This carries over to the confident, conversational way she recites Smith's poetry throughout the film. Jackson was apparently edgy and apprehensive

about reciting poetry directly into the camera, but had a breakthrough when the director suggested that she should think of the camera as a guest in her home. ("You don't always look at a person when you are speaking," the actress said. "It was more interesting than pretending I was talking to cinemas full of people.") The wisdom of this is evident in the final version: When Jackson recites poetry in the film one feels like a welcome visitor, a confidant, a co-conspirator.

Jackson also seems to have internalized the feeling in Smith's lyrics, which she also recorded—perhaps a little too somberly—for the Argo Record Company (*Glenda Jackson Reads Stevie Smith*, 1978). Reciting the poems aloud as if to a guest gives them an intimate spontaneity. At times she effectively says them as if musing to herself. The downside of the film's approach may be that all the poems seem content driven, primarily used to support the poet's biography—rather than the other way around. Yet a poet's biography primarily resides in the pattern of sounds she makes, the words she uses and arranges. (Stevie Smith liked to refer to her poems as "sound vehicles.") Some of the lines are also wrenched out of their fictive contexts to give them biographical applicability. Yet the supple strength of this approach is that the poems also seem to come bursting forth from Stevie's life. They brim up directly from experience—these stabbing intuitions that cried out to be written down and shaped, inscribed, spoken, heard.

Stevie never seemed to mind that her aunt didn't approve of her work and considered it all a "soppy waste of time." Maybe the aunt's incomprehension gave her the deep privacy—the interior space—she required to do her work. It must at times have taken its toll. The director hit on a device that resonates with—that parallels—Stevie's situation. It's as if our presence gives her the license—the opportunity—to talk away from Aunt, as she did in her own work, to express herself apart from domestic life. Still, there's no doubt Stevie was taken care of and cherished, steadied down and comforted, tethered to daily life by her mother's sister. Something in her was also arrested. "When you live with an old lady from an early age you never cease to be a child," Stevie admitted after her aunt had died. Childhood wasn't so much a stage in her development as an imaginative

place she could call on and return to at any time. It was a habitation always available to her. Childhood wasn't something she sought—as it was for, say, Wordsworth—but something she already possessed.

I confess that I find the English stage actress Mona Washbourne utterly endearing as Stevie's "Lion Aunt." Surely I'm not the only viewer who fell for her on first sight. Maybe it's her deeply infectious and affectionate laugh, or the delicious way she savors her sherry ("Where's me sherry?" she calls out in a Yorkshire accent), or even the way she tilts back her head and looks directly at her niece, declaring, "I've never heard such nonsense." She's the Old World aunt, or great-aunt, each of us should have had. (All through the movie I felt I recognized her from someplace, and only later realized I had encountered her as Henry Higgins's stalwart, kindhearted, practical-minded housekeeper in the film version of *My Fair Lady*.) Washbourne embodies the aunt's sterling, dependable, almost regal figure, a simple, stout, tender-hearted, no-nonsense, both-feet-on-the-ground sort of person (her favorite conversational refrain is "stuff and nonsense!"), an imposing woman wearing a fresh, brightly patterned floral dress. (Stevie quips whimsically that her aunt looks like an advertisement for Carter's Seeds: "I call it, 'Every One Came Up!'") Auntie Lion's dark, frizzy hair looks as if it's been crimped under a red-hot iron every night for the past forty years.

Watching Mona Washbourne as she takes things in hand, moving briskly around the house, reading her newspaper and calling out the sports scores or the murder stories, chiming in on Stevie's memories with an earthy, matter-of-fact interest, I kept thinking of the way Stevie's alter ego, Pompey Casmilus, introduces her surrogate mother in *Novel on Yellow Paper*: "This Lion has a very managing disposition, is strong, passionate, affectionate, has enormous moral strength, is a fine old Fielding creation."

Later Pompey hilariously describes her aunt dressed as a fan for a church bazaar, and then rapidly adds an apology: "Darling Auntie Lion, I do so hope you will forgive me for what I have written. You are yourself like shining gold."

The affectionate interplay and symbiosis between Stevie and her aunt is one of the sturdy pleasures of the film, a clear holdover from the play,

which first brought Jackson and Washbourne together. "Hmm! Well now, where shall I begin?" Stevie asks, settling in with a steaming cup of tea.

"Begin at the beginning and go through to the end, that's what I always say," Aunt declares with typical common sense.

"Stevie's Fate"

Stevie commences the story of her life with her birthday: September 20, 1902, a Virgo ("Rather a prim sign I always think, so I like to pretend I'm a bit of a Libra, too"), while her aunt adds additional facts and memories. ("A Yorkshire lass, born in Hull. Thirty-four Delapole Avenue, such a nice house.") This gives the film the texture of a reminiscence between two people who have comfortably spent their lives together. It also provides the scaffolding for the main biographical narrative.

What we are treated to is the somewhat cropped and necessarily compressed dramatic through-line of Stevie's story, her life condensed into a couple of emblematic hours, her fate. Her mother's unsuitable marriage. How her father deserted the family and ran away to sea ("What folly it is that daughters are always supposed to be/In love with papa. It wasn't the case with me"). How Margaret took her sister, who had a weak heart, and her two sickly nieces, and moved with them into Palmers Green when it was still a lovely rural hamlet, a country village. "I still find it very dreamy and poetical," Stevie says, looking out the window at this suburban site of her childhood, adolescence, maturity, old age. . . .

It was Stevie's lot to be sickly. "Fate, I suppose. Stevie's fate," she sings out, half mockingly, half in earnest. "Oh, I believe in fate, I really do."

The film cuts to the blanched light of the past, and the camera slowly closes in on a young girl's face mooning in a single square pane of glass. The other curtains are all closed. She has a look of pained homesickness on her face. She waits there until a nurse comes to pull her away. The sudden whimper of a child's voice somewhere in the background.

The Trevor Howard figure appears at momentous turning points, as if he is the exterior voice of Stevie's fate itself. He's there to deliver the dark news, the mournful tone, while in the background John Williams's haunt-

ing guitar solos inflect a general mood of ominousness. All through the movie the original music by Patrick Gowers creates an almost subliminal feeling—the unconscious texture—of sadness and melancholy, the mood of fatefulness. The nameless man sits on a park bench on a wintry day. He's holding a cane and wearing black gloves. He's there to convey the doomed undercurrent—the fatal music—in Stevie's life and work: "'It's like a man playing cards,' Stevie said. 'There's the man himself, and the cards he's playing, and there's another man watching over his shoulder. The player is life, the watcher is the spirit, and the cards are fate.' Stevie's fate was unfortunate, to say the least. It was tuberculosis."

Stevie contracted tubercular peritonitis and spent three years on and off in the Yarrow Convalescent Home, Broadstairs, on the Kent coast. She was precocious about death and claimed that the thought of suicide actually came to her for the first time when she was eight years old. It didn't depress her at all. "The thought cheered me wonderfully," she said. I like the way Jackson lights a cigarette and leans into the story while her aunt obliviously reads the paper. A telling moment. There's a huge part of her inner life that was always a secret from her companion. Jackson catches the stoic black humor in Smith's defining subject, how she often brought an odd brightness to the thought of oblivion. "'Life may be treacherous,' I remember thinking to myself, 'but you can always rely upon Death.' It also occurred to me that if one can remove oneself from the world at any time, why particularly *now*? I realized that Death is my servant; he's got to come when *I* call him. . . ."

The idea of Death (Smith always capitalized the word, as if it were a proper noun) as a devoted servant, a god one can call on to terminate suffering at any time, is one of the recurrent motifs in her mature work, and the playwright might well have quoted the Virgilian lines that Smith invented for her adaptation of "Dido's Farewell to Aeneas":

Come Death, you know you must come when you are called,
Although you are a god. And this way, and this way, I call you.

Stevie saw oblivion as an escape route, a destiny. "I cannot help but like Oblivion better," she wrote with some self-amusement, "Than being a

human heart and human creature." She seems always to have been pre-pared to call on the proud, tarrying, slippery figure of Death to carry her away in his arms. She did so in a jaunty, colloquial style that was part Mother Goose, part John Donne, and has archaic roots in the oldest pagan-Christian English poetry. No wonder Sylvia Plath was such a great admirer of Smith's poems. She recognized them.

Early in the film, Jackson sits on the couch and recites "Tender Only to One" with a simple evocative clarity. The speaker of this poem is play-ing a girl's game in which she plucks the petals of a flower to determine who will be her "lover." It's an adolescent game of chance—or narrowing fate. The game takes a startling turn in the final stanza:

> Tender only to one,
> Last petal's breath
> Cries out aloud
> From the icy shroud
> His name, his name is Death.

"One of Many"

Stevie eventually recovered from TB and came home to Avondale Road, to moments of a sunny childhood, a golden peacetime interlude. Belief in progress, in God. She reminisces gleefully about two old ladies who were neighbors, Miss Jessie and Miss Emily, about her experiences at school ("Schoolgirl Stevie," Jackson whistles with a raucous chuckle, a giddy high-pitched laugh), including a headmistress who recited her own Victorian moralistic verses at morning prayers. ("Oh, that's rather good," Aunt says sweetly after Stevie recites a particularly bad one.) Stevie's childhood reading, her jaunts in the woods, her love of nursery rhymes and fairy tales. There's an effective recitation in which Stevie, standing up straight as if at a school recital or kneeling primly on the floor next to the fireplace, and the Man outside, standing incongruously in a children's playground, pushing a swing, alternate reciting a medley of lines and stan-zas from four of Stevie's childhood poems ("The After-Thought," "Cool as

a Cucumber," "The Fairy Prince," and "The Wanderer"), which are so happily gruesome, Edward Lear by way of Edgar Allan Poe. The result is a dialogue between the inner world and the outer one, between safety and danger, between warm comfort and cold reality. "Yes, there's a lot of sadness in these poems," Stevie confesses,

> but that's because one soon realizes how brief it all is; schooldays, summer holidays by the sea-side, those cloudless September afternoons.
>
> Sooner or later adult fears are bound to seep in. Hey-ho, indeed they are. Sooner or later you're bound to realize that you're just another human being, nothing special, just an ordinary mortal like everyone else. What a terrifying moment that is.

The dialogue turns back to poetry when the Man recites "One of Many," a poem Smith scarily referred to as a self-portrait, a diabolic parable that exaggerates this sentiment so much that it is transfigured into a murderous rage. The unconscious is unleashed in Smith's spookily violent poem, and a lost innocence grows into a poisonous fury.

> You are only one of many
> And of small account if any,
> You think about yourself too much.
> This touched the child with a quick touch
> And worked his mind to such a pitch
> He threw his fellows in a ditch.
> This little child
> That was so mild
> Is grown too wild.
>
> Murder in the first degree, cried Old Fury,
> Recording the verdict of the jury.
>
> Now they are come to the execution tree.
> The gallows stand wide. Ah me, ah me.

Christ died for sinners, intoned the Prison Chaplain from his
 miscellany.
Weeping bitterly the little child cries: I die one of many.

This poem is cheerfully illustrated in *The Collected Poems* with one of
Stevie's stick figure sketches of a hanging child.

Stevie's mother was also one of many cut off before her time. Stevie
was sixteen when her mother died—not a young girl of ten or twelve as she
appears in the film—and Stevie never entirely recovered from the devas-
tating loss. A somber dirgelike music seems to announce a death. There's
a hearse pulling up to the house on Avondale Road, a band of three emerg-
ing in black, the slow procession to the cemetery, the ceremony by the
grave. Black crosses in a blasted cemetery landscape. It's all witnessed from
afar. At home the camera closes in on the Victorian-looking mother stand-
ing by a curtain. She seems alive, but spookily still, unmoving. The cam-
era pulls away—it was only a photograph—to Stevie picking up the framed
picture in her hands. Stevie always felt choked, impotent, enraged about
her mother's premature passing. She could contemplate her own death
with equanimity and even eagerness, but she could never accept the death
of her loved ones. "The nurses said my mother died quickly in a minute,"
Jackson bitterly muses, "but how long is that minute?" The answer hangs
unspoken in the air: an eternity.

Stevie sits at a table, looking down. She has been lost in thought—
some of the flashbacks take place in her mind. They are involuntary
memories, inescapable glooms from a downward-sinking Proust. Anyone
who knows Stevie Smith's work knows that she could get lost in sadness,
overwhelmed by the past, pulled under by grief, but Jackson also catches
the way she pulled herself back together, shaking her head ("*Brrr!*") and
getting up, clearing away the memory, the mood, wiping the slate, inter-
spersing her sentences with a signature *hey-ho* (part sigh, part ironic
chuckle). Bringing herself back from the brink into the world again, the
present tense. Calling out "Sherry!" in a high carrying falsetto that her
aunt never seemed to miss. Giving a hearty whooping laugh at one of

Aunt's dismissive responses to her ideas. Smoking too much. Stevie moves to the window and says:

> By and large I'm a forward-looking girl and don't stay where I am. "Left, right, be bright," as I said in a poem.

Whitemore is lifting here a key saying—key attitude—of *Novel on Yellow Paper*. "Above all I try to avoid getting too despairing. I try to remember what they said in the thirteen hundreds: Accidie poisons the soul stream."

Love: The War Room

Through its heroine's eyes, *Novel on Yellow Paper* also narrates the story of Stevie's two primary love affairs, the first with a German student named Karl, the other with a London suburbanite she wrote about as Freddy (his

real name was Eric Armitage). The film takes up both, reminiscing about the first, enacting the second. Stevie learned hard lessons when it came to the subject of erotic and romantic love. She was wayward, fierce, and repressed. The passionate affair with Karl foundered on nationality, came apart over politics. "He loved me, but he didn't like the English. I loved him, but I didn't like the Germans," Jackson summarizes. She ranted against the evil that was Germany in the thirties, what the country had become. And so they quarreled and parted.

Stevie and her aunt get into a tiff over the question—the long-standing disagreement—over whether or not Stevie should have married Freddy. This is also the key dilemma in Smith's fiction. "I am a friendship girl, not the marrying kind," Stevie reasserts. To which her aunt replies, "Stuff and nonsense!" Stevie raises her fists in the air in helpless fury. She seethes into the camera, bringing us into it: "Oooh. She doesn't understand, she never has. It is pointless trying to explain." Then she bends over toward her seated aunt, who has lost interest in the argument and disappeared behind her newspaper, and bursts out:

> I may look like a pocket Hercules, ha-ha, but I am dreadfully low on energy, and a tired person like me can't respond to love; either it wears her out and she'd rather be dead, or else she sees it as a last desperate clutch upon a hen-coop in mid-Atlantic. Ahh! Oh, the fights and ecstasies of the spirit and the sad pursuing bones!

By now Aunt is heading for the kitchen. "I think I'll just go and prod the joint," she says.

In a flashback scene McCowen takes up the role of Freddy. He's a hearty, slightly ridiculous figure who bounds into the house with a tennis racket. "Anyone for tennis?" he asks bouncily. He has been rained out of a match. He's wearing a country club outfit: a striped jacket, a V-neck sweater and ascot, white slacks. First he talks to Aunt, who is obviously charmed by him (they share a world), and then he turns his attention to Stevie. It's soon clear that she can't manage their relationship anymore, their engagement. She declares that she's not up to it and blames it on her tubercular glands, her lack of stamina. She insists that she's a friendship

girl whose true rhythm is to leave and to come back to people. Freddy won't have any of it. He's incredulous. Stevie turns away from him and recites a biting couplet:

> He'll have my heart, if not by gift his knife
> Shall carve it out. He'll have my heart, my life.

The scene escalates into a full-scale argument, reeling toward a sudden decisive parting.

Jackson is convincingly vehement, powerfully distraught, but this is one of the few scenes in the film that seems unworthy of its subject. The film lets us down because Freddy is such a caricature of a suburbanite that it's impossible to understand what Smith ever could have seen in him. "Give us a kiss and say you love me," he says, munching an apple and grinning dumbly at Stevie. It's impossible to believe that someone of S. S.'s sensibility could have been attracted to him. Yet in her terrific early poem "Freddy," she had written:

> But there never was a boy like Freddy
> For a haystack's ivory tower of bliss
> Where speaking sub specie humanitatis
> Freddy and me can kiss.

Smith was intensely ambivalent about marriage to Armitage, an intelligent man who was also painfully conventional. He wanted a kind of life, of traditional marriage, Smith could never subscribe to. I wish the film had quoted those wonderfully parodic lines from "Freddy":

> But all the same I don't care much for his meelyoo I mean
> I don't anheimate mich in the ha-ha well-off suburban scene
> Where men are few and hearts go tumpty-tum
> In the tennis club lub lights poet very dumb.

There's a revealing moment in *Ivy and Stevie* when Kay Dick asks the writer if she ever nearly married, as Pompey in *Novel on Yellow Paper* nearly

did. Smith's answer, so many years after her broken engagement, still has deep emotional reverberations:

> Oh no—well yes, I suppose I did really. At that period I thought it was the right thing to do, one ought to—that it was the natural thing to do—hey-ho—but I wasn't very keen on it. Then I felt I couldn't manage it. . . .

Smith was unwilling to give up her independence. She questioned the ideology of domesticity, of prescribed gender roles, of marriage. She felt that most young girls, especially in Palmers Green, clung to the idea of marriage like a life raft, as if getting married could somehow make everything right ("It is like the refrain in *The Three Sisters*," she says with sudden recognition: "It is the leitmotiv of all their lives. It is their Moscow"), whereas many times it wouldn't be right at all. Smith had a tremendous anxiety about losing herself to intimacy. She was apprehensive—gingerly—about commitment. She felt she could never maintain herself within marital relations.

There's a key moment in the film when she tries to explain to Freddy why it would be utterly foolish, utterly suicidal, for them to marry:

"If we get married, I won't be Stevie anymore. I'll be Mrs. Freddy. That's what frightens me."

"It's the same for any other girl," he says uncomprehendingly.

"I'm not any other girl. I'm me."

The scene takes a nasty turn, and Freddy erupts cruelly: "You'll die alone, and you'll deserve to. Little pets like you deserve to be lonely."

It's a stab to the heart. "Go to hell!" Stevie yells at Freddy as he slams the door behind him. Irrevocably gone.

Smith's refusal to marry was necessary for her psychic survival, but the emotional cost of her renunciation was high. She was grief stricken over what she had lost—perhaps not Freddy himself so much as the possibility he must at one time have represented, the possibility of a marital connection, union, a certain recognizable kind of happiness. The recognition that she would never be able to manage it must have been devastating. All her life she suffered from a restless unfulfillment in romantic love. There was

a great compensatory love in her relationship with the Lion Aunt, but she was also left with a secret and at times unbearable loneliness, a sense of desperately sinking.

It's years later. Stevie has her head down, her hands folded on the same table. Lost in thought, in memories. Jackson gathers herself together and gives a beautifully hopeless speech that reverberates in the direction of Smith's most famous poem, "Not Waving but Drowning."

> It's like escaping from a sunk submarine. You must stand quietly and without panic until the flood-water in the escape room is covering your shoulders, is creeping up to your mouth, and only then when the whole of your escape-room is flooded to drowning point will you be able to shoot up through the escape-funnel, to shoot up forever and away.
>
> Then it's over. But when it's over, then it's tearing inside, it's "tearing in the belly," and one wishes oneself dead and unborn.

Stevie lights a cigarette with shaking hands, and tells about sitting in a hot bath with tears running down her face into the water, her fringe awry. How things come to a sad, despairing, bitter end. How slowly time heals wounds, what a poor doctor time is. Jackson brings a deep musing regret to her recital of a sad poem about true love untimely slain, how it will never rise from the grave again.

"Not Waving but Drowning"

Behind Smith's work: the understanding that a lot of people carry around a sense of sad deficiency, that they pretend to being ordinary and fitting in, though in truth they don't feel at home in the world at all. They keep up pretenses, but sometimes, as she said, "they get tired and the brave pretense breaks down and then they are lost."

In the film Stevie notes that she wrote a poem about this once. She got the idea for it from a newspaper report about a man (Jackson pauses for a couple of pregnant beats) drowning.

There's a barren tree standing in the cold, gray lake we saw at the beginning of the film. It seems preternaturally still. Trevor Howard is sitting on the edge of a bench. With deep mournfulness, he recites—he speaks really—Stevie's lethal masterpiece. One feels the grave submarine laughter and the plunging depths behind this poem of fatal misunderstanding.

> Nobody heard him, the dead man,
> But still he lay moaning:
> I was much further out than you thought
> And not waving but drowning.
>
> Poor chap, he always loved larking
> And now he's dead.
> It must have been too cold for him his heart gave way
> They said.
>
> Oh, no no no, it was too cold always
> (Still the dead one lay moaning)
> I was much too far out all my life
> And not waving but drowning.

I had never heard this poem read aloud before, and I was struck anew by its comic awfulness, by the spooky fact that the speaker is already dead but still moaning, still suffering. How the speaker in the second stanza takes on an ordinary social voice, what a couple of people might say about someone while they're drinking beer in a pub. The clichés. The iron shock of the foreshortened twelfth line ("They said"). How that turns to the startled contradicting voice of the drowned one himself. His haunted explanation. How each of us who hears this little twelve-line poem, whether for the first or the fiftieth time, immediately recognizes it, knows it to be true.

After he recites the poem, the unnamed Man, poor chap, walks away from us down the wide path through the park. One more sign of departure. Let darkness fall.

Not Waving but Working

Stevie always felt out of step in the workaday world. She was much too brainy for her job. She went to secretarial college rather than university, and then got a job as a private secretary in a magazine publishing company, Newnes, Pearson, where she worked for thirty years. "I've been there almost the whole of my so-called, ha-ha, working life," Jackson declares: "All that *capitalismus* toil is very difficult and exasperating indeed. . . ."

Stevie let it be known that she was never really too overburdened at work. She liked her boss, and she stole a good deal of work time for her own writing. Sometimes she invited friends round for tea and hot buttered toast. She even suggested that if she had never been forced to work she would have become "some sort of invalidish person and never done any writing." She claimed that exile from domesticity produced her poems.

She also confessed, however, that she was never cut out for the business world. She didn't fit in. The pressure of daily life with its crushing routines, the pressure of having to earn a living for decade after decade, the inner isolation, could be overwhelming for a person so dreadfully low on energy, so temperamentally inclined toward despair. "Deeply morbid deeply morbid was the girl who typed the letters," she wrote. It's telling—it certainly wasn't accidental—that she was sitting at her office desk on a gloomy day in 1953 when she tried to commit suicide by slashing her wrists. It was just two months after she had written "Not Waving but Drowning."

It's a devastating moment in the film when Stevie's attempted suicide arises—even for those of us who know it's coming. The sadness of the scene—the black melancholy music—is nearly unbearable. It begins neutrally enough with a train coming from a distance and passing under a bridge. (The moving train is one of the refrains in this film, its clear way of marking passageways.) Then the Man is walking slowly toward us across that same bridge. It's a bleak day and something is awry. He intones:

> For most of her life Stevie followed an unchanging routine. Every
> morning she caught the train to her office near the Strand, and
> every evening she traveled back to Palmers Green, to Avondale

Road, and to the Lion Aunt. "Life is like a railway station," Stevie said. One day they brought her home early in great distress. Her wrists were bandaged.

While the Man is still talking—explaining—a black taxi is pulling up to the house. Watching the film for the first time, I'm sure I flinched, I almost had to hold up an arm to fend off the sight of Stevie being helped out of that car, crossing her arms as if to hide her wrists, while her worried and shocked aunt waits helplessly by the front door. She's near tears. Stevie goes into the house.

Trevor Howard recites some relevant lines from "Death Came to Me":

> I took the knife
> Its cruel edge would bite
> Into my flesh
> Had I the resolution or the art
> To bear the smart
> And drive it to my heart?

Stevie appears in the corner of the bay window. She looks utterly forlorn, defeated, half mad. The sense of a person drowning is intense. But she doesn't drown. The Man summarizes: "Death, that sweet and gentle friend, failed to respond to her summons. Life continued."

Death of a Lion

To her enormous relief, Stevie was retired—pensioned off—from work after her failed suicide attempt. She was greatly remorseful about what had happened, she said, not because of the violent act itself, or at least not only because of the act, but because of the pain she had inflicted on others: Her aunt, her friends in the office, her boss, whom she contended was dreadfully upset but not hugely surprised. ("He knew. Oh yes, he knew.") It shouldn't have happened at the office, she admitted. And so she tried to forget about what she referred to as "that suicide business." She soldiered on.

Mona Washbourne wonderfully portrays the Lion Aunt getting older, forgetting things. She goes out less and less. One looks in on her at night in a plaid bathrobe, her hair combed down for bed, at times in braids. Worrying about the income tax, about Stevie, who has just come back from another party, wearing a buttercup-yellow dress and complaining that she looked like one of the sheeted dead.

Suddenly in the film, as so often in life, Aunt is an old lady. It's terrifically difficult for her to cross the sitting room to her favorite chair. She collapses into it, wheezing heavily, as if she has just run several miles. She's too weak to pick up the soppy blanket dropped on the floor. "Peggy, Peggy!" she calls out, like a great distress signal. Peggy tucks her in, promising a special treat after she finishes her salad. How her face lights up with radiant joy when she gets her favorite treat—junket pudding. "Ooh, ooh, what a lovely lunch," she gushes. Her sweet nature is staggering. Everyone I've known in such situations has been impossible to deal with, utterly enraged. No wonder Stevie would move heaven and earth for her.

"Dearest Lion Aunt," she asserts, tenderly applying the words a wife says to her husband in the poem "The Starling":

> I will never leave you darling
> To be eaten by the starling
> For I love you more than ever
> In the wet and stormy weather.

While Aunt snoozes in the chair—this is the same chair where the narrator pauses with so much wistfulness in the second scene of the film—Stevie stoops beside her and strokes her cheek. "There's little laughter where you are going," she says softly, "and no warmth." Stevie can't bear losing her aunt, but insists she doesn't care about her own survival. One comes to believe her. By the end of the speech, she has worked herself around to praising Death again. "I don't know why people are taught that Death is a calamity," Stevie says memorably: "I think he must be rather a dish."

Stevie and Aunt have reversed roles. As the Lion becomes more childlike, Stevie increasingly mothers her. Niece runs the house now. Domestic,

uncomplaining. Cooking. Housework. Writing. The so-called occasional sherry. "I look after someone who used to look after me," Stevie wrote simply in her personal essay, "Simply Living." "I like this. I find it more enjoyable than being looked after. And simpler." One remembers the explanatory lines from "A House of Mercy":

> Now I am old I tend my mother's sister
> The noble aunt who so long tended us,
> Faithful and true her name is. Tranquil.
> Also Sardonic. And I tend the house.

In the film Stevie doesn't recite these lines. Perhaps consciously, perhaps unconsciously, the screenwriter gives Stevie lines that originally were meant to apply to her mother and aunt, but now so aptly also apply to her aunt and herself:

> It was a house of female habitation,
> Two ladies fair inhabited the house,
> And they were brave. For although Fear knocked loud
> Upon the door, and said he must come in,
> They did not let him in.

The shot of a yellow light reflected through a curtain in the upstairs window. The treading notes of a guitar. Aunt is confined to the upstairs bedroom now, lying weakly in bed. Stevie fusses, changes the hot water bottle, watches over her. She sits in a chair in a darkened room while Aunt sleeps her life away. She's lit by a small lamp behind her. This is the moment in the film, while the Aunt is on the verge of death, that Stevie names herself an Anglican agnostic and takes on Christianity. She loved the hymns, which were always deep in her, but refused the consolations of religion because she did not believe they were true. This is the tough-minded woman who rejected the sweetness of Christianity as well as what she called its hideous cruelty. She would be one of Larkin's "less deceived."

I'm strongly affected by the way Jackson recites "Thoughts About the Doctrine of Eternal Hell." While the camera closes in on her face illumi-

nated in the dark room, she says it with great conviction, pressing home her argument with ferocious intensity, fiercely biting off the final lines:

> Who makes a God? Who shows him thus?
> It is the Christian religion does.
> Oh, oh, have none of it,
> Blow it away, have done with it.
>
> This god the Christians show
> Out with him, out with him, let him go.

In the written text the emphatic change from a capital G to a small g in the Lord's name (from "God" to "god") enacts the brave renunciation.

Stevie felt that we should accept loneliness, not make a theology of it by inventing an all-powerful deity. She said memorably: "If I had been the Virgin Mary, I'd have said: No, no, I'll have no part in it, no savior, no world to come, nothing."

For me the most poignant scene in the film is the death of the Lion Aunt. (Washbourne looks as if she's somewhere in her eighties, though Margaret Annie Spears was in fact ninety-six years old when she died in 1968.) Leaning back against her pillow, half propped up, calling out weakly to Peggy for a drink of water. The touching way that Aunt reaches over with effort and Stevie takes her hand. Stevie says—talking partly to herself, partly to us: "People think because I never married I know nothing about the emotions. They are wrong." She looks intently into her aunt's face. "I loved my aunt."

There's a chill, a small shock, in the fact that she is already using the past tense. A close-up of Stevie's two hands covering her aunt's hand. The camera moves up along the body to focus on Aunt's face on the pillow. Slowly, almost uncannily, with her eyes still closed, Washbourne turns her head in our direction. There's a look of great repose on her face, which is partly in shadow, partly in light. The slightest trace of an inner smile. Death as an end and remedy. And then the traditional cinematic signal from the outside: a curtain closing across the darkening upstairs window.

I myself had grown so attached to the spirit of the Lion Aunt incar-

nated through Washbourne that the first time I saw the film I began to cry at her death and couldn't quite stop myself. I think I was in tears about it, on and off, for much of the rest of the movie. I knew even at the time that there is a deep reverberation for me with the death of my own practical-minded grandmother, whose name was Anna. I still get an icy shiver every time I come across the first stanza of Stevie's memorial poem to her aunt, "Grave by a Holm-Oak":

> You lie there, Anna,
> In your grave now,
> Under a snow-sky,
> You lie there now.

Worlds pass away with these tender, tough-minded women who gave us so much of their ferocious loyalty, their strength.

"Do Take Muriel Out"

Stevie would be next. The film makes it seem as if Stevie's death and her aunt's were separated by a wide span of years, but in fact Stevie followed her aunt into the ground just three years later. So we enter the final movement of the film, its last act.

The narrator doubles as one of many friends Stevie collected near the end of her life, taking on the urbane persona of someone on the literary fringe. He is driving slowly through the rain, talking to us through the windshield wipers about how he first met Stevie sometime after the war at a noisy, quasi-bohemian gathering. Stevie mostly complained about George Orwell, who had been her producer at the BBC (the film doesn't mention that the two were consistently rumored to have had an affair): "'He keeps lying to me,' she said. 'I'm bored to death with all the lies.'"

All Stevie's car-owning friends complained that she imperiously expected to be ferried around London. The tiresome duties had reached a peak with Stevie becoming, as the Man puts it, "something of a star-turn on the poetry reading circuit." Even so, he says, pausing at the front door,

"my affection for her has remained unimpaired"—he takes a long breath and laughs a little to himself—"relatively." The timing is impeccable. Then he rings the bell.

Stevie enters the sitting room wearing a badly dyed green suit. She wants to know how it looks. "Very nice," the Man says, meaning terrible. (The time she wore it to a poetry reading was in fact notorious.) Stevie taking her time to get ready, dithering around, trying to decide if she should wear a brooch or a locket, changing her plans about possibly staying overnight (she wants to, if asked; he can't), pouring herself a drink. They fall into petty bickering. Here we're treated to Stevie's difficult side. A willful woman who needs to be cherished, the least likable of her personas. But then the man says an acute thing about one of Stevie's readings, which I've always suspected to be true because it jives with other accounts:

> I remember once sitting at the back of a cheerless school hall while Stevie pranced about on the stage, chanting her poems like an elderly Shirley Temple. It should have been embarrassing, but it wasn't; it was touching, truthful, and haunting. . . .

Listening to the off-kilter chant and odd gait of a poet who loved to echo—and fracture—hymns and folk tunes, traditional ballads, whose quirky natural idiom lifted poetry in the direction of song, one was always conscious of poetry as an oral phenomenon, a physical medium, a bodily art. Perhaps wisely, Jackson veers away from S. S.'s notably performative way of reading her lyrics aloud. Near the end of the film however, she does give one highly intonated and haunting recital of a few stanzas from "Do Take Muriel Out," which she starts by intoning and ends by singing, like her real-life counterpart. The feeling is so strong that I wish she had been let loose to recite the entire poem.

It's incredibly hard to describe the rhythm of a film, its silent visual simultaneities, its tones, its pacing. The matter is complicated when there is music in the background, establishing a mood, creating a feeling, and an actor bringing poetry to the forefront. Here, looking in the oval

mirror on the wall (we can see the Lion Aunt's chair reflected on the other side of the room), Jackson begins to speak slowly and in a steeply low voice:

Do take Muriel out
She is looking so glum
Do take Muriel out
All her friends have gone.

Jackson turns around and by now is singing the third stanza, so that it sounds almost Germanic ("there is something of the Gretchen song in it," S. S. once said). She makes her way across the room and stops in the center. She sings the final stanza. For weeks afterward I walked through my days with the exact melodramatic timbre of Jackson's voice ringing in my head. Years later I can still close my eyes and see her, slowly—vehemently—swinging her arms from side to side; I can still hear her inviting Death, like a suitor, to take poor gloomy Muriel on a final eager date:

Do take Muriel out
Although your name is Death
She will not complain
When you dance her over the blasted heath.

A penultimate marker. We're inside a train fast approaching a black tunnel. It's moving at high speed toward a circle of light gradually becoming clearer and larger on the other side. The inference is clear: the dark music of time passing, the approaching brightness of Stevie's longed-for oblivion.

Stevie comes through the front door of the house. She's wearing a round black hat that she bought for five shillings at a rummage sale. Her hair is gray now, she has a pronounced limp. She moves around the sitting room and talks about living alone ("It's wonderfully dreamy to be in a house all by yourself"), about her newfound celebrity, about reading Gibbon's *Decline and Fall* ("I never tire of it") and Agatha Christie in

French ("Her murders are so polite"). How Death will come to her at the end with the pleasure of certainty.

Jackson launches into Stevie's account—by now almost legendary—of receiving the queen's gold medal for poetry. She recounts it with great esprit—the trip to Buckingham Palace, the giggly time she had in the outer room with a lady-in-waiting ("She asked me to say one of my poems, so I hissed a short one under my breath, well, you know, the one about the poor debutante all alone at the grand ball"), how she was ushered in by a naval man to meet the Queen Mother herself—a charming figure—who gave her the medal and motioned her to sit down. How the poor darling kept asking her about poetry: "She made me feel very like a schoolgirl again, being interviewed by a rather cordial headmistress." Telling the queen that she had written a lot about murder lately, which elicited a frozen smile. Walking out backwards, and at the end a taxi to a restaurant for a celebratory lunch, and then back to Avondale Road.

Stevie pauses at the end of her story, and one feels her trying to get her emotions under control. She looks stricken. "I did so wish the Lion Aunt could have been alive to see it." She moves around to the back of her aunt's chair. "Perhaps she would have changed her mind about my writing. Perhaps not." For a moment she pulls herself up and imitates her aunt's posture and voice: "Stuff and nonsense!" Then she gives her own signature: "Perhaps she was right, hey-ho."

Stevie sits in Aunt's chair and removes the black hat she had worn to meet the queen ("Perhaps a bit of a mistake"). The guitar sounds a melancholy backdrop while Stevie recites most of "Black March" with grave solemnity. At the end, she sighs to herself and sits back in Aunt's chair. The light holds steady—intently—on her lined face.

"Come Death"

Now for the last time—the final refrain—the train enters a tunnel that is completely black. We stay in that blackness for a few interminable moments listening to a funereal music. When we come out again Trevor Howard is standing in the house with the furniture covered in white

sheets. He recounts how Stevie's sister, Molly, suffered a severe stroke which left her helpless. Stevie went to help and fell ill herself. She wrote to an old friend from the hospital.

Stevie's voice precedes her, reciting the letter, "Dear John . . ." The camera slides slowly down to Aunt's chair where Stevie is relating the story of her illness to a good friend. I know this letter well—it's the last one Smith wrote—but I was nonetheless bowled over by Jackson reciting it entire, by Stevie's account of her illness, her ironic laughter, her sudden inability to speak or read properly. She goes through to the end, but near the bottom of the letter, Jackson imitates the great problem Stevie had in speaking correctly at the last. She writes with characteristic self-mockery: "I'm not sure I'll be very bright, ha-ha, as so often I cannot speech properly I scramble velly velly well." With tremendous difficulty, Jackson bites out, she stutters twice on the word "Dooo," "Dooo," calmly gathers herself and finishes: "Do forgive me dear John if I have been already over and over this again and again. I hope you are beautifully happy. Love, Stevie."

I've always been moved by this letter, but by the time Stevie had signed off I was pretty much beside myself. I could scarcely see, I was shaking so much I almost couldn't hear the Man returning to declare the inevitable—how Stevie had been diagnosed with a brain tumor and in the end lost the power of speech. In truth, by the end of the film I was sobbing so hard that afterward my somewhat bemused wife had to walk me around the parking lot for twenty minutes or so to calm me. I was flooded with grief.

After he finishes, the Man goes back to the parlor door. He pauses and surveys the room for one last time. Then he turns off the light and leaves. There's one last shadowy shot of the Lion Aunt's chair, which had also become Stevie's chair.

Stevie was sixty-nine when she wrote her last poem. Trevor Howard recites "Come Death (2)" with great dignity. It's deeply fitting that the last words of the film are the words of Stevie's final poem. They fill the mind, the theater, with their faithful summons, their fatal timely music. I was haunted when I first read them so many years ago, I was inconsolable when I first heard them in *Stevie*. I am still. Yet, in the end, Stevie Smith found at last the peace she had so desperately longed for and needed. She had

crossed to the other side. But at least on our side, one hopes, she had joined the company of lasting poets, the greeting figures.

COME DEATH (2)

I feel ill. What can the matter be?
I'd ask God to have pity on me,
But I turn to the one I know, and say:
Come, Death, and carry me away.

Ah me, sweet Death, you are the only god
Who comes as a servant when he is called, you know,
Listen then to this sound I make, it is sharp,
Come Death. Do not be slow.

RICHARD HOWARD

A MAN ESCAPED

(UN CONDAMNÉ À MORT

S'EST ÉCHAPPÉ)

DIRECTED BY ROBERT BRESSON

So compelling do I find the cinematic medium that even mediocre films seduce me—I would not be beguiled by a comparable mediocrity in the other performing arts. So my choice of a "favorite" film has little significance, if I were to speak as a connoisseur of movies.

Bresson's film, however, was the first film that struck me as a complete work of art—something on the order of *Coriolanus* or a Mozart quartet. I

have seen it several times—indeed, I have noted the same effect of entire artistic achievement in Bresson's later films (especially *Mouchette, Lancelot du Lac, The Trial of Joan of Arc,* and *Au Hazard Balthasar*). But it was in *A Man Escaped,* which produced this effect upon me after some ten years' besotted moviegoing, that I first realized that a film could be—that this film was—a work of art. Perhaps it was the very rigor of the film's means that brought the message home: black-and-white, virtually "silent"—dialogue reduced to the merest necessary whispered instructions, with that glorious burst of confirming music at the end; and for the first time—indeed, the very first time I saw the film—I realized what the combination of images and sound, cutting, framing, and what in poetry I would call the "phrasing" of narrative could achieve—in other words, I was confronting a totality of technical contrivance that so worked together that I received an overwhelming wholeness of effect, the kind of fulfilled emotional response I strive for in my own work as a poet. Of course I must acknowledge that I (now) recognize such achievement in other films, by other directors (Dreyer, for instance), but it was the austerity, the intensity, and the unity of *A Man Escaped* that I can identify as my initiation into film as art.

PHILIP LEVINE

THE DAWN PATROL

DIRECTED BY EDMUND GOULDING

A s a boy of six or seven I saw a film, or so I believe, in which a dead fighter pilot returns in a ghostly form to the room of a comrade to remind his friend he was once flesh and blood and must not be forgotten. I tried for years to see this movie again; I went to every film that had anything to do with World War I, and I waited in the charged dark for the scene to play itself out, to tell me I had not dreamed it, but I never succeeded. Nor since movies have become available on cassettes have I been able to see that scene on a tel-

evision screen. Did I ever see it? For years I thought I did, but now I don't know. I may have dreamed it, for as a child my dreams were incredibly vivid and many, like this one, I had over and over. Furthermore this was for me a typical dream in that it involved the return of someone who'd died. No doubt this had something to do with the loss of my father, who died when I was five, and whom I believed I'd failed, for in some mysterious way I still believed he was "present," and if I went about it right I could see him again. I'd seen him in his coffin, I'd attended his funeral, I'd stood at the graveside with my mother, and yet a part of me went on believing he was somewhere on earth, "present" like the ghostly airman I'd seen on the screen or in a dream.

Thus one Saturday afternoon at the Avalon Theater on Detroit's west side, when I saw the coming attractions of *The Dawn Patrol*, due there within a week, I was more than usually excited. Early afternoons on Saturdays at the movies were the highlight of those weeks, but one featuring a World War I war-in-the-skies film was over the top. A week later my twin brother, Eddie, and I walked the ten blocks to the Avalon in a state bordering on frenzy. The week before we'd seen snatches of Errol Flynn's dogfights with German planes, an unusually subdued Flynn except when he was in the cockpit of his flimsy cloth-and-wood Spad taking on the black fighter planes of Von Richter's squadron while something called trench warfare, something deadlier and less spectacular, went on unobserved below. As Major Courtney, Flynn bore a slight resemblance to photographs of my father: Both were tall, handsome, and wore moustaches as well as British uniforms, for my father had served as an officer in the British army in what came to be known as the Great War. I know that much of the excitement we felt that day had to do merely with the chance to see once again Flynn, who for us was the handsomest and "coolest" (though if that term existed in 1938 neither Eddie nor I knew it) presence in the universe.

Last week, watching a cassette of *The Dawn Patrol*, I was stunned by how much I recalled and how much I'd forgotten. The look of Flynn as Courtney and of his carefree, often drunken sidekick, Scottie, played wonderfully by a boyish David Niven, I recalled and of course their thrilling

dogfights with the Germans. All these years later I still knew the plot, knew that Courtney would replace Brand, played by Basil Rathbone, as squadron commander and be obliged to send Scottie's younger brother into combat and to his death, and that soon after—to make amends or just because of who he was—Courtney would trick Scottie into an interlude of drinking and, having talked Scottie into taking a nap, he would take his place on a suicide mission deep behind German lines and pay with his life.

I had forgotten how gray the film was. Although the jacket of the cassette proclaims it's "filmed in glorious black and white," in fact there's almost no white in the entire film. Most of the film takes place indoors with a few badly lighted rooms at squadron headquarters. These scenes are filled with talk, much of it less than believable, and within the first half hour I felt that the director, Edmund Goulding, must have wanted me to feel claustrophobic, to feel the same urge the pilots felt to escape these dim, confining rooms even if it meant risking their lives. I did feel an enormous relief when in the predawn the men went out to their planes, and something like elation when at last they took off into an overcast sky streaked with the day's first light.

Of my three-hours-plus in the Avalon I recall almost nothing. There had to have been another feature—there always was—and the standard Saturday matinee fare of newsreel, serial, coming attractions, and cartoon. I remember none of that, nor do I recall any horsing around that Eddie and I did—but then we behaved badly only when the movie bored us. Did I sit in charged expectation of the appearance of the "ghost pilot" of an earlier film or of my dreams? I'm sure I did. I'm also certain I accepted the film's overt theme, for it's stated over and over again by Courtney, Brand, and later Scottie: the senselessness of war, this war and all others. The film is an extended lamentation for the waste of young lives, and no one on screen sees any purpose in the war nor is a single patriotic spiel uttered. When a captured German pilot is brought to headquarters he behaves like a good-natured buffoon, and in his drunkenness he behaves—except for a complement of "German manners"—exactly like his captors. He takes a special shine to Courtney, who shot down his plane, and insists on singing

with him. Clearly the British pilots are motivated by the need to put up a good show and survive, and above all by their loyalty to each other. Their actual enemy is faceless, and we never see him: He phones from an almost mythical higher headquarters and day after day orders the squadron into battles in which the "replacements"—kids of eighteen with a dozen or so hours of flight training—are invariably slaughtered. No matter how pas-

sionately Brand and, later, Courtney beg for a few days in which to train these boys in the tactics of warfare, they are denied, and the next day's dawn patrol claims more boys who had no chance against the better equipped and more experienced Germans. Seeing it this time I was struck by the notion that both the director and the screenwriter were seeing the movie through the prism of Wilfred Owen's poetry. It's almost as if the telephone voice is that of Owen's "Field Marshal God," with his unquenchable thirst for young blood.

The strongest themes are unspoken, for all the exciting and expansive moments of the film are devoted to the glory of flight and the romance of these thrilling competitions in which skill, courage, and experience determine the winner. We're told that the British equipment is inferior, but when Courtney and Scottie take on the enemy in one-on-one combat they almost invariably win. This is war fought by gentlemen, knights of the air, who kill without rancor or disgust. I was reminded of the opening lines of Baudelaire's poem "L'Héautontimorouménos": "Je te frapperai sans colère/Et sans haine . . ." (I shall strike you without anger/And without hatred . . .). When I saw the film in 1938 one war was raging in Spain and "we" were losing; a larger one was waiting to engulf the world, one that might need my blood.

How much of this did I get at age ten? Without trying to sound brighter than I am or was, I'd guess almost all. The film is not that subtle. As a kid not immediately faced with armed combat I was free to luxuriate in the drama of brave men in a fair fight to the death, and as a shrewd city kid I knew all that was horseshit. Curiously what I remember most clearly from that distant afternoon, even more clearly than the excitement of anticipation, was the aftermath. The shadowy ghost of the slain airman who might be the ghost of my father asking not to be forgotten, not to be allowed to die, had not appeared on the screen. The search for this image would have to go on, though that day fortunately I didn't know for how long.

Eddie and I were quiet on the walk home. We'd been caught up in the action. We were kids. We loved the spectacle of gunfights, warfare, aerial acrobatics. Had I noticed the bad acting, how tiresome the one young,

brooding pilot was, the one who'd lost his best friend and couldn't stop whining? I loathed him. Did I hear how bad some of the lines were that Niven had to pretend had meaning; how overpumped the music was that (thankfully) lasted only a few minutes? Of course—even at ten I was a budding literary critic and a smart-ass. But I forgave it all, for I was being taken out of my humdrum life by the magic of the movies and into that great romantic enterprise, aerial warfare. So there we were, Eddie and I, in the aftermath of war, more than a little overwhelmed as light drained from a soot-filled autumn sky and the sun dropped below the three-story flats off Linwood Avenue. We were reentering both the gray world of everyday Detroit and the gray world of the movie, playing it over in our heads. Though chastened and subdued by the death of Major Courtney—I couldn't recall Flynn being offed in another movie—I was deeply moved by the beauty of his sacrifice. I did not say aloud or to myself, "There is no greater love than a man lay down his life for his friends." I'd never heard that statement. But that's what I felt. Eddie and I passed the dry cleaners and then the Sinclair station; we were halfway home, two small Jewish kids trekking through hostile territory. Our drama was not yet played out over the boundless skies above the Western Front, and yet the lesson was the same: There were massive forces out there led by men who meant us no good. Some of those men we could already name—Henry Ford, Francisco Franco, Father Coughlin, Mussolini, Hitler—but most of them were both nameless and faceless, like the telephone voices commanding Courtney and Brand. All we had in our defense were our wits, our stamina, and each other. Seeing the movie a second time sixty-two years later I found once again that it affirmed the absolute and utter need for brotherhood. If we did not stick together we would certainly lose, though not as dramatically as Courtney plummeting earthward in a smoking spiral. If we stuck together, if we were driven by the belief that we were a single being and fought with all the power of that belief, we'd probably lose anyway, but we would lose with honor. And honor meant everything to those two untested boys.

MARGOT LIVESEY

I KNOW WHERE I'M GOING

DIRECTED BY MICHAEL POWELL

My initial affection for *I Know Where I'm Going* stems from two factors that may have little relevance for most American viewers: The film is set in the West Coast of Scotland, a region of my homeland that has a particularly deep claim on my imagination, and the actor who plays the hero shares my surname. That was indeed how I first became aware of the film: People would ask whether I was related to Roger Livesey. For someone with few known ancestors—my father always claimed we were descended from

Oliver Cromwell, a warty, complicated figure in British history—and almost no living relatives this was an intriguing possibility. Maybe, I replied.

"Romantic" and "comedy" were not, I confess, words that made me yearn to pick up a book or see a film—I had never been exposed to the charms of *Some Like It Hot* or *It Happened One Night*—so I didn't hurry to watch *I Know Where I'm Going*. I was in my thirties when I finally succumbed. Michael Powell and Emeric Pressburger made the film in 1947, and from the quirky opening credits, which unroll alongside an encapsulated autobiography of our heroine, I was captivated. "When Joan was only one year old," a male voice declares as a baby crawls across the floor, "she already knew where she was going. Going right? Left? No, straight on."

The plot is classically simple. The bright, forceful Joan Webster (played by Wendy Hiller) announces to her bank manager father, over dinner in a restaurant, that she is going to marry Sir Robert Bellinger, the owner of Consolidated Chemical Industries. The marriage will take place two days later on the Scottish island of Kiloran. Her father is suitably impressed: Sir Robert is one of the wealthiest men in England. Then another thought surfaces. But surely, he speculates, Bellinger must be nearly as old as he is. "And what's wrong with you, Daddy?" says Joan and drags him onto the dance floor.

She catches the sleeper north to Glasgow, changes trains with the help of one of Sir Robert's minions, takes a ferry over to the island of Mull, and there finds her progress to Kiloran barred by unmistakably Scottish weather. The island, only a few miles away, is shrouded in fog. The dour ferryman refuses to take her over, and the boat Sir Robert has promised to send does not arrive. Stranded along with Joan is Torquil McNeil, played by my hypothetical relative, replete with thick, wavy hair, naval uniform, and pipe, home from the war for eight days of precious leave.

Watching the film now, after a decade of writing novels, I ponder how Powell can get away with such a simple, one might even say simplistic, plot. From the moment Joan and Torquil meet, indeed from the moment that ironic male voice declares that Joan knows her destination, we have no doubt what the outcome of the film will be; the suspense and the pleasure lie in seeing how events unfold and what will bring the strong-willed

Joan to her senses. The film flirts with that fine line between the inevitable and the predictable and remains triumphantly on the side of the former.

Powell never realized his long-held ambition to film *The Tempest*, and *I Know Where I'm Going* has some echoes of Shakespeare's play. Most obvious, of course, is the island setting and the way in which it both governs and contains the action. But Powell subverts Prospero in various ways. Torquil and Joan are on an island, but not one that's fully recognized as such, trying to reach an island that simultaneously contains the enemy, Sir Robert—he appears in the film only as a disembodied voice on the radio—and remains a place of mythic possibility, fecund with salmon and game. As in *The Tempest* the weather plays a crucial role, first bringing Torquil and Joan together and then nearly destroying them as Joan insists on trying to reach Kiloran anyway.

Beyond these similarities is some shared vision of romantic love that, at first glance, seems to be almost entirely informed by appearances and a lack of alternatives. "There's no art," says King Duncan in *Macbeth*, "to find the mind's conception in the face; /He was a gentleman on whom I built/an absolute trust." Happily this information has not yet reached Ferdinand and Miranda on Prospero's island. They are the only nubile people for miles around, and they have eyes only for each other. Similarly Joan and Torquil seem unable to escape each other's company, although more complicated issues of class are surely involved in Torquil's lack of choice. For our dashing naval officer turns out to be none other than the laird of Kiloran. Minus five to Sir Robert for allowing Joan to believe him the owner of the island rather than a mere tenant for the duration of the war. Ruthlessly stacking the decks, Powell goes on to make clear that while Torquil is off defending king and country (the eccentric local colonel names his golden eagle after him), Sir Robert is safely at home, building a swimming pool on Kiloran and perversely refusing to buy the local salmon. Whom would you choose?

With nowhere else to go, Joan and Torquil take refuge with Mrs. Potts, Catriona (Pamela Brown) to her friends, the owner of the local big house; she's only just got rid of eighty boys from the RAF. Glamorous, Gaelic speaking, a breeder of wolfhounds, and a competent shot, Catriona acts as

handmaiden to the lovers, pointing out to each what the viewer has long realized. In the real world Torquil would surely have a mad crush on Catriona but in Powell's version, of course, he pursues the straitlaced English Joan, who doesn't even recognize Gaelic, let alone speak it, and is woefully inept when it comes to skinning a rabbit.

The burgeoning attraction between our two lovers is both underscored and enlarged by the consciously fairy-tale quality with which Powell imbues the landscape. Over a last cigarette their first night at Catriona's, Torquil tells Joan to count the beams in her bedroom ceiling and make a wish. "As easy as that?" she asks. "It doesn't work if you don't believe it," he replies. Joan wishes and wakes to find the fog duly gone, only to be replaced by a tearing gale. "You wished too hard," Torquil admonishes.

Later he introduces her to two other legends: the Scylla and Charybdis of the film. Near Catriona's house lie the ruins of Key Castle, which the lairds of Kiloran are forbidden to enter under pain of a terrible curse. Neither his father, nor his grandfather, nor his great-grandfather, Torquil explains, has ever crossed the threshold, nor will he. Then there is the legend of Corryvreckan, the second largest whirlpool in Europe, which lies not far off the coast of Kiloran and which only a rope made from the hair of faithful maidens is strong enough to resist.

Of course all this pleases me immensely; I grew up stepping carefully around fairy rings and washing my face in the dew every May day. If I had known about the beams, I would have been busily counting. Day by day Joan battles with Torquil, and everything conspires against her. The wind refuses to drop. She visits some friends of Sir Robert's, "the only people worth knowing, my dear," he tells her over the radio, and they take her to tea with the owner of another castle, only to find Torquil already there, acting as butler. While the others settle down to a hand of bridge, he and Joan steal away to visit the *ceilidh*, a musical evening, being held in honor of the chief stalker's sixtieth wedding anniversary. Of course Joan resists the spell of Scottish culture—the skirling bagpipe music, the singing, and the dancing. Then of course she succumbs, and the flames of passion burn bright.

One of the main ways in which Powell balances so successfully between the predictable and the inevitable is by having Joan resist Torquil

as hard as she can, even to the extent of putting both their lives in jeopardy. Realizing that her marital plans are in danger, Joan bribes the boy who works for the ferryman to take her over to Kiloran by offering exactly the sum he needs to marry the ferryman's daughter. Everyone, including the daughter, tries to dissuade her, to no avail, and Torquil ends up joining the doomed expedition. In the extended scene in which he rebuilds the engine of the boat—remember, he is in the navy—and they drift closer and closer to Corryvreckan, Powell offers us a vision of romantic love both absurdly grandiose and touching. As Joan's wedding dress is swept away by the storm, few viewers probably sympathize with Sir Robert.

Perhaps you will have guessed by this point that my affection for *I Know Where I'm Going* does not depend on my feeling for any of the main characters. Joan, with her love of money and her passionate pursuit of a rich husband, is interesting only in her doomed struggle, and Torquil, with his immaculate hair and his everlasting pipe, makes some tediously heartfelt remarks (although I must confess that his membership in Scotland's impoverished aristocracy is a mitigating factor). Perthshire, the county where I grew up, has more castles per square mile than any other part of Britain, and we typically spoke of the inhabitants in pitying tones. Poor things as they wrestled with their leaky roofs, drafty halls, and wretched plumbing. Oh, for a cozy bungalow!

I do, however, relish the many minor characters, doughty Scots one and all, with whom Powell peoples the screen. It is they (along with the charged landscape) who embody the energy of the film and who, in some sense, speak on behalf of the main characters. No wonder, when one stops to think, that Joan and Torquil are virtually mute, for what can be said about the passion to which each has fallen prey? It is a maelstrom that threatens to wreck both their lives, and maybe it finally does, but not while we're watching. The film plays on our old yearning for happy endings: As if marriage could possibly be the end of the story.

PHILLIP LOPATE

BREATHLESS:
HOW DOES IT PLAY TODAY?

DIRECTED BY JEAN-LUC GODARD

An amiably cocky Frenchman in sunglasses steals a car, mugs people for petty cash to romance a cute American coed, tries to collect funds from shady characters so he can run away with the American girl to Rome, but she seems more interested in flirting with contacts to secure a writing job, besides which she is pregnant by the Frenchman and he seems indifferent to this fact, while a police manhunt closes in on them both. . . . No wonder they called it *Breathless*! Actually the original title, *A Bout de Souffle*,

might be better translated as *Out of Breath*, with darker connotations. Forty years after it shook up the movie world, Jean-Luc Godard's brilliant provocation has been revived nationwide, in a new print. For his debut feature Godard wanted to make a film where "anything goes," and there is still a strong whiff of the anarchic and dangerous in his concoction.

Susan Sontag once compared Godard's impact on his medium to Schoenberg's introduction of atonal music and the cubists' challenge to traditional painting.

Having been a young, impressionable film buff when *Breathless* first exploded on the scene, I can't help but experience nostalgic exhilaration at the memory of its freshness. Granted, *Breathless* had plenty of company: The early sixties was a time when such masterworks as *L'Avventura*, *La Dolce Vita*, *Psycho*, and the *Apu* trilogy were thrilling audiences worldwide, while Godard's confreres in the *Cahiers du Cinéma* circle, the critics-turned-filmmakers of the French New Wave—François Truffaut, Claude Chabrol, Eric Rohmer, Jacques Rivette, Louis Malle—were astonishing us with everything from *The 400 Blows* to *Zazie dans le Métro*. Yet only *Breathless* struck us as a revolutionary break with the cinema that had gone before. It seemed a new kind of storytelling, with its saucy jump cuts, digressions, quotes, in jokes, and addresses to the viewer. And yet, underneath all these brash interventions was a Mozartean melancholy that strongly suggested classical measure. "Classical = modern" was the way he phrased it in a later film, *Bande à Part*; that Godardian paradox was already operative in *Breathless*.

What seemed miraculous when it first opened remains its greatest coup: Godard's ability to infuse an improvisatory manner with an underlying mood of grave inevitability. The spontaneity came from working from a five-page outline by Truffaut, rather than a finished script, from the director writing the day's dialogue at the last moment, and speaking it to the actors just before they had to deliver their lines (they were shot silent, and dubbed in later), and from their employing a hand-held camera and a wheelchair to save the time of laying tracks. The gravity came from somewhere deep inside Godard, a defeatist quality symbolized by those fatalistic overhead shots he thought he was borrowing from Fritz Lang.

Godard remains the darling of film studies, if only for the way his

self-reflective movies highlight issues of cinematic fabrication. But will seventeen-year-olds still respond to *Breathless* as revolutionary? I think the chances are they might, because, however much its technical innovations may be assimilated, it still speaks to youth through its attitude of rebellious impudence. In a curious way, it could even be seen as the progenitor of the youth-cult film.

"If you don't like the sea, and don't care for the mountains, and don't like the big city either," the film's protagonist, Michel (Jean-Paul Belmondo), jibes at the camera/us while driving, "then go hang yourself." So he rattles on with his views of France, hitchhiking, women drivers; a few moments later, he has shot a traffic policeman to death. (This combination of yakking and violence would later lead a Godard-smitten Quentin Tarantino to attempt the same in *Pulp Fiction*.) Whether meant as a Gidean "gratuitous act" or one of survival, the shooting certainly complicates our attitude toward Michel. Is he a sociopath or just a likable none-too-bright guy in a jam? Perhaps both: He makes himself up as he goes along. Michel/Belmondo is forever adjusting his performance, doing faces in the mirror, practicing lines, imitating his hero, Humphrey Bogart, and aspiring to the tough-guy niche he insecurely occupies.

Life is a bluff; we are none of us authentic, the film seems to say (just as Godard is bluffing at genre, pretending to make an ordinary gangster B movie.) Meanwhile death awaits. "We are dead men on leave," the film quotes Lenin. *Breathless*'s existential pessimism and philosophy of self-invention fit right into the mood of young people exiting with relief the conformist Fifties. Godard also struck an antiauthoritarian note by mocking the police (who are portrayed like bumbling Keystone Kops, in what looks like a cheap shot today).

The son of a family of Swiss-Protestant physicians and bankers, the filmmaker came to antibourgeois sentiments early. As David Sterritt perceptively observes in his new book, *The Films of Jean-Luc Godard*, "Michel's character—including its more menacing side—draws some of its dark power from the filmmaker's own brushes with this territory. . . . Godard as late as 1952 was known as a chronic thief (relatives and the *Cahiers* office were among his targets), a failed homosexual prostitute, and enough of a social misfit to be committed by his father to a psychiatric

hospital for what one biographical sketch describes as "a considerable period." These antisocial impulses did not constitute the whole story, however: Godard was also an ethnology student, a sober, thoughtful film critic, and an artist of severe integrity.

The oddity is that this particular director, who in his later career so ignored the public's appetite for pleasure, should have struck such a popular chord with his first feature. Much of the film's appeal derives from its inspired pairing of Belmondo (a bit player before this role launched him as an international star) with Jean Seberg, as his American girlfriend, Patricia. The complexity of their psychological duet goes a long way toward restoring the sense of realism that Godard's alienation tactics elsewhere strip away. Belmondo, with his boxer's physique, is animalistic energy, impulsive in crime, masochistic in love; Seberg, with her short, boyish hairdo and striped polo, seems more cultivated and self-aware. In a sense their relationship is a reversal of the Henry James pattern: This time the Frenchman is the romantic naif, the American woman, the cool, worldly skeptic. She defines herself by ambivalent Cartesian epigrams: "I don't know if I am unhappy because I am not free, or if I am not free because I am unhappy."

Godard was obviously charmed by Seberg's gamine air of mysterious reserve, and he shot her profile in close-up like a silent film star—Louise Brooks, say. She had been discovered by Otto Preminger, who launched her in *Saint Joan* and *Bonjour Tristesse*; Godard, that most filial, ancestor-worshiping of iconoclasts, cast her in what he viewed as a continuation of her part in *Bonjour Tristesse*. Most critics have assumed that Belmondo was Godard's autobiographical stand-in, but there is at least as much of him in the analytical outsider, Patricia, as in the pantherlike Michel. In an interview Godard said that he found the theme of *Breathless* during the shooting when he "became interested in Belmondo. I saw him as a sort of block to be filmed to discover what lay inside." When Patricia says to Michel, "I've been staring at you for the past ten minutes and I can't see anything but a mask," her words might as well be Godard's.

Their long scene indoors, when Michel keeps coaxing Patricia to make love, is famous for its jump cuts, which disdain traditional film continuity. The conversation jumps all over the map, from fornication to Faulkner, from Renoir to remorse, and when the long-awaited sex scene finally

comes, Godard tweaks our prurience by filming it as undistinguishable shapes under bedsheets. What to show, what to leave out, which dialogue to render audible, what to drown out with car horns—all this is part of the cat-and-mouse game the filmmaker plays with us, to our off-balanced enjoyment.

The story goes that Godard, faced with an overlong three-hour film, decided that instead of losing the subplots (as his mentor, director Jean-Pierre Melville, advised him), he would cut within the sequences. The jump-cutting gives the film a jittery rhythm, which paradoxically plunges us into a prolonged sense of dawdling, since we can't judge real time anymore. The resulting effect is that of "hanging out" with these characters, rather than being pushed through a plot with them. "Hanging" is something that young people particularly understand; indeed, the attempt of Godard's imitators to capture the mystique of that (non)activity onscreen may be one of *Breathless*'s most enduring legacies, for better or worse.

Godard discovered in filming *Breathless* that storytelling was not his strong suit, so he compensated by privileging lyricism over narrative. This preference, too, seems to me now part of the international youth aesthetic, as seen in rock videos, for instance. Lyrical rushes break out in *Breathless* in many sensual directions: Seberg's sunniness as she twirls in a new frock, the joy of motion celebrated in long walking or car sequences, the quoted allure of poetry and Hollywood movies, and always Paris. As soon as the film moves outside, Paris swirls around and threatens to seduce the camera away. Godard, who broke into filmmaking with nonfiction shorts, said that "fiction is interesting only if it is validated by a documentary context"; and certainly there is half buried in *Breathless* a jaunty documentary about Parisian streets, bistros, travel agencies, monuments. Some of that documentary look comes from the use of newsreel stock; some from the deadpan style of *Breathless*'s great cameraman, Raoul Coutard.

What stands out forty years later is how elegant the city looks. Godard makes no attempt to startle us with grunge; surprisingly, this is tourist Paris, the Arc de Triomphe, the Champs-Elysées. Michel points out with pride how beautiful the Place de la Concorde looks, lit at night. The cunning score by Martial Solal, with its cool xylophone jazz or lush violin passages, suggests some big-budget studio comedy with music by Nelson

Riddle and counterpoints with ironic premonition the grubby end of a petty thug.

Godard took the atmospheric fatalism of the French gangster movie— the poetic realism of Marcel Carné and Jacques Feyder, down through Jacques Becker's *Touchez Pas au Grisbi*, in which Jean Gabin in pajamas drinks a glass of milk before going to bed—and hot-spliced it with the plot-driven fatalism of American film noir (Bogart, Lang, the double-crossing dame). *Breathless* still plays beautifully, like a charming ode to Franco-American relations. (Godard had not yet hardened into doctrinaire anti-Americanism; there is a fluidity in his feelings about the United States, both pro and con.) What does date is the film's lack of resistance to such sexist notions as the betraying female, and its willingness to discuss women in terms of their body parts. Another weakness of *Breathless* is simply that it is a young man's film: full of spectacular effects, vitality, but without quite the consequential depth that would mark Godard's later efforts, such as *Vivre Sa Vie* or *Contempt*. It runs on nerve until it stops, out of breath. "A shallow masterpiece," we might conclude, as Pauline Kael said (with less justification) about *Citizen Kane*. Its beguiling lightness seems both its strength and limit. Still, that brio captivated and influenced directors everywhere: in America (Robert Altman, Martin Scorsese, Hal Hartley), Japan (Nagisa Oshima, Shohei Imamura), Brazil (Glauber Rocha), Yugoslavia (Dusan Makavejev), Germany (Wim Wenders), Iran (Abbas Kiarostami), Hong Kong (Won Kar-wai), to name just a few. *Breathless* lit the fuse for the whole youth movement in cinema. If some of today's younger directors may not even know how indebted they are to his work, and if Godard himself has become something of a curmudgeon, unappreciative of the latest cinematic fads, nevertheless the fact remains that *Breathless* is where it/they all began.

RICK MOODY

DESTROY ALL MONSTERS!
AN ECSTATIC HAIKU SEQUENCE

DIRECTED BY ISHIRO HONDA

Today I speak in celebration! It's 1999 as I write these words, you are reading the past, and the Japanese nation has just established a special island on which to house all its retired film stars, this according to the lovely proem that begins *Destroy All Monsters!* the most Greek, the most classical, the most culturally constitutive of all Japanese monster movies: *The year is 1999. The*

United Nations Scientific Committee has established an exploratory base on the moon. A rocket base is also functioning on the earth, and spacecraft leave for the moon on a daily schedule. An underwater base was recently established near Ogasawara Island, and scientists are studying the habits of marine life. New kinds of fish are being bred here. While on land, all of the earth's monsters have been collected and are living together in a place called Monsterland. If the monsters try to leave the spaces provided for them, a special control apparatus goes into operation. They are confined within scientific walls. Each according to their own instincts and habits. There is food in abundance, and the monsters are free to eat as much as they please. You can see immediately how it is almost impossible *not* to consider rendering the ecstatic language of *Destroy All Monsters!* into the demanding and ancient poetic form known as the haiku. The rhythms are so perfect, so shapely. Through a discriminating cutting and pasting, I reveal here and below the inner workings of this important cinematic artifact:

> The monsters are free to eat.
> New kinds of fish are bred here.
> Food in abundance.

Note the similarities between the proem from which I have taken these lines, meanwhile, and Raymond Burr's stirring monologue, which opens the original *Godzilla* film of the late fifties: *This is Tokyo. Once a city of six million people. What has happened here was caused by a force which up until a few days ago was entirely beyond the scope of man's imagination. Tokyo, a smoldering memorial to the unknown, an unknown which at this moment still prevails.* Nice fragment at the conclusion of this passage, right? Of course, the similarities between these two introductory reveries are not at the level of content (because by the era of *Destroy All Monsters!* the monsters are no longer to be feared, they are instead big, stunning *friends*, to be admired from a safe distance!), but are rather similarities of declarative brio and rhythmical intensity. This tropological intensity, what I might call a syntactical iteration of place, also reminds me of the opening of the Gospel According to St. John, as translated in the New Revised Standard Version: "In the beginning was the word, and the word was God,

and the word was with God. He was in the beginning with God; all things were made through him, and without him was not anything made that was made," which in turn recalls the constitutive mythology of the book of Genesis (here I'm relying on a path traced by the biblical scholar Jim Lewis): "In the beginning God created the heavens and the earth. The earth was without form and void, and darkness was upon the face of the deep; and the Spirit of God was moving over the face of the waters." Ergo, Monsterland unavoidably recalls the beginning of Western civilization, six thousand years ago (according to literalist Christians): There's Godzilla, over there, in a special herbivorous section of the island where he can get at the tops of the taller shrubs and trees without having to stoop—everything in Godzilla's section is made of flame-retardant synthetics—and when he becomes irascible and levels his death ray at the topography the damage can be contained and actually used to promote new undergrowth; Rodan—a sort of modified pterodactyl—meanwhile has a helipad on which he can land after one of his evening cruises over the island to obliterate freestanding Doric columns that are also reerected for this purpose. Here's Mothra, summoned from his (or her?!) larval underground cave area by a pair of twelve-inch-high pipsqueaky geishas, Mothra, that muslin-and-canvas caterpillar, now able to forage for luminous molds, or whatever it is he (or she) eats, in a system of former mine shafts. Thus is Eden constructed—"out of the ground the Lord God made to grow every tree that is pleasant to the sight and good for food." These are Eden's lucky inhabitants.

> Rodan has attacked
> Moscow. Here's a bulletin:
> Limited Water.

As the ludicrous plot begins to turn, however, a conspiracy of aliens seizes control of this Eden of retired Japanese film stars, and, using among other weapons, really cheap laser or phaser-type popguns, they free the monsters of Monsterland in order to broadcast a fiendish conspiracy upon the land. Let's be honest. Just as, in childhood, all boys watch professional automobile racing only in order to experience the drama and tragedy of

the *crash*, bodies slumped over steering columns, pieces of chassis flying from the wreckage and into the crowds, so do we all eagerly wait through a Japanese monster movie's formulaic opening for the inevitable destruction of an entire city. It's coming. What, otherwise, would be the point? Our lust for civic destruction would be human and, in a way, admirable, were it not for, on the one hand, the historical incendiary bombing of Tokyo in World War II, and, on the other, our nuclear annihilation of two additional Japanese cities. This awesome cruelty hovers behind our Japanese monster movie afternoons, rendering them suspect. Rodan's destruction of Moscow in the haiku above, therefore, is our crime being exported back to us: the radiation sickness, the incineration, the blast, the grim history. Every Godzilla movie, excepting the repellent Hollywood remake of two years ago, therefore must be seen as a commentary on our shameful past.

Back to the story! The aliens initially loose the monsters, every monster that has ever been featured in one of the *Godzilla* spinoffs, on a host of global cities: Rodan, on Moscow; Gorasaurus on Paris (down comes l'Arc de Triomphe); Godzilla on my hometown of New York City, and so forth. One wonders that the filmmakers (the cabalistic Toho Co., Ltd., copyright holders of everything Godzilla) couldn't be bothered to erect bona fide New York landmarks for Godzilla's destruction of my homeland. Where's the Statue of Liberty? Where's the Chrysler Building snapped off at the top? Even those nefarious cultural imperialists, Emmerich and Devlin, remakers of the remake, could manage that much.

> Time is running out
> for the human race. Put an
> End to these people.

In the meantime the conspiracy of aliens has also appeared on the moon; in fact, it's here that they first attempt to make dominion, to subdue us. The aliens hail from the distant planet Kilaak, where they sport rhinestone-studded outfits that are rather stylish in a Glen-Campbell-in-space sort of way. Our base on the moon is small and easy to conquer. They take it first. In the *actual* 1999, of course, we have mainly a few pieces of

Apollo debris sitting around on that hunk of rock, maybe a lunar module, some colonialist Stars and Stripes that you always see in all the footage. But *Destroy All Monsters!* takes a very revolutionary stance, with respect to the moon footage. There is no good reason why the moon base needs to be in this story at all (since it's really about monsters marauding on the Earth—the supporting cast of humans is clearly secondary), and thus other political agendas must be at stake. Tellingly the film never refers to, or quotes from, or even alludes to the extant Apollo footage that we have all seen. True, it was made and released before the moon landing actually took place, but I don't believe that this should inhibit the free play of interpretation. I believe the film—premonitory, by failing to include Apollo footage—by extension, supports the hypothesis of American survivalist groups (as its Edenic opening would lead us to suppose) that the 1969 Apollo 11 landing was a hoax! Like the Apollo footage, therefore, the moon in *Destroy All Monsters!* is a simulation, taking place somewhere in a global military-cinematic conspiracy! In a film studio! All the moon-landing sequences in *Destroy All Monsters!* Indeed, any sequences in the entire movie taking place on the moon must therefore have been constructed with miniature *models!* You could make models just as effective in your own basement! Your H-O train sets, your Hot Wheels, they would work just as well as the models in this film! You can see, of course, an implied comparison with the Apollo moon missions, or what we were *led to believe* were actual moon missions, in the texture of *Destroy All Monsters!* Some future scholar really ought to make a split-screen comparison between the tenderly false Apollo 11 landing footage and the impressive moon sequences of *Destroy All Monsters!* The prevailing view of earthlings, the narcissistic view of earthlings, that the conquest of distant planets is our natural right and our ultimate journey, is thereby debunked in *Destroy All Monsters!* especially in the following *haiku* suggested by dialogue from the film.

> Can you explain this?
> There are many small planets.
> Watch out for UFOs.

How would the cinema of *our* contemporary times, of the millennium, tackle like themes? And what would American film be now, if he were a character, walking, disconsolately, upon the steppe (in a sharkskin suit and power tie), what would American film be like, and how would he or she talk, with what idiom, with what soothing tones, with what demographically pitched amalgam of voices and tastes; would he have a little male pattern baldness and an excessive tan that he has procured at a prohibitive cost from a tanning salon in the Valley? Would he have great difficulty staying interested in a conversation after its initial pleasantries were exhausted, purveying instead such hideous commercial bluster as *Size Matters* or *Now the Adventure Begins*? And might he not like to bore into the empty skulls of people, I mean literally, after dark, in certain deserted but affluent sections of bicoastal pleasure centers, might this allegorical figure not bore into the skulls of moviegoers with a small, battery-powered hand drill that comes in a leather overnight case along with an ergonomically designed cellular telephone, might he tap off a bit of the pink lemonade in which the human brain is packed?

> You three, follow me
> To the base of Mount Fuji
> People have their weak points

Destroy All Monsters! answers all these deep questions for us, and others, not only in its giddy destruction of foreign cities (and, later, Japanese cities), but also in the person of an old British windbag, who appears, ineffectually, throughout the film, as expert witness for the United Nations Scientific Committee, the world body at the heart of the experiment of Monsterland. Especially in the crucial dubbed version of the film (Does it go without saying that Japanese monster movies *must be seen dubbed?* That the versions in which homely translations are ill-appended to the masticating jaws of Japanese actors are actually *essential* to the power of these cinematic documents? That the Japanese-language versions are vastly inferior, in their belief in an efficacy of spoken language; whereas the dubbed versions, with their brutal and alarmingly content-free dialogue,

foreground the pointlessness of international consort and understanding?) this British character, speaking in an ill-attempted Oxbridge accent as his visual counterpart perorates in Japanese, stands in for Western civilization, just as Raymond Burr, in the original *Godzilla*, was dubbed into the movie after its completion, without ever appearing in a single scene with the Japanese stars of the film. This British character is foolish, old, and, according to the haiku text I'm constructing, *deaf,* as well, deaf to the special melancholy of the contemporary Japanese predicament, deaf to Japanese national character, deaf to the Western abridgement of Japanese sovereignty during its reconstruction, doomed to inconsequentiality in the film, as is the West as a whole:

> He's using radar.
> Don't get yourself excited.
> It's not a hearing aid.

All this reminds me of *The Crawling Eye,* one of my personal favorite monster movies, and so I must digress, but only because *Destroy All Monsters!* digresses itself. After establishing the existence of Monsterland and allowing Godzilla to take down some office buildings in Lower Manhattan, *Destroy All Monsters!* abandons its monsters for almost forty-five minutes. Half the course of the film! It concentrates instead on the rather dull conspiracy of the rhinestone-wearing aliens of Kilaak. To be consistent I digress: Let me describe *The Crawling Eye* for those who have not seen it. It features one of the actors from *F Troop,* Sarge, I think, Forrest Tucker, a strappingly physical man, called in by a cadre of guilty scientists in Switzerland to deal with a strange and harrowing Alpine plague, namely, giant Volkswagen-sized eyeballs, orbs with tentacles, that have been ensnaring people, squeezing the life out of them, leaving them for dead in the frozen alpine wastes. And with what motivation, these eyes, why menace the local populace—because there is nothing good to watch? What would the crawling eyes watch if they could watch? Is not the crawling eye the perfect metaphor for the monolith of the cinematic apparatus, girdling the globe, looking for exotic land-

scapes, looking for scantily clad women, for fast cars, exploding devices, and *monsters?* Are we, the audience, not the hideous crawling eyes ourselves? At the climax of *The Crawling Eye*, Sarge, trapped on the Swiss mountainside at the end of a mountain tramway, struggles to hack off the tentacle-like limbs of the several crawling orbs with a standard-issue fireman's ax, *to save the world from future peril* but only so that we can fight the same fight again another day. *Destroy All Monsters!* recognizes that this need to save the world is an essential part of any monster movie; it is a lesson that must be learned again and again and again:

> Low temperature.
> The fire dragon will be back.
> The dragon was a saucer.

I would suggest, however, that the best, the most frightening monster films necessarily involve *transformation*. Not wildlife in profusion (*Jaws*, *The Birds*, *Frogs*, *Anaconda*, for example) not extremely large animals (*King Kong*, or that one from the sixties with the extremely large crab and the extremely large chicken, *Mysterious Island*), not malevolent visitors from space. No, *transformation*, as in, of course, Ovid and Kafka. As in the last moment of *The Fly* (the original!), when the poor scientist, David Hedison, having stumbled around the set with his fly head on, has departed this world, and yet there is a large stylized spiderweb nearby, where his double, the little housefly with the *human scientist's head*, remains trapped, crying out, "Help me! Help me!" Or in *The Thing*, or *Invasion of the Body Snatchers*, or *Night of the Living Dead*, or any of a myriad werewolf movies. The menace is from *within*, is always an articulation of our own potential for criminality, murder, rape, plunder. Our very arteries run with menace, with evil: Dark forces are subliminal everywhere; our outside must eventually resemble our inside, must *change*. Though heedless of transformation in the ideal sense, *Destroy All Monsters!* recognizes its resonance, in the fabulous voice-over language with which it pinpoints the transmitters used by the people of Kilaak to control the monsters of Monsterland.

It was found in Dover, in Spain, in steeples of churches,
It was found in the Alps, in a very large chunk of ice,
It was found in Guam in a coconut. . . .

The cryptofundamentalist essence of the monster movie is endemic to the form—*it's* about human evil, and *it* is hidden plainly at the center of the film, it is everywhere, in the most mundane of landscapes, and we recognize its source anew, in the stark repetition of litanical imperatives, quoted above, prosodic relation to the Beatitudes of the Sermon on the Mount: "Blessed are the poor in spirit, for theirs is the Kingdom of heaven. Blessed are those who mourn, for they shall be comforted. Blessed are the meek for they shall inherit the earth." This biblical form clearly violates the shape of the haiku, the more frequent prosodic style deployed in the corners of *Destroy All Monsters*; however, just as we're getting comfortable with a detour through Anglo-American verse forms, the movie begins to lurch toward its powerful conclusion at Mount Fuji. Has ever a repudiation of world government been more frank and more brazen? Mount Fuji, practically the national symbol for the nation of the Rising Sun! Mount Fuji, the subject of countless watercolors and calligraphic masterpieces, the subject of Buddhistic meditations and idylls. Here the Japanese military makes its stand against the interlopers of Kilaak:

Now we will stop them!
Now you believe we are from space!
Godzilla is here!

And the film emerges from its doldrums. Well, actually, just preceding this shootout at Mount Fuji, we have the destruction of Tokyo by several of the monsters, clearly a self-inflicted reversal of the anti-Western first act of the film and thereby designed to get us more riled for the more satisfying battle scene in the countryside. It's not a bad touch. The filmmakers are willing to sacrifice Tokyo (as it was sacrificed in the first *Godzilla*, and a U.N. scientist here wearily alludes to that film when he remarks to a colleague, while surveying wreckage: *Tokyo is in ruins)* in order to make clear that the monsters are monsters of *nature*, of vegetation, of landscape, not

of *culture*, and that this relation to what is *natural* is perforce culturally Japanese. A dialectic is being constructed, it follows, not unlike those that operate in Claude Lévi-Strauss's celebrated *Tristes Tropiques*, or in the work of Ferdinand de Saussure: nature vs. culture, or maybe man vs. monster, or maybe monster vs. monster, or maybe man vs. nature, I don't know, some dialectic is in play, some kind of dialectic, as would be the case in any story reliant on the notions of character derived from Greek mythology, on the struggle between Apollonian and Dionysian models.

> Do not thank me now!
> They know their enemies by
> natural instinct.

The monsters (and the cult of the monsters) are therefore incarnations of ecstatic Dionysos, while the enfeebled United Nations Scientific Committee represents the Apollonian pole. A similar attack on science, I should say, is to be found in *The Manster*, another early film from my own critical education, that period in which I avoided doing schoolwork, avoided interacting with other boys and girls, so that I might instead sit in front of the nineteen-inch Sony Trinitron, sometimes for six or eight hours a day, blunted, wordless, wherever possible in the steady consumption of monster movies or science fiction. Let me summarize. In *The Manster*, the protagonist, an American reporter stationed in Tokyo, is deceptively given a treatment involving cosmic rays and liquid potions designed to induce evolutionary mutation by a sinister Japanese scientist who has already turned his brother into a lower primate and his wife into the kind of badly deformed burn victim that we necessarily associate with the devastating films of survivors of the American-engineered Japanese nuclear holocaust. The journalist begins to suffer a personality change, becomes a brutish alcoholic womanizer, but that's the least of it. After an argument with his wife (who attempts to cart him home to New York), he notices that his hand has turned into—well, a sort of a claw. A furry, mammalian hand with unclipped fingernails. He's also suffering with nonspecific pain in the region of his shoulder, which has been bothering him for weeks, ever since he visited that Japanese scientist friend of his. His boss at the newspaper

persuades him to see a psychiatrist, which health care professional our poor hero nonetheless ejects summarily from his apartment. At the end of this therapeutic interview he rips aside his dress shirt to reveal that a human eye has apparently sprouted in his shoulder—between his shoulder blade and his neck. The acme of this kind of story should be clear: The manster grows a *second* head, a very unattractive dwarf head, with meager linguistic skills (it *growls*, mainly) and in some kind of psychic torment. The two heads walk the streets at night, dispatching strangers. Among the victims is the misguided Japanese scientist mentioned above, who manages just in time to plunge a syringe of experimental antidote into the hide of the protagonist. In *The Manster* as in *Destroy All Monsters!* cinema, the most synesthetic and technologically adroit of the popular arts, nonetheless *opposes* the traditions of science and technology, finds them ineffectual and even malefic. Nature, again, is depicted reverently. Accordingly *The Manster* opens and closes with shots of Mount Fuji (or at least of a snowcapped volcano designed to suggest Mount Fuji)! When the manster finally splits in half, right down the middle, suggesting a dialectical splitting-off, the bestial half of him jumps into this snowy volcano! An inmost bestiality, a cold, unfeeling monstrosity, is hereby revealed in any American contact with the Japanese nation; what is human necessarily becomes *something else:*

> Some kind of metal.
> A very large chunk of ice.
> This in his body.

Just as at the beginning of *The Blob*, when the guy who looks sort of like Slim Pickens is out strolling in the woods, checking his traps to see if he has caught any ermine, any foxes. Or is he trying to shut down the still before the authorities arrive? In any event, he sees some of this cherry-flavored Jell-O (well, it was red in the remake) oozing nearby from the flying saucer that has plummeted out of the north sky, and he thinks, *Damn, what is that Jell-O?* and he grabs a stick and he probes at the ooze, which leads any practical audience member to make the assertion supported by all monster movies: *Never probe the remains of a flying saucer*

with a stick, and the Jell-O immediately travels up the stick and onto the arm of this Slim Pickens lookalike, and it moves pretty fast for Jell-O; he wouldn't have done so badly, old Slim, had he not been out alone checking the still, and yet the monster movie, as a form, is retributive, Old Testament, and he must pay, and dignity can only be restored to us after the blob is air-dropped, symbolically or actually, over the Arctic Circle.

> The voltage is high—
> Several thousand degrees.
> Are we all doomed?

In due course, *Destroy All Monsters!* summons us back to Mount Fuji, where aliens from planet Kilaak prepare to draw their line in the sand. Here they summon a three-headed dragon from space, a space monster, King Ghidorah; here they combat all the monsters of Monsterland at once. Thank God for this plot development, because the story was getting pretty slow, and we have all been waiting for the monsters. A sequence follows, having to do with the Kilaak's command center *under* Fuji, the moon, transmitters, flying saucers, etc., but I can't bring myself to discuss it. You can watch only so much of this expositional stuff before the action sequences. Thus we are out on the field of battle, all the monsters are there, Mothra, Rodan, Anguirus, Baragon, Manda, Kumonga, Gorosaurus, and even Godzilla's *son* is there—Minilla, a sort of baby Godzilla-thingy, as I have seen him described—who resembles, in part a lizard and, in part a stuffed teddy bear (there must have been a merchandising angle). Some really excellent pro-wrestling footage follows, wherein Anguirus steps on one of the heads of the three-headed monster, and then Gorosaurus super-heats another head with his *death ray*. Somebody bites King Ghidorah's tail and gets flung through the sky. Even monsters you don't remember from their initial appearances in the films have walk-ons.

> A burning monster
> And their cries of sudden death.
> I will get in touch.

The puppetry here, in the climactic sequences, reminds me most of another neglected subgenre of films I favored in my youth, namely the *dynamations* of Ray Harryhausen, auteur of *The Seventh Voyage of Sinbad, Jason and the Argonauts, Clash of the Titans,* and other films. The battle to the death between the monsters of Monsterland and the three-headed dragon (calling to mind medieval depictions of Saint George and his reptilian opponent), amounts to a battle between the cinematic mummery of Japanese animators and the Western stylings of Harryhausen et al. The climax of *Destroy All Monsters!* is itself a climax of the entire first flowering of Japanese monster movies, a tectonic collision between Occident and Orient, between the phallocentric military precision of Western cinema, as embodied in the aliens of Kilaak ("You will submit to us or you will die!"), in Emmerich and Devlin (*Size Matters!*), in the Greek mythologies of Edith Hamilton, in Ray Harryhausen, and offering in the meantime a sort of parodistic version of the Book of Revelation, that catchbasin of religious bile so prized by interpretive cranks: *Then I saw an angel coming down from heaven, holding in his hand the key of the bottomless pit and a great chain. And he seized the dragon, the ancient serpent, who is the Devil and Satan, and bound him for a thousand years, and threw him into the pit, and shut it and sealed it over him, that he should deceive the nations no more.* Yet the monsters of Monsterland are victorious, as they must be, and after their inevitable triumph we see them from a new vantage point, with a new respect. They almost seem to be waving at us, and eager to be returned to their Edenic home:

> Everything is
> controlled from the control
> center. Cute Monsters.

So why is it called *Destroy All Monsters!*? The Japanese title is *Kaiju Soshinheki,* or *Attack of the Marching Monsters.* A perfectly appropriate title. If none of our beloved monsters, Godzilla or Rodan, is going to be *destroyed* in this film, why the title? Does it refer to the three-headed monster, King Ghidorah, and his nefarious purpose? And why does it indicate an intent to destroy *all* monsters? The aliens of Kilaak are bent on *appro-*

priating the monsters, not destroying them, likewise the United Nations Scientific Committee. So why the title? I would submit to you that the cabalistic Toho Co., Ltd., were trying to destroy a *franchise* with the movie called *Destroy All Monsters!* What was brought to a close, with a post-modern commentary on all prior Godzilla episodes, was a history of enmity between East and West, cinematic or otherwise, mythological or otherwise, and with this metaphorical destruction flowered forth Japan's mastery over its own culture. The end of its cultural and political occupation by the West, the beginning of its cultural eminence. But I didn't give a shit about any of this back when I was young. Back when I first saw *Destroy All Monsters!* in Connecticut, I didn't give a shit. I was lonely. It was all vampires, mummies, poltergeists for me. I was a boy in summer, and I couldn't be bothered to mow the lawn or do my homework or talk to my mother or my brother. I was encamped in front of the television with that bowl of popcorn and a soda, liaising, again, with the blood-famished specter of cinema, in black cape, my familiar, seizing upon night visions and daydreams, confining them to his three-act structure, to his studio system, to his galaxy of stars.

Now it's 1999; the heat is pestilential; in Tennessee or Alabama or Alaska or Iowa, all across the nation, the kids are lining up in front of the downtown theater to see the new one with the ghosts and the digital effects. Or it is winter, and with wind chill the mercury has plunged down to single digits, and I just want to forget about all of it. I have goose bumps. Get me some Jujyfruits. Please.

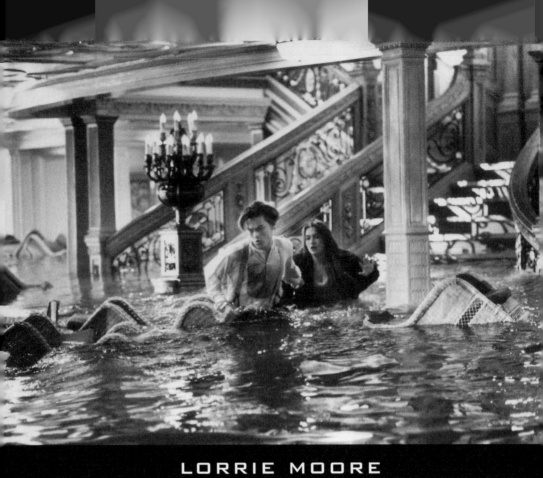

LORRIE MOORE

TITANIC

DIRECTED BY JAMES CAMERON

sometimes think of female adolescence as the most powerful life force human nature has to offer, and male adolescence as its most powerful death force, albeit a romantic one. For those of you who thought rationality and women's studies courses got rid of such broad and narratively grotesque ways of thinking, welcome. Coffee is available at the back of the room.

I will admit up front that I have often had a hard time getting people to go to the movies with me. My taste in movies is not a completely inex-

plicable thing, though perhaps I should insist preemptively that it is, so as not to tempt someone's brutally analytical eye. I am interested in the cinematic grapplings of Eros and Thanatos as performed, attractively, by young people. Such dramas comprise a kind of middle-aged pornography, which is usually made by middle-aged American men such as John Hughes (that "Chekhov of high school," to quote one critic). But I have been afflicted with a taste for this sort of film for decades, and for several years dated someone who refused to go with me to those "stupid teenage girl movies you like so much." So I grew accustomed to going alone, which made my experience of each one all that much more intense, overwhelming, and perhaps even sick. Passion in isolation is passion indeed.

So, without further ado, let me say this: By the third time one sees James Cameron's *Titanic*, believe me, its terrible writing is hardly even noticeable! The appalling dialogue no longer appalls. The irritating and obtrusive framework that surrounds the central narrative and that gives the viewer long lingering gazes at a minor actress with whom the director is having an affair tumbles away, inessentially. By this time too, one clearly no longer cares that not one adult one knows and respects doesn't despise the film; nor does one any longer care what any of these respectable adults might think about anything. Love misunderstood—the heart societally, perhaps cosmically, rebuked—is one's theme.

What is to be most appreciated about *Titanic* has little to do with its poster boy, Leonardo DiCaprio, though he is a brilliant actor for someone carrying on with Mariel Hemingway's face and such a thin, awkwardly pitched voice. What is to be appreciated about this film is that supported—and not overpowered—by a stunningly executed visual spectacle (surely unsurpassed in moviemaking) is an ephemeral little love story— part *Wild Kingdom*, part *Lady Chatterley's Lover*—in which we are allowed to see something very compelling that, in real life, can be awful and dispiriting to see: what young women in love are willing to do. Certainly, at the end, Leonardo DiCaprio as Jack gives Kate Winslet as Rose the best seat on their bit of flotsam, and upon his apparent death she does pluck him too precipitously from his post; still, it is Rose who surprises not just her mother but surely love itself and leaps from the safety of a lifeboat, through water, through air, to save her man, madly swimming upstream,

through the corridors of a *sinking ship* (oh, girls, don't we know it) like a salmon to spawn. The hormonal conviction of it is exhilarating to watch, and much more reminiscent of walruses than of Edwardians. It is an athletic enactment of grace (unanticipated, unearned, as grace always is). It is love that exceeds the deserts of the beloved. (The Germans got this down wonderfully, too, in *Run, Lola, Run.*) Writers from Shakespeare on have adored this idea of a young woman's macho cupidity, and why wouldn't they? Who wouldn't? It flatters everyone. It is, shall we say, fantastic. Juliet, dagger plunged to chest, was pure machismo compared to Romeo and his delicate, mishandled poison drinking. A young woman in love is a titanic force—at least it is time-honored theater to think so.

And so we—or I—go to the movies.

The successful communication of feeling is dependent on timing. Timing is dependent on editorial instinct. The dramatic last hour of *Titanic* is glorious editing. Has there been a movie that so rhythmically and succinctly joins the smashing up of a great groaning ship with the astonishing range of brutish panic and altruistic courtesy with which our species greets catastrophe? The frenzied rush to the ropes and lifeboats, the demented elegance of Mister Guggenheim, the small moments of fellowship and concern among the ship's musicians, the helplessness of the terrified crew, the gentle words between mother and child are not imagined in any original fashion; yet, perfectly spliced, their heartbreaking accuracy cannot be doubted. This is, after all, a movie with more than just a mechanical interest in maritime disaster on its movie mind. It is interested (even if ham-handedly) in the human animal, social class and injustice, grief, death, and shipboard romance as existential truth. As in every steerage-meets-first-class love story, the movie traffics in clichés, but it does so fluently; the clichés here are sturdy to the point of eloquence. From the sexually explicit names of the lovers, to the wicked fiancé (Billy Zane's moustache-twirling performance is something that improves on additional viewing; one can see he understood exactly the movie he was in), to Jack's dying, Gipperesque quip ("I don't know about you, but I intend to write a strongly worded letter to the White Star Line about all this") to the blithe repudiation of financial thinking (cutting corners to save money is what weakened the ship to begin with!), Cameron loves all the familiar stuff. It

is amusing to watch the number of times that characters simply throw money away into the air—in a film that, while shooting, went extravagantly over budget. It is hypocrisy, of course, that wealthy people make films saluting the poor, but let them benignly pretend. Even *Lady Chatterley's Lover*, a novel that sympathetically portrays and endorses a noblewoman's renunciation of her wealth for love, concludes with an afterword by Lawrence that is a multipaged fury about not having made a dime from foreign sales and pirated copies. One can toss it into the air, but money doesn't really go away that sweetly. One can, nonetheless, dream.

One can also admire *Titanic's* Victor Garber, the Sondheim tenor, who, although he has no songs, plays the ship's architect almost musically, his spoken voice (here in a Belfastian lilt) as lovely and precise as his sung one. The intrepid can even admire the movie's pseudo hymn, "My Heart Will Go On," sung by Celine Dion, accompanied by a baleful Irish fiddle. Part folk song, part cola anthem, the song struggles valiantly to do operatic work. Its harmonic progression ascends the scale not unlike Wagner— though not really like it either. A cheesy *Liebestod* may not be more beautiful than a great one, but it can sometimes, given its subject and context, be truer.

One can also admire Cameron's curtain call of the dead, who, arranged along the ship's mezzanine and sweeping staircase at the end, make a moving tableau when the aged heroine finally revisits them; the camera races, searches, swims like an eager mermaid through the ship until light bursts forth, doors swing open, and it finds them. DiCaprio, a physical actor, turns, in a subtle blend of surprise and expectation, but he does not rush forward. He is now pure spirit. He smiles soulfully, extends a hand, and is mercifully quiet. At the end life has provided and preserved only one golden memory, one great emotional adventure, as random as a lottery ticket: It is both too meager and too rich. Possession and loss at life's close are irrevocably knotted. The ghosts bearing witness applaud. The audience weeps.

Only hopeless romantics need to be told yet again that love is an illusion, that it dies, that it is for lunatics and addicts and fools. The rest of us may just occasionally like—even love—a little respite from what we know. This is what Hollywood movies, so humanely, have always been for.

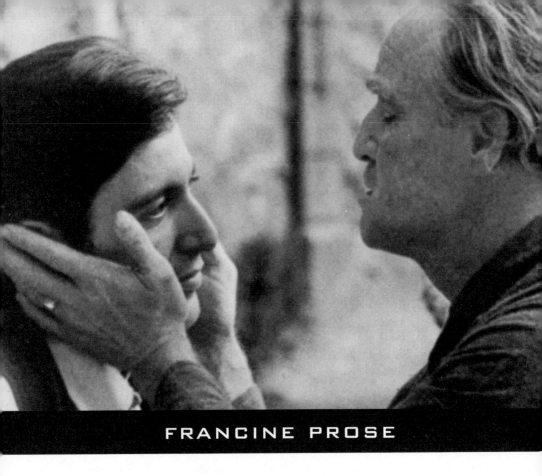

FRANCINE PROSE

THE GODFATHER

DIRECTED BY FRANCIS FORD COPPOLA

The Godfather is the closest that Hollywood has yet come to the Shakespearean historical tragedy and to the nineteenth-century novel. Only recently, since the Elizabethans, has a work of art been based on such a religious faith in the existence of a larger order, which, when undermined, can bring the universe crashing down. Rarely, since then, has art mounted quite such a Miltonic inquiry into the roots of power; rarely has such a prayerful faith in the status quo coexisted with the equally certain conviction that power must

eventually come leaking, then streaming, out through some tiny chink in the armor we call human nature. And rarely, since the novels of the last century, has a work of art managed to embrace so many characters, to compress so much of the world and so much of what happens over generations, so monumentally and ambitiously, with the necessarily delicate chemistry of complete naïveté and complete assurance, the simultaneously reckless and careful deployment of craft.

I've watched the film at least a dozen times over the last twenty years, and each time I notice all sorts of details and moments that eluded me before. What's less predictable is the sensation that the film—like time, so they say, like life, as we notice—is actually speeding up. Its many memorable scenes (the killings in the restaurant, Sonny's assassination, Clemenza adding his pinch of sugar to the spaghetti sauce, Don Corleone's "good death" in the garden with his grandson and the orange in his mouth) arrive in rapid succession, one on top of another, occupying a briefer, flashier space than they have staked out in our memory.

Yet this speeding up, this repeated watching, involves no diminution of power. By now we know perfectly well the contents and the significance of the package that announces Lucca Brazzi's long nap with the fishes, but we still gasp when Sonny unwraps the brown paper parcel. We know by now that the gun Michael needs to shoot Police Chief McCloskey and Salozzo is taped behind the toilet tank, but still have trouble breathing until Michael reaches up and finds it. We know what's at the bottom of the movie producer's bed, but the increasingly panicked rhythm of the peeling back of the blankets and the slippery redness of the blood make each time such a fresh horror that we feel as if the producer is screaming for *us*.

At the same time, I have by now—as happens with art—somehow lost track of the *plot*, of what the film *appears* to be about (that is, on the surface), so that I am often shocked to meet others who actually seem to believe that it's a movie about a bunch of Italian-American gangsters shooting each other in the eyes, or who object to the ways in which the film "glorifies" the Mafia, as if glorification weren't in the very nature of film, ensured by the size of the movie screen, to sound, the scale of the theater.

To watch, and pay attention, to the opening sequence—as stately, as burnished, and as dignified as a Dutch master painting—is not unlike reading the opening pages of Balzac and Stendhal, observing how immediately the storyteller's voice assumes sufficient authority to perform its psychic surgery and take us out of ourselves, out of our world, and into the darkened room in which the funeral director is passionately, economically (after all, the godfather's time, like the viewer's, is precious) telling the terrible story of his daughter's near-rape and beating. He is asking Don Corleone for justice—*real* justice, as opposed to *American* justice, which has earned the two men who attacked his daughter (the daughter whom he tried to raise in the American way) an American court date, and a suspended sentence. Before we're five minutes into the film, we have observed the first of numerous occasions in which "American" is used to mean "superfluous," or "neutered."

As the camera focuses, slowly receding, on the funeral director, he could be reporting his true-life experience in a documentary film, except that he is speaking in the way that one tells a story to someone who, the teller believes, can change the story's outcome. Solomonic, regal, King Lear before his decline, stroking the cat in his lap even as he weighs the alternatives (flat-out murder versus just a really vicious beating), the Don makes exquisite distinctions between justice and revenge, promises the former and extracts a parallel promise: that the favor he may someday need to ask—*as a friend*—will, at that point, be granted in return. The funeral director's ready agreement whisks us back into pure narrative, pure drama: the magical contract in the fairy tale, the prophecy in the Icelandic saga, the witches' blitherings in *Macbeth*, the gun that appears in the first act that, we feel pleasurably and uncomfortably certain, will go off by the final curtain.

What the godfather offers is protection and control: two commodities that we sense from childhood and learn (as an especially awful part of the process of growing up) are ultimately *not* in anyone's power. Still, the early part of the movie—the procession of supplicants paying court to Don Corleone, the sweep and majesty of his daughter's wedding, the courtly

grace with which he dances with Connie—deludes us into believing that protection can be offered, that control can be maintained. So that, as the film progresses, we are compelled to discover, heartbreakingly, and all over again, that safety and protection are simply not permanent options.

Here is what I noticed the last time I saw the film: how quickly it retools our instincts into those of the Don and his family. How soon we develop a newly acute peripheral vision, and learn what we need to watch out for—which is, in most cases, *absence*. Someone is supposed to be there who isn't; someone takes a powder. Someone is left vulnerable, and the inevitable happens. Paulie the bodyguard calls in sick on the day the Don is shot; the terror of the hospital scene is that no one is guarding the wounded Don. The rabbitlike disappearance of the Sicilian bodyguard warns Michael, an instant too late, that his car is about to blow up, and that his beautiful wife will be killed. The toll taker in the causeway booth ducks, disappears from the window—and Sonny is riddled with bullets.

And so the funeral director whose plea has opened the movie gets his chance to fulfill his part of the bargain, using all his skill to restore poor Sonny's ravaged body because the Don doesn't want his wife, Sonny's mother, to see what death has done to her boy. By then, of course, the Don's control has diminished so that he no longer commands quite the same absolute power to collect on his debt, and the double or triple (it's easy to lose count) irony is that he *does* ask as a *friend*, a word that, in the opening scene, signified something between what we normally think of as a friend . . . and a feudal subject.

So the first sequence offers protection, and the rest of the film withdraws it, including the final—ultimate—withdrawal of Don Corleone's death. And at least we are left with Michael, in charge but utterly alone, having snapped his last remaining bridge to the safe connected world by lying to his wife about the fact that he ordered his brother-in-law's murder.

Like classical drama, *The Godfather* persuades us of both sides of a paradox. First, that everything is inevitable, and second, that there is a moment when a step is taken and the inevitable takes hold. In the film,

this step—misstep, needless to say—occurs during the scene in which the Don, Freddo, Tom, and Sonny meet with Salozzo to discuss the family's position on branching out and entering the brave new world of drugs. A narcotics trafficker known as the Turk, "good with the knife," but only, as is so important in the code that governs this world, in matters of business, Salozzo is as froglike, slippery, homely, and shifty as the Corleones are presentable and attractive. Yet, like them, the Turk is the consummate businessman, and their meeting is all business—cash advances, percentages, 30 percent of the profits in exchange for a million-dollar loan from the Corleones, and the protection of their police and political connections. The degree to which we, the viewers, accept and believe in the Don's greater wisdom is measured by the fact that not until we've seen the film several times does it occur to us that the Don is *wrong*. As history would soon show, the police and the politicians would not, as he argues, sever their ties to organized crime because of some squeamish or high-minded moral reservations about accepting dirty drug money.

It's all business, but not American business, with its belief (lip service, really) in the value of "input" from the eager up-and-comers, the younger guys in the ranks. When Salozzo holds out the bait—the Tattaglias' willingness to guarantee the Corleones' loan—and Sonny interrupts his father to show interest in the proposal, the looks that cross the others' (Tom's, Clemenza's, Salozzo's) faces reveal that what has just transpired is not merely a breach of business etiquette and good manners but an irrevocable act, a break in the natural order, a signal that the center of the Don's empire will not hold, that the Don is slipping, and that his hot-head, testosterone-addled son (the Don will ask Sonny if his brain has gone soft from too much sex) has neither the brains nor the patience to assume command. When Don Corleone tells Salozzo, "I have a sentimental weakness for my children, and I spoil them, as you can see. They talk when they should listen," his touching and graceful attempt at damage control functions like the opening of a faucet, and what begins to flow is blood.

From now on, everything the Don does to staunch the flow will only increase it. Reflexively, he calls for Lucca Brazzi, and sends him to sound out the Tattaglias. But by now we know we are in the realm of tragedy and epic, where every gesture is the inevitable product of character and society,

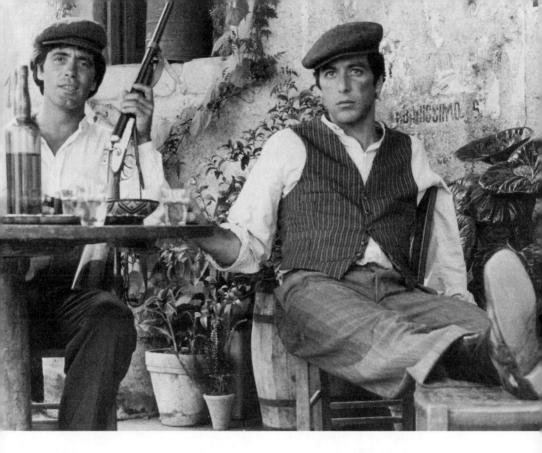

hope and fear, destiny and free will. We understand that Lucca Brazzi is too simply and innocently honest to shake Bruno Tattaglia's hand to formalize and solemnify a lie, so that Salozzo will have a chance to show off the fancy knifework for which he is so justly famous. The inexorable bondage of character, of society, community, fate—all the ropes are being wound around the characters and pulled as tight as the garrote that strangles Lucca Brazzi. Each time one sees the film, it becomes more apparent: how much of its conclusion is present at its beginning. Barzini, whose machinations set off the final round of slaughter, is a guest at Connie's wedding—the one who tears up the roll of film that one of his men grabs from the photographer.

For all the blood and gore and mayhem, the crescendos of messy violence spraying out like machine-gun volleys, *The Godfather* is an unusually literary film. It assumes what has been mostly the prerogative of fiction, the staging of two parallel dramas: the drama of the plot and the simultaneous tragedy that time is working out, all on its own. Like Lampedusa's

great novel, *The Leopard* (from which such a desiccated film version was made), like García Márquez's *Love in the Time of Cholera*, like certain stories of William Trevor and Alice Munro, the film takes on the question of what time does to people's lives. Too often, in film, such efforts are hopelessly unconvincing, in part because of the phony makeup jobs, the changes in fashion and hairstyle that are supposed to age actors, to carry us through the years. But *The Godfather* achieves this effortlessly by beginning at the moment at which the characters are poised on a brink—and hardly have to age at all in order to change an enormous amount; these changes are accelerated by the sheer numbers of deaths, the amount of bloodshed, and in Michael's case, by experience: saving a father from assassins, assassinating two men in a neighborhood restaurant, losing a wife.

For all the insistence with which it distinguishes the culture it represents from "American" culture, the film is, in innumerable ways, quintessentially American. Earlier movies that have become icons of American filmmaking—*Citizen Kane*, *The Searchers*—have always struck me as somehow . . . European, perhaps because of their acting styles, their subtleties, their baroque or, alternatively, spare and tasteful visual aesthetic. But *The Godfather* is pure, unadulterated America: its colors, its Velázquez-black interiors, its luscious California greens, its speed and violence, its vulgarity, its sentimentality, its brashness, its ambitious determination to say something about ambition; the impossibility, the unattainability of the godfather's effort to hold onto power turns him into the kindlier, saner, Mafioso Captain Ahab. At the same time it is a film about American *film*; its roots in the gangster melodrama of the thirties and forties are visible in the murky, portentous *noir* atmosphere that comes down like a curtain after the attempt on the Don's life, in the newspapers spinning toward us with their screaming banner headlines.

Like the world it portrays, the film keeps crossing and recrossing the paradoxically fragile and indestructible bridge between the old and the new, the traditional and the modern, between this country and Europe. In its distinctly American take on the great tragedies, the great novels of the Old World, *The Godfather* reminds us of how vivid, how moving, and—as is less widely acknowledged—how profoundly *entertaining* it is to find our-

selves in the presence of art. It returns us to a childhood state in which we can, like children, watch the film again and again, even as it tricks us into the childlike, vulnerable receptivity that leaves us open, as if for the first time, to the harshness of adult knowledge, the terrifying awareness of everything that is out of our control: the griefs and shocks from which not even the Don can promise to protect us.

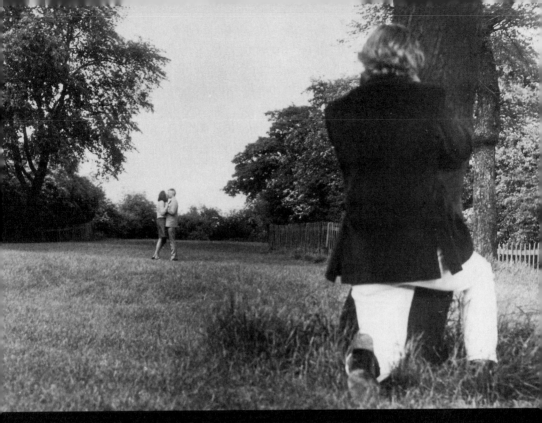

LAWRENCE RAAB

LIKE FINDING A CLUE IN A DETECTIVE STORY: REFLECTIONS ON **BLOW-UP**

DIRECTED BY MICHELANGELO ANTONIONI

At the center of *Blow-Up* is a story we recognize from the movies. The hero uncovers a murder. A beautiful woman is involved. Perhaps there are two beautiful women, one innocent, one guilty. The hero is sexually tempted. Also appealed to for help. Suddenly, crucial evidence in his possession is stolen. But he presses on, at increased personal risk, until patterns emerge and the truth—who did what and why—is finally revealed.

One of the surprises of *Blow-Up* is that only the beginning of this narrative remains intact.

The murder in *Blow-Up* is never solved, never even explained. Almost all traces of it vanish—first the photographs of the body, then the body itself. What's left is a single image, so blown up and blurred out it could be anything. It's like an abstract painting, one of Bill's pictures. "They don't mean anything when I do them," Bill, the photographer's friend, says. "Afterwards I find something to hang onto. . . . And then it sorts itself out. It adds up. It's like finding a clue in a detective story."

But the movie doesn't sort itself out, at least not as we might expect. The clues don't add up. They disappear. And finally, in the last shot, so does the hero himself.

The movie's hero, Thomas (David Hemmings), is a professional photographer. (In Antonioni's source, Julio Cortàzar's short story, Thomas's counterpart is an amateur photographer and a professional translator.) Thomas's job, like Antonioni's, is the creation of images, images capable of producing definable effects. The models he photographs will sell fashions. But his serious work appears to be a social critique. The photographs he's taken at the men's shelter, the script informs us, are "portraits of tramps, sordid surroundings, the scum of the earth surprised in their sleep." Those phrases, of course, are not in the film, though Thomas's reaction to the contact sheets is notably lacking in compassion. "Why, they're fabulous!" he exclaims. Then he gives his assistant the clothes he'd disguised himself in and says, "You can burn that lot."

When Thomas discusses the layout of his book with Ron, his collaborator, he mentions how violent most of it will be. So he wants to end with tranquillity—the photographs he took that morning in the park, pictures which he does not yet know will reveal a murder. Violence will lead to something "peaceful" and "still." "I think it's best to end it like that," Thomas says, and Ron replies, "Yeah. That's best. It rings truer." But we have no reason to believe that Ron possesses any large vision to guide the arrangement of the pictures. And for violence to lead to peace isn't a truth, but an effect.

Blow-Up is full of clues and effects. They hint at revelation but always end up revealing little, or nothing, or something different from what we expected. When Thomas discovers the body in the park, the scene is lit by

a large neon sign in a shape that's unrecognizable. "I wanted the sign to illuminate the scene," Antonioni said, "but I didn't want it to be of anything." But of course the sign *is* of something; it's just of something we can't understand.

When Thomas is caught up in the melee in the rock club, he struggles successfully for a piece of the smashed guitar. But as soon as he gets away from the crowd that wants what he has, what he has loses its meaning. Out on the street he looks at the broken guitar neck and discards it. A passerby picks it up, looks at it, and discards it.

The unreadable sign and the iconic fragment of guitar both seem fraught with a significance which, curiously, the characters have little interest in. Thomas pays no attention to the neon sign. (Actually, he does look at it, but the film provides no access to his response, if he has one.) And Thomas never reflects on why he fought for the guitar, then threw it away. He enters the rock club because he is looking for Jane, the mysterious woman from the park. Like a private detective, he's on the trail of the truth. Unlike a detective, he is easily distracted from his quest. As he enters, the Yardbirds are playing energetically, but the audience, unblinking, frozen like zombies, just stares at them. This is one of *Blow-Up*'s most stylized moments. Surely no audience ever acted this way. Yet the weirdness of the whole sequence is often seen as mere tourism on Antonioni's part, "a phenomenon observed by an outsider and included for completeness' sake," Stanley Kauffmann wrote in 1968. This is *Blow-Up* as social criticism, "a dazzling non-stop look at mid-sixties mod society," as the back of my MGM/UA videocassette box says. (This description continues wonderfully, in the vein of the cheesy exposé, *Mondo Blow-Up*: "Take a peek into the steamy world of London's fashion industry and its sexiest models. Where seductions are as free as a young lady's spirit, and where the music is even more devastating than the drugs. Witness everything from shocking public protests to the private moments of a couple in the park." All that's lacking are the multiple exclamation points: Thrill to the secret world *inside* a darkroom!!)

But I've allowed myself to become distracted by such lush prose. Appropriately, perhaps. Distraction—and interruption—are *Blow-Up*'s essential gestures. Consider the following moments from the film.

Once Thomas enlarges the pictures, he calls Ron to tell him excitedly, "Somebody was trying to kill somebody else. I saved his life. . . ." At which point the doorbell rings. Thomas asks Ron to hang on, but is then distracted by the two would-be models. Earlier, Thomas's lunch with Ron was interrupted by the appearance of a suspicious man outside the restaurant. (Perhaps he was the murderer; we never find out.) When Thomas is about to take Jane (Vanessa Redgrave) to his bedroom, they are interrupted by the delivery of the propeller. ("What's it for?" Jane asks. "Nothing," Thomas replies. "It's beautiful.") Soon after, Thomas interrupts Bill and his wife, Patricia (Sarah Miles), making love. Then, driving to Ron's house, Thomas thinks he sees Jane on the street. Looking for her in the rock club, Thomas is caught up in the frantic struggle for the broken guitar. Finally arriving at Ron's place, Thomas asks Ron, who is stoned, to go with him to photograph the body. "I'm not a photographer," Ron says, rather reasonably, whereupon Thomas replies dramatically, "I am!" After which the whole plot is basically abandoned. Thomas allows himself to be led off to get stoned, giving up without explanation his determination to photograph the body. When he returns to the park in the morning, the body is gone. And except for its cryptic final scenes, the movie is over.

Why did Thomas feel such an urgent desire to photograph the corpse? We could say he needs to replace the pictures that have been stolen. He needs evidence. But it would seem as if matters have gone beyond that point. He's touched the man's dead body. He doesn't need confirmation of his own perceptions. The "normal" course of action—notifying the police—is not seriously considered, though it isn't ignored either. Antonioni raises the issue. "Shouldn't you call the police?" Patricia asks. Thomas then nods toward the one remaining print, a grainy blow-up of the body that reveals a corpse only if one is looking for a corpse. "That's the body," he says, and Patricia answers, "It looks like one of Bill's paintings."

Thomas doesn't call the police because he doesn't call the police. He wants to photograph the body because that's what he wants to do, because, being a photographer, that's what he knows how to do. He doesn't photograph the body because he stays at Ron's place to get stoned. Is he surprised to find the body gone the next morning? What does all of this mean

to him? Even the script, which is frequently more forthcoming about Thomas's feelings than the film, turns strangely reticent at this moment in the park.

Close-up of Thomas from above looking at the grass. It looks perfectly normal. Hardly a blade is bent. He looks up into the sky: the wind has risen and is rustling the leaves more insistently. The boughs which had spread above the dead man's head are moved by a stronger gust of wind. Camera tilts down from them to Thomas. He looks down to the spot where the corpse should be, then turns and takes a few steps forward. Then he stops. Above the line of trees behind him the great neon sign looms up into the lightening sky. . . . The huge neon sign goes out. The daylight is strengthening. Thomas looks toward the sign and then back down to the grass under the bushes. Thomas stands disconsolately in front of the bushes.

Then he walks off and the mimes enter. Thomas is *disconsolate*. The corpse isn't where it *should* be. The wind and the sign participate in the moment, even appear to comment on it. But what are they saying? What does it all mean?

The blurring of the real and the imaginary happens most famously at the very end of the movie. Leaving the park where the body had been, Thomas encounters the group of mimes whose cavorting opened the film. Two of them begin to play an imaginary game of tennis, and after a few points, the invisible ball is hit out of the court. One of the mimes gestures for Thomas to return it. He consents, and as he watches the game resume, the sound of an actual ball being struck comes in on the soundtrack.

Reviewers of the film interpreted this moment in wildly different ways. "In the last scene," Charles Thomas Samuels writes, "when he hears their 'tennis ball,' he effectively actualizes the charade existence that they share in common. His final gesture of resignation . . . shows clearly that the photographer cannot change." Similarly, Carey Harrison says that Thomas "discovers that reality is unfaithful to him . . . all reality, he meekly concedes, is appearance," while John Freccero finds Thomas's "collaboration"

to be the sign that he "disappears both as person and artist." But other critics felt exactly the opposite, finding in the mimed game a "new-found faith in that invisible ground for men's sharing" (Herbert Meeker), or "a community, a sharing in super-personal reality" (George Slover), or even a "final affirmation . . . he is aligning himself with people who are joyfully alive (Arthur Knight). Others remained undecided, like F. A. Macklin: "The photographer has been brought into imagination or else he is exiled from it, or both." And James F. Scott suggests that by "accepting their game, the protagonist might be said to embrace a regressive fantasy-life which permanently corrupts his being." Scott then adds, "But maybe not."

On the one hand: resignation, exile, corruption. On the other: faith, sharing, affirmation. Or both. But maybe not. It all made for interesting conversation back in the late sixties, especially if you were stoned. And if

you were stoned, ending up with both or neither seemed as good a place to be as any. Or you could complain, as Pauline Kael did, about all this "prattle about illusion and reality." Nor was Antonioni himself much help, issuing vatic statements like, "My images have multiple possibilities," or, "I'm really questioning the nature of reality."

Critical responses to *Blow-Up* are further complicated by misrepresentations of what actually happens at the end of the film. Here's John Simon on the last scene: "Our hero finds himself caught up in the imaginary game. When the imaginary ball is hit out into the park, he actually mimes picking it up and tossing it back onto the court. Suddenly he begins to hear the nonexisting ball: its puck-puck grows louder as the camera comes in for an overhead shot of the bemused photographer, forlornly heading for home." How does Simon know that the photographer is bemused, or forlorn (which seems rather different), or that he is heading for home? In fact, at the end he is standing in the field, much too far away for us to guess at the expression on his face, and then, suddenly, he vanishes, dissolved into a shot of the same green and empty expanse.

Seemingly essential to any interpretation of the film is the viewer's sense of how Thomas feels as he watches the mimed tennis game. Anguished? Bemused? Corrupted? Chastened? Joyfully alive? So many radically different responses suggest a possibility none of *Blow-Up*'s critics considered: that we cannot know how Thomas is feeling at the end, and that we are not meant to know.

At the same time, it seems perfectly natural—indeed unavoidable—to suppose that we do know. We look at him looking and we can't help but wonder: What is he thinking? What is he looking at? "But actually he is not looking at anything," the script reads. "His eyes belong to someone who is following his own thoughts and is not sure if they are anguished or encouraging." But this is the script, and in the film (as Simon notes) we shift to "an overhead shot of the bemused photographer." If we had trouble reading Thomas's enigmatic expression before, now the distance should suggest the impossibility of interpretation. And then he is erased, like any clue we thought we could hold on to, or follow to the end.

Yet the final sequence is even more problematic. "Suddenly he begins to hear the nonexisting ball," Simon writes. But does he? Do we want to

assume that because we hear the tennis ball Thomas does as well? After all, when Herbie Hancock's background score comes in, we don't imagine that the characters are aware of it, even if similar music is a realistic part of earlier scenes, where we can see Thomas putting on a record.

There are at least three options here. First: Only we hear the sound of the ball. Then we are reminded not of an illusion that Thomas has fallen into, but of one that *we* have chosen to participate in—the artifice of a movie—which will be confirmed by Antonioni's self-conscious gesture of removing his character from the screen. Yet it's unlikely that any viewer would *not* initially imagine that Thomas hears the ball, however intriguing it may be to worry about the nature of that assumption.

Or: Thomas *does* hear the sounds (and we hear what he hears), thus indicating that the unreal has become palpable. But is it there only for Thomas? (What do the mimes hear?) Taking this as far as it can go means suggesting that the sound of the phantom tennis ball is a sign that all reality is nothing but appearance. Everything that seemed to happen earlier only *seemed* to happen. There may have been no murder. The body could have been an illusion. Nothing is really *real*. At Ron's party Thomas says to the model he'd photographed earlier, "I thought you were supposed to be in Paris." And she answers, "I am in Paris." You are where you think you are. The world is so unreliable you might as well just get stoned and forget about trying to sort things out. And this is what Thomas does.

The third—and most reasonable—possibility is to reject the universal collapse of reality. Thomas does hear the sound of the ball. If any of the mimes hear it, that's the work of their own individual imaginations. The soundtrack functions to give us access only to Thomas's perception of the moment. But does this suggest that he's a lost soul on the verge of insanity? Or that he's been liberated into some greater and larger communal world of illusion? Or that he's just playfully allowing himself to be distracted by a game?

What's interesting is that none of these readings can be proven right or wrong. We can assert preferences, choose the reasonable over the unlikely, the elegant over the clumsy, the consequential over the ordinary, but we can only *prove* that no reading can be proven. The film is designed to make us misperceive, or leap to conclusions, and then to respond with

necessary acts of correction. In this way, the "multiple possibilities" of Antonioni's images do indeed question "the nature of reality." More precisely, they make us question our confidence in what we've chosen to represent as reality. Assumptions, however unavoidable, are still assumptions; we deceive ourselves if we translate them into certainties. Our action as viewers (and serial viewers, since looking more than once is essential) is like Thomas's work in the darkroom—attempting to establish what happened through different perspectives on a series of linked moments. Getting it wrong at first. (A murder was foiled.) Then getting it right. (A murder was committed.) Then losing the evidence to prove it. (There's no case without a body.)

"What did you see in that park?" Ron asks Thomas in the film's final conversation. "Nothing," Thomas replies. And in fact Thomas has seen nothing directly. He's seen after the fact, through the manipulation and interpretation of images. He's used his art to construct a narrative in which he participates only briefly. Reality doesn't betray him—the story gets away from him.

When Thomas first enters the park we hear wind in the trees: a lovely effect. Perhaps a clue. Thomas kicks up his heels. He sees two lovers and begins taking pictures. The light is beautiful. Everything is peaceful. Like the wind rustling the leaves. When Thomas comes back at night to find the body, we hear the same sound. Thomas "looks up at the tree," Charles Samuels writes, "whose leaves now rattle angrily." The next morning Thomas returns once again. "The body is gone," Andrew Sarris writes. "The leaves flutter with chilling indifference." And somewhere in the middle, in the darkroom, jazz fades into silence, and then, as the story begins to emerge from the blow-ups, we hear those leaves rustling. What sound do they make? Mysterious? Threatening? Full of imminent possibility? But of course that sound is also meaningless—only leaves in the wind, without significance until we find it there, as if finding it weren't our doing, as if we really had discovered a clue.

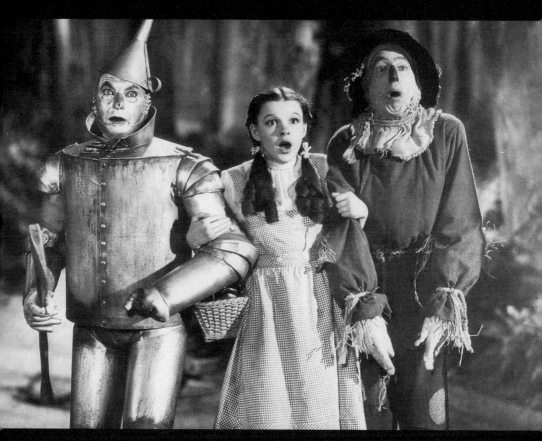

SALMAN RUSHDIE

OUT OF KANSAS:
THE WIZARD OF OZ

DIRECTED BY VICTOR FLEMING

I wrote my first story in Bombay at the age of ten; its title was "Over the Rainbow." It amounted to a dozen or so pages, dutifully typed up by my father's secretary on flimsy paper, and eventually it was lost somewhere on my family's mazy journeyings between India, England, and Pakistan. Shortly before my father's death, in 1987, he claimed to have found a copy moldering in an old file, but, despite my pleadings, he never produced it, and nobody else ever laid eyes on the thing. I've often wondered about this incident. Maybe he didn't really find the story, in which

case he had succumbed to the lure of fantasy, and this was the last of the many fairy tales he told me; or else he did find it and hugged it to himself as a talisman and a reminder of simpler times, thinking of it as his treasure, not mine—his pot of nostalgic parental gold.

I don't remember much about the story. It was about a ten-year-old Bombay boy who one day happens upon a rainbow's beginning, a place as elusive as any pot-of-gold end zone, and as rich in promises. The rainbow is broad, as wide as the sidewalk, and is constructed like a grand staircase. The boy, naturally, begins to climb. I have forgotten almost everything about his adventures, except for an encounter with a talking pianola, whose personality is an improbable hybrid of Judy Garland, Elvis Presley, and the "playback singers" of Hindi movies, many of which made *The Wizard of Oz* look like kitchen-sink realism. My bad memory—what my mother would call a "forgettery"—is probably just as well. I remember what matters. I remember that *The Wizard of Oz*—the film, not the book, which I didn't read as a child—was my very first literary influence. More than that: I remember that when the possibility of my going to school in England was mentioned, it felt as exciting as any voyage beyond the rainbow. It may be hard to believe, but England seemed as wonderful a prospect as Oz.

The Wizard, however, was right there in Bombay. My father, Anis Ahmed Rushdie, was a magical parent of young children, but he was prone to explosions, thunderous rages, bolts of emotional lightning, puffs of dragon smoke, and other menaces of the type also practiced by Oz, the Great and Powerful, the first Wizard Deluxe. And when the curtain fell away and his growing offspring discovered, like Dorothy, the truth about adult humbug, it was easy for me to think, as she did, that my Wizard must be a very bad man indeed. It took me half a lifetime to work out that the Great Oz's *apologia pro vita sua* fitted my father equally well—that he, too, was a good man but a very bad Wizard.

I have begun with these personal reminiscences because *The Wizard of Oz* is a film whose driving force is the inadequacy of adults, even of good adults; a film that shows us how the weakness of grownups forces children to take control of their own destinies, and so, ironically, grow up themselves. The journey from Kansas to Oz is a rite of passage from a world in

which Dorothy's parent substitutes, Auntie Em and Uncle Henry, are powerless to help her save her dog, Toto, from the marauding Miss Gulch into a world where the people are her own size and she is never, ever treated as a child but as a heroine. She gains this status by accident, it's true, having played no part in her house's decision to squash the Wicked Witch of the East; but, by her adventure's end, she has certainly grown to fill those shoes—or, rather, those ruby slippers. "Who would have thought a good little girl like you could destroy my beautiful wickedness," laments the Wicked Witch of the West as she melts—an adult becoming smaller than, and giving way to, a child. As the Wicked Witch of the West "grows down," so Dorothy is seen to have grown up. This, in my view, is a much more satisfactory reason for her newfound power over the ruby slippers than the sentimental reason offered by the ineffably loopy Good Witch Glinda, and then by Dorothy herself, in a cloying ending that seems to me fundamentally untrue to the film's anarchic spirit.

The weakness of Auntie Em and Uncle Henry in the face of Miss Gulch's desire to annihilate Toto leads Dorothy to think, childishly, of running away from home—of escape. And that's why, when the tornado hits, she isn't with the others in the storm cellar and, as a result, is whirled away to an escape beyond her wildest dreams. Later, however, when she is confronted by the weakness of the Wizard of Oz, she doesn't run away but goes into battle—first against the Wicked Witch and then against the Wizard himself. The Wizard's ineffectuality is one of the film's many symmetries, rhyming with the feebleness of Dorothy's folks; but the different way Dorothy reacts is the point.

The ten-year-old who watched *The Wizard of Oz* at Bombay's Metro Cinema knew very little about foreign parts, and even less about growing up. He did, however, know a great deal more about the cinema of the fantastic than any Western child of the same age. In the West the film was an oddball, an attempt to make a sort of live-action version of a Disney cartoon feature despite the industry's received wisdom that fantasy movies usually flopped. (Indeed, the movie never really made money until it became a television standard, years after its original theatrical release; in mitigation, though, it should be said that coming out two weeks before the start of World War II can't have helped its chances.) In India, however, it

fitted into what was then, and remains today, one of the mainstreams of production in the place that Indians, conflating Bombay and Tinseltown, affectionately call Bollywood.

It's easy to satirize the Hindi movies. In James Ivory's (1970) film *Bombay Talkie*, a novelist (the touching Jennifer Kendal, who died in 1984) visits a studio sound stage and watches an amazing dance number featuring scantily clad nautch girls prancing on the keys of a giant typewriter. The director explains that the keys of the typewriter represent "the Keys of Life," and that we are all dancing out "the story of our Fate" upon that great machine. "It's very symbolic," Kendal suggests. The director, simpering, replies "Thank you." Typewriter of Life, sex goddesses in wet saris (the Indian equivalent of wet T-shirts), gods descending from the heavens to meddle in human affairs, superheroes, demonic villains, and so on, have always been the staple diet of the Indian filmgoer. Blond Glinda arriving in Munchkinland in her magic bubble might cause Dorothy to comment on the high speed and oddity of the local transport operating in Oz, but to an Indian audience Glinda was arriving exactly as a god should arrive: *ex machina*, out of her own machine. The Wicked Witch of the West's orange smoke puffs were equally appropriate to her superbad status.

It is clear, however, that despite all the similarities, there were important differences between the Bombay cinema and a film like *The Wizard of Oz*. Good fairies and bad witches might superficially resemble the deities and demons of the Hindu pantheon, but in reality one of the most striking aspects of the worldview of *The Wizard of Oz* is its joyful and almost total secularism. Religion is mentioned only once in the film: Auntie Em, spluttering with anger at gruesome Miss Gulch, declares that she's waited years to tell her what she thinks of her, "and now, well, being a Christian woman, I can't say it." Apart from this moment in which Christian charity prevents some good old-fashioned plain speaking, the film is breezily godless. There's not a trace of religion in Oz itself—bad witches are feared and good ones liked, but none are sanctified—and, while the Wizard of Oz is thought to be something very close to all-powerful, nobody thinks to worship him. This absence of higher values greatly increases the film's charm and is an important aspect of its success

in creating a world in which nothing is deemed more important than the loves, cares, and needs of human beings (and, of course, tin beings, straw beings, lions, and dogs).

The other major difference is harder to define, because it is finally a matter of quality. Most Hindi movies were then and are now what can only be called trashy. The pleasure to be had from such films (and some of them are extremely enjoyable) is something like the fun of eating junk food. The classic Bombay talkie uses a script of appalling corniness, looks by turns tawdry and vulgar, or else both at once, and relies on the mass appeal of its stars and its musical numbers to provide a little zing. *The Wizard of Oz* has stars and musical numbers, but it is also very definitely a Good Film. It takes the fantasy of Bombay and adds high production values and something more—something not often found in any cinema. Call it imaginative truth. Call it (reach for your revolvers now) art.

But if *The Wizard of Oz* is a work of art, it's extremely difficult to say who the artist was. The birth of Oz itself has already passed into legend: The author, L. Frank Baum, named his magic world after the letters O–Z on the bottom drawer of his filing cabinet. His original book, *The Wonderful Wizard of Oz*, published in 1900, contains many of the ingredients of the magic potion: Just about all the major characters and events are there, and so are the most important locations—the Yellow Brick Road, the Deadly Poppy Field, the Emerald City. But the filming of *The Wizard of Oz* is a rare instance of a film improving a good book. One of the changes is the expansion of the Kansas section, which in the novel takes up precisely two pages at the beginning, before the tornado arrives, and just nine lines at the end; and another is a certain simplification of the story line in the Oz section: all subplots were jettisoned, such as the visits to the Fighting Trees, the dainty China Country, and the Country of the Quadlings, which come into the novel just after the dramatic high point of the Witch's destruction and fritter away the book's narrative drive. And there are two even more important alterations. Frank Baum's Emerald City was green only because everyone in it had to wear emerald-tinted glasses, but in the movie it really is a futuristic chlorophyll green—except, that is, for the Horse of a Different Color You've Heard Tell About. The Horse of a Different Color changes color in each successive shot—a

change that was brought about by covering six different horses with a variety of shades of powdered Jell-O. (For this and other anecdotes of the film's production, I'm indebted to Aljean Harmetz's definitive book *The Making of The Wizard of Oz*.) Last, and most important of all, are the ruby slippers. Frank Baum did not invent the ruby slippers; he had silver shoes instead. Noel Langley, the first of the film's three credited writers, originally followed Baum's idea. But in his fourth script, the script of May 14, 1938, known as the DO NOT MAKE CHANGES script, the clunky metallic and non-mythic silver footwear has been jettisoned, and the immortal jewel shoes are introduced. (In Shot 114, "the ruby shoes appear on Dorothy's feet, glittering and sparkling in the sun.")

Other writers contributed important details to the finished screenplay. Florence Ryerson and Edgar Allan Woolf were probably responsible for "There's no place like home," which, to me, is the least convincing idea in the film. (It's one thing for Dorothy to want to get home, quite another that she can do so only by eulogizing the ideal state that Kansas so obviously is not.) But there's some dispute about this too; a studio memo implies that it could have been the assistant producer, Arthur Freed, who first came up with the cutesy slogan. And, after much quarreling between Langley and the Ryerson-Woolf team, it was the film's lyricist, E. Y. "Yip" Harburg, who pulled together the final script: He added the crucial scene in which the Wizard, unable to give the companions what they demand, hands out emblems instead, and, to our "satiric and cynical" (the adjectives are Harburg's own) satisfaction, they do the job. The name of the rose turns out to be the rose, after all.

Who, then, is the *auteur* of *The Wizard of Oz*? No single writer can claim that honor, not even the author of the original book. Mervyn LeRoy and Arthur Freed, the producers, both have their champions. At least four directors worked on the picture, most notably Victor Fleming, who left before shooting ended, however, so that he could make *Gone With the Wind*—which, ironically, was the movie that dominated the Academy Awards in 1940, while *The Wizard of Oz* won just three: Best Song ("Over the Rainbow"), Best Original Score, and a Special Award for Judy Garland. The truth is that this great movie, in which the quarrels, firings, and near bungles of all concerned produced what seems like pure, effortless, and

somehow inevitable felicity, is as near as you can get to that will-o'-the-wisp of modern critical theory: the authorless text.

The Kansas described by Frank Baum is a depressing place. Everything in it is gray as far as the eye can see: The prairie is gray, and so is the house in which Dorothy lives. As for Auntie Em, "The sun and wind . . . had taken the sparkle from her eyes and left them a sober gray; they had taken the red from her cheeks and lips, and they were gray also. She was thin and gaunt, and never smiled now." And "Uncle Henry never laughed. . . . He was gray also, from his long beard to his rough boots." The sky? It was "even grayer than usual." Toto, fortunately, was spared grayness. He "saved [Dorothy] from growing as gray as her other surroundings." He was not exactly colorful, though his eyes did twinkle and his hair was silky. Toto was black.

Out of this grayness—the gathering, cumulative grayness of that bleak world—calamity comes. The tornado is the grayness gathered together and whirled about and unleashed, so to speak, against itself. And to all this the film is astonishingly faithful, shooting the Kansas scenes in what we call black-and-white but what is in reality a multiplicity of shades of gray, and darkening its images until the whirlwind sucks them up and rips them to pieces.

There is, however, another way of understanding the tornado. Dorothy has a surname: Gale. And in many ways Dorothy is the gale blowing through this little corner of nowhere, demanding justice for her little dog while the adults give in meekly to the powerful Miss Gulch; Dorothy, who is prepared to break the gray inevitability of her life by running away, and who, because she is so tenderhearted, runs back when Professor Marvel tells her that Auntie Em is distraught that she has fled. Dorothy is the life force of Kansas, just as Miss Gulch is the force of death; and perhaps it is Dorothy's feelings, or the cyclone of feelings unleashed between Dorothy and Miss Gulch, that are made actual in the great dark snake of cloud that wriggles across the prairie, eating the world.

The Kansas of the film is a little less unremittingly bleak than the Kansas of the book, if only because of the introduction of the three

farmhands and of Professor Marvel—four characters who will find their "rhymes," or counterparts, in the Three Companions of Oz and the Wizard himself. Then again, the film's Kansas is also more terrifying than the book's, because it adds a presence of real evil: the angular Miss Gulch, with a profile that could carve a joint, riding stiffly on her bicycle with a hat on her head like a plum pudding, or a bomb, and claiming the protection of the Law for her crusade against Toto. Thanks to Miss Gulch, the movie's Kansas is informed not only by the sadness of dirt poverty but also by the badness of would-be dog murderers.

And *this* is the home that "there's no place like"? *This* is the lost Eden that we are asked to prefer (as Dorothy does) to Oz?

I remember, or I imagine I remember, that when I first saw the film Dorothy's place struck me as a dump. Of course, if *I'd* been whisked off to Oz, I reasoned, I'd naturally want to get home again, because I had plenty to come home for. But Dorothy? Maybe we should invite her over to stay; anywhere looks better than *that*.

I thought one other thought, which gave me a sneaking regard for the Wicked Witch: I couldn't stand Toto! I still can't. As Gollum said of the hobbit Bilbo Baggins in another great fantasy, "*Baggins*: we hates it to pieces." Toto: that little yapping hairpiece of a creature, that meddlesome rug! Frank Baum, excellent fellow, gave a distinctly minor role to the dog: It kept Dorothy happy, and when she wasn't it had a tendency to "whine dismally"—not an endearing trait. The dog's only really important contribution to Baum's story came when it accidentally knocked over the screen behind which the Wizard stood concealed. The film Toto rather more deliberately pulls aside a curtain to reveal the Great Humbug, and, in spite of everything, I found this change an irritating piece of mischief-making. I was not surprised to learn that the canine actor playing Toto was possessed of a star's temperament, and even, at one point in the shooting, brought things to a standstill by staging a nervous breakdown. That Toto should be the film's one true object of love has always rankled.

The film begins. We are in the monochrome, "real" world of Kansas. A girl and her dog run down a country lane. "She isn't coming yet,

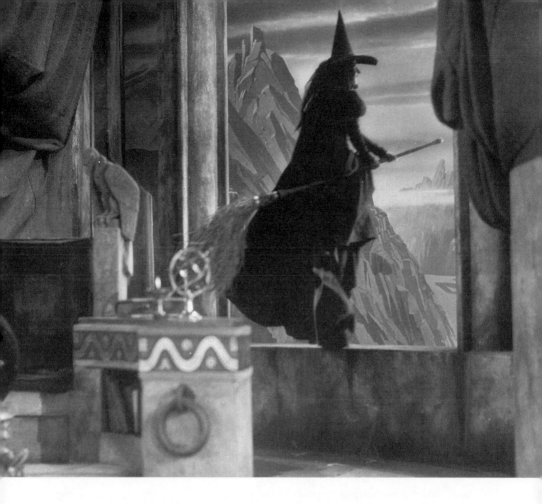

Toto. Did she hurt you? She tried to, didn't she?" A real girl, a real dog, and the beginning, with the very first line of dialogue, of real drama. Kansas, however, is not real—no more real than Oz. Kansas is a pastel. Dorothy and Toto have been running down a short stretch of "road" in the M-G-M studios, and this shot has been matted into a picture of emptiness. "Real" emptiness would probably not be empty enough. This Kansas is as close as makes no difference to the universal gray of Frank Baum's story, the void broken only by a couple of fences and the vertical lines of telegraph poles. If Oz is *nowhere*, then the studio setting of the Kansas scenes suggests that *so is Kansas*. This is necessary. A realistic depiction of the extreme poverty of Dorothy Gale's circumstances would have created a burden, a heaviness, that would have rendered impossible the imaginative leap into Storyland, the soaring flight into Oz. The Grimms' fairy tales, it's true, were often brutally realistic. In "The Fisherman and His Wife," the epony-

mous couple live, until they meet the magic flounder, in what is tersely described as "a pisspot." But in many children's versions of Grimm the pisspot is bowdlerized into a "hovel" or some even gentler word. Hollywood's vision has always been of this soft-focus variety. Dorothy looks extremely well-fed, and she is not really but unreally poor.

She arrives at the farmyard, and here (freezing the frame) we see the beginning of what will be a recurring visual motif. In the scene we have frozen, Dorothy and Toto are in the background, heading for a gate. To the left of the screen is a tree trunk, a vertical line echoing the telegraph poles of the previous scene. Hanging from an approximately horizontal branch are a triangle (for calling farmhands to dinner) and a circle (actually a rubber tire). In midshot are further geometric elements: the parallel lines of the wooden fence, the bisecting diagonal wooden bar at the gate. Later, when we see the house, the theme of simple geometry is present again: everything is right angles and triangles. The world of Kansas, that great void, is defined as "home" by the use of simple, uncomplicated shapes— none of your citified complexity here. Throughout *The Wizard of Oz*, home and safety are represented by such geometrical simplicity, whereas danger and evil are invariably twisty, irregular, and misshapen. The tornado is just such an untrustworthy, sinuous, shifting shape. Random, unfixed, it wrecks the plain shapes of that no-frills life.

Curiously, the Kansas sequence invokes not only geometry but arithmetic, too, for when Dorothy, like the chaotic force she is, bursts in upon Auntie Em and Uncle Henry with her fears about Toto, what are they doing? Why do they shoo her away? "We're trying to count," they admonish her as they take a census of chicks—their metaphorical chickens, their small hopes of income—which the tornado will shortly blow away. So, with simple shapes and numbers, Dorothy's family erects its defenses against the immense and maddening emptiness; and these defenses are useless, of course.

Leaping ahead to Oz, it becomes obvious that this opposition between the geometric and the twisty is no accident. Look at the beginning of the Yellow Brick Road: It is a perfect spiral. Look at Glinda's carriage, that perfect, luminous sphere. Look at the regimented routines of the Munchkins as they greet Dorothy and thank her for the death of the Wicked Witch of

the East. Move on to the Emerald City: See it in the distance, its straight lines soaring into the sky! And now, by contrast, observe the Wicked Witch of the West: her crouching figure, her misshapen hat. How does she arrive and depart? In a puff of shapeless smoke. "Only bad witches are ugly," Glinda tells Dorothy, a remark of high Political Incorrectness that emphasizes the film's animosity toward whatever is tangled, claw-crooked, and weird. Woods are invariably frightening—the gnarled branches of trees are capable of coming to menacing life—and the one moment when the Yellow Brick Road itself bewilders Dorothy is the moment when it ceases to be geometric (first spiral, then rectilinear), and splits and forks every which way.

Back in Kansas, Auntie Em is delivering the scolding that is the prelude to one of the cinema's immortal moments.

"You always get yourself into a fret over nothing. . . . Find yourself a place where you won't get into any trouble!"

"Someplace where there isn't any trouble. Do you suppose there is such a place, Toto? There must be."

Anybody who has swallowed the scriptwriters' notion that this is a film about the superiority of "home" over "away," that the "moral" of *The Wizard of Oz* is as sentimental as an embroidered sampler—EAST, WEST, HOME'S BEST—would do well to listen to the yearning in Judy Garland's voice as her face tilts up toward the skies. What she expresses here, what she embodies with the purity of an archetype, is the human dream of *leaving*—a dream at least as powerful as its countervailing dream of roots. At the heart of *The Wizard of Oz* is a great tension between these two dreams; but, as the music swells and that big, clean voice flies into the anguished longings of the song, can anyone doubt which message is the stronger? In its most potent emotional moment, this is inarguably a film about the joys of going away, of leaving the grayness and entering the color, of making a new life in the "place where you won't get into any trouble." "Over the Rainbow" is, or ought to be, the anthem of all the world's migrants, all those who go in search of the place where "the dreams that you dare to dream really do come true." It is a celebration of Escape, a grand paean to the Uprooted Self, a hymn—*the* hymn—to Elsewhere.

One of the leading actors in the cast complained that "there was no

acting" in the movie, and in the usual sense this was correct. But Garland singing "Over the Rainbow" did something extraordinary: In that moment she gave the film its heart, and the force of her rendition is strong and sweet and deep enough to carry us through all the tomfoolery that follows, even to bestow upon it a touching quality, a vulnerable charm, that is matched only by Bert Lahr's equally extraordinary creation of the role of the Cowardly Lion.

What is left to say about Garland's Dorothy? The conventional wisdom is that the performance gains in ironic force because its innocence contrasts so starkly with what we know of the actress's difficult later life. I'm not sure this is right. It seems to me that Garland's performance succeeds on its own terms, and on the film's. She is required to pull off what sounds like an impossible trick. On the other hand, she is to be the film's *tabula rasa*, the blank slate upon which the action of the story gradually writes itself—or, because it is a movie, the screen upon which the action plays. Armed only with a wide-eyed look, she must be the object of the film as much as its subject, must allow herself to be the empty vessel that the movie slowly fills. And yet, at the same time, she must (with a little help from the Cowardly Lion) carry the entire emotional weight, the whole cyclonic force, of the film. That she achieves both is due not only to the mature depth of her singing voice but also to the odd stockiness, the gaucheness, that endears her to us precisely because it is half unbeautiful, *jolie-laide,* instead of the posturing adorableness a Shirley Temple would have brought to the role—and Temple was seriously considered for the part. The scrubbed, ever-so-slightly lumpy unsexiness of Garland's playing is what makes the movie work. One can imagine the disastrous flirtatiousness young Shirley would have employed, and be grateful that Twentieth Century–Fox refused to loan her to M-G-M.

The tornado, swooping down on Dorothy's home, creates the second genuinely mythic image of *The Wizard of Oz*: the archetypal myth, one might say, of moving house. In this, the transitional sequence of the movie, when the unreal reality of Kansas gives way to the realistic surreality of the world of wizardry, there is, as befits a threshold moment, much business involving windows and doors. First, the farmhands open up the doors of the storm cellar, and Uncle Henry, heroic as ever, persuades Auntie Em

that they can't afford to wait for Dorothy. Second, Dorothy, returning with Toto from her attempt at running away, opens the screen door of the main house, which is instantly ripped from its hinges and blown away. Third, we see the others closing the doors of the storm cellar. Fourth, Dorothy, inside the house, opens a door in her frantic search for Auntie Em. Fifth, Dorothy goes to the storm cellar, but its doors are already battened down. Sixth, Dorothy retreats back inside the main house, her cry for Auntie Em weak and fearful; whereupon a window, echoing the screen door, blows off its hinges and knocks her cold. She falls upon the bed, and from now on magic reigns. We have passed through the film's most important gateway.

But this device—the knocking out of Dorothy—is the most radical and the worst change wrought in Frank Baum's original conception. For in the book there is no question that Oz is real—that it is a place of the same order, though not of the same type, as Kansas. The film, like the TV soap opera *Dallas*, introduces an element of bad faith when it permits the possibility that everything that follows is a dream. This type of bad faith cost *Dallas* its audience and eventually killed it off. That *The Wizard of Oz* avoided the soap opera's fate is a testament to the general integrity of the film, which enabled it to transcend this hoary, creaking cliché.

While the house flies through the air, looking like the tiny toy it is, Dorothy "awakes." What she sees through the window is a sort of movie— the window acting as a cinema screen, a frame within the frame—which prepares her for the new sort of movie she is about to step into. The special-effects shots, sophisticated for their time, include a lady sitting knitting in her rocking chair as the tornado whirls her by, a cow placidly standing in the eye of the storm, two men rowing a boat through the twisting air, and, most important, the figure of Miss Gulch on her bicycle, which is transformed, as we watch it, into the figure of the Wicked Witch of the West on her broomstick, her cape flying behind her, and her huge, cackling laugh rising above the storm.

The house lands; Dorothy emerges from her bedroom with Toto in her arms. We have reached the moment of color. But the first color shot, in which Dorothy walks away from the camera toward the front door of the house, is deliberately dull, an attempt to match the preceding monochrome. Then, once the door is open, color floods the screen. In these

color-glutted days, it's hard for us to imagine ourselves back in a time when color was still relatively rare in the movies. Thinking back once again to my Bombay childhood, in the nineteen-fifties—a time when Hindi movies were *all* in black and white—I can recall the excitement of the advent of color in them. In an epic about the Grand Mughal, the Emperor Akbar, entitled *Mughal-e-Azam*, there was only one reel of color photography, featuring a dance at court by the fabled Anarkali. Yet this reel alone guaranteed the film's success, drawing crowds by the million.

The makers of *The Wizard of Oz* clearly decided that they were going to make their color as colorful as possible, much as Michelangelo Antonioni did, years later, in his first color feature, *Red Desert*. In the Antonioni film, color is used to create heightened and often surrealistic effects. *The Wizard of Oz* likewise goes for bold, Expressionist splashes—the yellow of the Brick Road, the red of the Poppy Field, the green of the Emerald City and of the Witch's skin. So striking were the film's color effects that soon after seeing the film as a child I began to dream of green-skinned witches; and years afterward I gave these dreams to the narrator of my novel *Midnight's Children*, having completely forgotten their source. "No colours except green and black the walls are green the sky is black . . . the stars are green the Widow is green but her hair is black as black": so began the stream-of-consciousness dream sequence, in which the nightmare of Indira Gandhi is fused with the equally nightmarish figure of Margaret Hamilton—a coming together of the Wicked Witches of the East and of the West.

Dorothy, stepping into color, framed by exotic foliage, with a cluster of dwarfy cottages behind her, and looking like a blue-smocked Snow White, no princess but a good, demotic American gal, is clearly struck by the absence of her familiar homey gray. "Toto, I have a feeling we're not in Kansas anymore," she says, and that camp classic of a line has detached itself from the movie to become a great American catchphrase, endlessly recycled, and even turning up as one of the epigraphs to Thomas Pynchon's mammoth paranoid fantasy of World War II, *Gravity's Rainbow*, whose characters' destiny lies not "behind the moon, beyond the rain" but "beyond the zero" of consciousness, in a land at least as bizarre as Oz.

But Dorothy has done more than step out of the gray into Technicolor. Her homelessness, her *unhousing*, is underlined by the fact that, after all the door play of the transitional sequence, and having now stepped out-of-doors, she will not be permitted to enter any interior at all until she reaches the Emerald City. From tornado to Wizard, Dorothy never has a roof over her head. Out there amid the giant hollyhocks, which bear blooms like old gramophone trumpets, there in the vulnerability of open space (albeit open space that isn't at all like the Kansas prairie), Dorothy is about to outdo Snow White by a factor of nearly twenty. You can almost hear the M-G-M studio chiefs plotting to put the Disney hit in the shade—not simply by providing in live action almost as many miraculous effects as the Disney cartoonists created but also by surpassing Disney in the matter of the little people. If Snow White had seven dwarfs, then Dorothy Gale, from the called Kansas, would have a hundred and twenty-four.

The Munchkins were made up and costumed exactly like 3-D cartoon figures. The Mayor of Munchkin City is quite implausibly rotund; the Coroner sings out the Witch of the East's Certificate of Death ("And she's not only merely dead, she's really most sincerely dead") while wearing a hat with an absurdly scroll-like brim; the quiffs of the Lollipop Kids, who appear to have arrived in Oz by way of Bash Street and Dead End, stand up more stiffly than Tintin's. But what might have been a grotesque and unappetizing sequence in fact becomes the moment in which *The Wizard of Oz* captures its audience once and for all, by allying the natural charm of the story to brilliant M-G-M choreography (which alternates large-scale routines with neat little set pieces like the dance of the Lullaby League, or the Sleepy Heads awaking mobcapped and benightied out of cracked blue eggshells set in a giant nest), and, above all, through Harold Arlen and Yip Harburg's exceptionally witty "Ding Dong! The Witch Is Dead." Arlen was a little contemptuous of this song and the equally unforgettable "We're Off to See the Wizard," calling them his "lemon-drop songs," and perhaps this is because the real inventiveness in both tunes lies in Harburg's lyrics. In Dorothy's intro to "Ding Dong!" Harburg embarked on a pyrotechnic display of *a-a-a* rhymes ("The wind began to switch/the house to pitch"; until, at length, we meet the "witch . . . thumbin' for a hitch"; and "what

happened then was rich")—a series in which, as with a vaudeville barker's alliterations, we cheer each new rhyme as a sort of gymnastic triumph. This type of verbal play continues to characterize both songs. In "Ding Dong!" Harburg begins to invent punning, concertinaed words:

> Ding, dong, the witch is dead!
> *Whicholwitch?*
> The wicked witch!

This technique found much fuller expression in "We're Off to See the Wizard," becoming the real "hook" of the song:

> We're off to see the Wizard,
> The wonderful *Wizzerdovoz.*
> We hear he is
> A *Wizzovawizz,*
> If ever a *Wizztherwozz.*
> If *everoever* a *Wizzertherwozz*
> The *Wizzerdovoz* is one because . . .

And so on.

Amid all this Munchkining we are given two very different portraits of adults. The Good Witch, Glinda, is pretty in pink (well, prettyish, even if Dorothy is moved to call her "beautiful"). She has a high, cooing voice, and a smile that seems to have jammed. She has one excellent gag line, after Dorothy disclaims witchy status: Pointing at Toto, Glinda inquires, "Well, is *that* the witch?" This joke apart, she spends the scene looking generally benevolent and loving and rather too heavily powdered. Interestingly, though she is the Good Witch, the goodness of Oz does not inhere in her. The people of Oz are naturally good, unless they are under the power of the Wicked Witch (as is shown by the improved behavior of her soldiers after she melts). In the moral universe of the film, then, evil is external, dwelling solely in the dual devil figure of Miss Gulch/Wicked Witch.

(A parenthetical worry about the presentation of Munchkinland: Is it

not a mite too pretty, too kempt, too sweetly sweet for a place that was, until the moment of Dorothy's arrival, under absolute power of the evil and dictatorial Witch of the East? How is it that this squashed Witch had no castle? How could her despotism have left so little mark upon the land? Why are the Munchkins so relatively unafraid, hiding only briefly before they emerge, and giggling while they hide? A heretical thought occurs: Maybe the Witch of the East wasn't as bad as all that—she certainly kept the streets clean, the houses painted and in good repair, and, no doubt, such trains as there might be running on time. Moreover—and, again, unlike her sister—she seems to have ruled without the aid of soldiers, policemen, or other regiments of repression. Why, then, was she so hated? I only ask.)

Glinda and the Witch of the West are the only two symbols of power in a film that is largely about the powerless, and it's instructive to "unpack" them. They are both women, and a striking aspect of *The Wizard of Oz* is its lack of a male hero—because, for all their brains, heart, and courage, it is impossible to see the Scarecrow, the Tin Man, and the Cowardly Lion as classic Hollywood leading men. The power center of the film is a triangle at whose points are Glinda, Dorothy, and the Witch; the fourth point, at which the Wizard is thought for most of the film to stand, turns out to be an illusion. The power of men, it is suggested, is illusory; the power of women is real.

Of the two Witches, good and bad, can there be anyone who'd choose to spend five minutes with Glinda? Of course, Glinda is "good" and the Wicked Witch "bad"; but Glinda is a silly pain in the neck, and the Wicked Witch is lean and mean. Check out their clothes: frilly pink versus slimline black. No contest. Consider their attitudes toward their fellow women: Glinda simpers upon being called beautiful and denigrates her unbeautiful sisters, whereas the Wicked Witch is in a rage because of the death of *her* sister, demonstrating, one might say, a commendable sense of solidarity. We may hiss at her, and she may terrify us as children, but at least she doesn't embarrass us the way Glinda does. It's true that Glinda exudes a sort of raddled motherly safeness while the Witch of the West looks—in this scene, anyhow—curiously frail and impotent, obliged to mouth empty threats ("I'll bide my time. . . . But just try to stay out of my

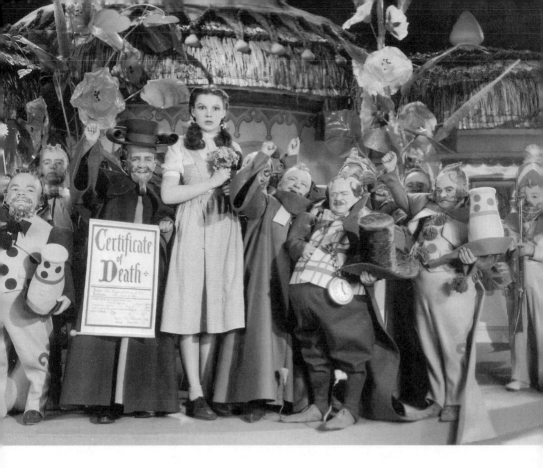

way"). Yet just as feminism has sought to rehabilitate pejorative old words such as "hag," "crone," and "witch," so the Wicked Witch of the West can be said to represent the more positive of the two images of powerful womanhood on offer here. Glinda and the Wicked Witch clash most fiercely over the ruby slippers, which Glinda magics off the feet of the dead Witch of the East and onto Dorothy's feet, and which the Wicked Witch seemingly has no power to remove. But Glinda's instructions to Dorothy are oddly enigmatic, even contradictory. She first tells Dorothy, "Their magic must be very powerful or she wouldn't want them so badly," and later she says, "Never let those ruby slippers off your feet for a moment or you will be at the mercy of the Wicked Witch of the West." Now, Statement No. 1 suggests that Glinda is unclear about the nature of the ruby slippers, whereas Statement No. 2 suggests that she knows all about their protective power. Neither statement hints at the ruby slippers' later role in helping to get Dorothy back to Kansas. It seems probable that this confusion

is a hangover from the long, dissension-riddled scripting process, in which the function of the slippers was the subject of considerable dispute. But one can also see Glinda's obliquities as proof that a good fairy or a good witch, when she sets out to be of assistance, never gives you everything. Glinda, after all, is not so unlike her description of the Wizard of Oz. "Oh, very good, but very mysterious."

"Just follow the Yellow Brick Road," says Glinda, and bubbles off into the blue hills in the distance; and Dorothy—geometrically influenced, as who would not be after a childhood among triangles, circles, and squares—begins her journey at the very point from which the Road spirals outward. And as she does so, and while both she and the Munchkins are echoing Glinda's instructions in tones both raucously high and gutturally low, something begins to happen to her feet: their motion acquires a syncopation, which by beautifully slow stages grows more and more noticeable until at last, as the ensemble bursts for the first time into the film's theme song, we see, fully developed, the clever, shuffling little skip that will be the leitmotif of the entire journey:

> You're off to see the Wizard,
> (s-skip)
> The wonderful Wizzerdovoz.
> (s-skip)
> You'll find he is a Wizzovawizz.
> If ever a Wizztherwozz. . . .

In this way, s-skipping along, Dorothy Gale, who is already a National Heroine of Munchkinland, who is already (as the Munchkins have assured her) History, who "will be a Bust in the Hall of Fame," steps out along the road of destiny, and heads, as Americans must, into the West: toward the sunset, the Emerald City, and the Witch.

I have always found off-camera anecdotes about a film's production simultaneously delicious and disappointing, especially when the film concerned has lodged as deep down inside as *The Wizard of Oz* has. It was a

little sad to learn about the Wizard's drinking problem, and to discover that Frank Morgan was only the third choice for the part, behind W. C. Fields and Ed Wynn. (What contemptuous wildness Fields might have brought to the role!) The first choice for his female more-than-opposite number, the witch, was Gale Sondergaard, not only a great beauty but, prospectively, another Gale to set alongside Dorothy and the tornado. Then I found myself staring at an old color photograph of the Scarecrow, the Tin Man, and Dorothy, posing in a forest set, surrounded by autumn leaves, and realized that what I was looking at was not the stars at all but their stunt doubles, their stand-ins. It was an unremarkable studio still, but it took my breath away; for it, too, was both melancholy and mesmeric. In my mind it came to be the very epitome of the doubleness of my responses.

There they stand, Nathanael West's locusts, the ultimate wannabes. Garland's shadow, Bobbie Koshay, with her hands clasped behind her back and a white bow in her hair, is doing her brave best to smile, but she knows she's a counterfeit, all right: There are no ruby slippers on her feet. The mock-Scarecrow looks glum, too, even though he has avoided the full-scale burlap-sack makeup that was Ray Bolger's daily fate. If it were not for the clump of straw poking out of his right sleeve, you'd think he was some kind of hobo. Between them, in full metallic drag, stands the Tin Man's tinnier echo, looking as miserable as hell. Stand-ins know their fate: They know we don't want to admit their existence, even though our rational minds tell us that when we watch the figure in this or that difficult shot—watch the Wicked Witch fly, or the Cowardly Lion dive through a glass window—we aren't watching the stars. The part of us that has suspended disbelief insists on seeing the stars, and not their doubles. Thus, the stand-ins are rendered invisible even when they are in full view. They remain off camera even when they are onscreen.

However, this is not the reason for the curious fascination of the photograph; that arises from the fact that, in the case of a beloved film, we are all the stars' doubles. Our imaginations put us in the Lion's skin, fit the sparkling slippers on our feet, send us cackling through the air on a broomstick. To look at this photograph is to look into a mirror; in it we see ourselves. The world of *The Wizard of Oz* has possessed us. We have become

the stand-ins. A pair of ruby slippers found in a bin in a basement of M-G-M was sold at auction in May 1970, for the amazing sum of fifteen thousand dollars. The purchaser was, and has remained, anonymous. Who was it who wished so profoundly to possess—perhaps even to wear—Dorothy's magic shoes?

On being asked to pick a single defining image of *The Wizard of Oz*, most of us would, I suspect, come up with the Scarecrow, the Tin Man, the Cowardly Lion, and Dorothy s-skipping down the Yellow Brick Road. (In point of fact, the skip continues to grow throughout the journey, and becomes a full-fledged h-hop.) How strange that the most famous passage of this very filmic film—a film packed with technical ingenuity and effects—should be the least cinematic, the most "stagy," part of the whole! Or perhaps not so strange, for this is primarily a passage of surreal comedy, and we recall that the equally inspired clowning of the Marx Brothers was no less stagily filmed; the zany mayhem of the playing made any but the simplest camera techniques impossible.

The Scarecrow and the Tin Man are pure products of the burlesque theater, specializing in pantomime exaggerations of voice and body movement, pratfalls (the Scarecrow descending from his post), improbable leanings beyond the center of gravity (the Tin Man during his little dance), and, of course, the smart-ass backchat of the cross-talk act:

> TIN MAN (*rusted solid*): (Squawks)
> DOROTHY: He said "Oil can"!
> SCARECROW: Oil can what?

At the pinnacle of all this clowning is that fully realized comic masterpiece of a creation, Bert Lahr's Cowardly Lion, all elongated vowel sounds ("Put 'em uuuuuuuup"), ridiculous rhymes ("rhinoceros" and "imposserous"), transparent bravado, and huge, operatic, tail-tugging, blubbering terror. All three—Scarecrow, Tin Man, and Lion—are, in T. S. Eliot's words, hollow men. The Scarecrow, of course, actually does have a "head-piece filled with straw, alas," but the Tin Man, the ancestor of C–3PO

in *Star Wars*, is completely empty—he bangs on his chest to prove that his innards are missing, because "the Tinsmith," his shadowy maker, forgot to provide a heart—and the Lion lacks the most leonine of qualities, lamenting:

> What makes the Hottentot so hot?
> What puts the ape in apricot?
> What have they got that I ain't got?
> *Courage!*

Perhaps it is because they are all hollow that our imaginations can enter them and fill them up so easily. That is to say, it is their anti-heroism, their apparent lack of Great Qualities, that makes them our size, or even smaller, so that we can stand among them as equals, like Dorothy among the Munchkins. Gradually, however, we discover that, along with their "straight man," Dorothy (she occupies in this sequence the role of the unfunny Marx Brother, the one who could sing and look hunky and do little else), they embody one of the film's "messages"—that we already possess what we seek most fervently. The Scarecrow regularly comes up with bright ideas, which he offers with self-deprecating disclaimers. The Tin Man can weep with grief long before the Wizard gives him a heart. And Dorothy's capture by the Witch brings out the Lion's courage, even though he pleads with his friends to "talk me out of it." For this message to have its full impact, however, it is necessary that we learn the futility of looking for solutions *outside*. We must learn about one more hollow man: the Wizard of Oz himself. Just as the Tinsmith was a flawed maker of tin men—just as, in this secular movie, the Tin Man's god is dead—so too must our belief in wizards perish, so that we may believe in ourselves. We must survive the Deadly Poppy Field, helped by a mysterious snowfall (why *does* snow overcome the poppies' poison?), and so arrive, accompanied by heavenly choirs, at the city gates.

Here the film changes convention once again, becoming a portrait of hicks from the sticks arriving in the metropolis—one of the classic

themes of American films, with echoes in *Mr. Deeds Goes to Town*, and even in Clark Kent's arrival at the *Daily Planet* in *Superman*. Dorothy is a country hick, "Dorothy the small and meek"; her companions are backwoods buffoons. Yet—and this, too, is a familiar Hollywood trope—it is the out-of-towners, the country mice, who will save the day.

There was never a metropolis quite like Emerald City, however. It looks from the outside like a fairy tale of New York, a thicket of skyscraping green towers. On the inside, though, it's the very essence of quaintness. Even more startling is the discovery that the citizens—many of them played by Frank Morgan, who adds the parts of the gatekeeper, the driver of the horse-drawn buggy, and the palace guard to those of Professor Marvel and the Wizard—speak with what Hollywood actors then liked to call an English accent. "Tyke yer anyplace in the city, we does," says the driver, adding, "I'll tyke yer to a little place where you can tidy up a bit, what?" Other members of the citizenry are dressed like Grand Hotel bellhops and glitzy nuns, and they say—or, rather, sing—things like "Jolly good fun!" Dorothy catches on quickly. At the Wash & Brush Up Co., a tribute to urban technological genius with none of the dark doubts of a *Modern Times* or a *City Lights*, our heroine gets a little Englished herself:

DOROTHY (*sings*): Can you even dye my eyes to match my gown?
ATTENDANT: Uh-huh!
DOROTHY: Jolly old town!

Most of the citizenry are cheerfully friendly, and those who appear not to be—the gatekeeper, the palace guard—are soon won over. (In this respect, once again, they are untypical city folk.) Our four friends finally gain entry to the Wizard's palace because Dorothy's tears of frustration undam a quite alarming reservoir of liquid in the guard. His face is quickly sodden with tears, and, watching this extreme performance, you are struck by the sheer number of occasions on which people cry in this film. Besides Dorothy and the guard, there is the Cowardly Lion, who bawls when Dorothy bops him on the nose; the Tin Man, who almost rusts up again from weeping; and Dorothy again, while she is in the clutches of the Witch. It occurs to you that if the hydrophobic Witch could only have

been closer at hand on one of these occasions the movie might have been much shorter.

Into the palace we go, down an arched corridor that looks like an elongated version of the Looney Tunes logo, and at last we confront a Wizard whose tricks—giant heads and flashes of fire—conceal his basic kinship with Dorothy. He, too, is an immigrant; indeed, as he will later reveal, he is a Kansas man himself. (In the novel, he came from Omaha.) These two immigrants have adopted opposite strategies of survival in a new and strange land. Dorothy has been unfailingly polite, careful, courteously "small and meek," whereas the Wizard has been fire and smoke, bravado and bombast, and has hustled his way to the top—floated there, so to speak, on a cloud of his own hot air. But Dorothy learns that meekness isn't enough, and the Wizard finds (as his balloon gets the better of him for a second time) that his command of hot air isn't all it should be. (It is hard for a migrant like me not to see in these shifting destinies a parable of the migrant condition.)

The Wizard's stipulation that he will grant no wishes until the four friends have brought him the Witch's broomstick ushers in the penultimate, and least challenging (though most action-packed and "exciting"), movement of the film, which is in this phase at once a buddy movie, a straightforward adventure yarn, and, after Dorothy's capture, a more or less conventional princess-rescue story. The film, having arrived at the great dramatic climax of the confrontation with the Wizard of Oz, sags for a while, and doesn't really regain momentum until the equally climactic final struggle with the Wicked Witch, which ends with her melting, her "growing down" into nothingness.

Fast forward. The Witch is gone. The Wizard has been unmasked, and in the moment of his unveiling has succeeded in performing a spot of true magic, giving Dorothy's companions the gifts they did not believe until that moment that they possessed. The Wizard is gone, too, and without Dorothy, their plans having been fouled up by (who else but) Toto. And here is Glinda, telling Dorothy she has to learn the meaning of the ruby slippers for herself.

TIN MAN: What have you learned, Dorothy?

DOROTHY: . . . If I ever go looking for my heart's desire again, I won't look any further than my own backyard; because if it isn't there, I never really lost it to begin with. Is that right?

GLINDA: That's all it is. . . . Now those magic slippers will take you home in two seconds. . . . Close your eyes and tap your heels together three times . . . and think to yourself . . . there's no place like . . .

Hold it.

How does it come about that at the close of this radical and enabling film—which teaches us in the least didactic way possible to build on what we have, to make the best of ourselves—we are given this conservative little homily? Are we to think that Dorothy has learned no more on her journey than that she didn't need to make such a journey in the first place? Must we believe that she now accepts the limitations of her home life, and agrees that the things she doesn't have there are no loss to her? "Is that right?" Well, excuse *me*, Glinda, but it is not.

Home, again, in black and white, with Auntie Em and Uncle Henry and the rude mechanicals clustered around her bed, Dorothy begins her second revolt, fighting not only against the patronizing dismissals by her own folk but also against the scriptwriters and the sentimental moralizing of the entire Hollywood studio system. "It wasn't a dream, it was a place!" she cries piteously. "A real, truly live place! . . . Doesn't anyone believe me?"

Many, many people did believe her. Frank Baum's readers believed her, and their belief in Oz led him to write thirteen further Oz books, admittedly of diminishing quality; the series was continued, even more feebly, by other hands after his death. Dorothy, ignoring the "lessons" of the ruby slippers, goes back to Oz, in spite of the efforts of Kansas folk, including Auntie Em and Uncle Henry, to have her dreams brainwashed out of her (see the terrifying electroconvulsive-therapy sequence in the recent Disney film *Return to Oz*); and, in the sixth book of the series, she sends for Auntie Em and Uncle Henry, and they all settle down in Oz, where Dorothy becomes a Princess.

So Oz finally *becomes* home. The imagined world becomes the actual world, as it does for us all, because the truth is that, once we leave our childhood places and start to make up our lives, armed only with what we know and who we are, we come to understand that the real secret of the ruby slippers is not that "there's no place like home" but, rather, that there is no longer any such place *as* home—except, of course, for the homes we make, or the homes that are made for us, in Oz. Which is anywhere—and everywhere—except the place from which we began.

In the place from which I began, after all, I watched the film from the child's—Dorothy's—point of view. I experienced, with her, the frustration of being brushed aside by Uncle Henry and Auntie Em, busy with their dull grownup counting. Like all adults they couldn't focus on what was really important: namely, the threat to Toto. I ran away with her and then ran back. Even the shock of discovering that the Wizard was a humbug was a shock I felt as a child, a shock to the child's faith in adults. Perhaps, too, I felt something deeper, something I couldn't then articulate; perhaps some half-formed suspicion about grownups was being confirmed.

Now, as I look at the movie again, I have become the fallible adult. Now I am a member of the tribe of imperfect parents who cannot listen to their children's voices. I, who no longer have a father, have become a father instead. Now it is my fate to be unable to satisfy the longings of a child. And this is the last and most terrible lesson of the film: that there is one final, unexpected rite of passage. In the end, ceasing to be children, we all become magicians without magic, exposed conjurers, with only our simple humanity to get us through.

We are the humbugs now.

DEAD MAN WALKING

DIRECTED BY TIM ROBBINS

W hen *Dead Man Walking* was released in 1995, some crit-
ics called it a violent film. It is not a violent film. Violent
films violate the viewer. But it is certainly *about* violence,
both its causes and its consequences (which violent
films are not). In this regard the film's center of gravity is the rapist-
murderer, Mathew Poncilet (Sean Penn), although the principal character
is Sister Helen Prejean (Susan Sarandon), and it's unquestionably her
story told in the cinematic equivalent of close-third-person point of view.

We are with her all the time, until the thirty-five seconds between Mathew's confessing his crimes to her and his becoming a dead man walking. He has finally told her the truth about what he has done, and decided to take responsibility for it, insofar as he now can, by using his last words to apologize to the parents of the young man he murdered and the young woman he raped. Then the guards call Sister Helen away, so they can come manacle Mathew to walk to his execution. The camera doesn't move when she leaves the frame, and it has the effect of a sudden shift in pronouns. Mathew is sobbing, then he stops, and swallows, and opens his eyes. He doesn't say anything. There are no violins on the soundtrack, no music to instruct us how to feel. All we're given is what we see: him alone, in three-quarter profile, shot through the bars. Although the context is certainly more firmly established than in most moments of real life, what he's thinking and feeling is no more clear to us than when we see any other person. We must read what that is—"must" also in the sense of moral imperative. Since we live in a world where images lie to us a thousand times a day, we must work that much harder to understand what we see when what we see is a person. We have been prepared well enough in the previous hundred minutes of the movie. The facial expression of feeling is its main language (although it also has much more dialogue than most movies), and the feelings move quickly across the screen. It's because of the moment-by-moment manifold relationships among what's said, what isn't, and the camera's showing them that static scenes are not in the least static. Sean Penn and Susan Sarandon perform a tour de force tightrope act and so does the camera with its subtle shifts.

There would have been a million ways to ruin this movie. It's almost funny to imagine how Steven Spielberg would have done it, with his talent for turning even the worst historical catastrophes into schlock. For a Hollywood production to expose the ugly underside of attitudes about sex and violence that Hollywood sells in shiny packages is about as likely as Free Condom Day at the Vatican. When you read the script of *Dead Man Walking*, you can see what the director, Tim Robbins, and the actors did to translate it. Watching the movie, their prowess is exhilarating, as human prowess always is if it's not used arrogantly, because it's a source of hope. "Gaiety transfiguring all that dread," is the way Yeats put it, by

which I understand him to mean the gaiety of making art. Yeats's line explains why genuine art is hopeful no matter its subject—indeed, especially if its subject is riddled with otherwise unanswerable, inarticulate despair. The subjects of *Dead Man Walking* are thus riddled up the wazoo. Their vivid presentation, even so artfully formed by this much star power, was unsurprisingly way too much for the Spielberged moviegoer.

This is the story: A letter from a death-row inmate arrives at the Catholic learning center in a New Orleans housing project, Sister Helen answers it, they exchange letters, and by the time the credits have rolled she's walking through the prison metal detector (which is set off by the crucifix around her neck). She sits down across from Matt Poncilet, and they talk face-to-face, for the first of what turns out to be thirteen times (five on the last day of his life). He is almost opaque behind the screen between them. He looks like the devil (and kind of ridiculous): big slick pompadour, sparse little moustache and goatee. He brags and he smirks. What he says is racist, brutish, arrogant, ignorant, and repugnant. Aryan Brotherhood stuff. This guy is *really* out there. He wants her to get him a lawyer to file an appeal to the federal court and represent him before the parole board to have his sentence reduced to life. She agrees to do so, despite having been warned that he'll try to con her. When the parole board turns him down, he asks her to be his spiritual adviser (a privilege of the condemned), and she agrees to do that, too. He gets a whole lot more than he was asking for. She brings him to the truth about himself, and it is a painful process, as it is for most of us at some point in our lives, intensified because that truth for him is the heart of darkness. For most of us, the heart may not be this dark nor the process this compressed by an imminent execution date, but, amplified by the drama (as drama does), what he undergoes is nonetheless familiar to our experience. (One's willingness to recognize this, as well as to identify with Sister Helen, probably controls one's overall response to the movie. The film is presentational, but it presents these unmitigated challenges to the viewer.) Matt's humanity is increasingly apparent as Sister Helen socratically, respectfully, fiercely, and lovingly strips him of his lies, self-delusions, blaming, and denial of responsibility. What's left of him is fear, which is only exceeded by his fear of dying. That's when the door opens for God to walk through.

Matt's breakdown and turn to faith, twenty minutes before he is to die, is an amazing few minutes of film. Its intensity is further intensified by the temporal structure of the film as a whole: from the opening sequence that represents weeks to his execution that occurs in almost real time. As the noose tightens, time becomes more dramatically packed because it is running out for him. His confession explodes from the pressure. Weeks that became days become hours then minutes then excruciating seconds as he is strapped to the table and the camera tracks the fluid of the lethal injection pumping into his vein.

While the drug is killing him, the execution is intercut with night woods where the trees are black and the grass stop-light green, accompanied by a moaning, keening soundtrack by the Sufi singer Nusrat Fateh Ali Khan. Matt drops his pants to rape the girl, swiveling his hips in a clownish parody of sexual anticipation. The lethal-injection machine—with red, yellow, and green brightly lit buttons marked "Armed," "Start," and "Finish"—and Matt's tattooed surreal white flesh twitching with terror, Sister Helen behind the glass in the observation room symbolically

extending her hand to him. His partner pulls Matt off for his turn on the girl, but, apparently impotent, furiously stabs her with a hunting knife; Matt darts over to the boy who is screaming with his face in the mud and his wrists handcuffed behind him, props one foot between his shoulder blades, and shoots him in the back of the head with the shotgun. The execution chamber, the lethal-injection machine mechanically depressing the syringes, the virulent colorless liquid, Matt's eyes closing as the drug takes effect. The girl crawls on her belly toward her dead boyfriend, and Matt's partner shoots her in the back of the head, the sound a soft pop like a party favor. Machine, stainless steel pistons, syringes, IV tubes, Matt's immobile corpse, Sister Helen praying behind the glass in the observation room. The woods where the two murderers are running away, the camera tracking back toward the corpses, but before it gets to them the images of the victims all dressed up for a date appear on the glass of the execution chamber superimposed over Matt's immobile body; the green-lit button on the lethal-injection machine marked "Finish"; Sister Helen's face, her eyes opening; Matt's face, shot from above, his eyes opening at death. Finally, an aerial pan of the woods at morning, beautiful until the corpses are shown facedown in a clearing, the camera receding and rotating ninety degrees clockwise over Matt's corpse strapped onto the table as if it were all one continuous aerial view.

Four minutes of real time have elapsed from the moment the lethal-injection machine was switched on to this last aerial shot of the sequence. My description takes almost as long to read as the sequence takes to watch. It goes without saying that no verbal description can represent a single photograph much less these moving pictures. The dominant middle-distance horizontal tracking shot from behind the black trees, to cite just one example, is crucial to our experience of the rape-and-murder scene, as is the contrast of its infernal darkness to the surgical brightness of the execution chamber. This film does a world of things with tone and gesture that writing can't. Despite the bromide for beginning writers, writing necessarily tells rather than shows, but it can do so with the fluidity of perception, and it can also move in time and space in a way no movie ever will be able to, no matter how big the budget for special effects. Film makes dreams of the apprehensible world; writing makes the dream of consciousness apprehen-

sible. Both are best when they tug at their anchors. A movie that is nothing but spectacle is boring; spectacle is its tendency and temptation. Writing that never puts you in a real place and time (including the real place and time of your innermost being) is lifeless. Robert Frost said, "all writing is as good as it is dramatic." I think he was almost right.

Some reviewers, citing the aerial view of the woods and execution table, criticized Tim Robbins for arguing that these deaths are "morally equivalent." Even if you could translate camera angles into statements, this ignores the previous two hours of the movie, which show that every death is the death of a specific person with specific consequences for many other specific persons. Neither of the two times I saw *Dead Man Walking* in a theater did anyone cheer, unlike an action movie when someone gets blown away. Death in an action movie has no consequences. It's a cartoon of death, spectacular and irresponsible, appealing to boys of all ages and both genders, affecting those most who are least able to discern the distortion they're seeing. A real person's death radiates into the community, touching everyone in direct proportion to his or her emotional proximity to the person who died. No death is comparable to any other death, nor "equivalent," morally or otherwise. Which is worse: to murder someone in an antiseptic execution chamber or to shoot him face down in the mud? To shoot someone in the head or stab her in the heart? To starve a baby or kill its mother? The answer in every case is: Both. Neither should ever happen. Neither is acceptable. Just because these questions can be formed grammatically does not mean they are real questions. Wiser criminal justice systems than ours require the criminal to sit in a room with all the people he has harmed by his crime—to take responsibility for it—instead of just locking him up or knocking him off and sparing him the harder task of facing himself. Very few people are sociopathic enough to kill other people without an airtight system of self-delusion. Matt is by any standard a sociopath. The film does "argue" that by taking responsibility for his crime, by puncturing the bubble of his self-serving beliefs, a sociopath can be changed back into the person he started out being as a child. At least this specific person, Mathew Poncilet, in these particular circumstances, with the "spiritual adviser" he was fortunate enough to have. It is after all a story, not a parable, much less a tract. It does not suggest that everyone

facing execution has a religious conversion (which, in one right-wing fundamentalist's antipodean interpretation, turned the film into an argument *for* capital punishment). Matt's mother brings his baby photos to the parole board, which of course they would never be interested in seeing. But, in the case of her son, she has it right. So does the prosecuting attorney, when he says that Matt Poncilet has given the parents of his victims an "unbearable loss": "their families will never see their children graduate from college, they will never attend their wedding, they will never have Christmas with them again, there will be no grandchildren." These are real consequences. Unbearable.

Parental love, so rarely packaged by Hollywood without a saccharine coating, is here presented variously and specifically (specificity being one antidote to sentimentality). Another unusual aspect of this unique film is to focus on this kind of love without any "romantic interest" to distract from it. There's no boy-gets-girl subplot, none of the usual divination of romantic love. Sister Helen's pastoral relationship to Matt is maternal, not sexual (where he initially tries to steer it), and as loving as her mother's relationship to her. But we also see parental love in its dispossession, in the unbearable losses of the parents of the girl, of the parents of the boy, and of Matt's mother. These contrasts illuminate this wrenching subject. None of them suffer the death of his or her child in exactly the same way, but they all suffer it as much as it's possible to suffer. And that's why the four-minute rape-and-murder-and-execution sequence, for which Robbins was also harshly criticized, is so essential. Its horror is not mediated, even through Sister Helen's close-third-person point-of-view. She is there behind the glass in the observation room, and acts to serve as what she calls the "face of love" for Matt as he dies. But the camera is *inside* the execution chamber and *in* the woods. We are not so much with her as with It: the worst fear realized: this happening to your child. How could this happen to anyone? The movie shows us how. It renders a media headline as experience, not ignorable information. The receding aerial view is a kind of mercy to us, a literal lengthening of perspective, after the dual dramatic climax resolving the suspense of what's going to happen to Matt and what really happened in the woods and merging them into one timeless, unforgettable event that we have finally witnessed.

It also marks a pause before we switch back to the passage of time in the life of Sister Helen and resume our close-third-person relationship to her. The scene changes to Matt's burial, and she's at graveside when she sees Mr. Delacroix (the father of the boy Matt murdered) standing at a distance. When she walks over to him, he says, "I don't know why I'm here. I've got a lot of hate. I don't have your faith." She answers, "It's not faith. I wish it were that easy. It's work."

This work of hers, which she has been doing the entire movie, continues through its closing minutes. Mr. Delacroix's unbearable loss is far from finished. He has lost his wife to divorce, as well as his son to death, as consequences of the action of Matt Poncilet. There were no other children. He has lost his whole family. In contrast to Matt's family at the graveside, Mr. Delacroix's standing alone at a distance makes visible how bereft he is. Sister Helen says to him, "Maybe we could help each other out of the hate." He replies, "I don't know. I don't think so. I should go," and drives away in his car, but the final shot of the movie is through a window of a church where they're praying together, which then dollies back through the daylight on the foliage and the green trees.

These trees are green, not black, as they were during the murder. It's certainly a hopeful ending, but Sister Helen's work is to have hope by giving it to others on a daily basis, and we're never allowed to think that this isn't work. Her theology is simple to summarize and difficult to live: As she puts it, she's "just trying to follow the example of Jesus." To her this means answering the call of God from the mouths of the lost, and that is how and why she becomes involved with Matt Poncilet, through his overwhelming need, the true character of which he's completely unaware of. She is fully aware of it, but helping him causes her conflict with almost everyone in her life, including herself. In response to her mother's asking what has drawn her to him, she answers, "I feel caught more than drawn. The man's in trouble and for some reason I'm the only one he trusts." In fact, her conflicts with other characters represent self-conflicts: the conservative prison chaplain, Matt, her family, and the parents of the victims (to name just the major ones in order of their appearance) all occasion the difficulty of weighing her responsibilities and loyalties and doing the next right thing despite what the church or society or even her own family might think or

suffer as a result. No matter what she herself suffers as a result. Who should be the object of compassion? Is anyone excluded by virtue of his "unworthiness"? In her view Jesus had the most compassion for the most lost, and this, her compass, guides her through adversity within and without, at no small price. It is why Matt's confession to her is the dramatic climax for her as well as for him. Her drama is likewise snugly encased in and intensified by the temporal structure of the story. Her antagonists reappear and her self-conflicts trouble her until the last hours of Matt's life when it's just her and him, and she focuses solely on him, on the conflict of good and evil within him. She has one purpose, which she quotes from scripture and understands as the word of God: "The truth shall make you free."

That's also the purpose of the movie, insofar as purposes guide a good story beautifully told. Sister Helen's struggle is of course the hero's struggle through adversity, a story as old as *The Odyssey*. It presents a configuration for living life which expresses an enduring truth we identify with, but which can also be easily distorted. Hollywood's version is a paean to rugged individualism and following your "dream" (or self-aggrandizing obsession). This version usually ends in public triumph, often before an applauding audience, as if fame were salvation. (In the religion of celebrity, it is.) Sister Helen's reward is a bunch of children's drawings pasted on the door of her room in the housing project. One of them says, "We love you, Sister Helen." We can understand why. The love she gives to these children, glancingly portrayed, is parental love, like the love she gives to Matt. She does it for their sake, but also—and primarily—for her own. As she tells Matt, "You have to participate in your own redemption." The work of faith must be renewed every day, which is why we don't doubt her sincerity when she says to Mr. Delacroix, "Maybe we can help each other out of the hate." The "we" includes her. She needs *him*—to be a lovable person: to herself and in the reified eyes of God, the love of other people for her being the byproduct, not the objective.

This is her strength, the same strength that impressed William James when he studied the varieties of religious experience, although he was not himself a believer. It makes her able to love Matt before he's lovable, which he becomes when he thanks her for loving him, after he has spoken the

truth. He is anything but lovable when she meets him, annealed in lies and grandiosity measured in the common currencies of masculine value (besides money): toughness and sex appeal. These are the currencies Hollywood trucks to the bank, and has always trucked to the bank, although recent technological advances that shine them up seem to have accelerated Gresham's Law (bad money drives out the good). In Matt, we see what filthy lucre they are. They have served him as disastrously false measures of himself. He has spent his life trying to prove how tough and sexy he is, projecting his self-loathing onto others as racism, sexism, and just about every other ignorant prejudice in the book.

Dead Man Walking, despite its critical and commercial success and Academy Award for Susan Sarandon, had no perceptible effect on ignorant prejudice, capital punishment, or Hollywood movies. To judge the effectiveness of art in such terms is like trying to measure electricity with a ruler. Chekhov, weary of such criticism, said that art doesn't provide answers; it can only correctly formulate questions. *Dead Man Walking* correctly formulates a number of questions that now press on everyone not completely anaesthetized by entertainment. It dramatizes how irreplaceable a person is; how we judge ourselves and others; how we use our influence on others for good or ill; and how lucky a person is to have a vocation (religious or secular) that calls her out of herself into the world of irreplaceable persons, including the vocation to make a film like this one, which singularly renders this world.

JIM SHEPARD

THE 400 BLOWS

DIRECTED BY FRANÇOIS TRUFFAUT

There's a sequence late in François Truffaut's *The 400 Blows* in which the protagonist, thirteen-year-old Antoine Doinel, as played by thirteen-year-old Jean-Pierre Léaud, is interviewed by the staff psychologist at the Center for Delinquent Minors. The sequence is a succession of medium shots of Antoine at a table answering questions lobbed at him by an offscreen voice. For an hour and twenty-five minutes before that we've watched a haphazard group of mostly harried and distracted adults, including

Antoine's parents and teachers, attempt without success to understand his mild rebelliousness. The interview represents their world's final and most systematic attempt to figure out what's wrong. Each question, answered, is a little set piece, connected to the others by dissolves. The whole thing as it unfolds epitomizes how stylistically unclassifiable Truffaut's debut first seemed. Was it an appropriately sober neorealist slice of life?—after all, there *were* dismal locations, nonprofessional actors, and social problems everywhere you looked—or was it look-Ma-no-hands filmmaking: Was this young man *showing off*?

Turns out it was both. Watching Antoine field all those questions, we can't help feeling as if we're getting a glimpse of unvarnished access to the real. (At one point Léaud, clearly thrown by the unexpectedness of the off-screen voice's "Have you ever been to bed with a girl?" looks past the camera to where Truffaut is sitting with a "You *sonofa* . . ." grin on his face.) The *cinema verite* effect is, after all, reinforced by what seems to be the hopelessly sloppy way in which the classical methods of establishing time and space in a dialogue are flouted.

But that same rule flouting is so flagrant that it points to a controlling hand, with the understatement of a plank across the forehead. What is this: strobe realism? Where's the seamlessness that we expect? There are not only dissolves between answers; there are dissolves *during* answers. Why can't we see who he's talking to? How do we know these aren't the rearranged highlights of *five* sessions? Whatever happened to the integrity of the long take?

That stylistic eclecticism Truffaut termed his attempt to combine "poetry and journalism," and it was one of the defining features of the movement known as the French New Wave, which became an international phenomenon with *The 400 Blows'* selection as the grand prizewinner at Cannes in 1959. It was quite a wave: In the next four years, 170 young French directors, including Jean-Luc Godard, Eric Rohmer, Alain Resnais, and Claude Chabrol, made their first features. Every so often we forget what we owe to that hubris-filled pack of shut-ins, rebels, and malcontents. They were the first film brats—most had been film critics before becoming filmmakers—and because of the spectacular range of their enthusiasms, they trumpeted their willingness to use any and all stylistic

methods and break any and all rules according to the dramatic needs of a scene. A moment might call for a Pasolini *and* an Eisenstein, a Hitchcock *and* a Dreyer. Without the inspirational example of their seat-of-the-pants exuberance and simultaneous iconoclasm and reverence when it came to film history, the stop-traffic combinations of realism and expressionism in the works of filmmakers like Martin Scorsese seem almost unthinkable.

But I love *The 400 Blows* for more than that. The New Wave's revolutionary methods and aims turned out to be perfectly suited to the rendering of that unstable mixture of mystery, delight, unhappiness, ambiguity, and just plain drift that seems to comprise childhood. We follow Antoine on his daily circuit of school and home, chores and hooky, keeping track of his escalating and unremarkable transgressions en route to his unhappy end at the Observation Center for Delinquent Minors. We pass along the way all sorts of seeming irrelevancies that are tossed off or unexplained— a boy rifling coat pockets in the hall while Antoine's being thrown out of class, or a life-size stuffed horse in the apartment of his best friend—and we begin to realize that the improvised quality of the narrative parallels the improvised quality of Antoine's life. Truffaut's dedication to spontaneity and improvisation brought him to children as a subject, just as his dedication to children returned him to spontaneity and improvisation. "Everything a child does on screen he seems to do for the first time" he once remarked (never having lived, of course, to witness Macaulay Culkin's work) and his ability to capture that quality of childhood is what allowed his "cinema of the first person singular," as he called it, to become for the audience the first person plural. The poor kid who keeps smearing ink during dictation and tearing out pages and falling farther and farther behind, the little boy so delighted by a puppet show that he keeps slapping his own face, or the stool pigeon who turns Antoine in to his parents, who's so incredibly geeky he wears swim goggles home from school: They all dare us, when considering them, to separate the comedy from the sadness, their possibilities from their predicaments.

Vittorio De Sica remarked about his *Bicycle Thieves* that "There are no small events when it comes to the poor." *The 400 Blows* makes the same claim about childhood. Throughout it, trivial events—a bit of parental manipulation, or an unexpected family outing to the movies—hurt, and

help, more than we ever would have guessed. The adults, overtaxed and selfish and oblivious, are outmaneuvered easily in the short run, but the rules ensure that if the kids win most of the battles, they lose the war. "I pity France in ten years," Antoine's teacher complains grimly, but as far as the audience is concerned, there's no reason to wait. While we watch, everyone from parent to judge to psychologist satisfies him- or herself that they've done what they can, and no more, and the children pay the price. The bas-relief adorning Antoine's school proclaims the sacred French triumvirate—Liberty, Fraternity, Equality—and summarizes neatly the three things he'll be denied.

About halfway through the movie, he takes a carnival ride on a centrifuge called the Rotor. Like just about everything else we see, the scene feels casually random and irrelevant and turns out to be neither. As a ride the Rotor's both wondrous and tacky. In fact, gross: Antoine takes a position a safe distance from what we have to assume are some old vomit stains. When the thing begins to spin, we see his point of view, and then him. Both images are apt, given his life: Everything hurtles by, and yet he's irrevocably stuck, pinned to the wall by this impersonal force. As he struggles, two things are immediately clear: He can't succeed, but he can enjoy himself. The riders whiz by fixed like butterflies on a tray. This is *fun*, though; it's exhilarating, a way to live. One of the butterflies, the sharp-eyed viewer notices, is Truffaut himself, riding along next to his alter ego, both of them arranged as self-conscious specimens for our examination. The huge revolving drum of the ride is a dead ringer for a zoetrope, that earliest forerunner of the movie camera, and once we really accelerate, the images from Antoine's point of view become the recognizably fluid frames of a swish pan. While we're considering the sadness and resiliency of kids exiled from schools and homes passing their time on tacky rides, in other words, we're also taking part in a celebration of moving images, a celebration that collides head-on, conceptually, with the movie's final image—maybe the ultimate *non*moving image in film history: that famous freeze-frame of Antoine, having escaped his delinquents' center and run to the sea, and having turned to face us.

That legendary freeze-frame is the movie's last successful attempt to pin him down and last unsuccessful attempt to figure him out. Much was

made, way back in 1959, of the ambiguity of such an ending: Where'd it leave poor Antoine? ("I avoided solving the problem by dramatizing it," Truffaut said, by way of explanation.) Much more should have been made of the other lesson filmmakers carried away from that moment. In a movie about the ways in which a boy's world could never bring itself to grant him adequate consideration, the final image forced an audience's focus on the heart of the matter. If there'd been any agenda at all to the previous 133 minutes, it had been to draw attention to the natural weight of importance that should accrue to that boy's face. That process culminated in the film's final gesture, which left us with *only* his face; or, to focus our attention even more, with only his face at one moment in time. Seventeen years after Simone Weil had written that "[a]ttention is the rarest and purest form of generosity," François Truffaut reminded us of the cinematic possibilities of that sort of gift, at least as far as children were concerned. The only close attention Antoine receives in his life, as far as we know, comes from us. Only through us can be he granted the attention he deserves.

CHARLES SIMIC

COPS

DIRECTED BY BUSTER KEATON
AND EDWARD CLINE

nly recently, with their issue on videotape, have all the films of Buster Keaton become widely available. It's likely that one may have seen *The General* in some college course or caught a couple of shorts at some museum retrospective of silent comedy, but such opportunities were rare or, for most moviegoers in this country, nonexistent. When Keaton's name came up, people who knew who he was would often say how much they preferred his laid-back

stoicism to Chaplin's sentimentality, admitting in the same breath that, regrettably, they had not seen one of his films in a long time.

I first heard about Buster Keaton from my grandmother, who was also of the opinion that he was the funniest of the silent movie comedians. This didn't make much sense to me at the time, since she described him as a man who never smiled, who always stayed dead serious while she and the rest of the audience screamed with delight. I remember trying to imagine his looks from what she told me, going so far as to stand in front of a mirror with a deadpan expression until I could bear it no longer and would burst out laughing. In the early post–World War II days in Belgrade, there was still a movie theater showing silent films. My grandmother took me to see Chaplin, Harold Lloyd, the cross-eyed Ben Turpin, but for some reason we never saw Keaton. "Is that him?" I would occasionally nudge her and whisper when some unfamiliar, somber face appeared on the screen. Weary of my interruptions, which disrupted her passionate absorption in films, one day upon returning home she produced a pile of old illustrated magazines. She made herself her customary cup of chamomile tea and started thumbing through the dusty issues, allowing me to do the same after she was through. I remember a black-and-white photograph of a sea of top hats at some king's or queen's funeral; another of a man lying in a pool of blood in the street; and the face of a beautiful woman in a low-cut party dress with partly exposed breasts watching me intently from a table at an elegant restaurant. My grandmother never found Keaton. It took me another seven years to actually see a film of his. By the time I did, my grandmother was dead, the year was 1953, and I was living in Paris.

Most probably I was playing hooky that afternoon, sneaking into a cinema when I should've been in class, but there was Buster Keaton finally on the screen, wearing a porkpie hat and standing on the sidewalk at the end of a long breadline. The line kept moving, but for some reason the two fellows standing in front of him did not budge. They were clothing store dummies, but Buster did not realize that. He took a pin out of his lapel, pricked one of the slowpokes, but still there was no reaction, while the line up ahead grew smaller and smaller as each man was handed a loaf of bread. Then Buster had an idea. He pricked himself to see if the pin worked. At

that moment the store owner came out, stuck his hand out to check for rain, took the two fully dressed dummies under his arms and carried them inside.

A few other gags have remained vivid in my memory from that first viewing of Keaton's shorts. In the one called *Cops*, Buster buys an old horse and a wagon. The horse is deaf and doesn't hear his commands, so he puts a headset over the horse's ears, sits in the driver's seat, and tries to telephone the horse. In another scene he pats the horse on the head and its false teeth fall out. In the short called *The Playhouse*, Keaton plays all the roles. He's the customer buying the ticket, the conductor of the orchestra and all his musicians, the nine tap dancers, the stagehands, and everyone in the audience, both the grownups and the children.

As for the appearance of Buster himself, everything about him was at odds. He was both strange looking and perfectly ordinary. His expression never changed, but his eyes were eloquent, intelligent, and sad at the same time. He was of small stature, compact, and capable of sudden astonishing acrobatic feats. Keaton, who was born in 1895 in a theatrical boardinghouse in Piqua, Kansas, started in vaudeville when he was three years old. His father, the son of a miller in Oklahoma, left his parents to join a medicine show. That's where he met his future wife. Her father was coproprietor of one such show. For the next twenty years they toured nationally, often in company of famous performers of the day, such as Harry Houdini. Eventually, the Three Keatons, as they were called, developed a vaudeville comic act that consisted of acrobatic horseplay centered on the idea of a hyper child and his distraught parents. Buster hurled things at his pop, swatting him with fly swatters and brooms while his father swung him around the stage by means of a suitcase handle strapped to the boy's back. What looked like an improvised roughhouse was really a carefully planned series of stunts. The point is worth emphasizing, since it is with such and similar acts in vaudeville that silent film comedy stagecraft originates.

The first principle of Keaton's comic persona is endless curiosity. Reality is a complicated machine running in mysterious ways, whose working he's trying to understand. If he doesn't crack a smile, it's because he's too preoccupied. He is full of indecision, and yet he appears full of pur-

pose. "A comic Sisyphus," Daniel Mowes called him. OUR HERO CAME FROM NOWHERE, a caption in *High Sign* says, continuing: HE WASN'T GOING ANY-WHERE AND GOT KICKED OFF SOMEWHERE. Bedeviled by endless obstacles, Buster is your average slow-thinking fellow, seeking a hidden logic in an illogical world. "Making a funny picture," he himself has said, "is like assembling a watch: you have to be 'sober' to make it tick."

In the meantime my mother, brother, and I were on the move again. We left Paris for New York. A few years later I was back as an American soldier in France. It turned out that they were still showing Keaton films in small cinemas on the Left Bank. That's when I saw most of the shorts and a few of the full-length films like *The General* and *The Navigator*. Since there always seemed to be a Keaton festival in Paris, a day would come when I would take my children to see the films. They loved them and made me see the gags with new eyes, since they often noticed comic subtleties I had missed.

"A good comedy can be written on a postcard," Keaton said. A comic story told silently, that even a child can enjoy, we should add. Is it the silence of the image that frees the comic imagination? Of course. Think of cartoons. In silent films we can't hear the waves, the wind in the leaves, the cars screeching to a halt, the guns going off, so we fill in the sound. For instance, in Keaton's full-length film *Seven Chances*, a man learns that his grandfather is leaving him seven million dollars providing he is married before seven o'clock in the evening on his twenty-seventh birthday—which just happens to be that day. He proposes to every woman he knows and is rebuffed, places an ad in the afternoon paper, explaining his predicament and promising to be in church at five that afternoon. Several hundred prospective brides, old and young, show up wearing bridal gowns, one of them even arriving on roller skates. The prospective bridegroom runs for his life, and the brides stampede after him through busy downtown Los Angeles. All of us who saw the movie can still hear the sound of their feet.

In an essay entitled "How to Tell a Story," Mark Twain makes the following observations: "To string incongruities together in a wandering and sometimes purposeless way, and seem innocently unaware that they are absurdities, is the basis of American art. Another feature is the slurring of

the point. A third is the dropping of a studied remark apparently without knowing it, as if one were thinking aloud. The fourth and the last is the pause."

Twain explains what he means. "The pause is an exceedingly important feature in any kind of story, and a frequently recurring feature, too. It is a dainty thing, a delicate thing, and also uncertain and treacherous; for it must be exactly the right length—no more and no less—or it fails of its purpose and makes trouble. If the pause is too short, the important point is passed and the audience have had the time to divine that a surprise is intended—and then you can't surprise them, of course."

Comedy is about timing, faultless timing. It's not so much what the story is about, but the way it is told, with its twists and surprises, that makes it humorous. With chalk Keaton draws a hook on the wall and hangs his coat on it. A brat in the theater drops his half-sucked lollipop from the balcony on an elegant lady in a box, who picks it up and uses it as a lorgnette. The hangman uses a blindfold intended for the victim to polish the medal on his jacket. The shorts, especially, are full of such wild inventions. No other silent film comic star was as ingenious. Among hundreds of examples from Keaton's films, one of my favorites comes from *Cops*. At the annual New York City policemen's parade, Buster and his horse and wagon find themselves in the midst of the marching cops. Buster wants to light a cigarette, is searching his pockets for matches, when a bomb thrown from a rooftop by an anarchist lands next to him on the seat, with its short fuse already sizzling. There's a pause, "an inspiring pause," as Twain says, building itself to a deep hush. When it has reached its proper duration, Buster absentmindedly picks up the bomb, lights his cigarette with it, and, as if it were the most normal thing to do, throws it back over his head.

Cops is paradigmatic Keaton. Again the plot is simplicity itself. In the opening scene we see Buster behind bars. The bars turn out to belong to the garden gate to the house of a girl he is in love with. "I WON'T MARRY YOU TILL YOU BECOME A BUSINESSMAN," she tells him. Off he goes, through a series of adventures, first with a fat police detective in a rush to grab a taxi, the contents of whose wallet end up in Buster's hands. Next he is conned by a stranger who sells him a load of furniture on the sidewalk, pretending

that he is a starving man being evicted. The actual owner of the furniture and his family are simply moving to another location. When Buster starts to load the goods into the wagon he has just bought, the owner mistakes him for the moving man they've been expecting. His trip across town through the busy traffic culminates when he finds himself at the head of the police parade passing the flag-draped reviewing stand where the chief of police, the mayor, and the young woman he met at the garden gate are watching in astonishment. Still, the crowd is cheering, and he thinks it's for him. After he tosses over the anarchist's bomb and it explodes, all hell breaks loose. "GET SOME COPS TO PROTECT OUR POLICEMEN," the mayor orders the chief of police. People run for cover, the streets are empty, the entire police force takes after the diminutive hero. What an irony! It all started with love and his desire to better himself and impress the girl he adores, and all he got in return was endless trouble. It's the comic asymmetry between his extravagant hope and the outcome that makes the plot here. The early plot of the movie, with its quick shuffle of gags, gives the misleading impression of a series of small triumphs over unfavorable circumstances. Just when Buster thinks he has finally conquered his bad luck, disaster strikes again. The full force of law and order, as it were, descends on his head. Innocent as he is, he is being pursued by hundreds of policemen. Whatever he attempts to do—all his stunts and clever evasions—come to nothing because he cannot outrun his destiny. After a long chase he ends up, unwittingly, at the very door of a police precinct. The cops are converging on him from all sides like angry hornets, blurring the entrance in their frenzy to lay their nightsticks on him, but incredibly Buster crawls between the legs of the last cop, he himself now dressed in a policeman's uniform. Suddenly alone on the street, he pulls a key out of his pocket, locks the precinct's door from the outside, and throws the key into a nearby trashcan. At that moment the girl he is smitten with struts by. He looks soulfully at her, but she lifts her nose even higher and walks on. Buster hesitates a moment, then goes to the trashcan and retrieves the key. "No guise can protect him now that his heart has been trampled on," Gabriella Oldham says in her magnificent study of Keaton's shorts. At the end of the film, we see him unlocking the door and being pulled by hundreds of policemen's hands into the darkness of the building.

In this and his other films, what makes Keaton unforgettable is the composure and dignity he maintains in the face of what amounts to a deluge of misfortune. It's more than anyone can bear, we think. Still, since it's the American dream Buster is pursuing, we anticipate a happy ending or at least that the hero has a melancholy air. When a lone tombstone with Buster's porkpie hat resting on it accompanies THE END in *Cops*, we are disconcerted. The image of him running down the wide, empty avenue or of his feeble attempt to disguise himself by holding his clip-on tie under his nose to simulate a moustache and goatee is equally poignant. Let's see if we can make our fate laugh, is his hope. Comedy at such a high level says more about the predicament of the ordinary individual in the world than tragedy does. If you seek true seriousness and you suspect that it is inseparable from laughter, then Buster Keaton ought to be your favorite philosopher.

SUSAN SONTAG

BERLIN ALEXANDERPLATZ

DIRECTED BY RAINER WERNER FASSBINDER

We take it for granted that film directors are, if they so wish, in the game of recycling. Adapting novels is one of the most venerable types of movie projects, although a book that calls itself the "novelization" of a film seems, rightly, barbarous. Being a hybrid art as well as a late one, film has always been in a dialogue with other narrative genres. Movies were first seen as an exceptionally potent kind of illusionist theater, the rectangle of the screen corresponding to the proscenium of a stage, on which appear—actors.

Starting in the early silent period, plays were regularly "turned into" films. But filming plays did not encourage the evolution of what truly was distinctive about a movie: the intervention of the camera—its mobility of vision. As a source of plot, character, and dialogue, the novel, being a form of narrative art that (like movies) ranges freely in time and space, seemed more suitable. Many early successes of cinema (*The Birth of a Nation, The Four Horsemen of the Apocalypse, Ramona, Stella Dallas, It*) were adaptations of popular novels. The 1930s and 1940s, when movies attained their largest audience and had an unprecedented monopoly on entertainment, were probably the heyday of novel-into-film projects—the sleek Hollywood classic-comics of the novels by the Brontë sisters or Tolstoy being no more or less ambitious, as films, than those adapted from such bestsellers as *Gone With the Wind, Lost Horizon, Rebecca, The Good Earth, Gentleman's Agreement.* The presumption was that it was the destiny of a novel to "become" a film.

Since the film that is a transcription of a novel is riding piggyback on the reputation and interest of the novel, comparisons are inevitable. And now that movies have ceased to have a monopoly on entertainment, standards have risen. Who can see the films made from *Lolita* or *Oblomov* or *The Trial* without asking if the film is adequate to the novel—the making of invariably invidious comparisons depending on whether or not the novel belongs to literature. Even a merely very interesting novel, like Klaus Mann's *Mephisto*, turns out to be far richer, more complex than the film. It seems almost in the nature of film—regardless of the film's quality—to abridge, dilute, and simplify any good novel that it adapts. In fact, far more good movies have been made from good plays than from good novels—despite the view that such films tend to be static and thereby go against the grain of what is distinctly cinematic.

Certain directors of the 1930s and 1940s like Wyler, Stevens, Lean, and Autant-Lara were particularly drawn to good-novel-into-movie projects—as have been, more recently, Visconti, Losey, and Schlöndorff. But the failure rate has been so spectacular that since the 1960s the venture has been considered suspect in certain quarters. Godard, Resnais, and Truffaut declared their preference for subliterary genres—crime and adventure novels, science fiction. Classics seemed cursed: It became a dic-

tum that cinema was better nourished by pulp fiction than by literature. A minor novel could serve as a pretext, a repertoire of themes with which the director is free to play. With a good novel there is the problem of being "faithful" to it. Visconti's marvelous first film, *Ossessione*—adapted from James M. Cain's *The Postman Always Rings Twice*—is a far nobler achievement than his handsome, respectful transcriptions of *The Leopard* or his stiff, rather absent version of Camus's *The Stranger*. Cain's melodrama did not have to be "followed."

There is also the obstacle posed by the length of the work of fiction, not just by its quality as literature. Until this past winter I had seen only one film adaptation of a literary work I thought entirely admirable: a Russian film, *The Lady with the Little Dog*, made from a short story by Chekhov. The standard, and arbitrary, length of feature films is about the time in which one can render a short story or a play. But not a novel— whose nature is expansiveness. To do justice to a novel requires a film that is not just somewhat longer than an hour and a half to two hours (a length that has, anyway, been stretching in the last two decades) but a radically long film—one that breaks with the conventions set by theatergoing. This was surely the conviction of Erich von Stroheim when he attempted his legendary, aborted adaptation of *McTeague*, called *Greed*. Stroheim, who wanted to film all of Frank Norris's novel, had made a film of ten hours, which the studio had reedited and eventually reduced to two hours and forty-five minutes (ten reels out of Stroheim's forty-two); the negative of the thirty-two reels of discarded footage was destroyed. The version of *Greed* that survived this butchery is one of the most admired films ever made. But movie lovers will be forever in mourning for the loss of the ten-hour *Greed* that Stroheim edited.

Fassbinder has succeeded where Stroheim was thwarted—he has filmed virtually all of a novel. More: He has made a great film of, and one faithful to, a great novel—although, if in some Platonic heaven, or haven, of judgments, there is a list of the, say, ten greatest novels of the twentieth century, probably the least familiar title on it is *Berlin Alexanderplatz* by Alfred Döblin (1878–1957). Stroheim was not allowed to make a film of ten hours. Fassbinder, thanks to the possibility of showing a film in parts, on television, was allowed to make a film of fifteen hours and

twenty-one minutes. Inordinate length could hardly assure the successful transposition of a great novel into a great film. But though not a sufficient condition, it is probably a necessary one.

Berlin Alexanderplatz is Fassbinder's *Greed* not only in the sense that Fassbinder succeeded in making *the* long film, the great film of a novel, but also because of the many striking parallels between the plot of *Berlin Alexanderplatz* and the plot of *Greed*. For, indeed, the American novel, published in 1899, tells a primitive version of the story related in the German novel, published thirty years later, which has a much thicker texture and greater range. Writing in San Francisco at the end of the last century, the youthful Frank Norris had Zola as a model of a dispassionate "naturalism." The far more sophisticated Döblin, already in midcareer (he was fifty-one when *Berlin Alexanderplatz* was published) and writing in the century's single most creative decade in the arts, had the inspiration (it is said) of Joyce's *Ulysses*, as well as the expressive hypernaturalist tendencies in German theater, film, painting, and photography with which he was familiar. (In 1929, the same year that *Berlin Alexanderplatz* appeared, Döblin wrote an elegant essay on photography as the preface to a volume of work by the great August Sander.)

A burly, sentimental, naive, violent man, both innocent and brute, is the protagonist of both novels. Franz Biberkopf is already a murderer when *Berlin Alexanderplatz* starts—he has just finished serving a sentence of four years for killing the prostitute with whom he lived, Ida. The protagonist of *McTeague* eventually kills a woman, his wife, Trina. Both novels are anatomies of a city, or part of it: San Francisco's shoddy Polk Street in Norris's novel and the Berlin district of workers, whores, and petty criminals in Döblin's novel are far more than the background of the hero's misfortunes. Both novels open with a depiction of the unmated hero afoot and alone in the city—McTeague following his Sunday routine of solitary walk, dinner, and beer; Biberkopf, just discharged from prison, wandering in a daze about the Alexanderplatz. A former car boy in a mine, McTeague has managed to set himself up in San Francisco as a dentist; by the middle of the novel he is forbidden to practice. The ex-pimp Biberkopf tries to earn his living honestly in a series of menial jobs, but when he can no longer work (he loses his right arm), the woman he loves goes on the street to support them.

In both novels, the downfall of the protagonist is not just bad luck or circumstantial, but it is engineered by his former best friend—Marcus in *McTeague*, Reinhold in *Berlin Alexanderplatz*. And both pairs of friends are studies in contrasts. McTeague is inarticulate; Marcus is hyperverbal—a budding political boss, spouting the clichés of reactionary populism. Biberkopf, who has vowed on coming out of prison to go straight, is not inarticulate; Reinhold belongs to a gang of thieves and is a stutterer. The gullible hero is obtusely devoted to the secretly malevolent friend. In Norris's novel, McTeague inherits—with Marcus's permission—the girl Marcus has been courting and marries her, just as she wins a large sum of money in a lottery; Marcus vows revenge. In *Berlin Alexanderplatz*, Biberkopf inherits—on Reinhold's urging—a number of Reinhold's women: and it is when he refuses to discard one ex-girl of Reinhold's as the next is ready to be passed on to him that Reinhold turns treacherous. It is Marcus who has McTeague deprived of his livelihood and fragile respectability: He reports him to the city authorities for practicing dentistry without having a diploma, and the result is not only destitution but the ruin of his relation to his already deranged, pathetic wife. It is Reinhold who puts an atrocious end to Biberkopf's valiant efforts to stay honest, first tricking him into taking part in a burglary and then, during the getaway, pushing him out of the van into the path of a car—but Biberkopf, after the amputation of his arm, is strangely without desire for revenge. When his protector and former lover Eva brings the crippled Biberkopf out of his despair by finding him a woman, Mieze, with whom he falls in love, Reinhold, unable to endure Biberkopf's happiness, seduces and murders Mieze. Marcus is motivated by envy; Reinhold by an ultimately motiveless malignity. (Fassbinder calls Biberkopf's forbearance toward Reinhold a kind of "pure," that is, motiveless, love.)

In *McTeague* the fatal bond that unites McTeague and Marcus is depicted more summarily. Toward the end of the novel Norris removes his characters from San Francisco: The two men find each other in the desert, the landscape that is the city's pure opposite. The last paragraph has McTeague accidentally handcuffed to Marcus (whom he has just killed, in self-defense), in the middle of Death Valley, "stupidly looking around him," doomed to await death beside the corpse of his enemy/friend. The

ending of *McTeague* is merely dramatic, though wonderfully so. *Berlin Alexanderplatz* ends as a series of arias on grief, pain, death, and survival. Biberkopf does not kill Reinhold, nor does he die himself. He goes mad after the murder of his beloved Mieze (the most lacerating description of grief I know in literature), is confined to a mental hospital; and when released, a burnt-out case, finally lands his respectable job, as night watchman in a factory. When Reinhold is eventually brought to trial for Mieze's murder, Biberkopf refuses to testify against him.

Both McTeague and Biberkopf go on savage, character-altering alcoholic binges—McTeague because he feels too little, Biberkopf because he feels too much (remorse, grief, dread). The naive, virile Biberkopf, not stupid but oddly docile, is capable of tenderness and generosity, as well as real love, for Mieze; in contrast to what McTeague can feel for Trina: abject fascination, succeeded by the stupor of habit. Norris denies hulking, pitiable, semiretarded McTeague a soul; he is repeatedly described as animal-like or primitive. Döblin does not condescend to his hero—who is part Woyzeck but part Job. Biberkopf has a rich, convulsive inner life; indeed, in the course of the novel he acquires more and more understanding, although this is never adequate to events, to the depth or the gruesome specificity of suffering. Döblin's novel is an educational novel, and a modern *Inferno*.

In *McTeague* there is one point of view, one dispassionate voice— selective, summarizing, compressive, photographic. Filming *Greed*, Stroheim is said to have followed Norris's novel paragraph by paragraph— one can see how. *Berlin Alexanderplatz* is as much (or more) for the ear as for the eye. It has a complex method of narration: free-form, encyclopedic, with many layers of narrative, anecdote, and commentary. Döblin cuts from one kind of material to another, often within the same paragraph: documentary evidence, myths, moral tales, literary allusions—in the same way as he shifts between slang and a stylized lyrical language. The principal voice, that of the all-knowing author, is exalted, urgent, anything but dispassionate.

The style of *Greed* is anti-artificial. Stroheim refused to shoot anything in studio, insisting on making all of *Greed* in "natural" locations. More than a half-century later, Fassbinder has no need to make a point about

realism or about veracity. And it would hardly have been possible to film in the Alexanderplatz, which was annihilated in the bombing of Berlin during World War II. (It would be in what is now East Berlin.) Most of *Berlin Alexanderplatz* looks as if it were shot in a studio. Fassbinder chooses a broad, familiar stylization: illuminating the principal location, Biberkopf's room, by a flashing neon sign on the street; shooting often through windows and in mirrors. The extreme of artificiality, or theatricality, is reached in the sequences in the circuslike street of whores, and in most of the two-hour epilogue.

Berlin Alexanderplatz has the distension of a novel—but it is also very theatrical, as are most of Fassbinder's best films. Fassbinder's genius was in his eclecticism, his extraordinary freedom as an artist: He was not looking for the specifically cinematic, and borrowed freely from theater. He began as the director of a theater group in Munich, directed almost as many plays as movies, and some of his best films are filmed plays, like his own *The Bitter Tears of Petra von Kant* and *Bremen Freedom*, or take place mostly in one interior, such as *Chinese Roulette* and *Satan's Brew*. In a 1974 interview Fassbinder described his first years of activity thus: "I produced theater as if it were film, and directed film as if it were theater, and did this quite stubbornly." Where other directors, adapting a novel to a film, would have thought to abridge a scene because it went on too long, and thereby became (as they might fear) static, Fassbinder would persist, and insist. The theatrical-looking style that Fassbinder devised helps him stay close to Döblin's book.

Apart from the invention of one new character—an all-forgiving mother figure, Biberkopf's landlady Frau Bast—most of the changes Fassbinder has made in the story simply render the action more compact visually. In the novel Biberkopf does not always live in the same one-room apartment as he does in the film, and Fassbinder sets events there that in the novel take place elsewhere. For example, in the novel Franz kills Ida at her sister's place; in the film, the gruesome battering—which we see in repeated, hallucinatory flashback—takes place in Biberkopf's room, witnessed by Frau Bast. In the novel, Biberkopf doesn't live with all the women with whom he takes up; in the film they each, one by one, move into his place, reinforcing the film's visual unity, but also making the rela-

tionships that precede Biberkopf's union with Mieze perhaps a bit too cozy. The women seem more whores-with-hearts-of-gold than they do in the book. One last invention: It is hard not to suspect that the canary in a cage Mieze gives Biberkopf (such a gift is just mentioned, once, in Döblin's novel), which we see Biberkopf doting on, and is often shot in many of the scenes that take place in Biberkopf's room, is a reincarnation of the canary that is McTeagues's most cherished possession, the only thing he salvages from his wrecked domestic felicity, and still by his side "in its little gilt prison" when his doom is sealed in the desert.

Fassbinder's cinema is full of Biberkopfs—victims of false consciousness. And the material of *Berlin Alexanderplatz* is prefigured throughout his films, whose recurrent subject is damaged lives and marginal existences—petty criminals, prostitutes, transvestites, immigrant workers, depressed housewives, and overweight workers at the end of their tether. More specifically, the harrowing slaughterhouse scenes in *Berlin Alexanderplatz* are anticipated by the slaughterhouse sequence in *Jail Bait* and *In a Year of 13 Moons*. But *Berlin Alexanderplatz* is more than a résumé of his main themes. It was the fulfillment—and the origin.

In an article he wrote in March 1980, toward the end of the ten months it took to film *Berlin Alexanderplatz*, Fassbinder declared that he had first read Döblin's novel when he was fourteen or fifteen, and had dreamed of making it into a film from the beginning of his career. It was the novel of his life—he described how his own fantasies had been impregnated by the novel—and its protagonist was Fassbinder's elected alter ego. Several heroes of his films were called Franz; and he gave the name of Franz Biberkopf to the protagonist of *Fox and his Friends*, a role he played himself. It is said that Fassbinder would have liked to play Biberkopf. He did not; but he did something equally appropriate. He became Döblin: His is the voice of the narrator. Döblin is omnipresent in his book, commenting and lamenting. And the film has a recurrent voice-off, the voice of the novel, so to speak—and Fassbinder's. Thus we hear many of the parallel stories, such as the sacrifice of Isaac, related in the novel. Fassbinder preserves the extravagant ruminating energy of the novel, but without breaking the narrative stride. The ruminating voice is not used as an antinarrative device, as in Godard's films, but to intensify the narrative; not to

distance us but to make us feel more. The story continues to evolve, in the most direct, affecting way.

Berlin Alexanderplatz is not outside the norms of film narratives, like Godard's cinema. It is not a meta-film, like Hans-Jürgen Syberberg's *Hitler*; Fassbinder has nothing of Syberberg's aesthetic of the grandiose, for all the length of *Berlin Alexanderplatz*, or his reverence for high culture. It is a narrative film . . . but one that is *that* long: a film that tells a story, in decors of the period (the late 1920s), with more than a hundred actors (many roles are taken by actors from Fassbinder's regular troupe) and thousands of extras. A fifty-three-year-old theater actor who has had minor roles in a few of Fassbinder's films, Günther Lamprecht, plays Franz Biberkopf. Splendid as are all the actors, particularly Barbara Sukowa as Mieze and Hanna Schygulla as Eva, Lamprecht's Biberkopf overshadows the others—an intensely moving, expressive, brilliantly varied performance, as good as or better than anything done by Emil Jannings or by Raimu.

Though made possible by television—it is a coproduction of German and Italian TV—*Berlin Alexanderplatz* is not a TV series. A TV series is constructed in "episodes," which are *designed* to be seen at an interval—one week being the convention, like the old movie serials (*Fantômas, The Perils of Pauline, Flash Gordon*) which were shown every Saturday afternoon. The parts of *Berlin Alexanderplatz* are not really episodes, strictly speaking, since the film is diminished when seen in this way, spaced out over fourteen weeks (as I saw it for the first time, on Italian TV). Presentation in a movie theater—five segments of approximately three hours each, over five consecutive weeks—is certainly a better way to see it. Seeing it in, say, three or four consecutive days would be far better. The more one can watch over the shortest time works best, exactly as one reads a long novel with maximum pleasure and intensity. In *Berlin Alexanderplatz*, cinema, that hybrid art, has at last achieved some of the dilatory, open form and accumulative power of the novel by being longer than any film has dared to be—and by being theatrical.

ROBERT STONE

THE KRAYS

DIRECTED BY PETER MEDAK

I n his autobiography, *A Child of the Century*, Ben Hecht more or less claimed to have invented the gangster movie with his 1928 script for *Underworld*. Hecht drew on his experience as a Chicago newspaperman to create a form that was to prove even more durable than the Western. Sometime during the sixties, a fatal combination of lost confidence and self-consciousness hit the Hollywood Western like Dutch elm disease, leaving a few stunted or potted curiosity pieces but generally sweeping the genre away, apparently beyond recall. However, the gangster movie, in various

modes, continued to flourish. That may have been because what happened in gangster movies bore a greater relevance to "real life" than the stylized moralizing that informed Westerns. On the other hand, it's questionable whether verisimilitude was ever all that important, either to the quality of pictures or to audience taste. In any case, organized crime has provided a rich and reliable source of filmic invention for more than sixty years.

The gangster movie, like every genre, has passed through various phases with changing times. The social realism and class consciousness behind the Warner Brothers crime sagas of the thirties has been extensively examined. The forties produced a few movies that look distinctly peculiar today. At approximately the time when Bugsy Siegel and his cohorts were setting up their scene in Las Vegas and frequenting Hollywood night spots like the Mocambo and Romanoff's, movies like *Mr. Lucky* and *The Strange Love of Martha Ivers* introduced a character who might be described as the "good gangster." The good gangster, the Cary Grant character in *Mr. Lucky*, for example, or Van Heflin in *Martha Ivers*, was not a misunderstood proletarian head breaker like James Cagney in *The Roaring Twenties*; he was a virtuous knight errant. His profession was usually described as that of "gambler," with the inference that he made his way through life on good fortune. When he stooped to violence, which of course he regularly did, it was invariably a case of saving the heroine from dastards, or in self-defense. Plots involved battles between good and bad gangsters just as the contemporary swashbucklers pitted good pirates against bad ones. Lucky Luciano was said to have been so pleased with *Mr. Lucky* and its cornball pieties that he regarded it as the film industry's homage to his career.

During the fifties, gangster movies often paid less attention to the mob types than to the wholesome cops who pursued them. Unlike the seedy police hacks of the thirties pictures, fifties films portrayed incorruptible and well-spoken young officers who were usually equipped with the cute little wives and suburban kitchens so esteemed in that period. The mobsters were overdressed greaseballs, pathetically craving respectability, who lost it all in the end and showed not a grain of grace under pressure. With the Vietnam years, gangster movies became a vehicle for the chastisement of corporate Amerika, usually under the auspices of such revolutionary outfits as Gulf & Western or the Transamerica Corporation.

Every so often a season's films seem to guarantee that the genre will carry on, renewed by the skill and invention of some of the more original talents presently at work. In 1990 *The Krays* represented Peter Medak's first American release since *The Men's Club* in 1985, although most film-goers more readily recalled his 1971 film, *The Ruling Class*, with Peter O'Toole. *The Krays* is in some ways a less adventurous exercise than the grim, brilliant comedy of *The Ruling Class* but it's no less sparing of audience complacency. Its plot concerns a pair of gangsters, twins from Bethnal Green in London's proletarian East End, who dominated the city's rackets during the 1960s and who today are in prison. What it's about is another story.

It is not particularly about the London underworld, concerning which it offers neither insights nor much information. The naive filmgoer could reasonably mistake Reg and Ronnie Kray for a pair of unreasonably contentious and incredibly violent restaurateurs. Nor, in spite of first impressions, is it about urban poverty and alienation. The East End world of clubs and council houses is visually sanitized and tidy, translated almost into surrealism. In spirit *The Krays* is a world away from the varieties of traditional film naturalism that its subject suggests. There are no nervous documentary street scenes, nor is there any of the sweaty socially conscious theatricality in which ambitious gangster movies used to indulge.

Much of what goes on seems to be about love—between the brothers themselves; between the brothers and their savage, willfully protective mother; between them and their weird, doting Aunt Rose; between Reggie Kray and the unfortunate young woman who marries him. Love, not poverty, squalor, or wartime deprivation seems to be what's making everybody crazy. The Krays are not stoical or inchoate; as a family they're ready to talk about how they feel and to act it out. For Ronnie and Reg this means stomping the bejesus out of any representative of the outside, non-Kray world incautious or unlucky enough to be convenient. The outside world responds to this behavior, in the short run at least, by providing them with wealth and reputation.

So concerned is the narrative with relationships that the surface structures sometimes appear downright soap-operatic. There are births, bereavements, and weddings that involve apparently emotional, volatile people.

There is much sighing, reflection, and taking stock, which—though it can sound at times like conventional movie sentimentality—seems actually to capture the rhythms of sociopathic mimicry. In fact, whatever the faults of *The Krays*, sentimentality is not one of them. A less heartwarming collection of colorful Cockneys never drew cinematic breath.

At a certain point in *The Krays*, it becomes apparent that its subjects exist on a plane beyond the normal run of human pathology. Beady-eyed as sparrows and about as genuinely introspective, they are constitutionally heartless, more nonhuman than inhuman, less alive than undead. Their chief animating force is a kind of predatory alertness that gives a new dimension to the concept of us and them.

Extremely contemporary in style, *The Krays* actually takes the audience back in time. If the East End of London today is a vanishing link with the brutal, murky London of the past, so the story of the East End Kray brothers links the London of the Beatles with that of Jack the Ripper, a neighborhood hero, whose legend figures in the film. The Ripper's story obviously holds some fascination for Medak, since he also used it prominently in *The Ruling Class*.

Performances are universally excellent. Gary and Martin Kemp of the British musical group Spandau Ballet are fascinating as the brothers. Billie Whitelaw, arch-interpreter of Samuel Beckett's work, is all too believable as the formidable Mother Kray. Susan Fleetwood is a memorable Aunt Rose.

Life-into-legend is the true subject of *The Krays*. The film begins and ends with the bleached image of a swan in flight, accompanied by the voice of the twins' mother crooning a homemade fairy tale about their quasi-miraculous birth. Rather than subjecting it to social analysis or existential speculation, Medak places the story of the brothers Kray in the ancient tradition of foggy London lore, with the stuff of street ballad, chapbook, and penny dreadful. The twins take their place as sacred monsters with the likes of the Ripper, Fagin, and Mack the Knife. The world invoked by the film is as pre-Freudian and pre-Marxist as the work itself is post-Freudian and post-Marxist—intelligent, cruel, and very violent.

ELLEN BRYANT VOIGT

ON CHINATOWN

DIRECTED BY ROMAN POLANSKI

Jack Nicholson has made a career of seducing us, making us like unlikable characters; in *Chinatown* he gets a lot of help from his director, Roman Polanski, and the enormous wad of cotton on his nose.

We see the bandage first full frontal, and the way it is strapped to his cheeks, with crisscrossed pieces of tape, suggests a muzzled dog. The camera gives us all the time we need, lingering in close. A white clown's nose,

in profile a scavenger's beak, it overwhelms his face—and it's hilarious, of course, as image and as metaphor (he's a snoop-for-hire—*get it?*). We deserve a few good *yuks* after the preceding scene, and we're happy to get them at Nicholson's expense. He has, in the film's opening third, played Jake Gittes to type: bantamweight, cocky, overdressed, tightly wound, a professional liar and arrogant sleaze. His introduction to Evelyn Mulwray (the never more erotic Faye Dunaway) reinforces this view: She remains composed and elegant in the background, wearing one of her terrific hats, as he persists in repeating (and guffawing over) a crude and only mildly funny ethnic joke. Meanwhile the narrative structure itself forfeits complex or carefully nuanced character—in the first forty minutes there are more than a dozen changes of scene, indoors and out, day and night, with three plot reversals, two threatened fistfights, and one dead body. Suddenly Jake is swept up into something larger and darker. There is no musical score (such cues have been rare so far), only two rifle shots in the dark, the sound of water pouring through the opened sluice, and Jake's scramble up a metal fence and out of the way. Then the previously introduced, previously baited goon, Mulvihill, pins his arms while the *real* professional (Polanski, in another brilliant bit of casting) slices his nose.

"Next time, you lose the whole thing. [I] cut it off and feed it to my goldfish. Understand? *Understand?*" It's generic tough talk to end the scene but also, like a Freudian slip, an unremarked clue to Jake's eventual revelations, mistaken (that Evelyn Mulwray has killed her husband) and true (that Noah Cross, her father, has). Still flinching from the knife, we don't connect the dialogue to the goldfish pond we saw earlier, in the first of the movie's two longest scenes (both at Mulwray's house), or to the unidentified object we saw glinting there in the water, a quick visual with its own verbal clue: "Bad for glass," the Asian gardener told Jake, hauling out a clump of ruined vegetation. We register what's said and what's seen but make no links between them.

In truth we're not about to trust anything we're *told*. The first "Evelyn Mulwray" (Diane Ladd) was an imposter, the real Evelyn Mulwray has lied to the police and to Jake, Jake has lied to Mulwray's secretary, to Mulwray's colleague and to the cops as blithely as he will steal from the Hall of Records, misrepresent himself at the rest home, and try to trick Noah

Cross (John Huston, in a small role famously enlarged), who apparently lies to everyone. Even proper names wobble: "Gittes" is *mis*pronounced two different ways, "Albacore" is distorted into "apple core," the dead turn up on deeds of sale, and "the girl" is left nameless for most of the movie.

Language also has been, from the beginning, contrasted with *evidence*, like the photographs of Cross and Mulwray arguing. The movie has opened on covert shots by Gittes's "operatives"—proof of infidelity by Curly's wife—and Jake on his new assignment has gathered similar "proof" against Hollis Mulwray and the girl. The stills of the boat, the apartment, and the new dress accurately record a tenderness, but Jake misreads and mislabels it. That false assumption of adultery will stand unchallenged until the film's final ten minutes, when it is overturned not by the clarification language provides but by its failure.

For such a bleak, disturbing movie, there is surprisingly little onscreen violence in *Chinatown*. The tone, and the dramatic tension, come instead from incipience, "what [we are] capable of." Jake is a self-confessed "snoop," but the punishment fits that crime only in a context either broadly comic or vastly appalling, alternatives suggested equally by the disproportion of the bandage. Its hyperbolic cover-up in fact recalls the painful injury and extends it, carrying that violence forward to the next enactments, the fights in the orange grove and at the rest home, spaced out at ten-minute intervals. In this middle third of the movie, as "Mr. Smith Goes to The Valley," the bandage brilliantly undercuts the pretensions of the quest narrative even as it provides a credential for our protagonist in that role. As he moves out into a larger geographical setting, and into greater risk, the irritating bit player becomes our agent, our proxy, a man put upon and aroused to justice, a man who wants "the truth" and is determined to have it. Meanwhile, of course, Jack Nicholson is no Jimmy Stewart (and "No question from you is innocent, Mr. Gittes"). The visual playfulness of the bandage enlivens the development section of one plot line (economic greed) and, like the magician's visible hand, distracts us from the other.

It is also worth noting that the bandage shrinks over the next forty minutes. By the orange grove fight, it is a square patch strapped to the left side of his nose, the better to bleed through and under. And by the time

Jake has gotten rid of it altogether, he has been rescued twice by Evelyn Mulwray, and she gets to ask the questions. This second of three important scenes at her house is the longest in the film, and wonderfully framed by Evelyn's fancy car and the haunting trumpet solo (reappearing from the opening credits). Giddy with danger, they'll sleep together, of course. But first—the sex must be neither comic nor ironic—the bandage comes off ("I had no idea," she says, looking at the ugly wound), and he notices "something black in the green part" of her eye. Postcoital they're both visually exposed, and Jake, as guarded and evasive as Evelyn, makes a glancing reference to Chinatown, "where you can't always tell what's going on." This is the place in the movie where what's said and what's seen, language and image, are most consonant. But the telephone call precludes any elaboration and divides the pair irrevocably. As the scene ends and the faster pace resumes, Evelyn's car is now in front of us, and Jake tails it easily, having knocked out one taillight in what is just the first of his damaging betrayals.

The bandage also comes off because Polanski no longer needs it. From here on, and in contrast to the opening third of the film, he scores the action liberally, alternating percussive piano, woodblock, and plucked harp for suspense with *tremolo* violins, treble piano, strummed harp, and trumpet in the love theme's dramatic Puccini-esque seconds and sevenths. At the same time, since the badly healing cut is handily located at the side of one nostril, the camera angle can display or hide it, as needed; in several backlit profile shots, one can count the bristling stitches.

In *Chinatown* it's not simply appearances versus reality. Things *are* what they seem: elusive, paradoxical, inexplicable. In the film's final action sequence, in a failed effort to stop his granddaughter's screams of terror and comprehension, Noah Cross will try clumsily to cover her eyes with his hand. Our pair of eyes has been Jake. In the first action sequence, he sees Mulwray clearly through binoculars, but what he sees "makes no sense." So he squints, and sees a partial truth. Polanski gives us plenty of warning signals—the camera, the rearview mirror, the magnifying glass (in Mulwray's drawer), the smashed bifocals fished from the pond, the single taillight, Curly's wife's black eye.

In the film's middle, when his nose was bandaged, "Our Man in LA"

pursued his quarry rationally, logically. In the last third, Polanski uncovers the bully in his terrier-after-the-rat. Unwrapped, unmuzzled, he's free again to "follow his nose" to answers not "contrary to my experience"— which makes him dangerous. He doesn't hurt Evelyn by "trying to help," as he claims happened before in Chinatown: What does harm is his insistent, arrogant need to know, to simplify, to name, to solve. He cannot in fact tolerate truth, with its nuances and reversals, its contradictions and multiplicity.

> I'll tell you the truth.
> Good. What's her name?
> Katherine.
> Katherine who?
> She's my daughter.
> (He slaps her.) I said I want the truth.
> She's my sister.
> (He slaps her.)
> She's my daughter (slap), my sister, my daughter (two slaps).
> I SAID I WANT THE TRUTH.
> (He throws her against the wall.)
> (Weeping.) She's my sister *and* my daughter. . . . My father and I . . .
> Understand? Or is it too tough for you?
> He raped you?
> (She shakes her head.)

What he's forced up from the garden pond is the unspeakable.

The rest is denouement. Dwarfed by a vast and powerful malevolence, Gittes becomes the "operative" we first met, delivering Evelyn to Noah Cross, and then handcuffed to Loach (the deputy he has twice antagonized), who shoots and kills her. In Chinatown, Polanski films him in tight close-up from the left, with his wound, and his wasted lesson, front and center. Then the music comes up and he's led away, into the curious, uncomprehending crowd.

GEOFFREY WOLFF

GETTING IT:
CARNAL KNOWLEDGE

DIRECTED BY MIKE NICHOLS

Men I hung out with must have heard the far-off thunder years before, but by 1971, when Mike Nichols's *Carnal Knowledge* was released, we couldn't ignore the storm. At symposiums, at the dinner table, in bed—women were furious and in full cry: questioning (Why should I? Why shouldn't I? Who needs it?); exhorting (Be free, sisters! Grow up, boys!); complaining (about wages, physiology, macho mind-set, musk); repudiating (marriage, motherhood, housekeeping, men).

A quarter century ago it was disconcerting to watch Jack Nicholson play Jonathan, a prisoner of sex, a pussy hound treed by the game he chased. Viewed through the optic of that time's sexual politics, the poor sap's progressive decline into foolishness, mopery, and impotence invited a judgment upon him that felt oddly distanced, like the QED of a moral allegory in which the prosecutor failed to identify himself—myself, really—as an accomplice.

Years after its release I settled in to watch *Carnal Knowledge* with a friend, and prepared to indict Jonathan again. This time the movie bushwhacked me, shocked me with recognition. It is after all not a movie meant to confirm generalized woman's darkest suspicions of generalized man. It's instead about a distinctive American caste (privileged college graduates) living through a particular time (from the end of World War II to the late sixties). The proprietary idiocy of Jonathan and his Amherst roommate, Sandy (Art Garfunkel), is the consequence of a singular culture's particular way of regarding sex and, more important, power.

The culture of the fifties served the self above all masters—but more urgently (or innocently) so than now. The moral of *Carnal Knowledge* today, unclouded by the thunderheads of women's liberation, looks clear and bleak: The unaccompanied self is a scourge. Jules Feiffer's screenplay and Mike Nichols's direction, together with the costumes and props, make a comprehensive inventory of my generation's idiom and artifacts, of middle-class manners, totems, taboos, and missions. To see the movie now is to look in what Nabokov named "memory's rearview mirror," to see myself and my pals, to hear us bullshitting about women, wondering what they wanted and what we could trick out of them.

Sandy's and Jonathan's saddle shoes, baggy flannels, tweed jackets, V-neck sweaters, and three-piece suits worn with narrow ties precisely situate *Carnal Knowledge* on campus and in time. It is fixed in spirit (cool) by the chums' droopy eyelids and smirky leers. Like every Joe College then, Sandy aches to lose his cherry, though sometimes he crabs that an unspecified "they" unjustly pressure him to get laid. He's the roommate who wears pajamas, so he apprentices himself to Jonathan, who sleeps bare-assed and itches to lose *his* cherry.

To "get in," to have had "it," to grab "it" is their entire preoccupation.

I recall strategy sessions with roommates, the lists I made during lectures on *Paradise Lost* or *The Faerie Queene* of girls I had known, ranked according to which base they had let me reach. Like us then, Jonathan and Sandy classify "nice" versus "hot," "hot" versus "beautiful"; they cerebrate the ultimate epistemological conundrum: Which is better, to be loved by it or to "bang" it?

"It" is first seen at an Amherst-Smith mixer, embodied in Susan (Candice Bergen) encased in a plaid wool skirt and soft sweater. "I'm Getting Sentimental Over You" plays; Jonathan smirks, advises Sandy to go after Susan, to throw her a line, to trade on his (bogus) unhappy childhood. Sandy and Susan instead stiffly discuss parties, how much they hate them. (Every partygoer in those days hated parties; "I never go to parties," said boys and girls at parties.) The newlymets discuss masks and disguises, the "real me" and—less interestingly—the "real you." The usual. Sandy has an inkling he might score, as he of course tells Jonathan, who then wants Susan. "She's mine," Sandy whines. "You gave her to me."

This world's women are organs and orifices, possessions merely—once possessed. (Aye, there's the rub!) Jonathan and Sandy are consumers competing for the only available piece of something; this is called a triangle. Jonathan seduces Susan, which Sandy intuits years later. Jonathan believes that his line snags her, assures her that his father is a communist (wooing her, a Republican's daughter, on the bohemian platform) and lifelong failure (setting up a fallback position on the pity front, a play for a mercy fuck). "After I get set up as a lawyer," he says, "what I'd really like to do is go into politics—public service." Whatever. They do it under the stars, groaning unhappily. Oh Christ, oh Jesus, *this* is it? Afterward, freed from virginity, Jonathan rolls off her. He looks bewildered, disappointed, as though he had tunneled into a locked vault, digging with his fingers to get the treasure, had *made* it, had found locked in there . . . nothing. He's already a goner. He wants what we wanted then, to be hooked up (when he wants to be hooked up) and to go solo (when he wants that); he doesn't know what he wants or why he wants it.

Jonathan tells Sandy that he's scored but not with whom. This is another attainment, fruition of will; it's of a piece with Jonathan's mission to be a lawyer, Sandy's to be a doctor. They neither to-and-fro about these

ambitions nor fret about whether they will succeed. They move forward, taking ground; now Sandy must have what Jonathan has had. His campaign is inexorable, responsive only to the logic of progress. He moves from base to base, raising the stakes: A kiss today must be followed by a touch tomorrow, covered tit by bare, a touch by a taste, this thing by the next. Feiffer and Nichols have the desperate folly of that time tone-perfect: the glancing allusion to rubbers ("Do you have anything?"), lover's nuts, geographical confusion (here? there? where?) climaxing through the escape hatch of a hand job after failed appeals to "friendship."

I remember that pigheaded dexterity, yearning from the backseat for three hands, praying that she'd fall asleep (better, pretend to fall asleep!), the bodacious ta-ta gestalt, the farcical battles fought as though the stakes were high. It encouraged in us boys sharp wits and dull vision, an eye for the near opening rather than the far goal. "I love you," Sandy says. "Let's do it."

Sandy scores, but not before Susan pleads with him: "How can it be fun if you know I don't want it?"

Sandy is too busy with his hands to reply, but when I first saw *Carnal Knowledge* a male friend answered for him from the crowded theater: "You supply the pussy, I'll supply the fun." "Amen!" came a cry from the balcony. Watching years later with that same friend, I asked what he thought now of Susan's question. We're at my place, running the VCR, but we check the room for "them" or their representatives before we speak; my friend and I were not alone in the viewing room with Susan's question: "Sensible question from the woman," said my friend, grinning a secret agent's inscrutable grin: Bullshit artist.

"Bullshit artist!" is the movie's chorus cry, what Sandy and Jonathan call each other. Tracking "it" is dark and lonely work, a man's got to do what a man's got to do, and a man doing it can't afford to be softened by the truth. Truth will finally soften Jonathan, though, in the most awful way. The first truth to reach him is that Susan never cared about his line, personality, mind. She used him; he was what we now know as a sex object, a sex toy. Apprehending this before he's even a college grad, he sees what's waiting down the line. The horror, the horror. About to marry Sandy, Susan says: "Jonathan, I'll always be your friend." Dear Jonathan replies: "Jesus, I hope not."

A few scenes later Jonathan begins to manipulate the movie's signature line, a litany of self-pity that is more an expression of fifties misogyny than of subsequent wimpery: women are "ball busters," women "today" (whenever he chances to make the observation) "are better hung than the men."

After college Jonathan's a lawyer, making a bundle; Sandy's a doctor, making a bundle. Boys back then, we did okay, we made out. But the myth of eternal progress was a myth, as *Carnal Knowledge* shows; progressing by the rake's decline, sure as gravity. Time, history, and detail are inferred by jump-cuts, Glenn Miller to Ol' Blue Eyes to Ravi Shankar. If you've heard of entropy and the Second Law of Thermodynamics, if you've heard of growing old, you're wise to these jokers' fate.

We don't see their marriages, their divorces. At lunch Jonathan tells Sandy he's worn down by one-night stands, wouldn't mind putting together a family, like Sandy's even. He tells Sandy he's met a girl, Bobby (Ann-Margret). "I could get serious, she's a lot of fun." By which he means she's got a fine rack and puts lead in his pencil. "But you know girls," Jonathan complains. "They judge you." (To which that fellow roosting in the balcony back in 1971 would have called out, "Preach the gospel, brother!" Today, after years of consciousness-tuning, that guy would have to wonder: Why shouldn't they judge us? God knows we judge them, part by part, piece by piece.)

Jonathan and Bobby (nice name, no?) shack up, but not before he sets limits to his encumbrance. He wants to face-up his cards on the bedside table so "there can be no possibility of a misunderstanding. I don't know how many business deals I've seen come to grief because the parties misunderstood each other." He wants what he wants, which is her because he wants her. Bobby quits her job, lies in bed, dreams about being a mother. He spends a lot of time in the shower, alone. He advises her to get a job.

"I don't want a job," she says. "I want you."

"I'm taken! By me!"

One night, late sixties now, Sandy shows up at Jonathan's white-on-white bachelor penthouse to watch a slide show, the history in pictures of Western love between men and women of my generation, the Silent, Smug, Cunning, Can-Do Generation. Women and kids, "girls" every one, flash on the screen; this one Jonathan "banged," that one busted his balls.

Sandy and his latest, a fruit-and-nut eater (Carol Kane) from Greenwich Village, deplore Jonathan's bad character. Sandy wears blue jeans, has had his spirituality nourished, has been laid plenty. He's a bullshit artist too, that pathetic figure of that time after the Great Pussy Drought ended, the born-again feminist looking to score. He tells Jonathan about his partner, Jennifer, in Jennifer's hearing: "She knows more at eighteen than we do. She's my love teacher."

After the slide show Jonathan goes to a whore (Rita Moreno), gives her a hundred dollars. If she says the right words, tells him how blameless he is and how wrongful women are, maybe he can get it up. I said *maybe*. Bullshit artist! His balls are broken. His heart is broken. What he did, what we did—a weird way to put in hours. The unaccompanied self is a pathetic tool, as funny as a rubber crutch.

CONTRIBUTORS

Julian Barnes is the author of eight novels, most recently *England, England,* and a collection of short stories, *Cross Channel.* He lives in London.

Rick Bass is the author of sixteen books of fiction and nonfiction, including *Winter, The Lost Grizzlies, In the Loyal Mountains,* and *The Sky, the Stars, the Wilderness.* He lives in Montana.

Charles Baxter is the author of four books of stories, three novels (most recently *The Feast of Love,* published by Pantheon), and a book of essays on fiction, *Burning Down the House,* published by Graywolf. He teaches at the University of Michigan and lives in Ann Arbor.

Anne Carson is the author of six books of essays and poetry, including *Eros the Bittersweet, Autobiography of Red,* and, most recently, *Men in the Off Hours.* She lives in Canada.

J. M. Coetzee was born in South Africa in 1940. He is the author of eight novels (most recently, *Disgrace* [Viking, 1999]), and numerous works in other genres. He is Distinguished Professor of Literature at the University of Cape Town and a member of the Committee on Social Thought at the University of Chicago.

Robert Coover is the author of numerous works of fiction, including *A Night at the Movies, Pricksongs and Descants*, and *The Public Burning*. He teaches electronic and experimental writing at Brown University.

Stephen Dobyns has published ten books of poems, twenty novels, a book of essays on poetry (*Best Words, Best Order*), and a book of short stories (*Eating Naked*). His most recent book of poems is *Pallbearers Envying the One Who Rides*. His most recent novels are *Boy in the Water* and *The Church of Dead Girls*. He lives near Boston.

Deborah Eisenberg is the author of six books, including a play, *Pastorale*, and four collections of stories, most recently *All Around Atlantis* and *The Stories (So Far) of Deborah Eisenberg*. She lives in New York City and teaches at the University of Virginia.

Ron Hansen is the author of the novels *Hitler's Niece, Atticus, Mariette in Ecstasy, The Assassination of Jesse James by the Coward Robert Ford*, and *Desperadoes*, and the short story collection *Nebraska*, for which he received an Award in Literature from the American Academy and Institute of Arts and Letters. He lives in Northern California, where he is Gerard Manley Hopkins, S.J., Professor in the Arts and Humanities at Santa Clara University.

Edward Hirsch's most recent books are *On Love: Poems* (1998) and *How to Read a Poem (and Fall in Love with Poetry)* (1999). He is a 1998 MacArthur Fellow and teaches in the Creative Writing Program at the University of Houston.

Richard Howard, whose eleventh book of poems, *Trappings*, was published in 1999, is a translator and a critic as well; he teaches literature in the Writing Division of Columbia University's School of the Arts.

Philip Levine is the author of numerous books of poetry, including most recently *What Work Is, New Selected Poems*, and *The Mercy*. He lives in Fresno, California.

Margot Livesey was born and grew up on the edge of the Scottish Highlands and now divides her time between London and Massachusetts, where she presently teaches at Emerson College. She is the author of a collection of stories and three novels, *Homework, Criminals*, and, most recently, *The Missing World*.

Phillip Lopate has written essay collections (*Bachelorhood, Against Joie de Vivre, Portrait of My Body*), novels (*Confessions of Summer, The Rug Merchant*), and books of poetry (*The Eyes Don't Always Want to Stay Open, The Daily Round*). His most recent book is a collection of writings on film, *Totally Tenderly Tragically*. He is a professor at Hofstra University, and has served on the Selection Committee of the New York Film Festival.

Rick Moody is the author of the novels *The Ice Storm* and *Purple America*, and two collections of stories, *The Ring of Brightest Angels Around Heaven* and *Demonology*.

Lorrie Moore is the author of two novels and three short story collections, including most recently *Birds of America*. She is a professor of English at the University of Wisconsin at Madison.

Francine Prose is the author of a collection of essays, books for children, short-story collections, and novels. Her most recent book is *Blue Angel*, a novel.

Lawrence Raab is the author of five collections of poetry, including *What We Don't Know About Each Other*, a winner of the National Poetry Series and a finalist for the National Book Award, and most recently *The Probable World* (Penguin, 2000). He teaches literature and creative writing at Williams College.

Salman Rushdie is the author of numerous works of fiction, including his most recent novel, *The Ground Beneath Her Feet*.

Michael Ryan is Professor of English and Creative Writing at the University of California at Irvine. His poetry has won the Lenore Marshall Prize, a National Book Award Nomination, a Whiting Writers Award, NEA and Guggenheim Fellowships, and the Yale Series of Younger Poets Award. His autobiography, *Secret Life*, was a New York Times Notable Book for 1995, and *A Difficult Grace: On Poets, Poetry, and Writing* was published by the University of Georgia Press.

Jim Shepard is the author of five novels, including most recently *Nosferatu*, and one collection of stories, *Batting Against Castro*. He teaches at Williams College.

Charles Simic has published fourteen collections of his own poetry—including most recently *Jackstraws* and *Selected Early Poems*—five books of essays and memoirs, and numerous books of translations. He has received numerous literary awards for his poems and his translations, including the MacArthur Fellowship and the Pulitzer Prize. He teaches American literature and creative writing at the University of New Hampshire.

Susan Sontag has written novels, stories, essays, and plays; written and directed movies; and worked as a theater director in the United States and Europe. Her most recent book is *In America*, a novel. A new collection of essays, *Where the Stress Falls*, will be published early next year. She is working on another novel. The essay in this volume first appeared in September 1983 in *Vanity Fair*.

Robert Stone is the author of six novels—including his most recent, *Damascus Gate*—and one collection of stories, *Bear and His Daughter*.

Ellen Bryant Voigt is the author of five volumes of poetry—*Claiming Kin, The Forces of Plenty, The Lotus Flowers, Two Trees,* and *Kyrie,* a National Book Critics Circle Award Finalist—and *The Flexible Lyric,* a collection of essays on the craft of poetry. She teaches at the Warren Wilson College low-residency MFA Program for Writers and is currently the Vermont State Poet.

Geoffrey Wolff's nine books include *The Duke of Deception,* so inevitably he hangs his dreams on a hat peg in the movie capital. While he waits for his neighbors to come to their senses and spin one of his publications into gold, he directs the MFA Program in Writing at the University of California at Irvine. (Film rights to his most recent novel, *The Age of Consent,* are thought to be available.)